STYLE ON THE STREET
from TOKYO and beyond
by Rei Shito

Colophon

First published in the United States of America in 2020
by Rizzoli International Publications, Inc.
300 Park Avenue South
New York, NY 10010
www.rizzoliusa.com

Style on the Street: From Tokyo and Beyond

Copyright © 2020 Rei Shito
Texts: Rei Shito, Chitose Abe, Motofumi "Poggy" Kogi and Scott Schuman

For Rizzoli:

Editor: Ian Luna
Project Editor: Meaghan McGovern
Design Coordination: Olivia Russin
Production Manager: Kaija Markoe
Copy Editor and Proofreader: Angela Taormina

Publisher: Charles Miers

For Rei Shito:

Editors: RCKT/Rocket Company* (Yukari Ohyama, Yusuke Osawa,
 Ayako Ikegame, Yui Nogiwa) + Toshiko Nakashima + Makoto
Art Direction & Book Design: Ryohei Kaneda (YES Inc.)
DTP Operation: Itaru Mizutani
Illustration: Yoshifumi Takeda
Interview Text: Mari Fukuda and Ayumi Kinoshita
Translation: Marie Iida
Contribution: Adastria Co., Ltd.

Rizzoli would like to thank the support of the following individuals
for their invaluable assistance: Kaori Oyama, Marie Iida and Taichi Watanabe.

Printed in China

2024 2025 2026 / 10 9 8 7 6 5 4

ISBN: 978-0-8478-6872-8
Library of Congress Control Number: 2020940917

Visit us online: Facebook.com/RizzoliNewYork
Twitter: @Rizzoli_Books
Instagram.com/RizzoliBooks
Pinterest.com/RizzoliBooks
Youtube.com/user/RizzoliNY
Issuu.com/Rizzoli

STYLE
ON THE STREET

from TOKYO and

beyond by Rei Shito

RIZZOLI
NEW YORK

New York · Paris · London · Milan

Fashion is a kind of philosophy.

That is one of the things I've felt while taking pictures around the world as a street photographer and journalist. In the process of documenting street fashion, I've learned many important things about life.

The first lesson is that there is no such thing as the right answer in fashion.

No matter who wears what, when, or how, there is no right or wrong—good or bad. The criterion for judging fashion should always be, "Do you like it or not?" This criterion is personal and liberal; it is not something to be forced upon other people.

Even if your tastes and preferences are different from others, if you feel that you love something,

it's best to commit to it. Other people's opinions are just that—opinions. What matters is that you take initiative when deciding what you wear.

When you realize that you have initiative, the way you live will take a 180-degree turn. From a passive way of life, you'll become more active and positive.

Fashion has a power to change your life.

The second lesson is that mastering fashion not only leads to self-affirmation, but it also teaches you to be more forgiving of others.

To be concerned about the way you look on the outside is to appreciate yourself. You are treating yourself with love and care.

Self-love and self-care lead to self-affirmation,

allowing you to be more confident. Confidence also gives you the space you need in your heart to be kinder to others.

Fashion is often talked about as a superficial subject, especially as a means to compare yourself with others. Yet, at its core, fashion provides an opportunity to live your ideal life, a life that affirms who you are. In other words, it is a way to confront yourself. It is a kind of philosophy.

That, to me, is the essence of fashion.

The foundational principle of a journalist is to "capture and communicate the truth." The photos in this book were taken in the spirit that has been passed down from great mentors such as Bill Cunningham and also Shoichi Aoki, the creator of Street magazine who first guided me into this world.

My objective is not to take beautiful photos or capture a cool moment. My stance is to capture fashion "as it is" in its most real form. That is my policy.

Contained within these pages are not fashion that belongs in a highly editorialized fantasy world. The real styles from the streets are overflowing with tips and hints that can be immediately incorporated so that you can take your own fashion one step further. The book also explains behind the idea that "It's not what you wear, but how you wear it."

I hope that this book will become a way for you, dear reader, to live each day with abundance, comfort, laughter, and happiness.

Enjoy fashion!

Contents

SMALL STORIES

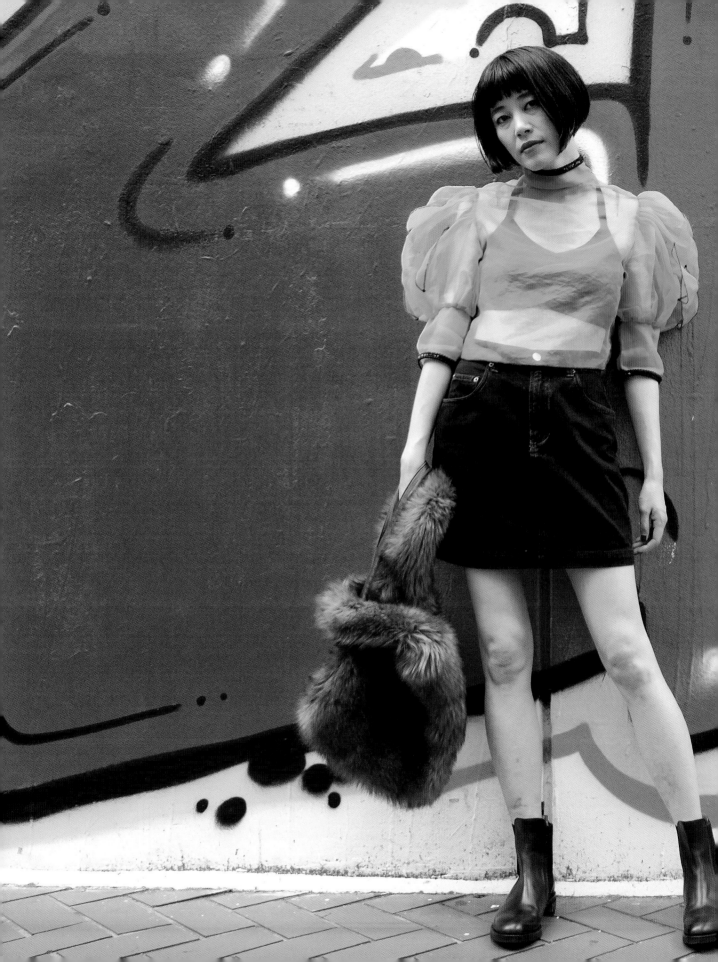

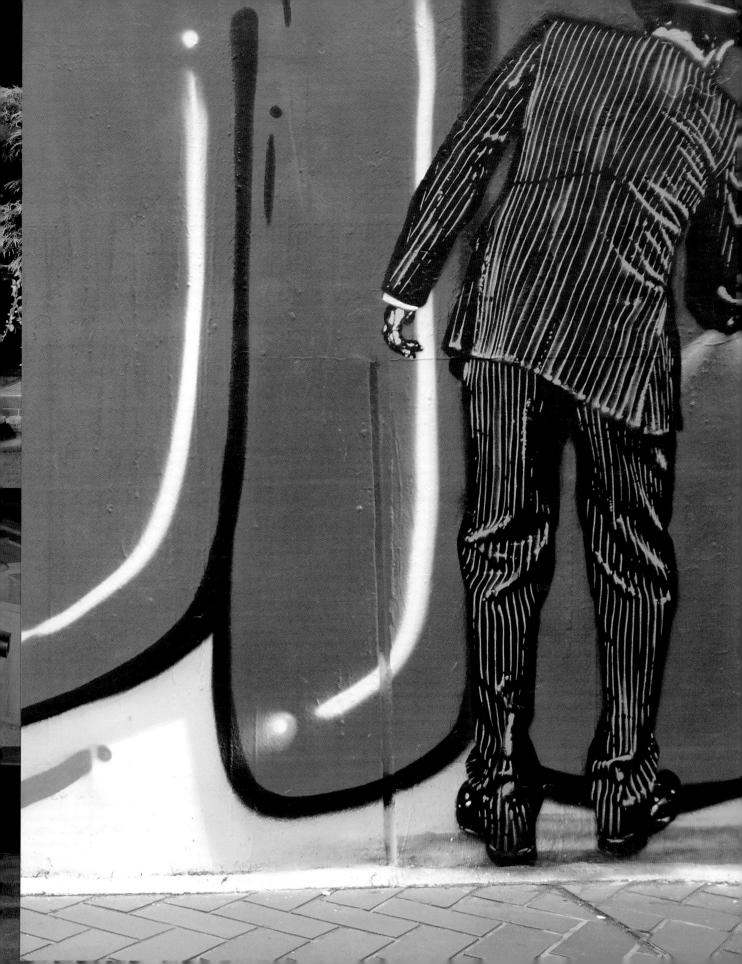

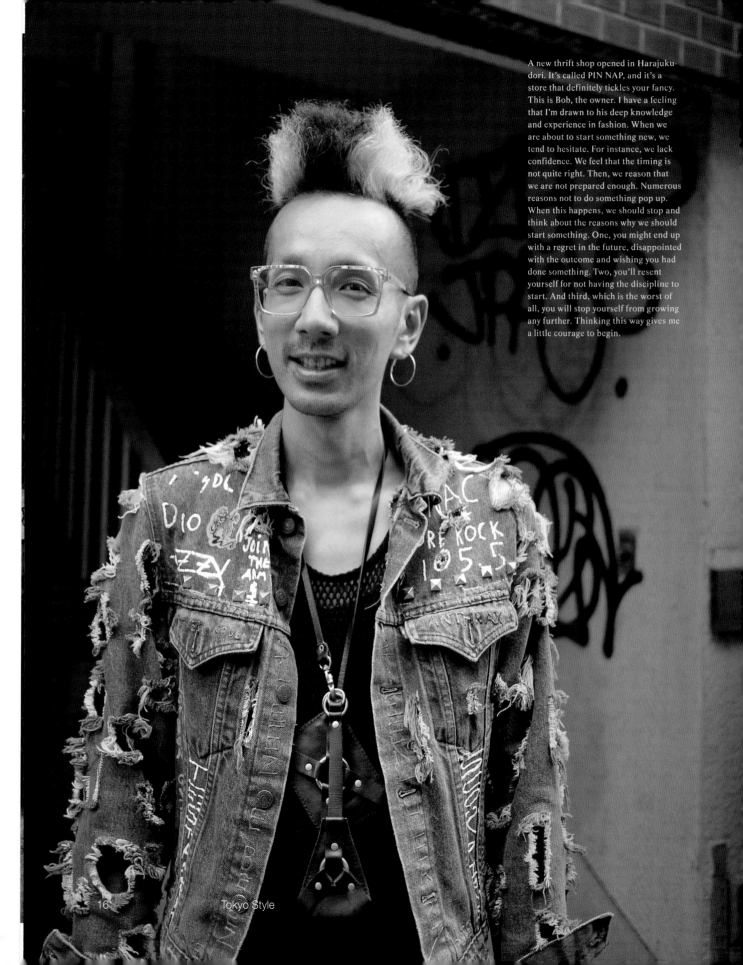

A new thrift shop opened in Harajuku-dori. It's called PIN NAP, and it's a store that definitely tickles your fancy. This is Bob, the owner. I have a feeling that I'm drawn to his deep knowledge and experience in fashion. When we are about to start something new, we tend to hesitate. For instance, we lack confidence. We feel that the timing is not quite right. Then, we reason that we are not prepared enough. Numerous reasons not to do something pop up. When this happens, we should stop and think about the reasons why we should start something. One, you might end up with a regret in the future, disappointed with the outcome and wishing you had done something. Two, you'll resent yourself for not having the discipline to start. And third, which is the worst of all, you will stop yourself from growing any further. Thinking this way gives me a little courage to begin.

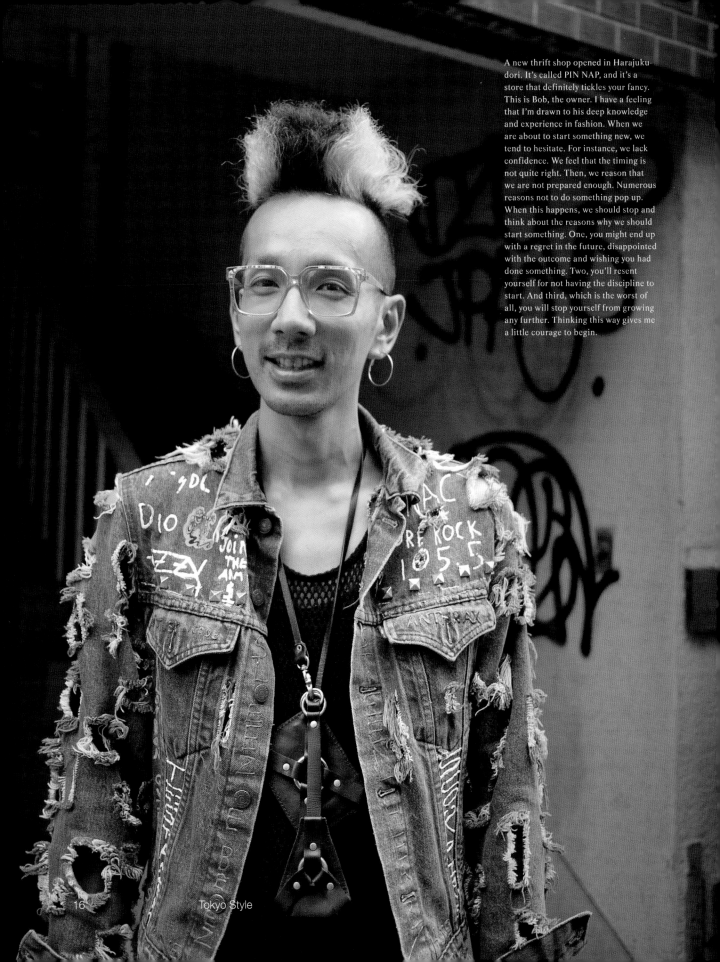

A new thrift shop opened in Harajuku-dori. It's called PIN NAP, and it's a store that definitely tickles your fancy. This is Bob, the owner. I have a feeling that I'm drawn to his deep knowledge and experience in fashion. When we are about to start something new, we tend to hesitate. For instance, we lack confidence. We feel that the timing is not quite right. Then, we reason that we are not prepared enough. Numerous reasons not to do something pop up. When this happens, we should stop and think about the reasons why we should start something. One, you might end up with a regret in the future, disappointed with the outcome and wishing you had done something. Two, you'll resent yourself for not having the discipline to start. And third, which is the worst of all, you will stop yourself from growing any further. Thinking this way gives me a little courage to begin.

This spot in front of the Comme des Garçons store in Aoyama is my favorite place to shoot. There is a tiny shrine next to it, and sometimes there are people who stop by to pay their respects. They stroll through the gates and into the shrine casually, as if they are going to buy a cup of takeout coffee. Whenever I see a resident of Aoyama walk by, I am moved by the sense of courtesy that lies at the heart of Japan. In a good way, this place in Aoyama feels out of place. Mode meets tradition. Countless tourists from overseas and lifelong residents. Modesty and the avant garde. A city in transition and a shrine that—presumably, hopefully—will stand the test of time, surpassing the generations.

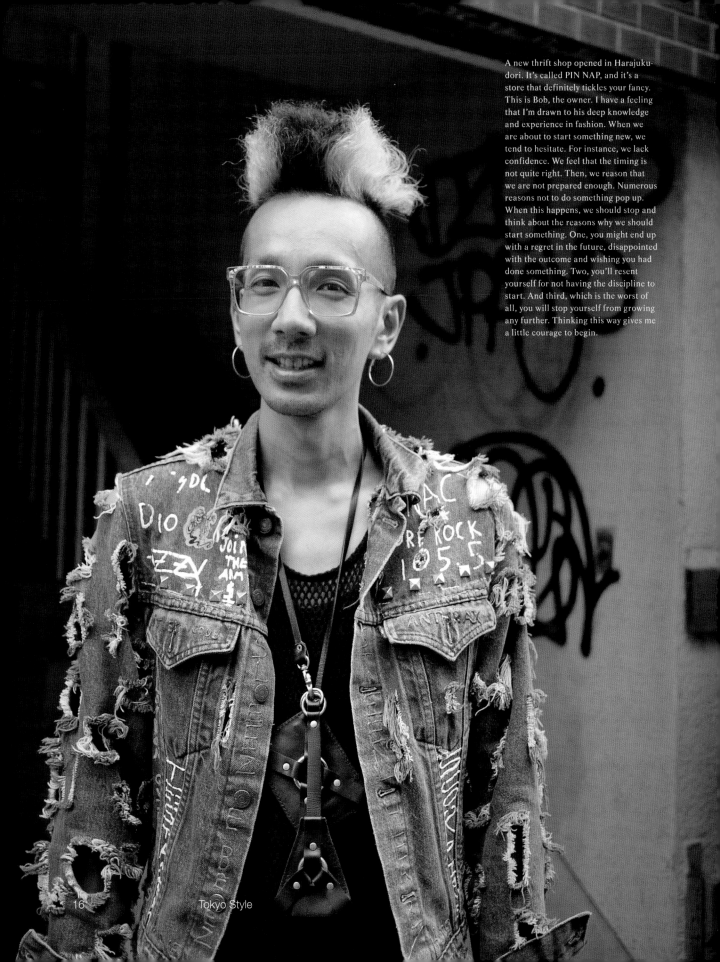

A new thrift shop opened in Harajuku-dori. It's called PIN NAP, and it's a store that definitely tickles your fancy. This is Bob, the owner. I have a feeling that I'm drawn to his deep knowledge and experience in fashion. When we are about to start something new, we tend to hesitate. For instance, we lack confidence. We feel that the timing is not quite right. Then, we reason that we are not prepared enough. Numerous reasons not to do something pop up. When this happens, we should stop and think about the reasons why we should start something. One, you might end up with a regret in the future, disappointed with the outcome and wishing you had done something. Two, you'll resent yourself for not having the discipline to start. And third, which is the worst of all, you will stop yourself from growing any further. Thinking this way gives me a little courage to begin.

This spot in front of the Comme des Garçons store in Aoyama is my favorite place to shoot. There is a tiny shrine next to it, and sometimes there are people who stop by to pay their respects. They stroll through the gates and into the shrine casually, as if they are going to buy a cup of takeout coffee. Whenever I see a resident of Aoyama walk by, I am moved by the sense of courtesy that lies at the heart of Japan. In a good way, this place in Aoyama feels out of place. Mode meets tradition. Countless tourists from overseas and lifelong residents. Modesty and the avant garde. A city in transition and a shrine that—presumably, hopefully—will stand the test of time, surpassing the generations.

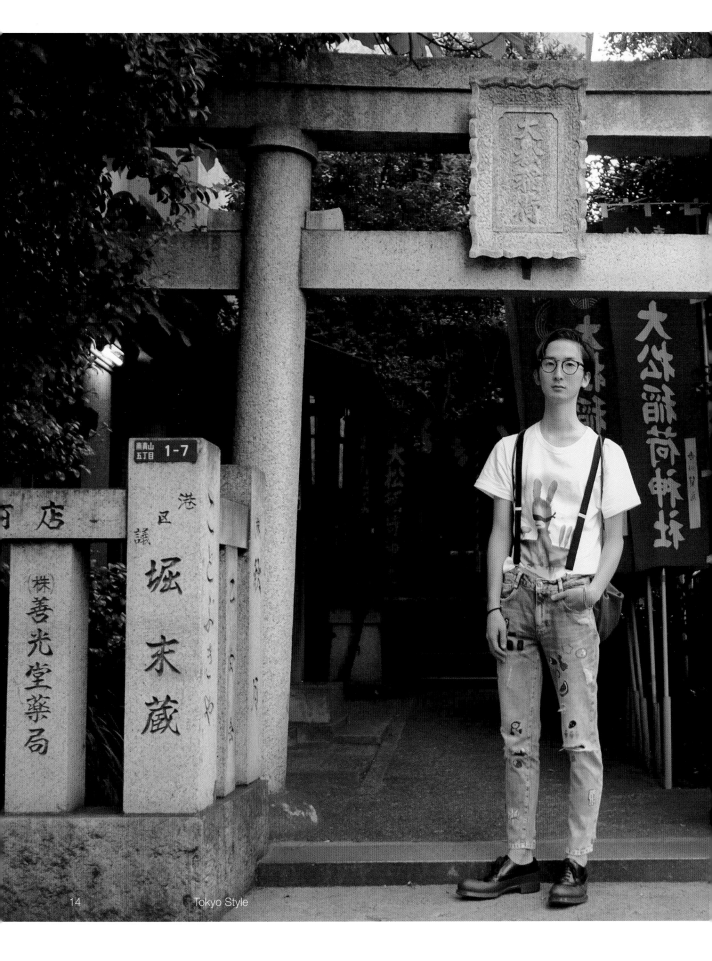

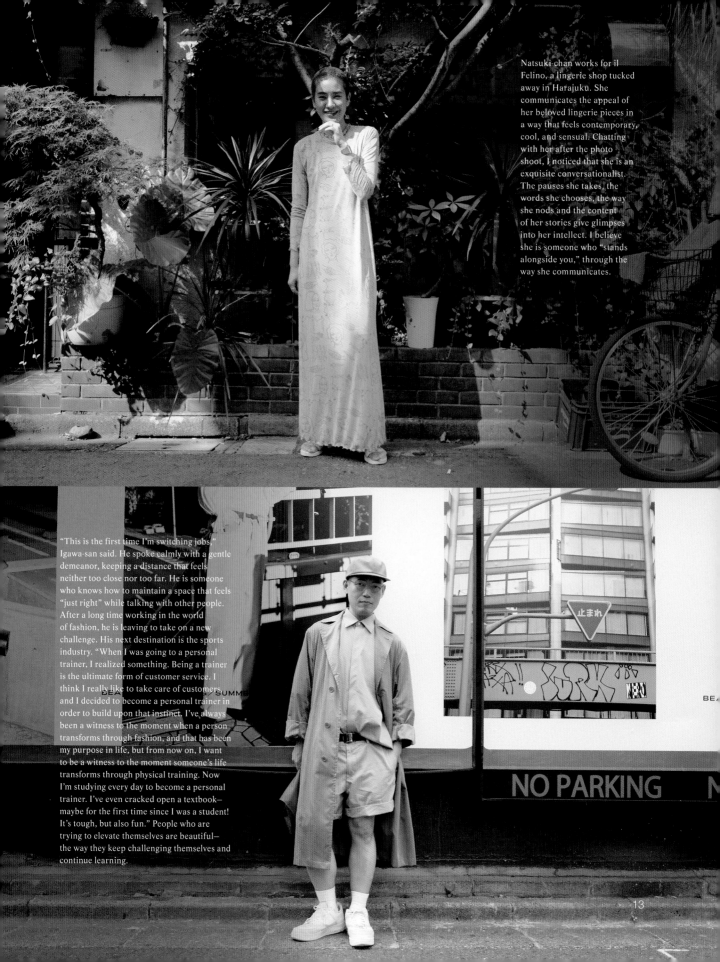

Natsuki-chan works for il Felino, a lingerie shop tucked away in Harajuku. She communicates the appeal of her beloved lingerie pieces in a way that feels contemporary, cool, and sensual. Chatting with her after the photo shoot, I noticed that she is an exquisite conversationalist. The pauses she takes, the words she chooses, the way she nods and the content of her stories give glimpses into her intellect. I believe she is someone who "stands alongside you," through the way she communicates.

"This is the first time I'm switching jobs," Igawa-san said. He spoke calmly with a gentle demeanor, keeping a distance that feels neither too close nor too far. He is someone who knows how to maintain a space that feels "just right" while talking with other people. After a long time working in the world of fashion, he is leaving to take on a new challenge. His next destination is the sports industry. "When I was going to a personal trainer, I realized something. Being a trainer is the ultimate form of customer service. I think I really like to take care of customers and I decided to become a personal trainer in order to build upon that instinct. I've always been a witness to the moment when a person transforms through fashion, and that has been my purpose in life, but from now on, I want to be a witness to the moment someone's life transforms through physical training. Now I'm studying every day to become a personal trainer. I've even cracked open a textbook— maybe for the first time since I was a student! It's tough, but also fun." People who are trying to elevate themselves are beautiful— the way they keep challenging themselves and continue learning.

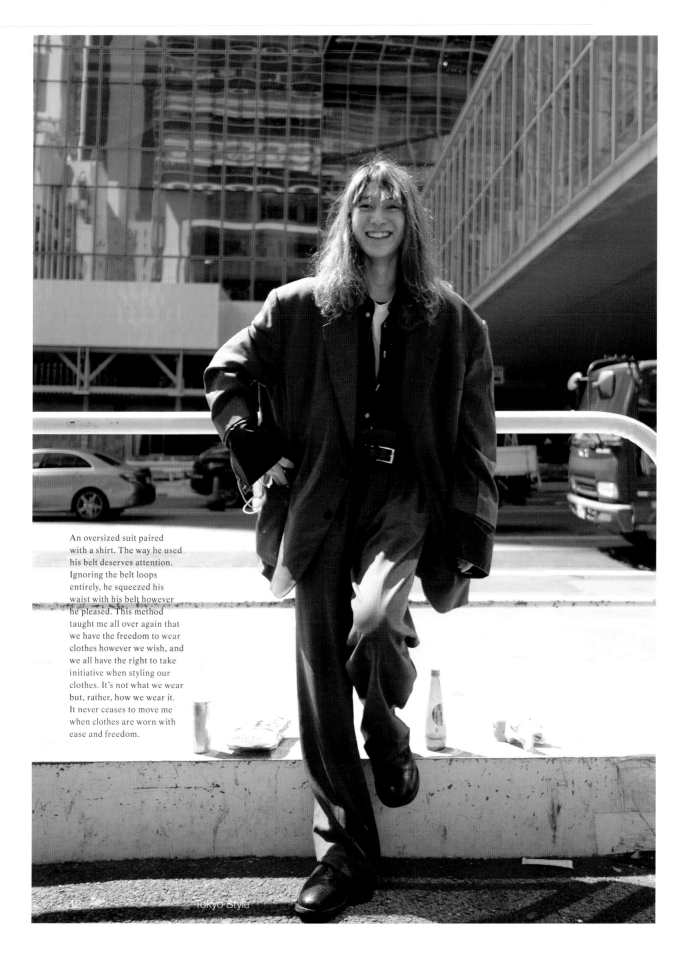

An oversized suit paired with a shirt. The way he used his belt deserves attention. Ignoring the belt loops entirely, he squeezed his waist with his belt however he pleased. This method taught me all over again that we have the freedom to wear clothes however we wish, and we all have the right to take initiative when styling our clothes. It's not what we wear but, rather, how we wear it. It never ceases to move me when clothes are worn with ease and freedom.

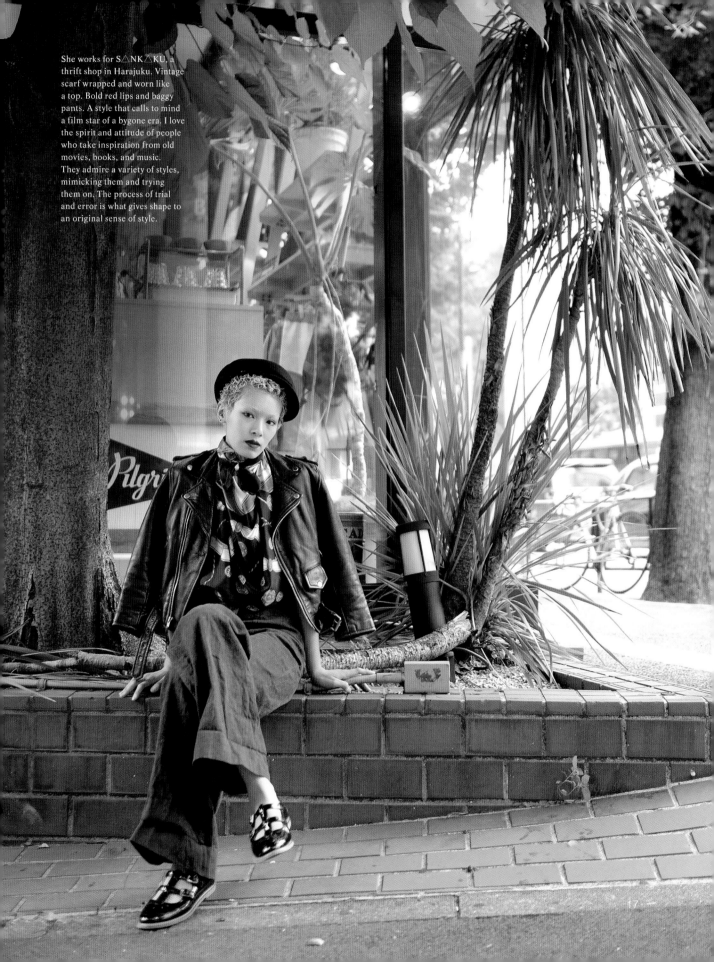

She works for S△NK△KU, a thrift shop in Harajuku. Vintage scarf wrapped and worn like a top. Bold red lips and baggy pants. A style that calls to mind a film star of a bygone era. I love the spirit and attitude of people who take inspiration from old movies, books, and music. They admire a variety of styles, mimicking them and trying them on. The process of trial and error is what gives shape to an original sense of style.

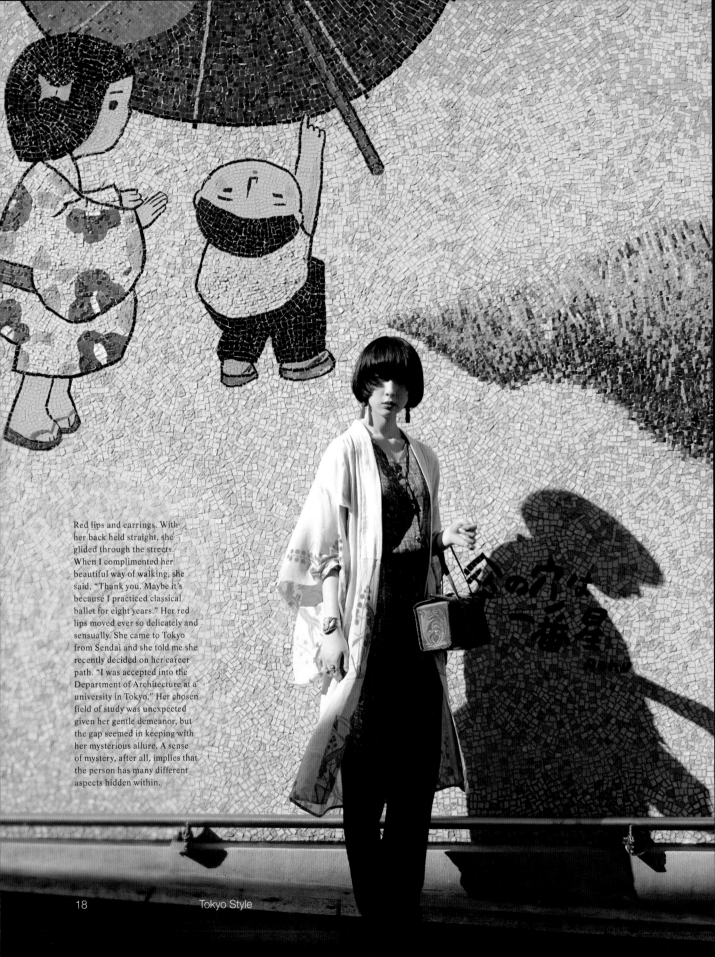

Red lips and earrings. With her back held straight, she glided through the streets. When I complimented her beautiful way of walking, she said, "Thank you. Maybe it's because I practiced classical ballet for eight years." Her red lips moved ever so delicately and sensually. She came to Tokyo from Sendai and she told me she recently decided on her career path. "I was accepted into the Department of Architecture at a university in Tokyo." Her chosen field of study was unexpected given her gentle demeanor, but the gap seemed in keeping with her mysterious allure. A sense of mystery, after all, implies that the person has many different aspects hidden within.

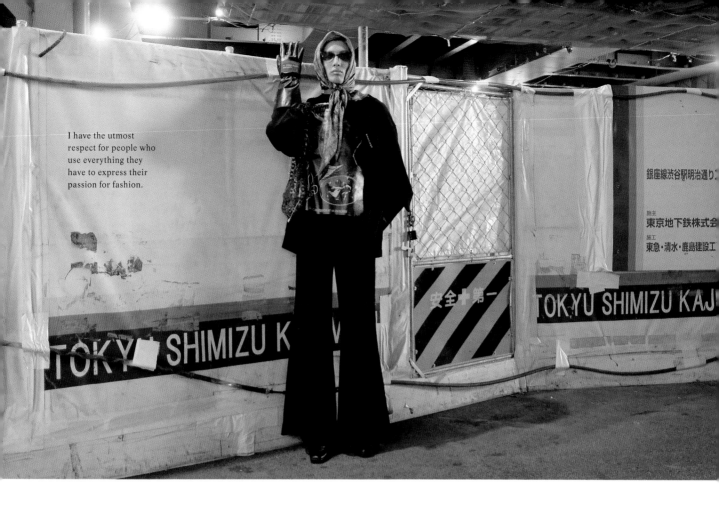

I have the utmost
respect for people who
use everything they
have to express their
passion for fashion.

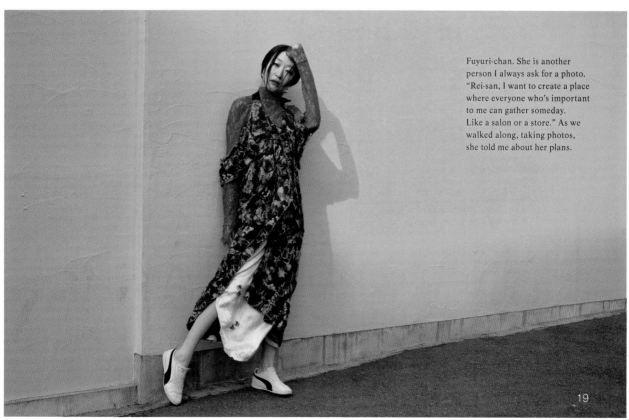

Fuyuri-chan. She is another
person I always ask for a photo.
"Rei-san, I want to create a place
where everyone who's important
to me can gather someday.
Like a salon or a store." As we
walked along, taking photos,
she told me about her plans.

19

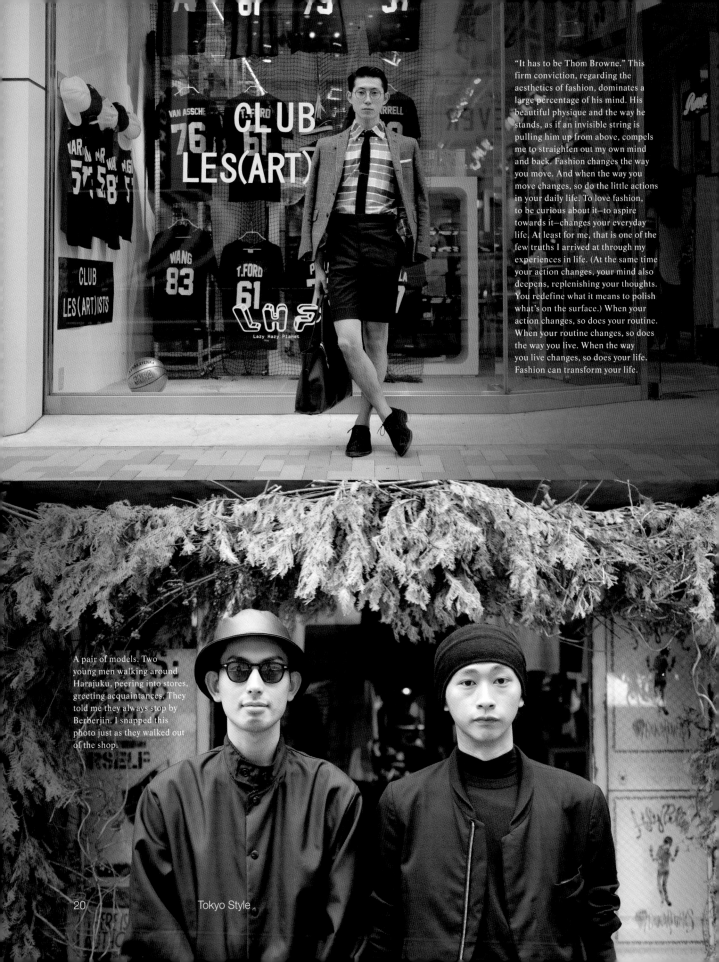

"It has to be Thom Browne." This firm conviction, regarding the aesthetics of fashion, dominates a large percentage of his mind. His beautiful physique and the way he stands, as if an invisible string is pulling him up from above, compels me to straighten out my own mind and back. Fashion changes the way you move. And when the way you move changes, so do the little actions in your daily life. To love fashion, to be curious about it—to aspire towards it—changes your everyday life. At least for me, that is one of the few truths I arrived at through my experiences in life. (At the same time your action changes, your mind also deepens, replenishing your thoughts. You redefine what it means to polish what's on the surface.) When your action changes, so does your routine. When your routine changes, so does the way you live. When the way you live changes, so does your life. Fashion can transform your life.

A pair of models. Two young men walking around Harajuku, peering into stores, greeting acquaintances. They told me they always stop by Berberjin. I snapped this photo just as they walked out of the shop.

Tokyo Style

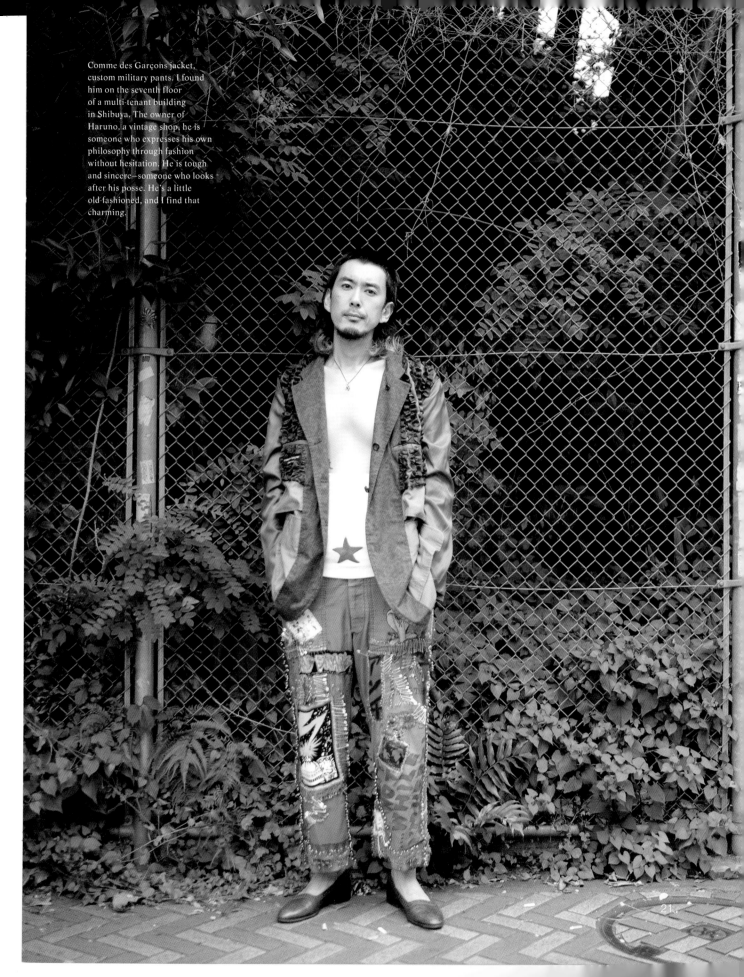

Comme des Garçons jacket,
custom military pants. I found
him on the seventh floor
of a multi-tenant building
in Shibuya. The owner of
Haruno, a vintage shop, he is
someone who expresses his own
philosophy through fashion
without hesitation. He is tough
and sincere—someone who looks
after his posse. He's a little
old-fashioned, and I find that
charming.

21.

It's been a while since I last saw Shen-chan. She has a new goal in life—to become a successful actress working overseas—and is currently working backwards from it, taking on, one by one, the challenges that will help her realize her dream. They include acting and learning another language (Chinese). "Rei-chan, acting is so interesting! It's like confronting yourself! It's about opening a part of you that you don't necessarily want to see, sort of gouging it out," she told me. "I've been working really hard these days." She talks with such refreshing candor. It's what makes her radiant and it makes me jealous in the best way.

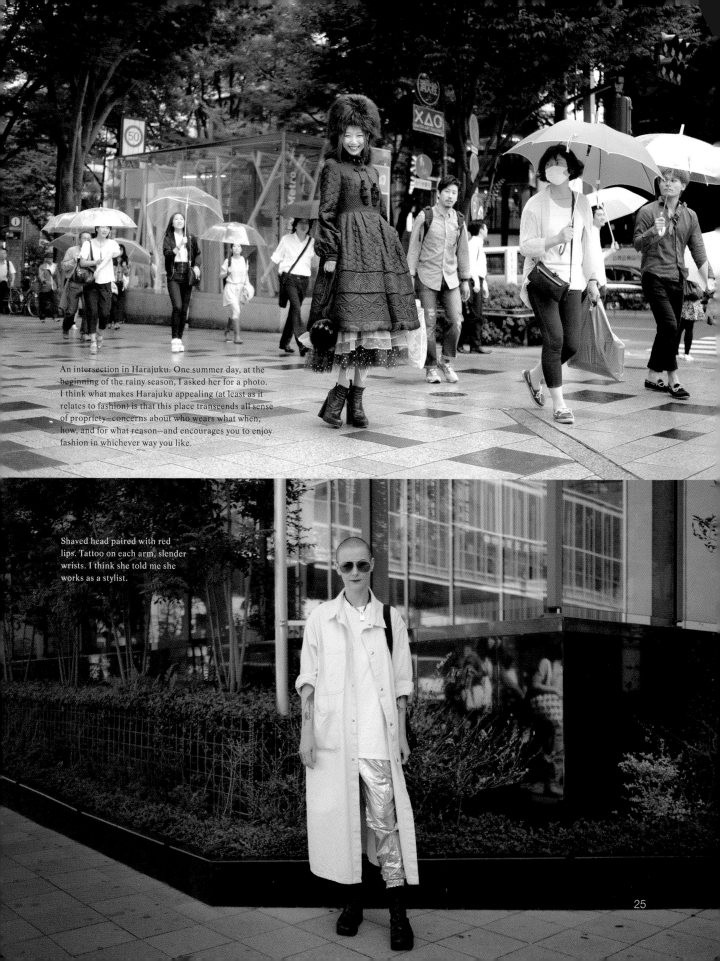

An intersection in Harajuku. One summer day, at the beginning of the rainy season, I asked her for a photo. I think what makes Harajuku appealing (at least as it relates to fashion) is that this place transcends all sense of propriety—concerns about who wears what when, how, and for what reason—and encourages you to enjoy fashion in whichever way you like.

Shaved head paired with red lips. Tattoo on each arm, slender wrists. I think she told me she works as a stylist.

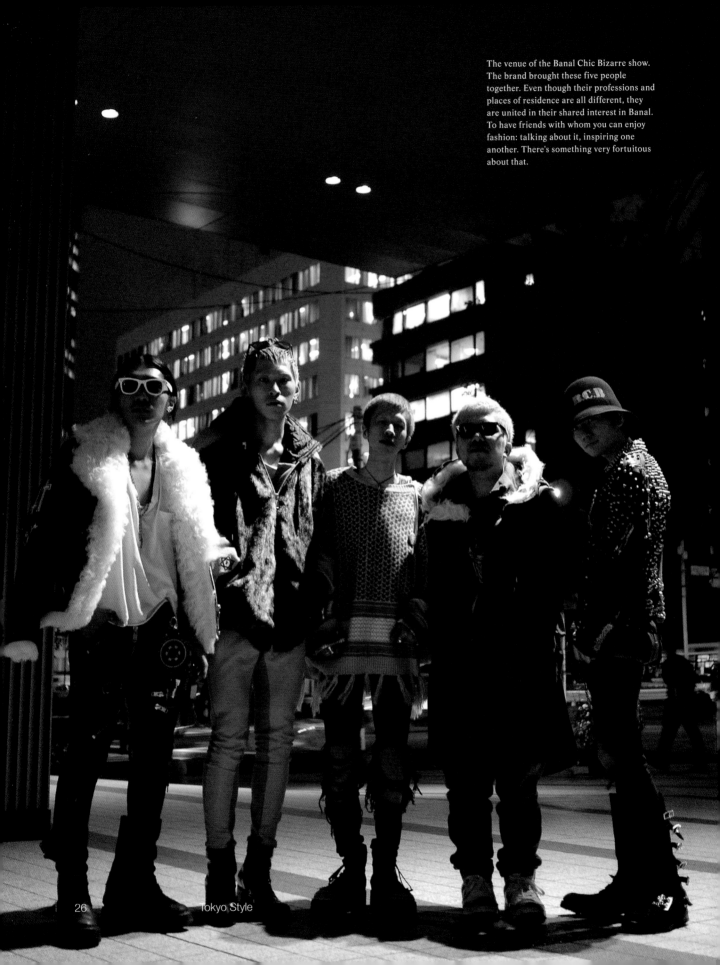

The venue of the Banal Chic Bizarre show.
The brand brought these five people
together. Even though their professions and
places of residence are all different, they
are united in their shared interest in Banal.
To have friends with whom you can enjoy
fashion: talking about it, inspiring one
another. There's something very fortuitous
about that.

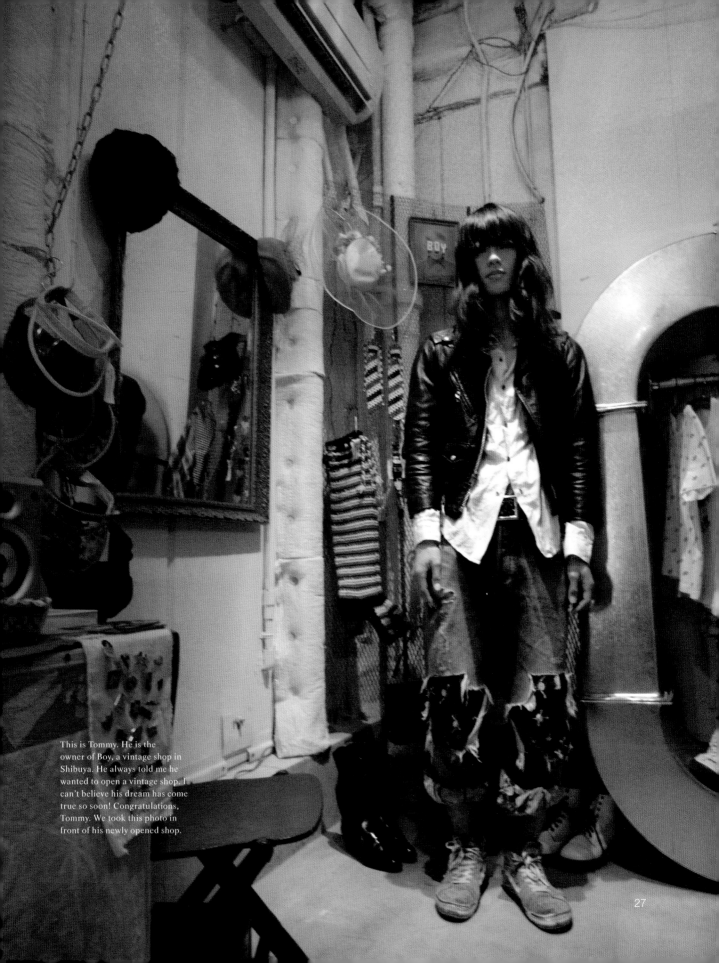

This is Tommy. He is the owner of Boy, a vintage shop in Shibuya. He always told me he wanted to open a vintage shop. I can't believe his dream has come true so soon! Congratulations, Tommy. We took this photo in front of his newly opened shop.

27

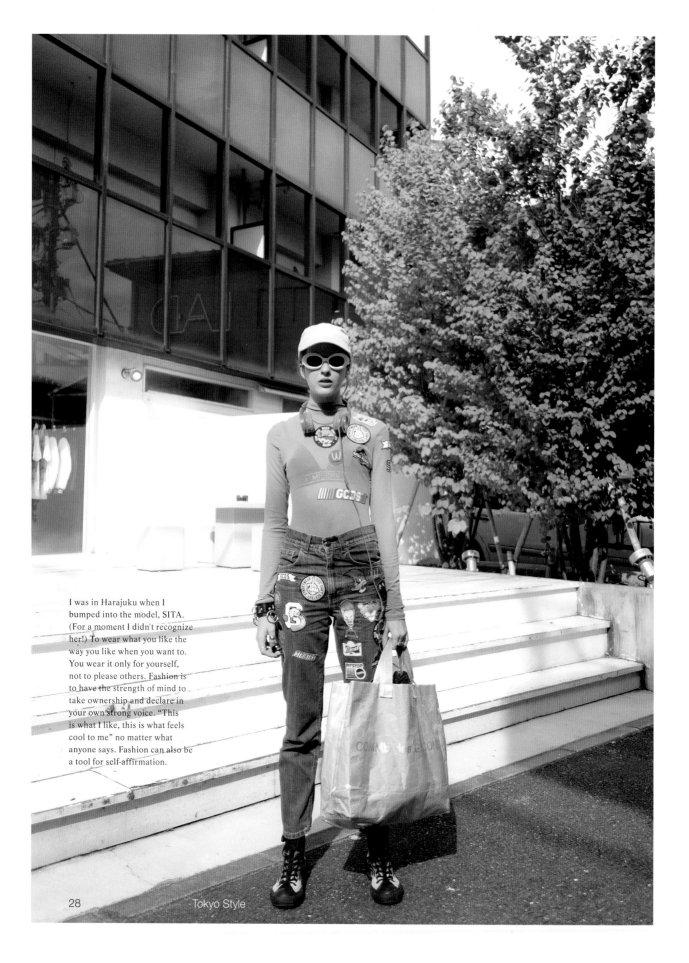

I was in Harajuku when I bumped into the model, SITA. (For a moment I didn't recognize her!) To wear what you like the way you like when you want to. You wear it only for yourself, not to please others. Fashion is to have the strength of mind to take ownership and declare in your own strong voice. "This is what I like, this is what feels cool to me" no matter what anyone says. Fashion can also be a tool for self-affirmation.

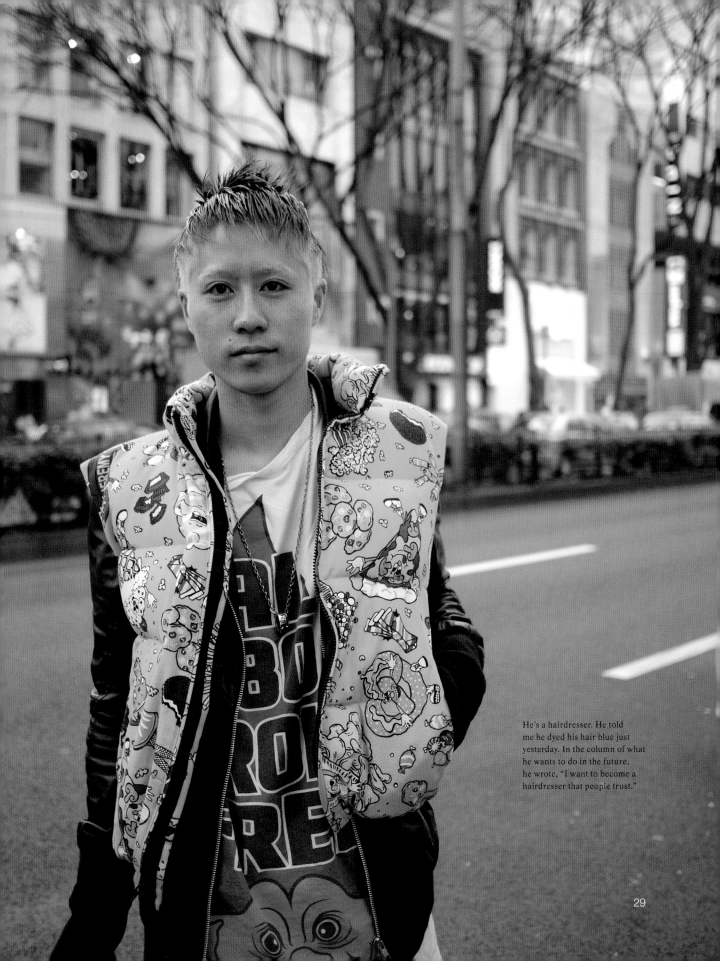

He's a hairdresser. He told me he dyed his hair blue just yesterday. In the column of what he wants to do in the future, he wrote, "I want to become a hairdresser that people trust."

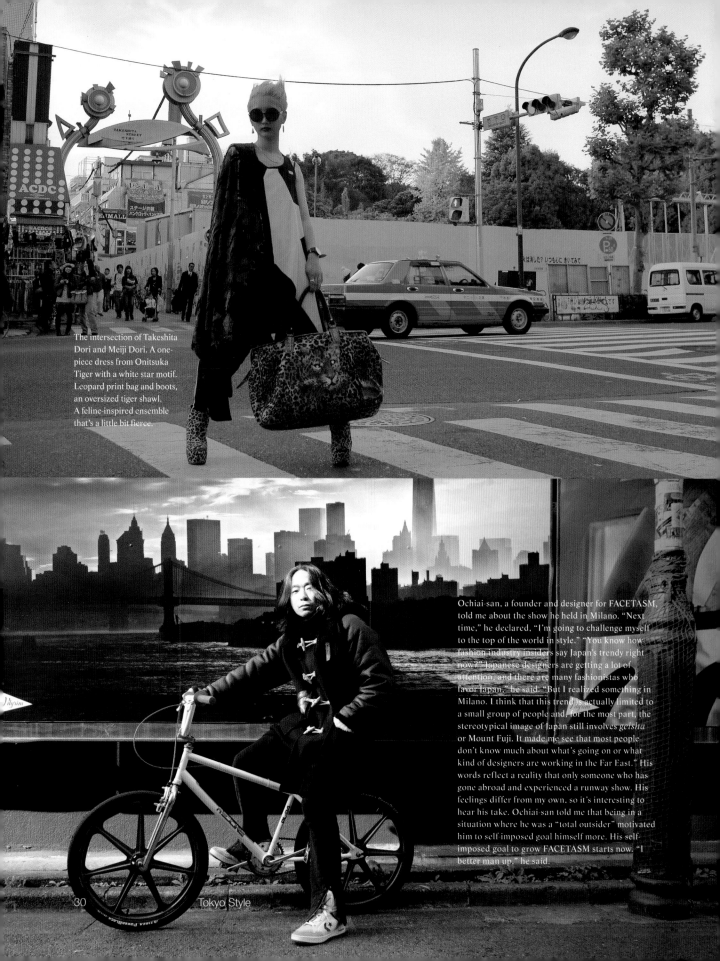

The intersection of Takeshita Dori and Meiji Dori. A one-piece dress from Onitsuka Tiger with a white star motif. Leopard print bag and boots, an oversized tiger shawl. A feline-inspired ensemble that's a little bit fierce.

Ochiai-san, a founder and designer for FACETASM, told me about the show he held in Milano. "Next time," he declared, "I'm going to challenge myself to the top of the world in style." "You know how fashion industry insiders say Japan's trendy right now?" Japanese designers are getting a lot of attention, and there are many fashionistas who favor Japan," he said. "But I realized something in Milano. I think that this trend is actually limited to a small group of people and, for the most part, the stereotypical image of Japan still involves *geisha* or Mount Fuji. It made me see that most people don't know much about what's going on or what kind of designers are working in the Far East." His words reflect a reality that only someone who has gone abroad and experienced a runway show. His feelings differ from my own, so it's interesting to hear his take. Ochiai-san told me that being in a situation where he was a "total outsider" motivated him to self-imposed goal himself more. His self-imposed goal to grow FACETASM starts now. "I better man up," he said.

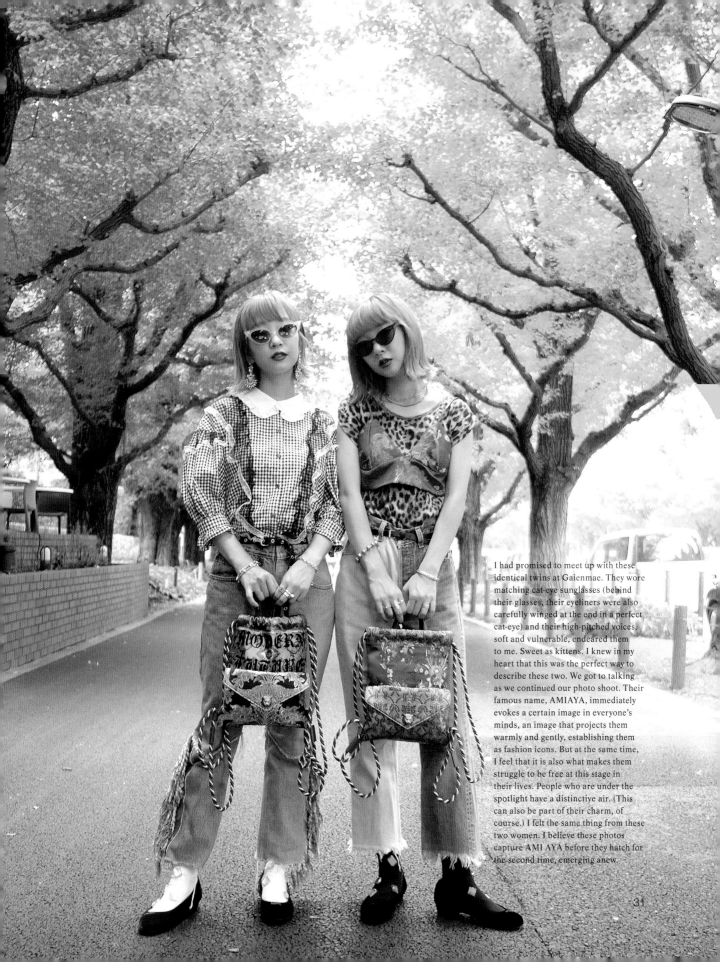

I had promised to meet up with these identical twins at Gaienmae. They wore matching cat-eye sunglasses (behind their glasses, their eyeliners were also carefully winged at the end in a perfect cat-eye) and their high-pitched voices, soft and vulnerable, endeared them to me. Sweet as kittens. I knew in my heart that this was the perfect way to describe these two. We got to talking as we continued our photo shoot. Their famous name, AMIAYA, immediately evokes a certain image in everyone's minds, an image that projects them warmly and gently, establishing them as fashion icons. But at the same time, I feel that it is also what makes them struggle to be free at this stage in their lives. People who are under the spotlight have a distinctive air. (This can also be part of their charm, of course.) I felt the same thing from these two women. I believe these photos capture AMI AYA before they hatch for the second time, emerging anew.

31

Styling Tip #1

MITATE

Mitate, or the art of seeing the resemblance of one thing in another, is part of Japanese culture.

In a traditional Japanese outdoor garden, waves are drawn on the surface of sand to express the waves of the ocean, or a rock is likened to a mountain to illustrate the natural landscape. From long ago, Japanese people have instilled the art of *mitate* into their everyday lives. In fashion, a knitted sweater can be seen as a scarf, a jacket can be a shirt, and a coat or a skirt can turn into a one-piece dress. It is styling through resemblance.

When you think about it, a scarf, a coat, or a skirt is nothing but a piece of fabric in the beginning. Seeing clothes outside of their function and utility—understanding them simply as "cloth"—expands the possibilities of fashion and makes it more fun.

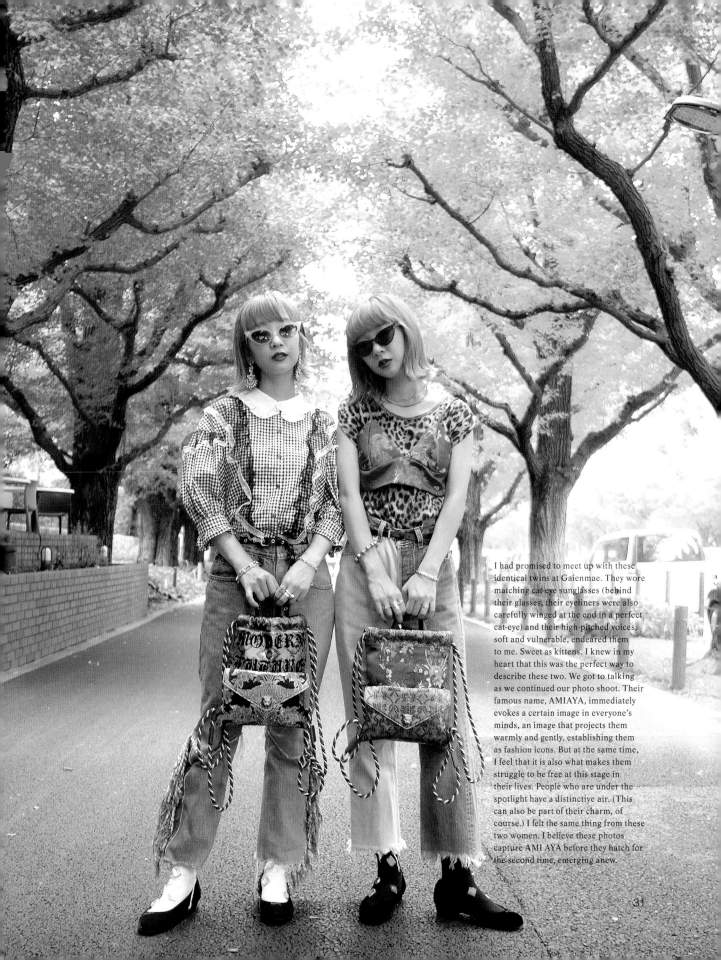

I had promised to meet up with these identical twins at Gaienmae. They wore matching cat-eye sunglasses (behind their glasses, their eyeliners were also carefully winged at the end in a perfect cat-eye) and their high-pitched voices, soft and vulnerable, endeared them to me. Sweet as kittens. I knew in my heart that this was the perfect way to describe these two. We got to talking as we continued our photo shoot. Their famous name, AMIAYA, immediately evokes a certain image in everyone's minds, an image that projects them warmly and gently, establishing them as fashion icons. But at the same time, I feel that it is also what makes them struggle to be free at this stage in their lives. People who are under the spotlight have a distinctive air. (This can also be part of their charm, of course.) I felt the same thing from these two women. I believe these photos capture AMI AYA before they hatch for the second time, emerging anew.

It's not what you wear, but how you wear it.

This is a philosophy I value most in street fashion. When I see a person styling his or her clothes with creativity and unexpected ideas—the "how" of it all—I feel moved from the bottom of my heart.

I believe the "how" of fashion is what we call "taste." Even though a part of having taste is innate (people who are born with a genius for style are few and far between, but they do exist), it is possible to cultivate it to a certain degree with the right techniques.

Here, I would like to introduce the styling techniques behind the creation of good taste.

MITATE

Mitate, or the art of seeing the resemblance of one thing in another, is part of Japanese culture.

In a traditional Japanese outdoor garden, waves are drawn on the surface of sand to express the waves of the ocean, or a rock is likened to a mountain to illustrate the natural landscape. From long ago, Japanese people have instilled the art of *mitate* into their everyday lives. In fashion, a knitted sweater can be seen as a scarf, a jacket can be a shirt, and a coat or a skirt can turn into a one-piece dress. It is styling through resemblance.

When you think about it, a scarf, a coat, or a skirt is nothing but a piece of fabric in the beginning. Seeing clothes outside of their function and utility—understanding them simply as "cloth"—expands the possibilities of fashion and makes it more fun.

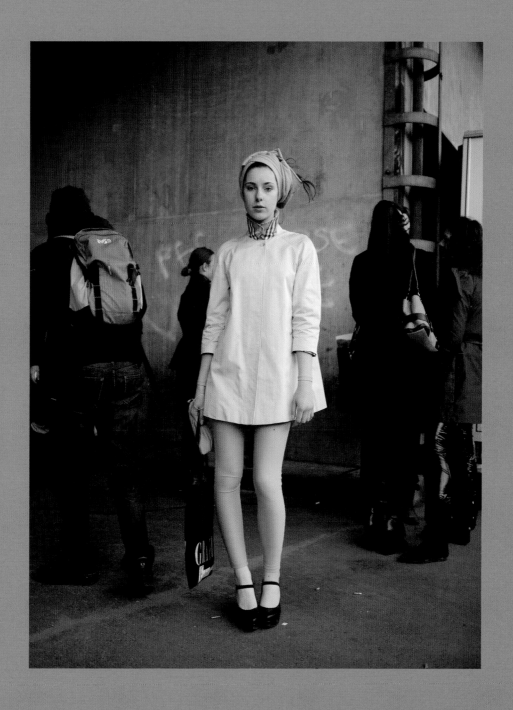

A kids' size Burberry coat worn as a
one-piece dress. On children the coat
falls below the knees, but on her it's a
mini dress, complete with three-quarter
sleeves. The length is a subtle perfection!

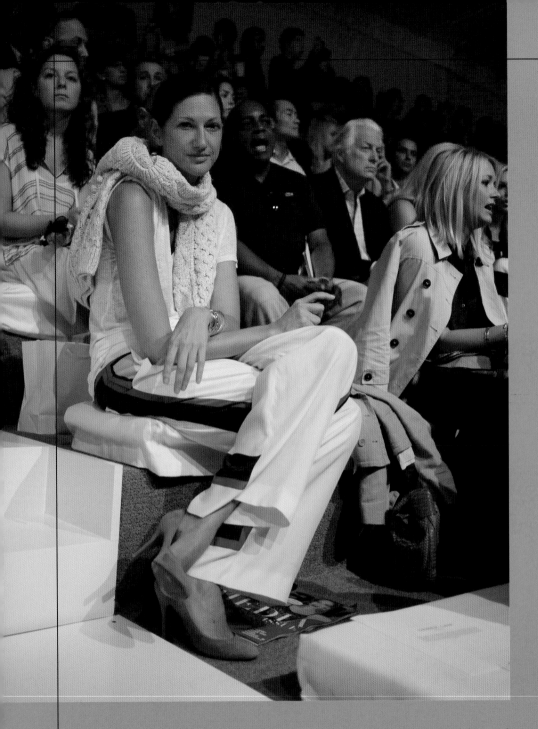

A fisherman sweater styled as a scarf.
I love the freedom of using winter
accessories in the summer. A fun
seasonal "mix and match."

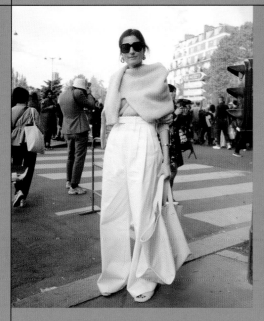

A knitted sweater stands in for a soft shawl. The *mitate* technique can instantly elevate your style, and it's easy to pull off if you coordinate with similar colors as she does here.

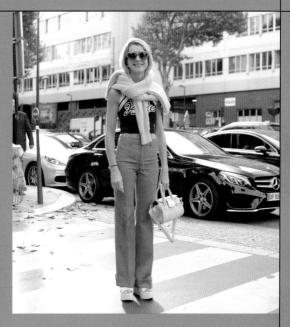

Another knitted sweater worn as a scarf. The added volume around the neck has a slimming effect.

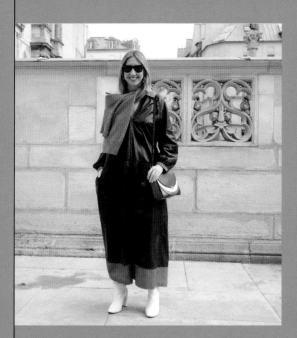

A knitted sweater wrapped like a scarf. The placement of the knot is key.

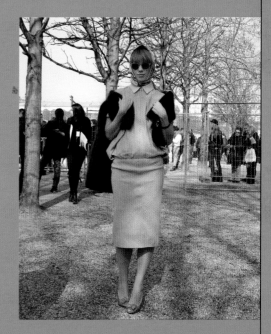

A thick fur coat is worn over the shoulders like a cardigan. If the sleeves aren't quite long enough, simply hold them in your hands! An inventive new way to wear coats.

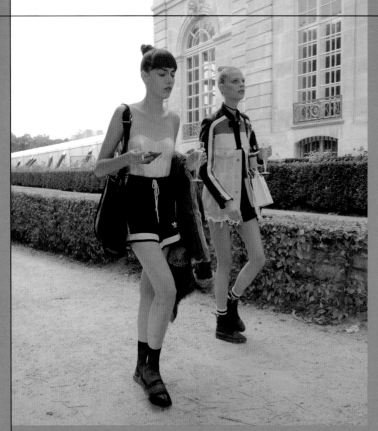

A corset doubles as a bra top. A style that embodies the freedom and flexibility of seeing clothes simply as fabric beyond their function and utility.

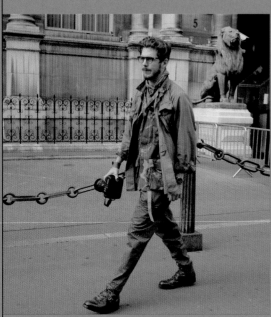

A camouflage military jacket worn as a shirt. The result is a uniquely layered ensemble, a twist on a jacket-on-jacket style. I love the way the jacket worn underneath peers out at the hem.

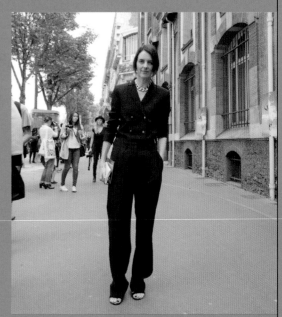

A jacket worn as a shirt. Tucking the jacket into the pants immediately upgrades the ensemble! Remember: it's not what you wear but how you wear it.

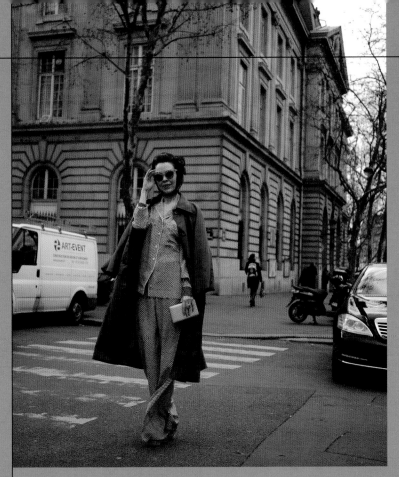

Two examples of pajamas worn as
streetwear. Stylistic possibilities
in your closet expand when
you consider sleepwear and
loungewear as outfits you can
wear in public. Doesn't that make
you feel excited?

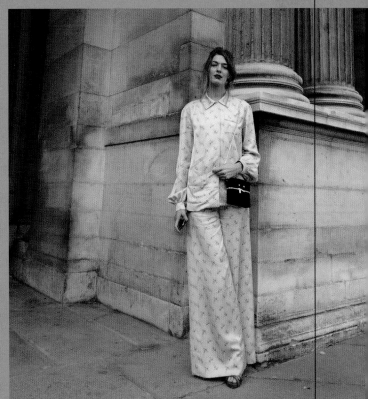

Styling Tip #2

HAZUSHI / ZURASHI

Hazushi (undoing) or *zurashi* (shifting) is a helpful stylistic technique when you want to wow the crowd and make them say, "Why didn't I think of that?"

Intentionally mixing different elements that might not seem to go together can create a style that feels familiar yet idiosyncratic—a style *déjà vu*. The key is how you calibrate the quirkiness.

It's important to keep in mind, however, not to be overzealous with this technique or you'll run the risk of looking zany. When it comes to fashion, the mark of a superior dresser is a nonchalant quirkiness.

Let's take a look at a few specific examples.

1) Items
Incorporating a single item that looks out of place in terms of genre or color is a quick way to create *hazushi* or *zurashi*. Before you worry if items go together, ask yourself if you have made such a combination or attempted it before. If the answer is no, don't wait another second and go for it! Don't worry at all if things match. The whole point of *hazushi* and *zurashi* is to be intentionally off-kilter!

2) Genre
Mode, sporty, girly, elegant…. Fashion can be categorized into various genres. When you combine items in the same category, you'll have a style that's flawless and safe, but if you are in the mood for something playful the key is to mix items across different genres. As I mentioned above, no need to worry if things go together!

3) Balance
Try undoing the stylistic balance that makes you "look the best" on purpose. Accessorize with a slightly larger item or choose a piece that is a little too short.

We tend to be caught up with a silhouette that makes us look the most "beautiful" or "well proportioned," but when you let go of such concerns—which are only holding you back—fashion can be much more playful.

Take a traditional gentleman's suit and twist it with a casual New York Yankees baseball cap. The color of the hat is coordinated with the shirt and tie. This Yankee fan (I assume) reflects what he loves in his clothes, and he looks charming and sweet.

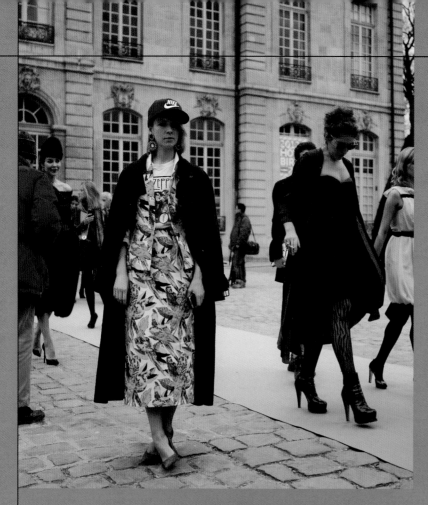

A classic ensemble gets a genre twist when paired with street- style baseball cap and T-shirt.

The white baseball cap tones down the high-end glamor of the jacket.

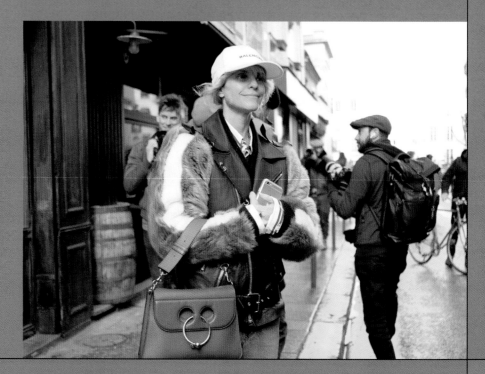

ZEN MINIMALISM

Minimalism is the spirit of Zen. Meditation, tidying, the simple way of life. The spirit of discarding what is unnecessary and keeping only the things that matter can be described as truly Japanese. Minimalism exists in fashion as well, but what I'd like to introduce here is a fun minimalism! Here are few styles that are minimal yet joyous.

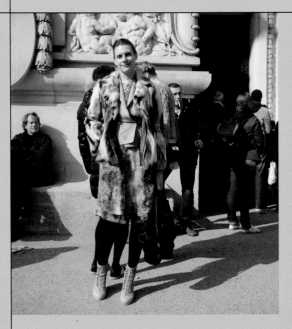

A thin floral skirt, a floral shirt, a crisp jacket, and a fluffy fur vest. A variety of colors, patterns, and fabrics are incorporated in layers, but the balance of sizes and colors is just right.

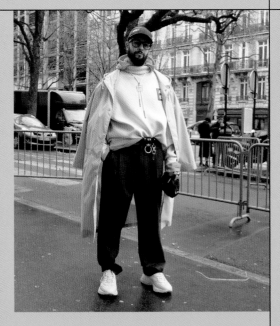

A turtleneck sweatshirt is layered over a hoodie. The volume around the collar deserves attention! A style that feels familiar yet never-been-done-before.

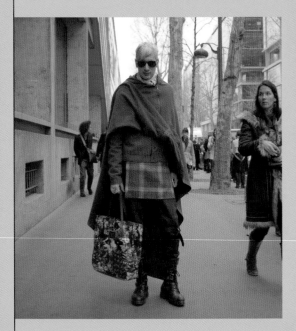

A checkered skirt is layered over a pair of skinny pants. There's a lot going on here—a bag with large patterns and a voluminous poncho—but it's all tied together with a good sense of balance.

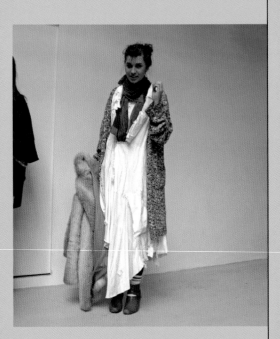

An elaborate cotton dress with heavy drapes, a knitted coat, and a fur coat in hand. Wearing various textures creates depth to your layered style.

A gray flared skirt beneath a lace skirt. Once again, the top is kept short and the bottom long.

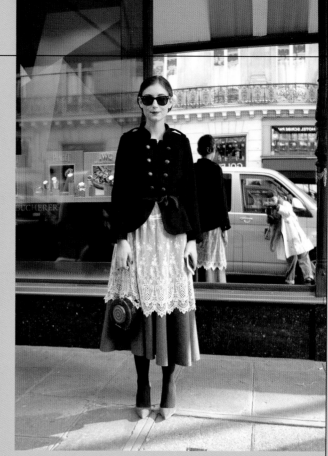

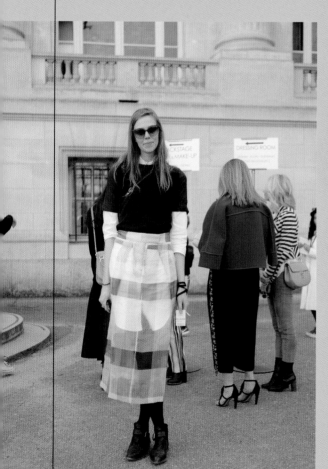

A sheer wrap skirt is layered over a shirt dress. A layered "skirt-on-skirt" style.

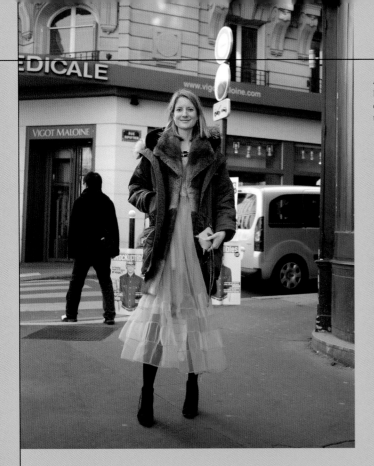

A military jacket over a fur coat. Leaving the front part of the ensemble largely open emphasizes the layered technique.

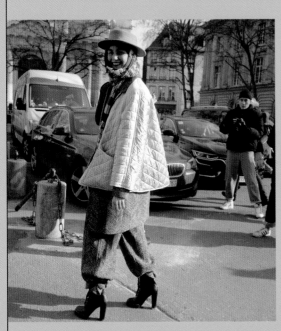

A quilted military liner over a tweed jacket. Liners are generally worn as an inner layer, but here it's worn on the outside. The shift in existing norms and practices is intriguing.

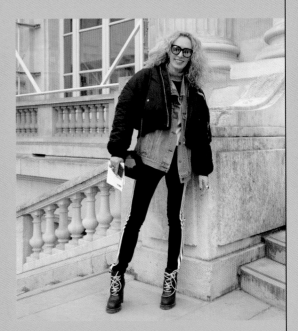

Two techniques—"keep your top layer short and bottom layer long" and "layer the same items"—put into effect. Keeping the top layer short and voluminous flatters your figure.

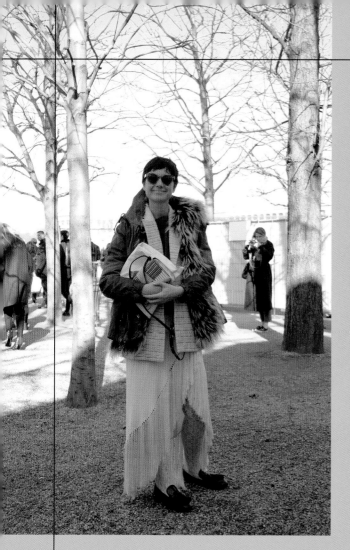

Coat-on-coat. This style remains faithful to the theory that you should keep your top layer short and bottom layer long.

Another monsieur in a coat-on-coat style. Both the beige and the checkered coats are basic items, but when the outer layer is kept short and the inner layer long, it instantly elevates the look.

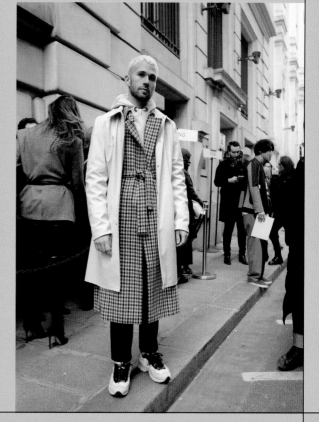

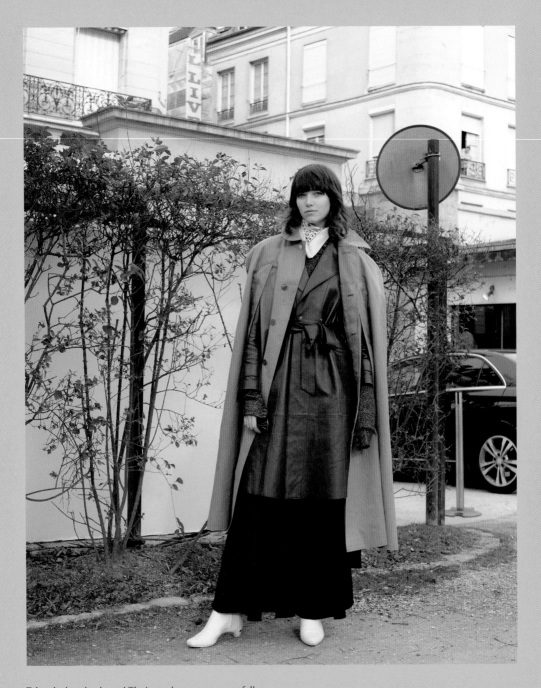

Take a look at the sleeves! The inner sleeves are purposefully pulled down below the sleeves of the coat to create a layered effect, and a beige poncho-shaped coat is layered over another coat. Repeating the same item is a technique you want to remember when creating layers—you'll look like an expert in no time! Since the silhouette here is on the heavier side with layers and a long full skirt, she balances it out with white scarf and boots.

LAYERED

Since the era of the *junihitoe*, the style of layered formal dress worn by noblewomen of the Heian period, layering clothes has been part of the root of Japanese fashion.

The beauty of Japanese formal wear, for example, is found in the combination of colors at the collar where the robes overlap. (In *The Tale of Genji*, the *junihitoe* appears as the epitome of stylishness.) Layering is a generational art in Japan.

The trick to layering clothes is found in the length. A quick rule of thumb: everything will work out if you consider the length of the sleeves and hem. Keep the length of what you wear on top shorter and what you wear underneath longer—this is a shortcut to creating an effective layered look.

Imagine Russian nesting dolls. The doll on the top layer is the largest, and as you open them the doll becomes smaller. Think of layering as its opposite!

A frankly exposed décolletage! A *roshutsu* that says, "Look if you must!" A bold attitude is key when exposing with intention.

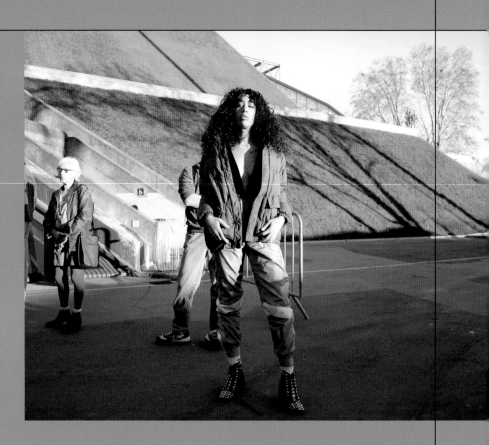

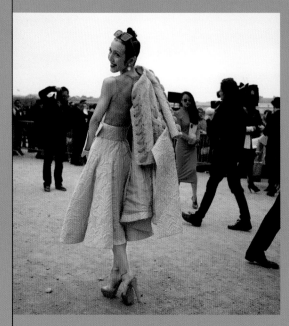

Talk about an open back! Don't be shy if you want to present yourself—commit and go all the way!

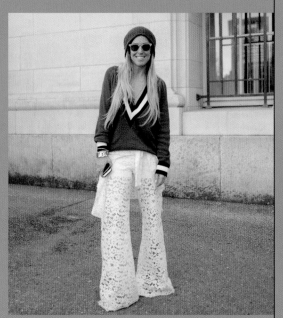

The open collar and sheer pants. This double exposure requires skill, and her confidence and energy uplift the ensemble.

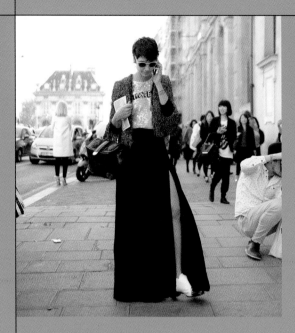

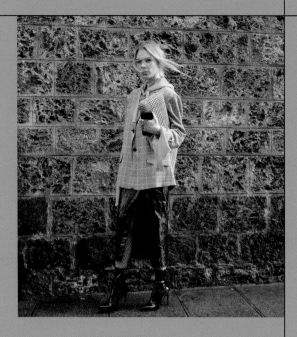

Skirts that reveal a deep and daring slit with every move. The flash of leg is undeniably flirty.

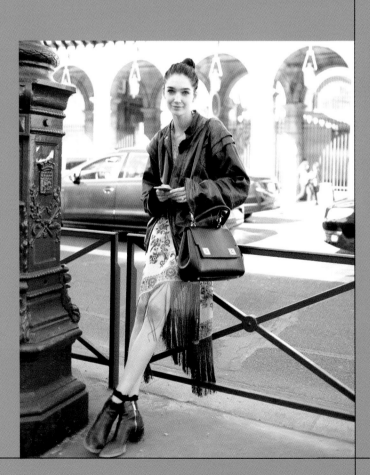

The flash of skin
through the fringes is
so sexy!

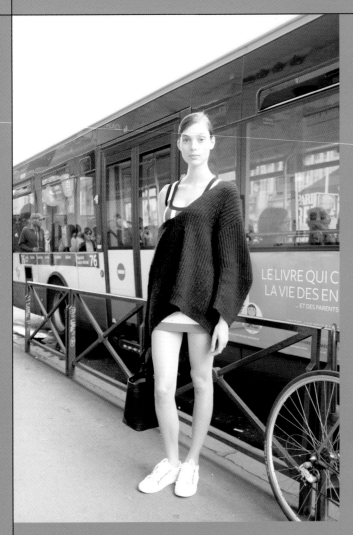

Exposing one shoulder with a slouchy top creates a relaxed vibe.

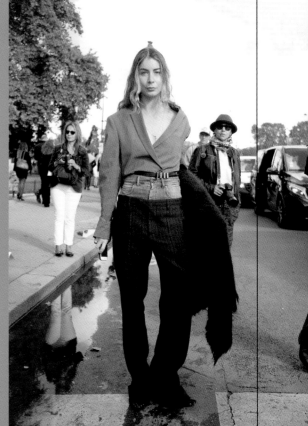

An exposed shoulder and a jacket tucked into pants. I spy an expert!

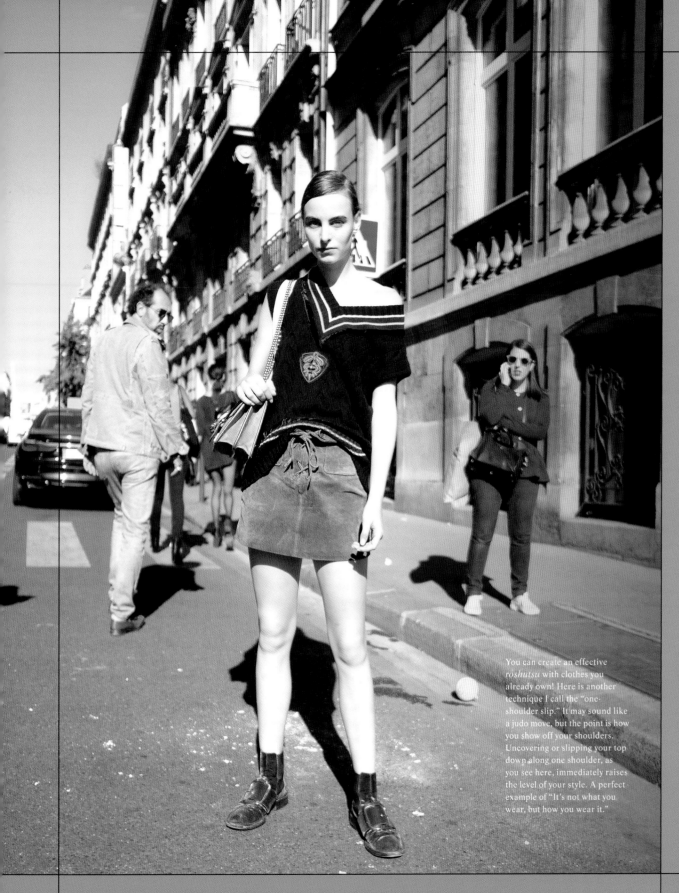

You can create an effective *roshutsu* with clothes you already own! Here is another technique I call the "one-shoulder slip." It may sound like a judo move, but the point is how you show off your shoulders. Uncovering or slipping your top down along one shoulder, as you see here, immediately raises the level of your style. A perfect example of "It's not what you wear, but how you wear it."

Translucency is another indispensable topic when discussing *roshutsu*. Here are three ways to style lace.

"Something that can almost be seen but remains hidden" creates the Caligula effect and naturally draws our attention. If it draws the eye, it means it's attractive. Use the Caligula effect and translucent material to your advantage!

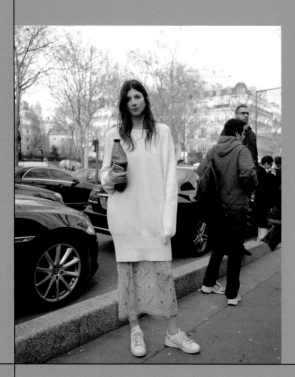

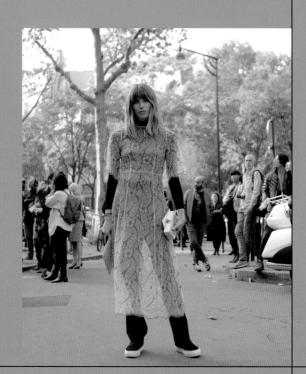

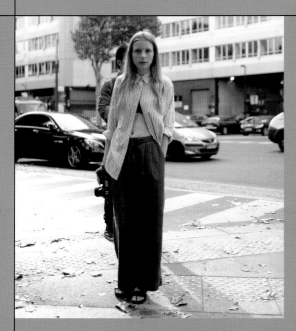

An eye-catching outfit that offers subtle glimpses of her bra whenever she moves her arms.

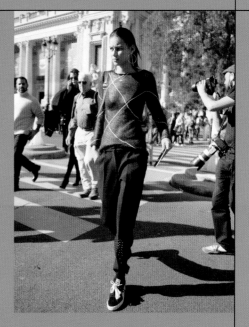

Bold and masculine look amplified with slicked-back hair!

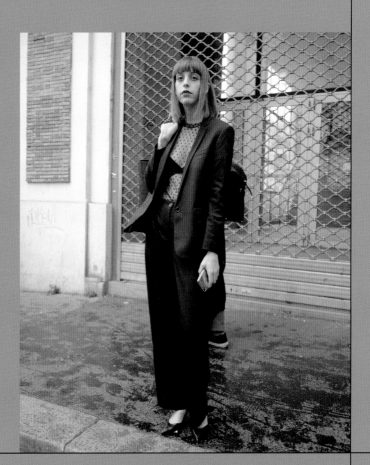

A bold exposure that announces, "Look if you must!"

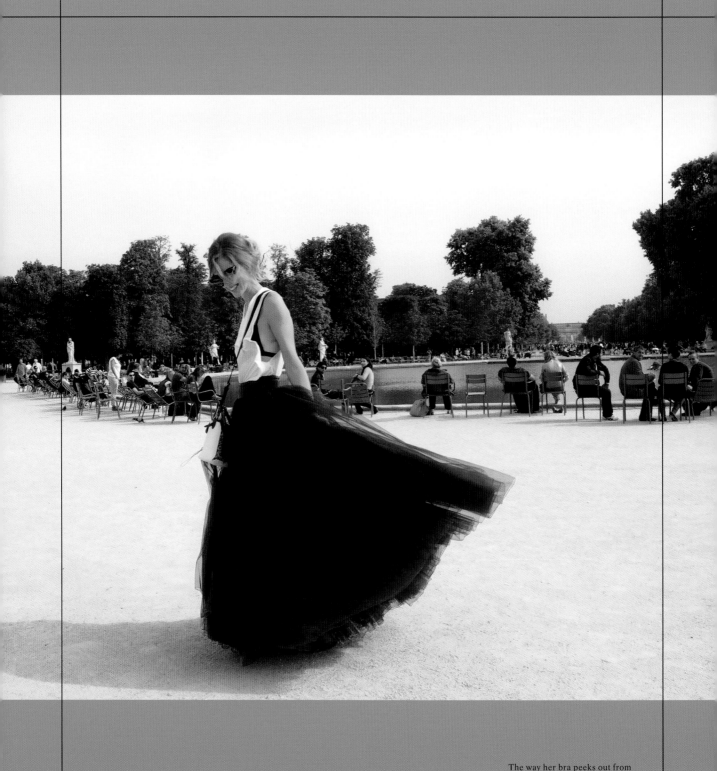

The way her bra peeks out from
the side is so alluring!

ROSHUTSU

Sexy

I feel where Japan and other countries diverge the most is how we think about women and *roshutsu*, or exposure.

From the *Tale of Genji* and traditional folktales like *The Grateful Crane* to the portraits of women in the literature of Junichiro Tanizaki, Japanese women have valued what they choose to conceal.

To reveal by concealing might sound like a contradiction but think back to when you were a teenager. The more you were told not to smoke or drink, the more you grew curious. For some reason, we yearn to see something more when we are told not to look at it.

This psychological phenomenon of wanting to do something the more it is forbidden is known as the Caligula effect, and it is the essence of how Japanese women reveal themselves in fashion.

Japanese culture has always equated feminine virtue with a coy modesty whereas flashiness is seen as uncouth and lacking in sophistication, a subject of scorn.

What this cultural context has wrought is the idea of stolen glimpses—a method of exposure that is meant to seem unintended. Unconscious exposure can be described as the height of eroticism, shrouding it behind a sense of refinement.

In contrast, I feel that women outside of Japan like to "present" themselves. They showcase their attractiveness clearly and boldly, without a hint of pretension. This method of exposure, no matter how frank, feels fresh because it is entirely devoid of calculation, tying the act to a healthy sense of authenticity.

When it comes to how women reveal themselves in fashion, what's most important is their stance!

Do you want to (unintentionally) reveal yourself?
"Do you envision yourself as a delicate and graceful woman?"
Or
Do you want to present yourself?
"Do you envision yourself as a powerful woman?"

Envision the woman you want to be and make fashion choices that reflect your intention. The most important question you should ask yourself is, "How do I want to be?"

Fashion is "self" expression. I believe that fashion—and life—begins with a journey of self-inquiry that helps you discover your latent hopes and desires.

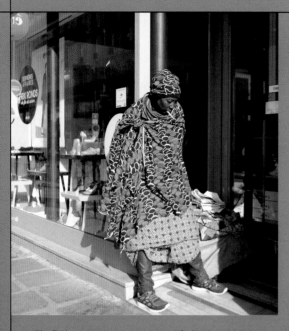

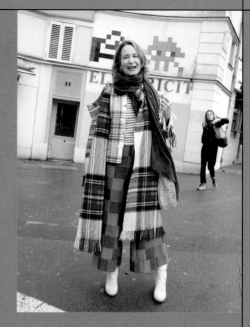

The flashy pattern-on-pattern is amplified with multiple layers of scarves. The unique silhouette creates a studied "too much-ness."

Checks, stripes, and patchwork--an onslaught of too many patterns! A pro move!!

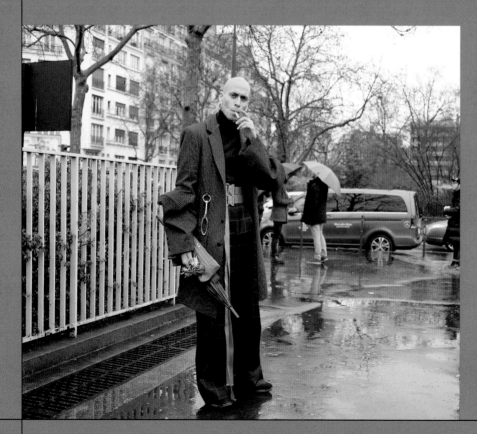

Two (overlong) belts, long pants, and oversized accessories at the waist. A decadent style made with extra-large components.

Styling your clothes so that they look smart and pulled together may be the standard practice in fashion, but why not try a style that seems "too much" on purpose? Here are seven hazushi or eclectic looks by pros who know how to play with fashion.

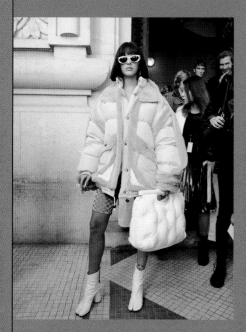

A sense of balance made to feel "over the top." The contrast between the oversized jacket and minimalist bike shorts is key.

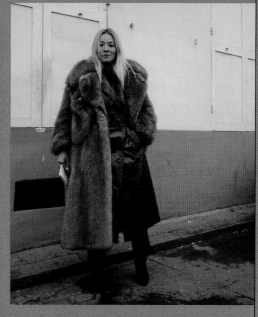

A long voluminous coat paired with a fur coat that's got even more bulk. The abundant volume gives the style an unexpected twist.

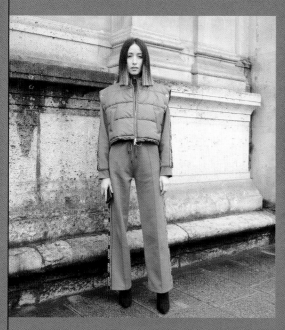

Pay attention to the down vest. The sense of balance—impossible to tell if it's really working or not—creates an exquisite twist.

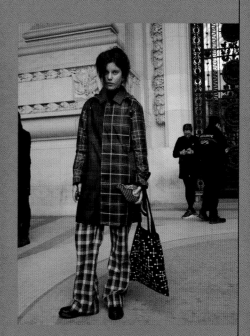

A crazy all-over checkered pattern. The check-on-check-on-check (ad infinitum) is a masterful twist.

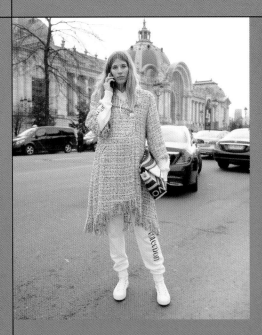

Casual and sporty sweatshirt paired with a luxurious Chanel tweed. The more distinct the genres of the items combined, the higher the level of "twist."

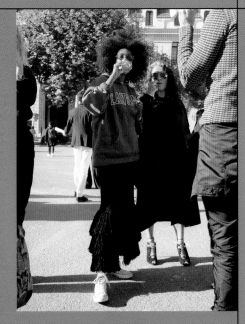

A sporty hoodie clashes with the elegance of the long ruffled skirt.

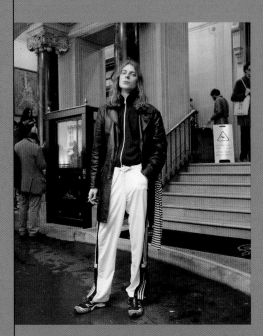

A sporty look with a slightly dorky spin. The purposeful lack of sophistication is the point!

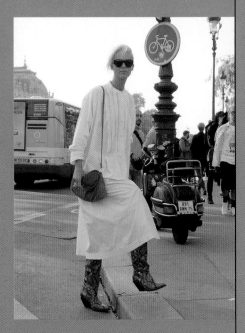

An aggressive pair of snakeskin boots (strong and mode) meets a graceful cotton one-piece. An expert dresser who pushes the envelope.

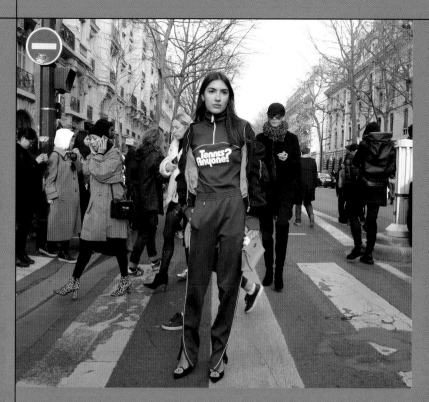

A mode pair of heels is the unexpected addition to her sporty look.

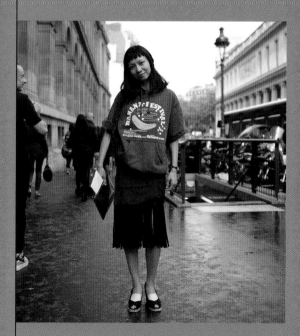

A casual sweatshirt and mode fringe skirt. A variation on the genre twist.

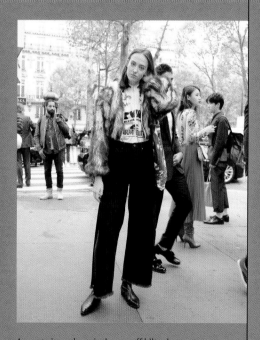

A sporty inner layer is thrown off kilter by a voluminous and luxurious fur coat.

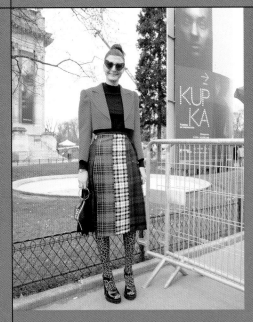
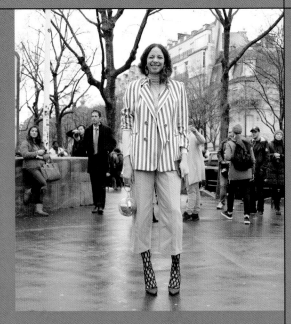

Pay close attention to what's going on around their feet!
Left: A plaid skirt (which is enough to complete an ensemble by itself)
boldly paired with leopard-print tights. Right: Fishnet tights punch
up a pink candy-striped jacket. Small accessories can add a bit of flair
to completed ensembles, in much the same way as an extra helping of
bonito flakes or mayonnaise can deepen the flavor of a dish!

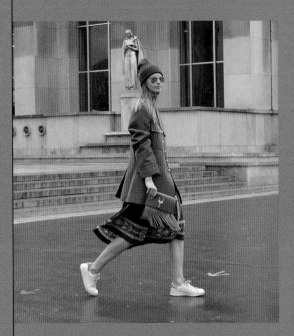
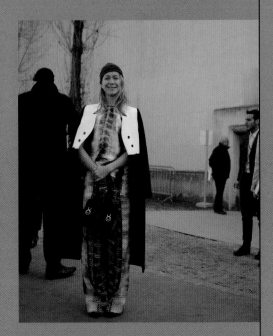

Knitted beanies give an unexpected twist.
Left: A green beanie casually shifts the sophisticated ensemble. Right: From
her neck down she is all mode but adding a red-and-navy–striped beanie—a
twist in color and genre—makes her a master of this technique! This ensemble
features many patterns, but it's impressive how she ties them all together.

Brune
Buonomano's style

The queen of minimal style is Brune from *Mastermind* magazine! All the items she wears are simple, but her smart selection of choices and the way she balances her silhouette are the reasons why I keep taking her photos.

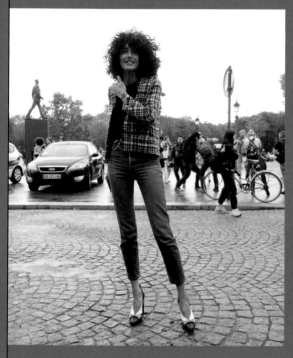

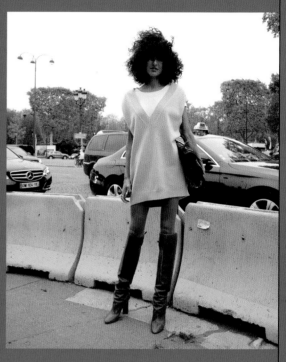

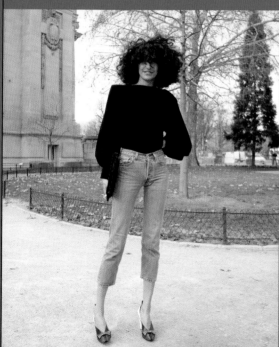

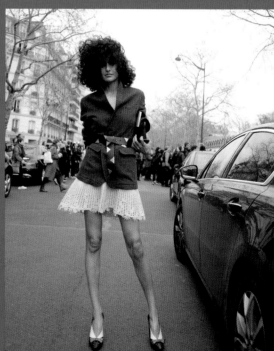

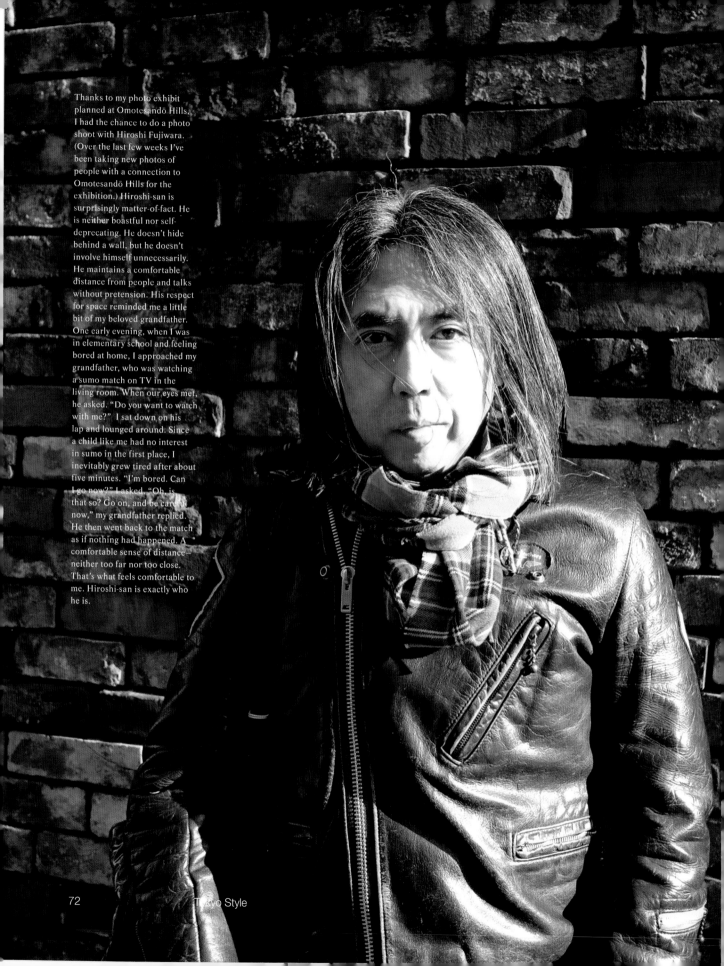

Thanks to my photo exhibit planned at Omotesandō Hills, I had the chance to do a photo shoot with Hiroshi Fujiwara. (Over the last few weeks I've been taking new photos of people with a connection to Omotesandō Hills for the exhibition.) Hiroshi-san is surprisingly matter-of-fact. He is neither boastful nor self-deprecating. He doesn't hide behind a wall, but he doesn't involve himself unnecessarily. He maintains a comfortable distance from people and talks without pretension. His respect for space reminded me a little bit of my beloved grandfather. One early evening, when I was in elementary school and feeling bored at home, I approached my grandfather, who was watching a sumo match on TV in the living room. When our eyes met, he asked, "Do you want to watch with me?" I sat down on his lap and lounged around. Since a child like me had no interest in sumo in the first place, I inevitably grew tired after about five minutes. "I'm bored. Can I go now?" I asked. "Oh, is that so? Go on, and be careful now," my grandfather replied. He then went back to the match as if nothing had happened. A comfortable sense of distance—neither too far nor too close. That's what feels comfortable to me. Hiroshi-san is exactly who he is.

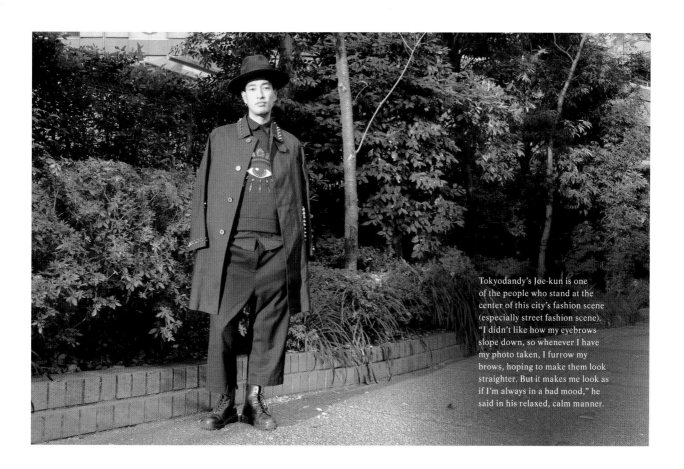

Tokyodandy's Joe-kun is one of the people who stand at the center of this city's fashion scene (especially street fashion scene). "I didn't like how my eyebrows slope down, so whenever I have my photo taken, I furrow my brows, hoping to make them look straighter. But it makes me look as if I'm always in a bad mood," he said in his relaxed, calm manner.

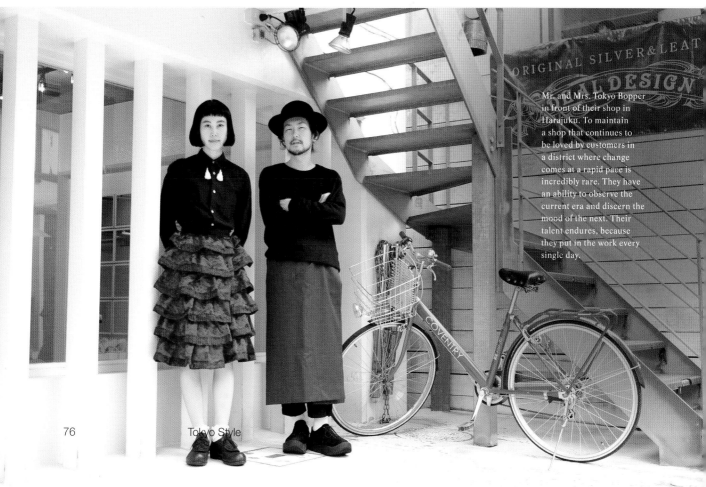

Mr. and Mrs. Tokyo Bopper in front of their shop in Harajuku. To maintain a shop that continues to be loved by customers in a district where change comes at a rapid pace is incredibly rare. They have an ability to observe the current era and discern the mood of the next. Their talent endures, because they put in the work every single day.

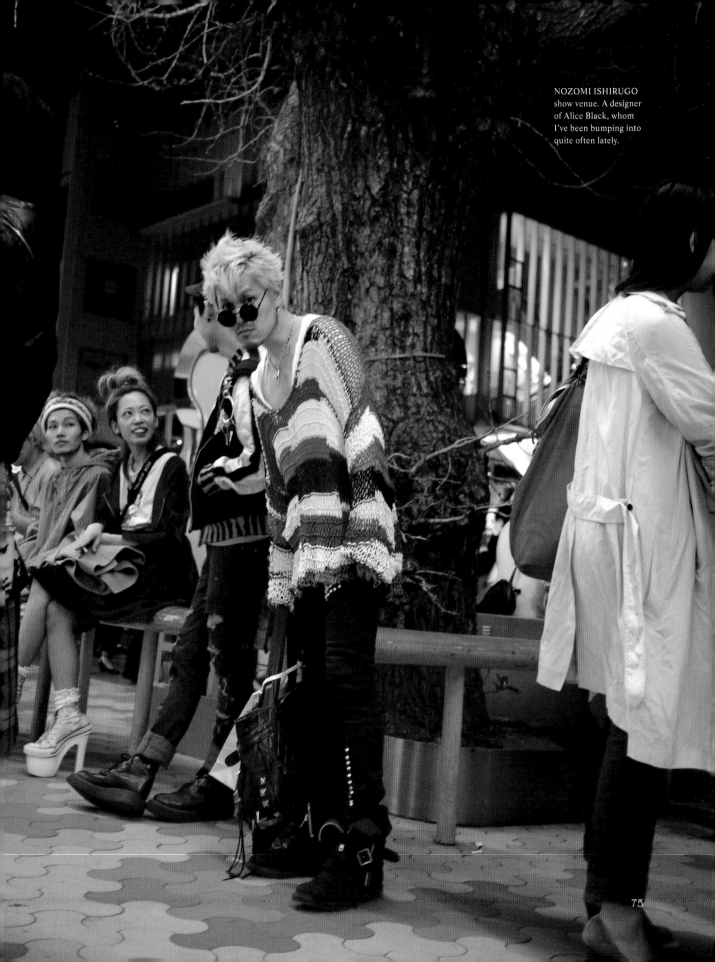

NOZOMI ISHIRUGO
show venue. A designer
of Alice Black, whom
I've been bumping into
quite often lately.

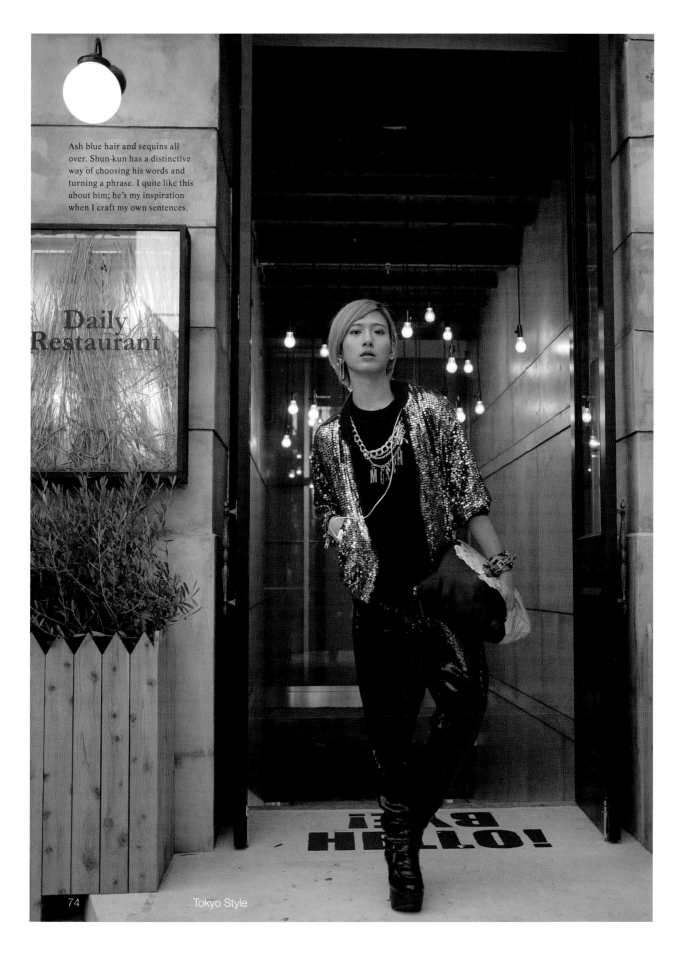

Ash blue hair and sequins all over. Shun-kun has a distinctive way of choosing his words and turning a phrase. I quite like this about him; he's my inspiration when I craft my own sentences.

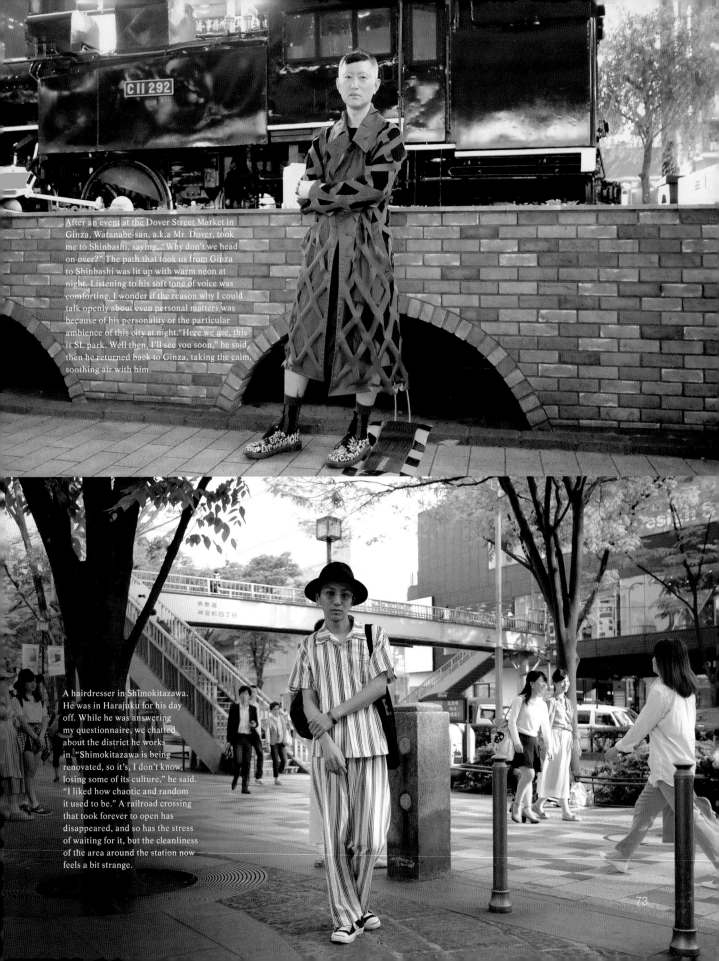

After an event at the Dover Street Market in Ginza, Watanabe-san, a.k.a Mr. Dover, took me to Shinbashi, saying, "Why don't we head on over?" The path that took us from Ginza to Shinbashi was lit up with warm neon at night. Listening to his soft tone of voice was comforting. I wonder if the reason why I could talk openly about even personal matters was because of his personality or the particular ambience of this city at night. "Here we are, this is SL park. Well then, I'll see you soon," he said, then he returned back to Ginza, taking the calm, soothing air with him.

A hairdresser in Shīmokitazawa. He was in Harajuku for his day off. While he was answering my questionnaire, we chatted about the district he works in. "Shimokitazawa is being renovated, so it's, I don't know, losing some of its culture," he said. "I liked how chaotic and random it used to be." A railroad crossing that took forever to open has disappeared, and so has the stress of waiting for it, but the cleanliness of the area around the station now feels a bit strange.

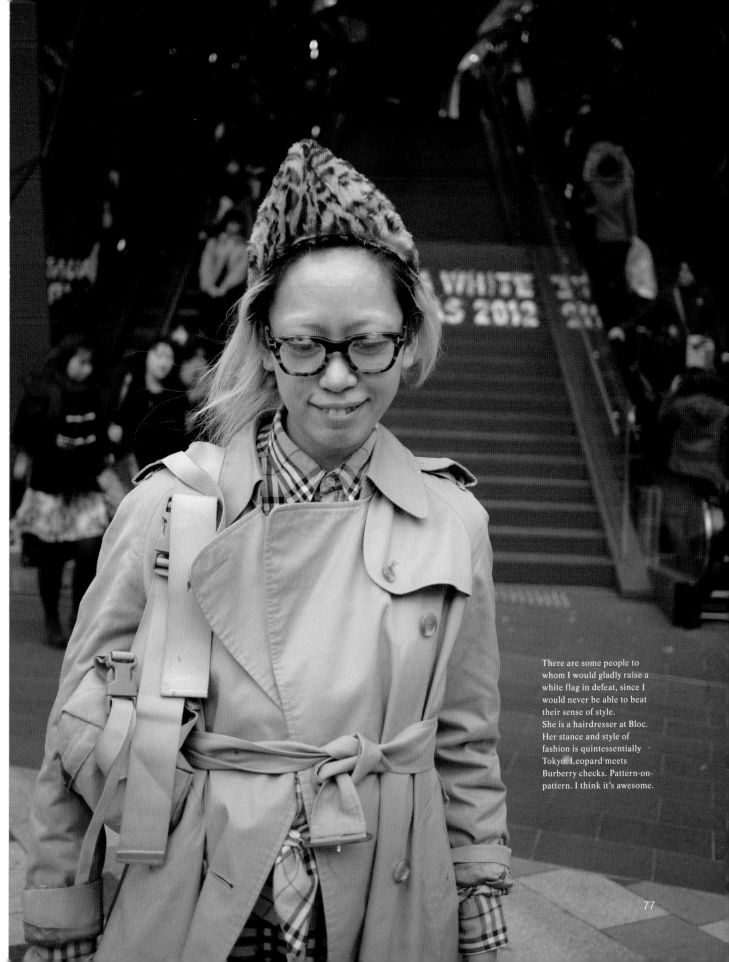

There are some people to whom I would gladly raise a white flag in defeat, since I would never be able to beat their sense of style.
She is a hairdresser at Bloc. Her stance and style of fashion is quintessentially Tokyo. Leopard meets Burberry checks. Pattern-on-pattern. I think it's awesome.

77

Yulia-chan is someone who knows how to choose what she wants to wear, right now. She is a woman with the ability to create an original style and generate her own personal trend. She cares deeply about her creations, which rise from deep within her. I respect this about her, and I always ask her for a photo. People I want to photograph share something in common: they have style. They are also people who constantly "update" their style.

Clothes, hair, nails, and cologne. Everything you adorn yourself with is fashion. (In that sense, the way you stand, the way you move, your tone of voice and your culture—everything can be fashion.) The most important thing in fashion is how you organize your sense of value. When someone tells you, "You are so stylish!" or "You look so great today!" do those compliments mean you are cute and sexy or stolid and cool? Does it mean you have the ability to present yourself in a way that is comforting to others, that's beautiful or worthy of love? Does it mean you are mode, expressing your deep understanding of what is contemporary? Or are you more traditional, a continuation of the long arc of history? Are you "unique" or, in other words, "original"? Does it mean

that you are "different" from others? Does it mean that you possess a kind of stability (a sense of comfort) that makes anyone who looks at you see that you are "proper"? Or does it mean you look sophisticated? Who we are as living organisms and how we should be—these are questions that our ancestors have grappled with since the beginning of mankind. "How we should be" and "How we want to be" are two sides of the same coin, and it comes down to the question, "How do we hope others will see us?" When someone tells you, "You are so stylish!" or "You look great today!" ask yourself again for what reason those words make you happy. When you ponder this question, your sense of value will manifest itself little by little. It is key to seeing yourself clearly from an objective point of view.

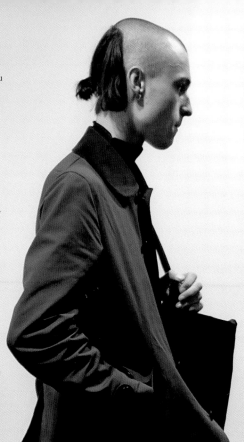

This is Sawamura-san from Garden, a select shop hidden in Shibuya. I know a few connoisseurs of men's fashion in Tokyo, but he is undeniably at the top. I often exchange information with him about the latest trends in town, the upcoming brands and designers.

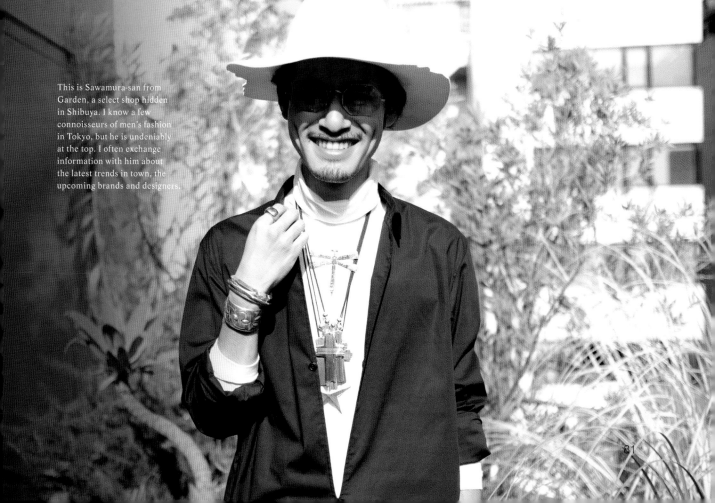

81

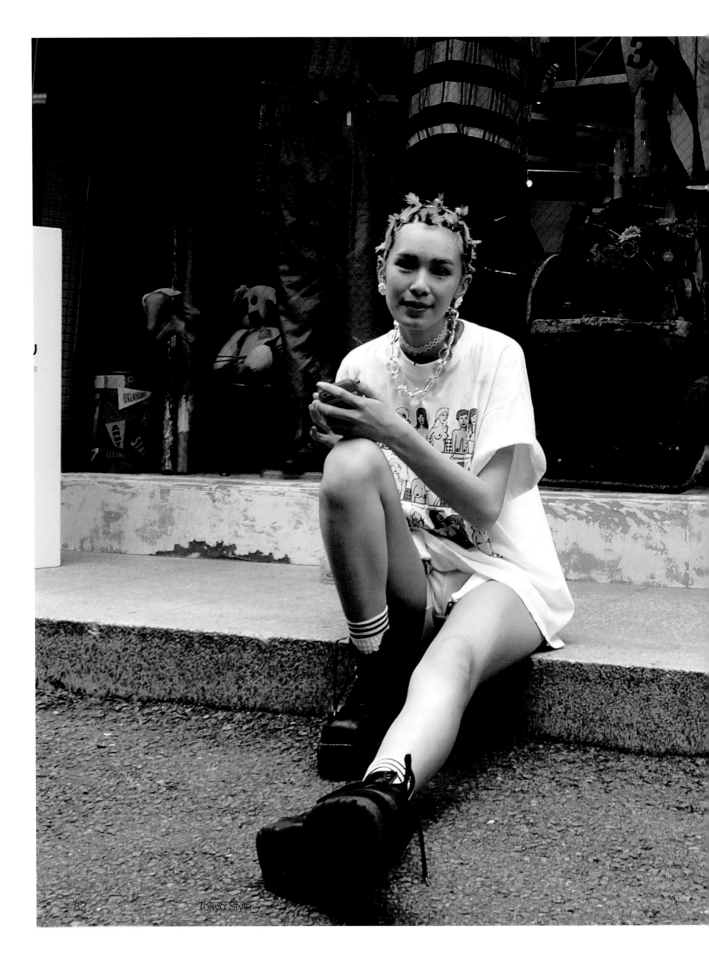

Blue hair, boobies(!) T-shirt, a plastic necklace. A pair of Dr. Martens at the ends of her long, lean legs. I think my camera tends to naturally gravitate toward those whose sense of fashion offers a glimpse into their purity and refinement.

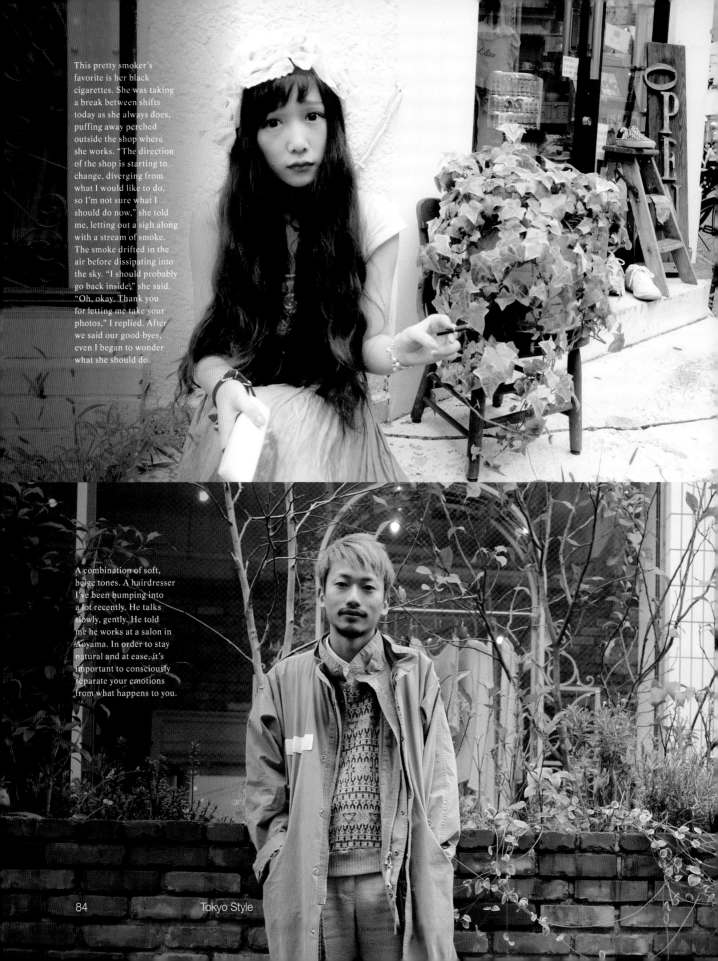

This pretty smoker's favorite is her black cigarettes. She was taking a break between shifts today as she always does, puffing away perched outside the shop where she works. "The direction of the shop is starting to change, diverging from what I would like to do, so I'm not sure what I should do now," she told me, letting out a sigh along with a stream of smoke. The smoke drifted in the air before dissipating into the sky. "I should probably go back inside," she said. "Oh, okay. Thank you for letting me take your photos," I replied. After we said our good-byes, even I began to wonder what she should do.

A combination of soft, beige tones. A hairdresser I've been bumping into a lot recently. He talks slowly, gently. He told me he works at a salon in Aoyama. In order to stay natural and at ease, it's important to consciously separate your emotions from what happens to you.

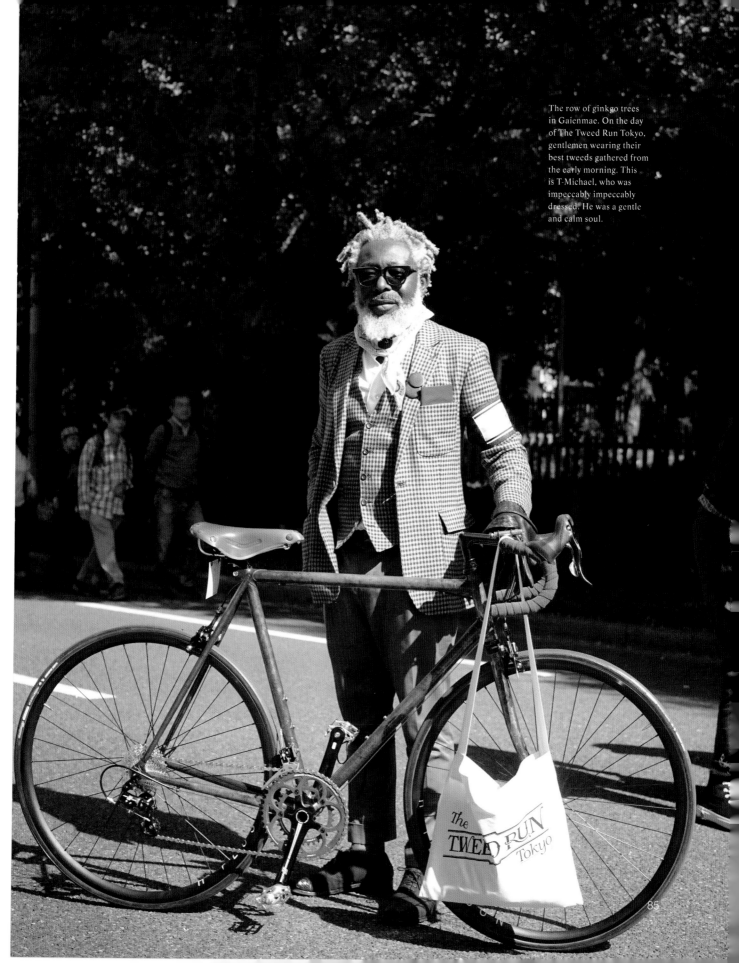

The row of ginkgo trees
in Gaienmae. On the day
of The Tweed Run Tokyo,
gentlemen wearing their
best tweeds gathered from
the early morning. This
is T-Michael, who was
impeccably impeccably
dressed. He was a gentle
and calm soul.

85

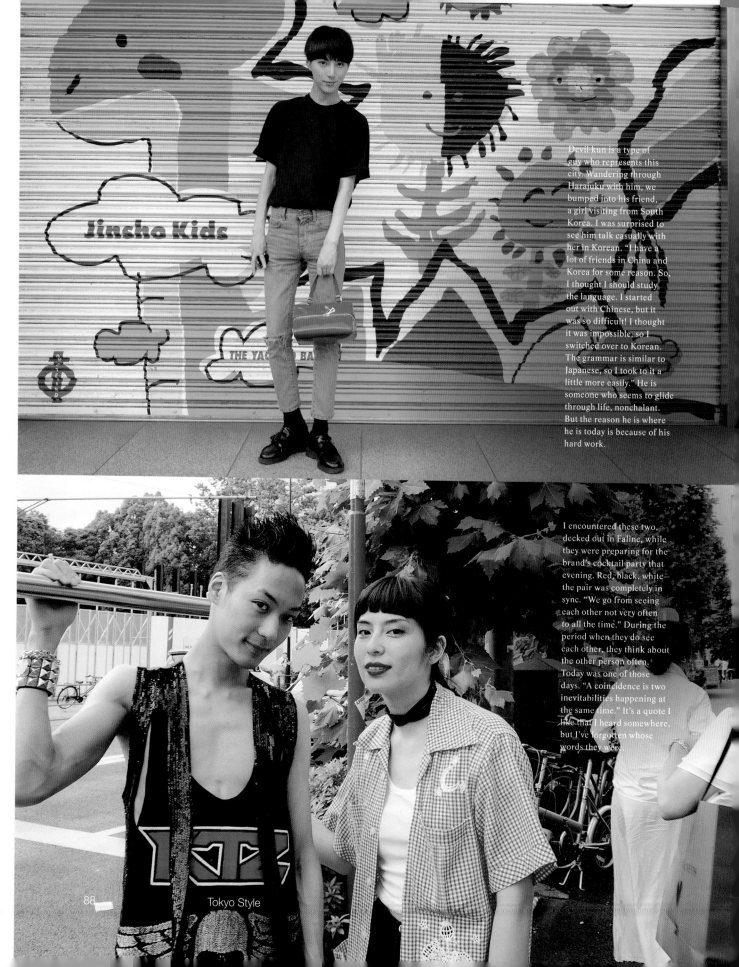

Devil-kun is a type of guy who represents this city. Wandering through Harajuku with him, we bumped into his friend, a girl visiting from South Korea. I was surprised to see him talk casually with her in Korean. "I have a lot of friends in China and Korea for some reason. So, I thought I should study the language. I started out with Chinese, but it was so difficult! I thought it was impossible, so I switched over to Korean. The grammar is similar to Japanese, so I took to it a little more easily." He is someone who seems to glide through life, nonchalant. But the reason he is where he is today is because of his hard work.

I encountered these two, decked out in Faline, while they were preparing for the brand's cocktail party that evening. Red, black, white—the pair was completely in sync. "We go from seeing each other not very often to all the time." During the period when they do see each other, they think about the other person often. Today was one of those days. "A coincidence is two inevitabilities happening at the same time." It's a quote I like that I heard somewhere, but I've forgotten whose words they were.

Tokyo Style

STANDARD: WHITE T-SHIRT

A plain white T-shirt is a staple in most people's closet—it transcends age, gender, generations, and countries. It's a simple and classic item that deftly complements any style or genre. A white T-shirt is like the almighty tile in a game of mah jongg! Ahead are some of the loveliest white T-shirt stylings I have encountered.

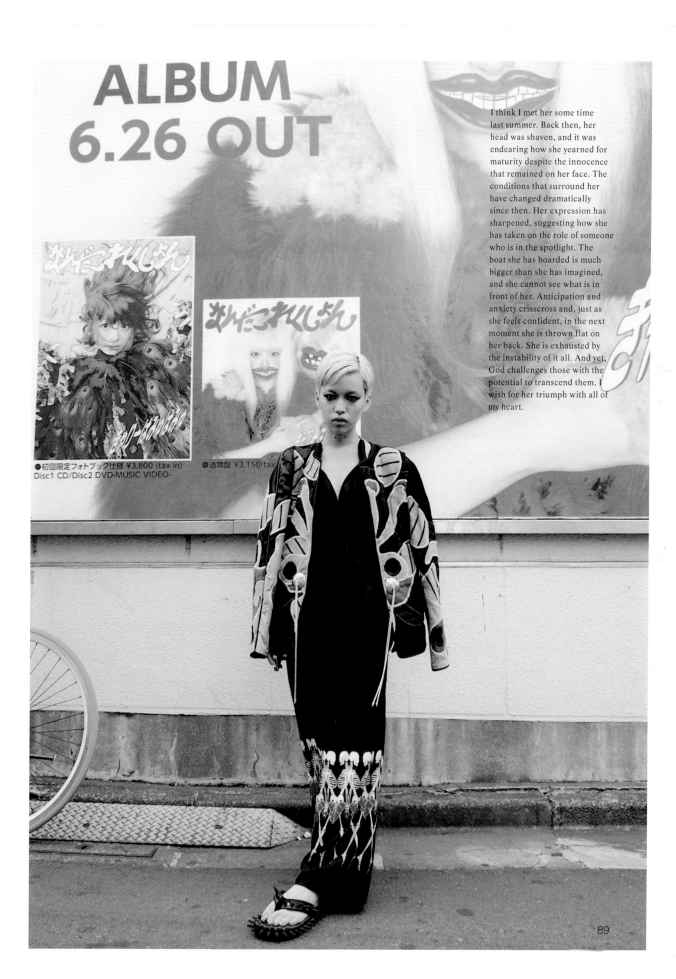

ALBUM
6.26 OUT

I think I met her some time last summer. Back then, her head was shaven, and it was endearing how she yearned for maturity despite the innocence that remained on her face. The conditions that surround her have changed dramatically since then. Her expression has sharpened, suggesting how she has taken on the role of someone who is in the spotlight. The boat she has boarded is much bigger than she has imagined, and she cannot see what is in front of her. Anticipation and anxiety crisscross and, just as she feels confident, in the next moment she is thrown flat on her back. She is exhausted by the instability of it all. And yet, God challenges those with the potential to transcend them. I wish for her triumph with all of my heart.

STANDARD: WHITE T-SHIRT

A plain white T-shirt is a staple in most people's closet—it transcends age, gender, generations, and countries. It's a simple and classic item that deftly complements any style or genre. A white T-shirt is like the almighty tile in a game of mah jongg! Ahead are some of the loveliest white T-shirt stylings I have encountered.

trendy? By asking yourself which definition suits you, you'll be able to find your own approach to fashion, i.e. your signature style. (By the way, I subscribe to both definitions because I'm greedy!)

Going back to the first definition, the key to having good taste is how you incorporate classic or "eternal" pieces into your own style and—most importantly—how you continue to update them.

Finding your original style is important, but what matters even more is how you update that style every day.

Thanks to advancement in technology, cities, lifestyles, and the environment that surrounds us are in a constant state of scrap-and-build, always being updated at a dizzying pace.

In Japan, there is a confectionary company called Toraya that has been in operation since the 16th century. (Their café in Akasaka is my favorite spot.) I read somewhere that the company's secret to longevity is keeping the essence of the company the same while evolving to fit the changing world.

I think the same thing can be said about styles that are considered eternal in fashion. What is essential should remain the same, but it's important to update eternal styles depending on your feeling and situation.

STANDARD STYLE

One of the things I've learned while documenting street fashion is that there are two approaches to being stylish.

The first approach is to have good taste. Some people, even when they aren't wearing anything special, exude stylishness. Taste—whether it's true or not—is often described as a kind of athletic prowess, a talent one is born with. Taste is exclusive, so the cool factor comes from being one of "the chosen."

The second approach is to be trendy. Some styles are catchy because they capture the feeling of the times. They show that you are a keen observer of the era, that you are knowledgeable about what's happening around you. The cool factor comes from being "in-the-know."

I'm not here to discuss whether one approach is better than the other. You should choose your style based on how you want to be.

When someone tells you that you are stylish, do you define "stylishness" as having good taste or being

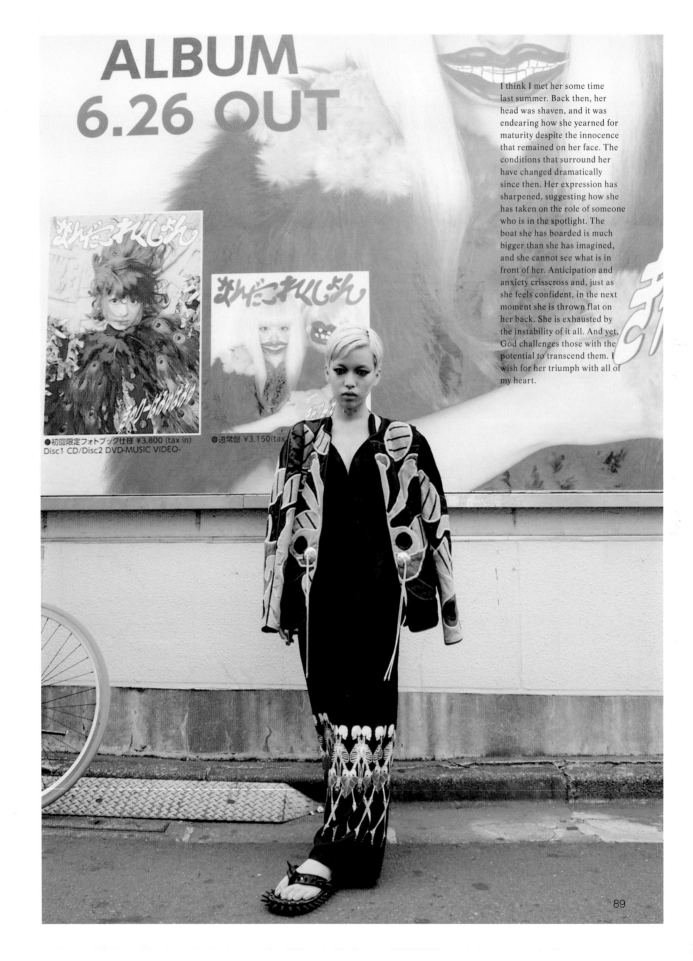

ALBUM
6.26 OUT

I think I met her some time last summer. Back then, her head was shaven, and it was endearing how she yearned for maturity despite the innocence that remained on her face. The conditions that surround her have changed dramatically since then. Her expression has sharpened, suggesting how she has taken on the role of someone who is in the spotlight. The boat she has boarded is much bigger than she has imagined, and she cannot see what is in front of her. Anticipation and anxiety crisscross and, just as she feels confident, in the next moment she is thrown flat on her back. She is exhausted by the instability of it all. And yet, God challenges those with the potential to transcend them. I wish for her triumph with all of my heart.

●初回限定フォトブック仕様 ¥3,800 (tax in)
Disc1 CD/Disc2 DVD-MUSIC VIDEO-

●通常盤 ¥3,150(tax

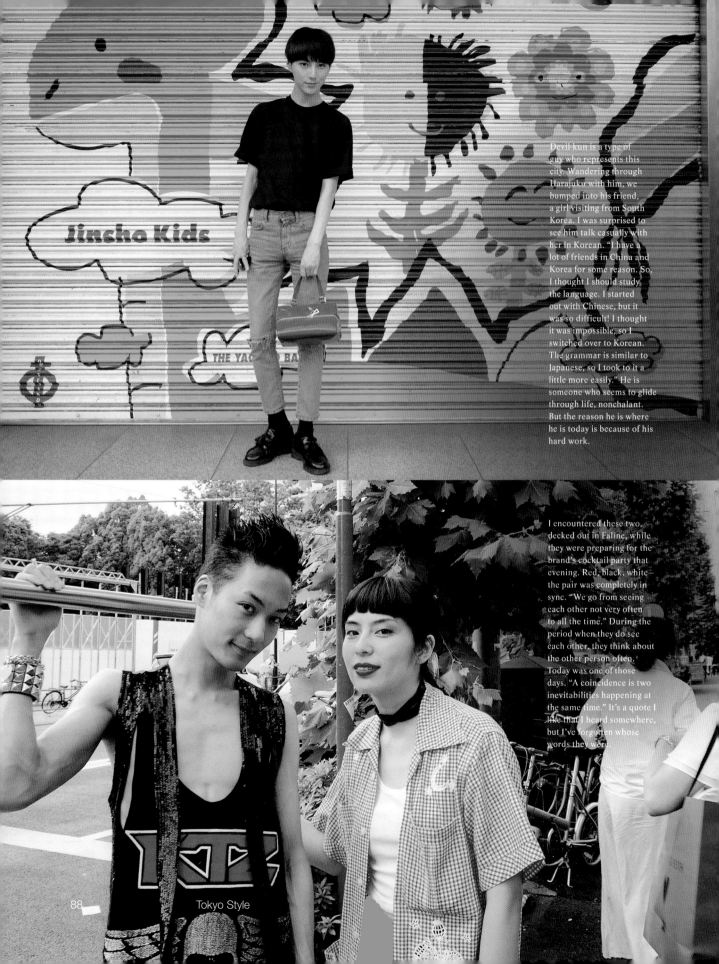

Devil-kun is a type of guy who represents this city. Wandering through Harajuku with him, we bumped into his friend, a girl visiting from South Korea. I was surprised to see him talk casually with her in Korean. "I have a lot of friends in China and Korea for some reason. So, I thought I should study the language. I started out with Chinese, but it was so difficult! I thought it was impossible, so I switched over to Korean. The grammar is similar to Japanese, so I took to it a little more easily." He is someone who seems to glide through life, nonchalant. But the reason he is where he is today is because of his hard work.

I encountered these two, decked out in Faline, while they were preparing for the brand's cocktail party that evening. Red, black, white— the pair was completely in sync. "We go from seeing each other not very often to all the time." During the period when they do see each other, they think about the other person often. Today was one of those days. "A coincidence is two inevitabilities happening at the same time." It's a quote I like that I heard somewhere, but I've forgotten whose words they were.

Tokyo Style

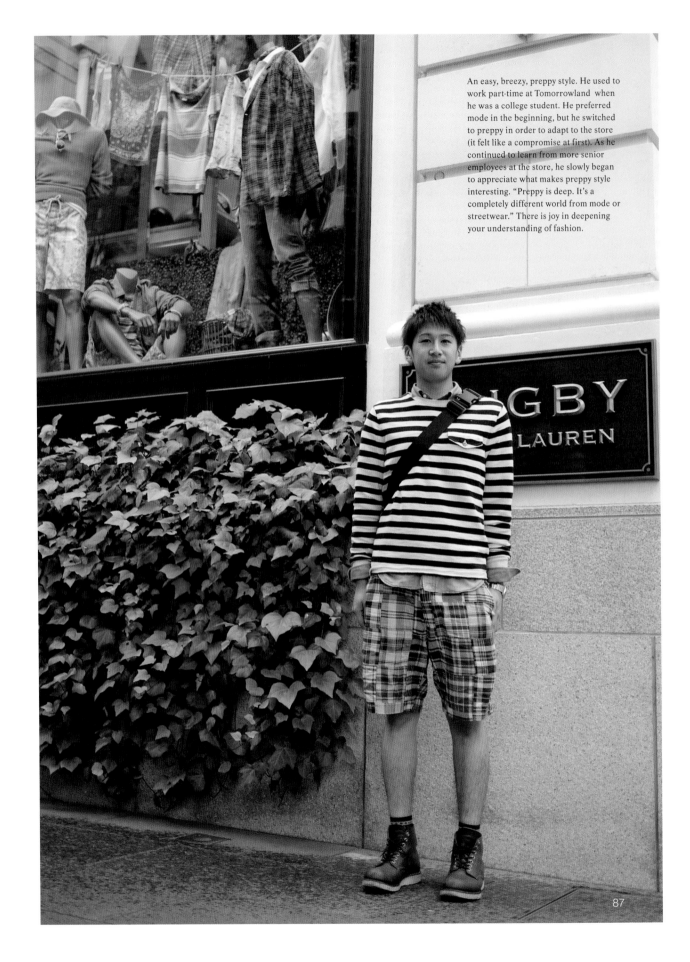

An easy, breezy, preppy style. He used to work part-time at Tomorrowland when he was a college student. He preferred mode in the beginning, but he switched to preppy in order to adapt to the store (it felt like a compromise at first). As he continued to learn from more senior employees at the store, he slowly began to appreciate what makes preppy style interesting. "Preppy is deep. It's a completely different world from mode or streetwear." There is joy in deepening your understanding of fashion.

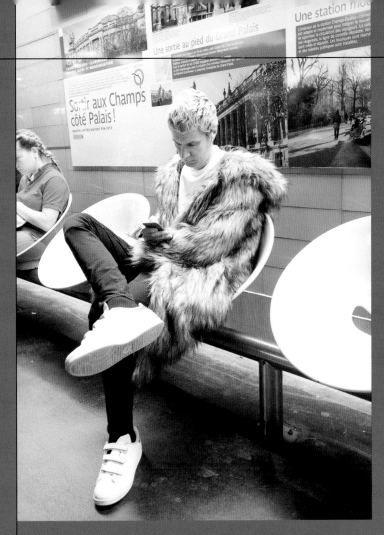

A gorgeous fur coat is offset with a white T-shirt. I recommend a white tee when you want to "subtract" from an ensemble.

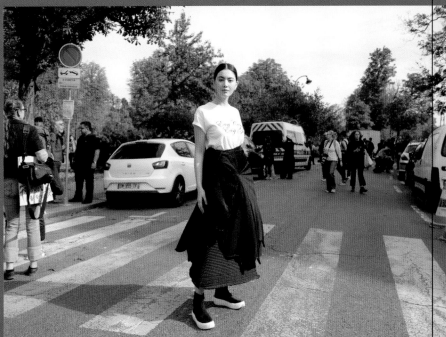

A white T-shirt is once again chosen for its "subtracting" role. The t-shirt brings out the decorative and voluminous skirt, which is the star of the ensemble.

Styling Tip #7

STANDARD: STRIPES

Stripes are probably the most beloved pattern in the whole world (according to my own survey). You can wear them simply on their own or challenge yourself a little by mixing patterns. A striped shirt is versatile enough to complement even mode items.
A striped pattern is like a mother's love—it embraces everything.

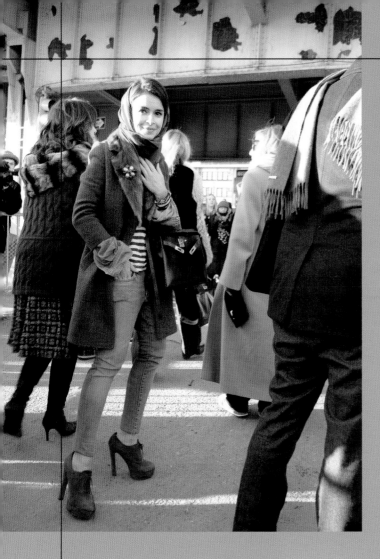

Stripes function as neutrals when paired with items that make a strong impact, like these fur tops and large brimmed hats.

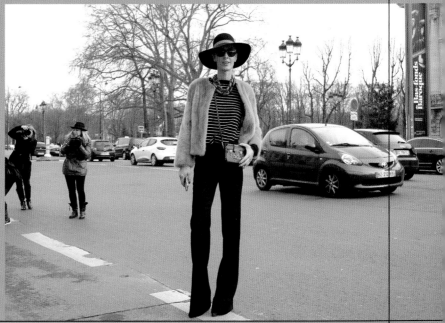

Styling Tip #8

STANDARD: DENIM

Jeans are my all-time favorite item! Anyone can wear jeans, but a pair of jeans demand your full attention. Trends as well as the position and environment you find yourself in can continually influence the size and type of jeans you wear. This is why a pair that you've been loving can suddenly feel wrong. Jeans require constant consideration so that you can choose a pair that feels true to you. A pair of jeans is like a mirror that reflects you in the moment.

STANDARD: MILITARY

Military clothing, given its roots, is often known
for its functionality and historical background, but
the stylings that follow zoom past such concerns
and embrace it purely as fashion! Here are military
pieces styled with free-spirited creativity.

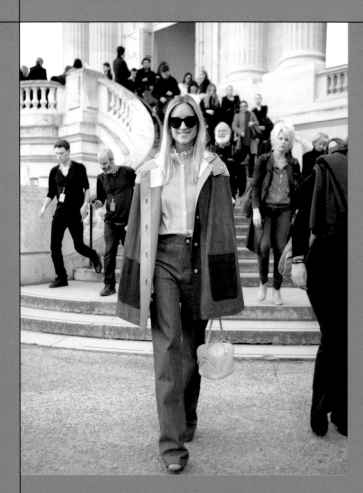

Another denim-on-denim style. The denim poncho is a slightly girly touch.

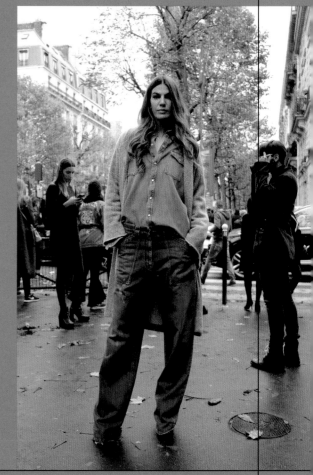

A handsome woman in denim-on-denim! Take a look at how she wears her slightly baggy denim low on her hips,
and the way she casually tucks in her oversized shirt. The "looseness" ties to the fluency of her style, and it never
looks slovenly thanks to the pair of heels (not pictured) on her feet.

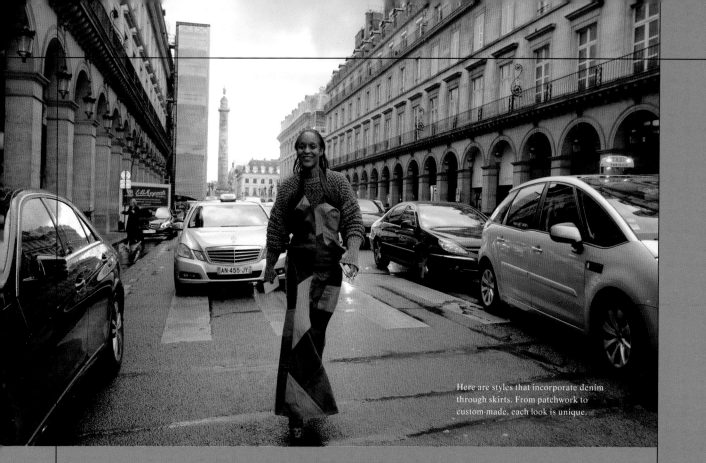

Here are styles that incorporate denim through skirts. From patchwork to custom-made, each look is unique.

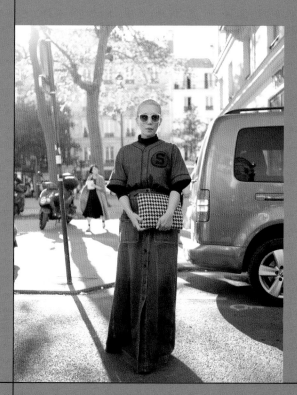

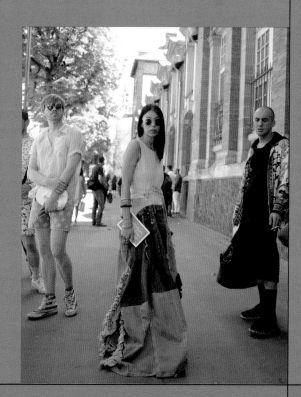

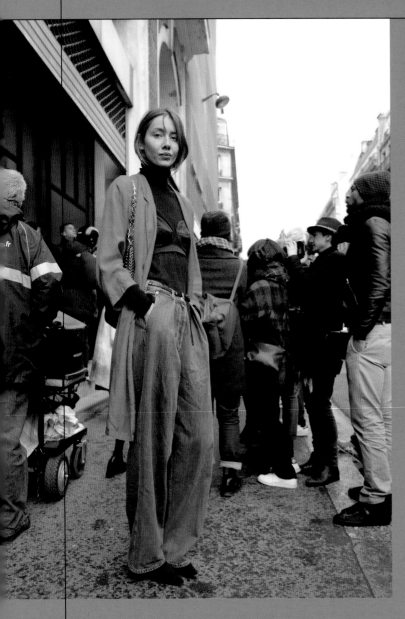

What deserves attention here is the size of the jeans and the way they are worn! The voluminous pair is worn low on the hips. This sense of balance can only be attained by a superior dresser.

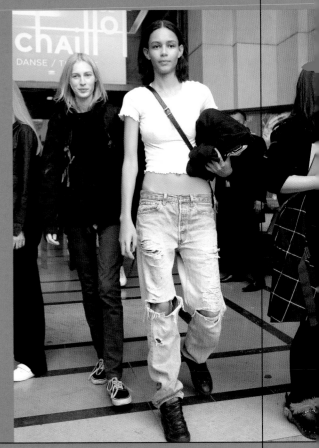

Here's a look that smashes the assumption that a white T-shirt and jeans will always look fresh and innocent! A roomy pair of ripped jeans is worn low on the hips while the tight, cropped top shows off a daring amount of skin. Once again, the key is the size of the jeans. If you want to master jeans, you've got to have an eye for size!

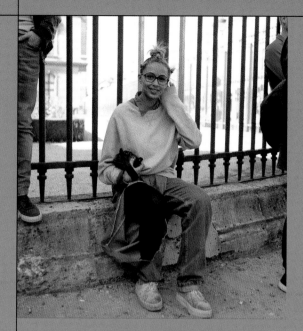

When a pair of jeans is ripped as boldly as these, there's no choice but to wear them with attitude. Fashion takes courage!

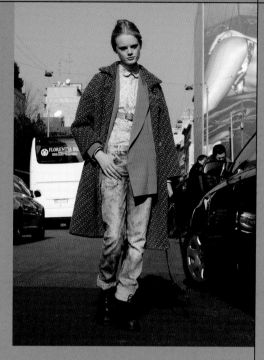

A beautifully layered top in a subtle color is counterbalanced with damaged jeans. An elegant style that eschews stuffiness.

No matter how idiosyncratic the item, everything works out when paired with denim.

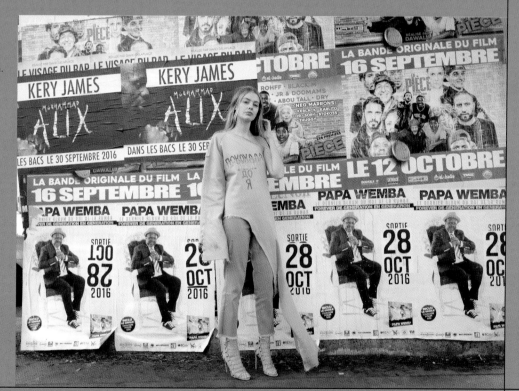

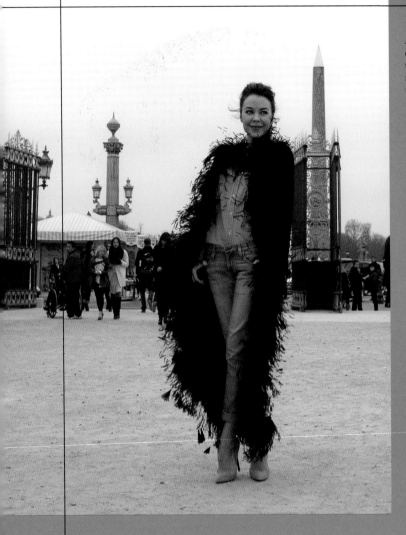

An elegant way of wearing denim-on-denim, which tends to become too casual. What makes the ensemble work is the luxurious coat!

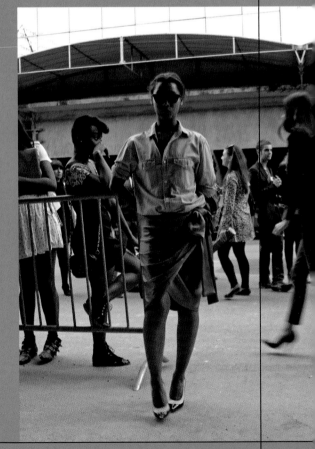

The draped satin skirt, which can be a bit much for daily wear, is toned down with a denim shirt. The color blue unifies the ensemble.

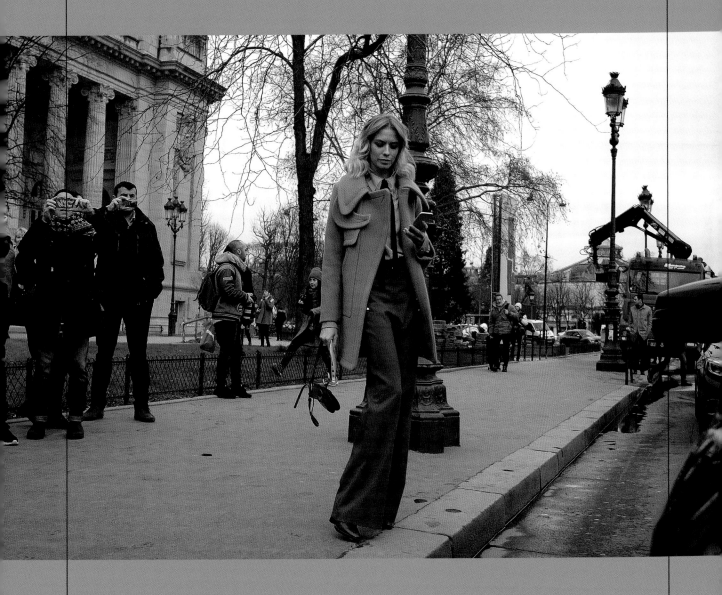

Vintage styles outlast ephemeral trends and transcend generations. A skinny black necktie (a necktie! Another staple in a classic wardrobe) sharpens a look that features mostly brown tones.

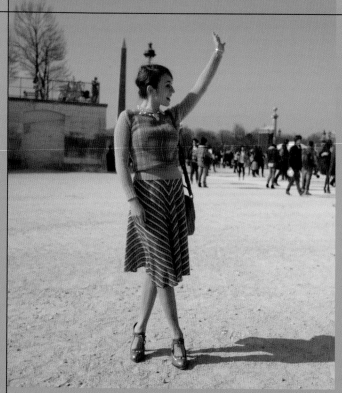

Retro patterns (a pattern-on-pattern no less!), a body-hugging silhouette, hair in a *Yokai Maki* updo, strappy heals. Clad in vintage elements from head to toe. A dedicated performance!

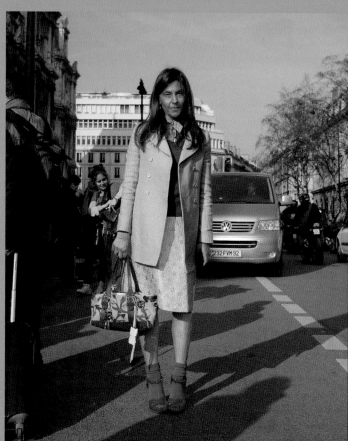

Vintage styles feel classic, so we tend to keep them in conservative colors. Add a dash of vivid color instead for an update.

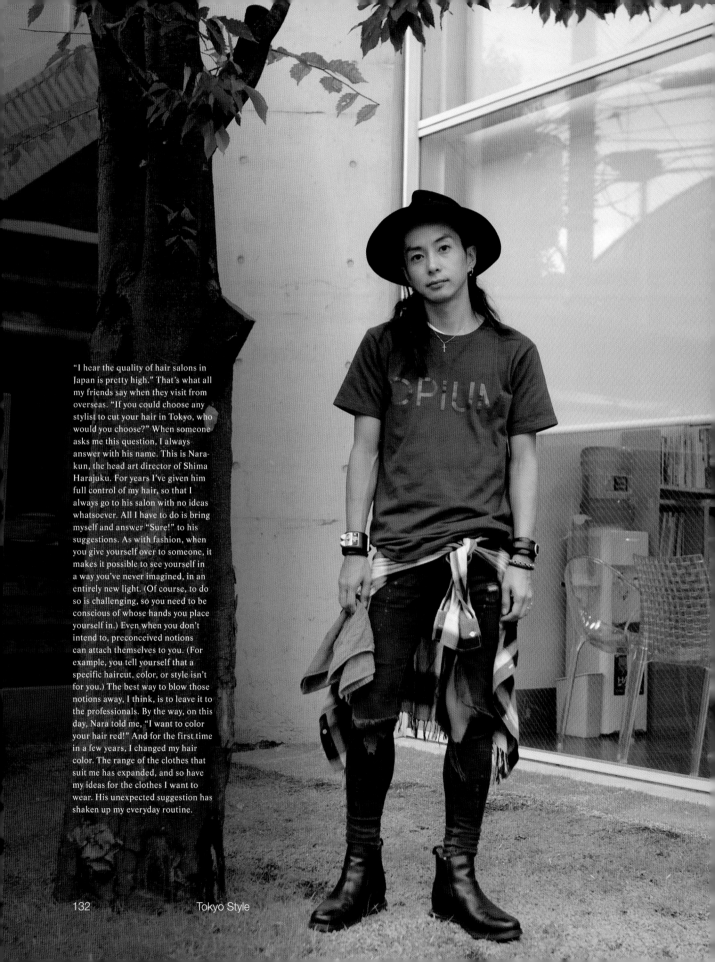

"I hear the quality of hair salons in Japan is pretty high." That's what all my friends say when they visit from overseas. "If you could choose any stylist to cut your hair in Tokyo, who would you choose?" When someone asks me this question, I always answer with his name. This is Nara-kun, the head art director of Shima Harajuku. For years I've given him full control of my hair, so that I always go to his salon with no ideas whatsoever. All I have to do is bring myself and answer "Sure!" to his suggestions. As with fashion, when you give yourself over to someone, it makes it possible to see yourself in a way you've never imagined, in an entirely new light. (Of course, to do so is challenging, so you need to be conscious of whose hands you place yourself in.) Even when you don't intend to, preconceived notions can attach themselves to you. (For example, you tell yourself that a specific haircut, color, or style isn't for you.) The best way to blow those notions away, I think, is to leave it to the professionals. By the way, on this day, Nara told me, "I want to color your hair red!" And for the first time in a few years, I changed my hair color. The range of the clothes that suit me has expanded, and so have my ideas for the clothes I want to wear. His unexpected suggestion has shaken up my everyday routine.

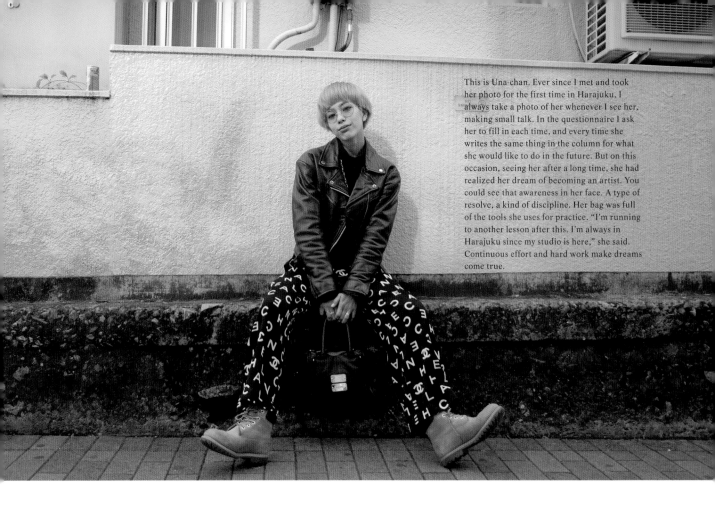

This is Una-chan. Ever since I met and took her photo for the first time in Harajuku, I always take a photo of her whenever I see her, making small talk. In the questionnaire I ask her to fill in each time, and every time she writes the same thing in the column for what she would like to do in the future. But on this occasion, seeing her after a long time, she had realized her dream of becoming an artist. You could see that awareness in her face. A type of resolve, a kind of discipline. Her bag was full of the tools she uses for practice. "I'm running to another lesson after this. I'm always in Harajuku since my studio is here," she said. Continuous effort and hard work make dreams come true.

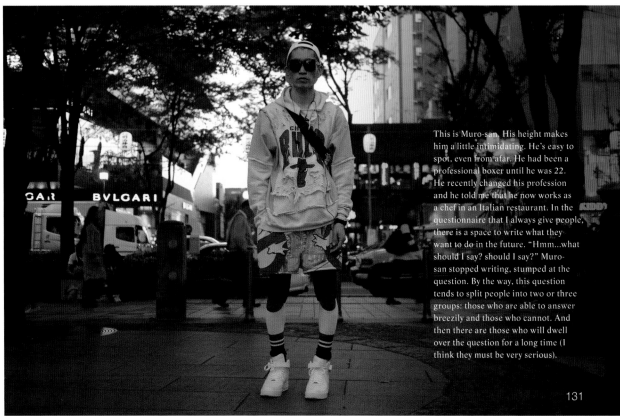

This is Muro-san. His height makes him a little intimidating. He's easy to spot, even from afar. He had been a professional boxer until he was 22. He recently changed his profession and he told me that he now works as a chef in an Italian restaurant. In the questionnaire that I always give people, there is a space to write what they want to do in the future. "Hmm...what should I say? should I say?" Muro-san stopped writing, stumped at the question. By the way, this question tends to split people into two or three groups: those who are able to answer breezily and those who cannot. And then there are those who will dwell over the question for a long time (I think they must be very serious).

131

The other day, I had the chance to talk to a gentleman who knows fashion very well. The two of us discussed various matters related to Tokyo fashion (particularly street fashion). According to him, what people often say when describing fashion in Tokyo is that it lacks "hierarchy" and that it is "genderless." He told me that those characteristics are the source of what makes Tokyo unique. Recently, it feels that the "genderless" aspect has gained even more momentum. It's also interesting how in Japan, fashion is genderless on the surface, more so than an expression of a mentality. The clothes are not an expression of a genderless mentality (in other words, style), but a way to show one's genuine preference for a certain silhouette, looks, or taste (in other words, fashion).

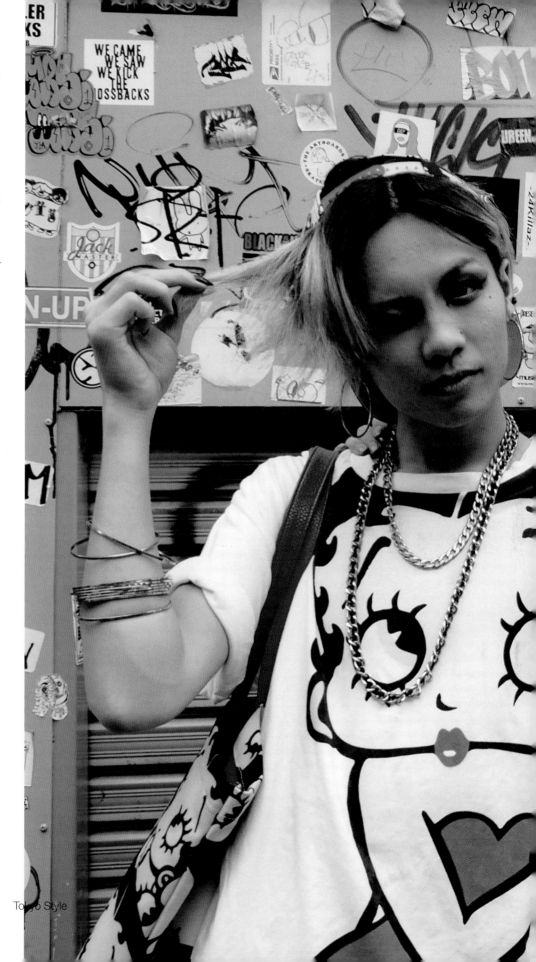

Tokyo Style

skateboarders walk through the streets that may seem ordinary to most people with a "skater's view," seeing which tricks they can attempt or whose stickers are displayed there. I think this artistic perspective is one of the reasons why street art has grown so influential.

—— It seems that street culture is integral to fashion and art for you. What attracts you to street fashion?

Long ago, a mentor of mine taught me, "To be street is to forge a new path in a way that nobody else is attempting." So many things are called street fashion and I feel that its definition has become so vague in the recent years. The answer doesn't exist, but what my mentor told me has resonated with me the most. In the same way, Nigo is someone who created not only fashion but also a new path, meaning a new sense of value. For instance, he would drive a luxury car and go to a luxury hotel dressed in a T-shirt and a baseball cap. No one had ever done that before him. I'm sure there are many arguments around it, but for me the greatest appeal of street culture is that it has the potential to create entirely new values and generate styles that have never been seen before. Fashion is supposed to be liberating but, especially in Japan, the compliances and rules can be so strident that they hinder freedom. But street fashion and art still embrace freedom. That's also why I'm drawn to them.

—— Is there anything you would like to try next?

I think we need to start thinking about adding new value to fashion. Today, you can buy a song for a few hundred yen, but a VIP ticket to Coachella can sell for hundreds of thousands of yen. It means that people want to experience the music in person, even at a high cost. In the same way, other than simply wearing clothes, I wonder if there could be a way to merge fashion with other genres such as art and food, so that we can enjoy them together. As for the future, I'm curious what it would mean for fashion if things could be "playable" much like we do with music. There could be a wearable device that uses 3D graphics to transform what you are wearing or adapt it to different scenes and occasions.... I think it's possible to attain that kind of future. I've also recently started to build more relationships with people in the tech industry. Those in IT are constantly thinking about what would make things more interesting instead of just following the rules. I think that mentality connects to the street spirit, so it's fun to talk to them. Something that I've been dreaming about for a long time is fashion in zero gravity. Fashion is something that works because of gravity, so I would love to know how you would enjoy fashion in its absence. You can't wear a hat, for instance (LOL). The audience would float and so would the clothes. I always think about how fun it would be to put on a show like that.

Motofumi "Poggy" Kogi

After joining United Arrows in 1997 where he worked as a shop attendant and then in P.R., he established Liquor, Woman & Tears, a select shop that merged luxury with streetwear in 2006. In 2010, he became the director of United Arrows & Sons. Since becoming independent in 2018, he has worked as a fashion director of 2G in Parco Shibuya and also as an advisor. With his trademark hat and beard and a style that mixes suits with streetwear, he is a world-renowned fashion icon representing Japan.

Small Stories #2

trails of cocktail dresses behind you on international red carpets? I don't think that would have happened in Japan— we would have altered the length so that they won't drag. Clothes stop being fashion and become daily wear as soon as you consider their utility. Perhaps there is so much daily wear in Japan because culturally there aren't many special events here. It makes sense that ideas like washable tuxedos was born in Japan. Lately, designers abroad have also begun incorporating this practical way of thinking and it has become a trend to create clothes that are comfortable to wear every day. Japanese tendencies could be making some impact on international fashion.

——You fly all around the world, but what makes Tokyo different from other cities in the world? What are the strengths and weaknesses of Tokyo, if any?

I don't think there is any other place beside Japan, especially Tokyo, where you can encounter so many genres of fashion just by walking a few hundred meters. Japanese people also have so much knowledge about fashion. After the war, Japanese people admired the U.S., which compelled them to thoroughly research American fashion. So many how-to books with titles like, *"The Coolest Way to Wear Denim"* and *"What Is Ivy Style?"* were published, and even now there are so many publications in a similar vein. In an environment like ours, there is a maniacal level of knowledge in fashion, so that we only need to look at the collar of a shirt to determine if it's more Italian or American. However, having such a thorough understanding of the rules can also become a weakness, since it makes it more difficult for people to embrace and generate new styles.

——Are there other elements in the fashion scene that you are intrigued by?

I'm intrigued by the resurgent interplay between fashion brands and street art, which had happened in the '90s and the early aughts in Japan. Back then, the graffiti artist Stash, who had a relationship with the clothing brand Hectic, introduced Kaws and Futura to the brand. Stash also started creating clothes with Futura, connecting fashion and art. I get the impression that American brands today have absorbed this trend that was happening in Japan at the time and are now transmitting it to the world. Dior's Kim Jones has collaborated with Hajime Sorayama and Kaws, for example, and Futura has also done a live painting during a Louis Vuitton show. I feel there is a strong exchange between fashion and street art.

——What has sparked your recent interest in art?

I always had an interest in art, but the biggest trigger was when I opened the studio 2G. I attended a talk show by Sotheby's at Art Basel in Hong Kong, China, where I heard that there has been a noticeable rise in the popularity of street art in recent years, so much so that buyers have begun to hire people with an expertise in street fashion. This year, Nigo also made headlines when he auctioned his personal collection and his Kaws painting set a new auction record. I sensed that the art world was starting to lean closer to what's going on in the streets and I started to feel much more familiar to it. I also thought skateboarders were such an important part of why street art became so popular. In the skateboard world, the boards known as decks serve as canvases, and they have a long tradition of searching for and hooking up young emerging talent. Moreover,

——What sort of work have you been doing since you left United Arrows?

I've continued to work as an advisor for the concept store, United Arrows & Sons, while also leading the studio 2G, which merges art from Nanzuka and art toys from Medicom Toy with selected fashion. I also serve as a fashion advisor for a talent production company, consultant for fashion brands, and a judge for the Fashion Prize of Tokyo, a competition that aims to select Tokyo-based designers with the potential to become an international brand.

——You get a lot of attention from around the world as a fashion icon, but how would you describe your own style? What are your some of your influences?

I like to mix suits with items cadged from the street; I call it "sartorial street style." I became obsessed with the fashion of Ura-Harajaku such as Goodenough and A Bathing Ape when I was in high school. I joined United Arrows when I was twenty years old and began learning about suits and trad styles. I was working in PR in the early aughts, around the time Hedi Slimane was at the helm of Dior Homme, and the skinny, rock 'n' roll fashion was all the rage in Japan back then. This was also when I went to New York for the first time, and I was galvanized by the fashion of the hip-hop community. Instead of the so-called "baggy" style, artists like Kanye West and Pharrell Williams were dressing down trad clothes like Ralph Lauren in a rough and casual way, and I thought they looked incredibly cool.

——So your experiences in New York were how you came to establish your "sartorial street style."

Yes. When I was at United Arrows, I was taught that "men should learn to wear style, women should learn to wear mode." In womenswear, what's considered mode or fashionable changes every six months. In menswear, the emphasis is on choosing clothes based on where you are going and how you are getting there. As you repeat this selection process, you start to realize that whether you are wearing a T-shirt or a suit, you are what makes the clothes. Money can buy fashion, but it can't buy style—what naturally flows out of that person is called style. Back then, I didn't understand this idea very well, but I continued to dress in the sartorial street style that I love, and lately I've started to feel as if it's my duty to wear a hat and a beard and pair a jacket with street items, so I think I'm beginning to understand it (LOL).

——Even if your style stays the same, do you have something that you are particularly into at the moment?

I've been wearing Issey Miyake's Pleats Please series and the brand Kapital. I saw people from overseas wearing both, and I liked them. When people from other countries wear brands with an established image in Japan in a contemporary way, it allows me to appreciate them again and reaffirm what makes Japan great. I'm also really into Toraichi trousers worn by Japanese scaffold workers.

——What do you think are the distinctive characteristics of Tokyo fashion?

I think everyone here just enjoys fashion. I think you need peace for fashion to thrive, so Japan, where so many different genres of fashion coexist, must be very peaceful indeed. Also, you know how it's acceptable to drag the

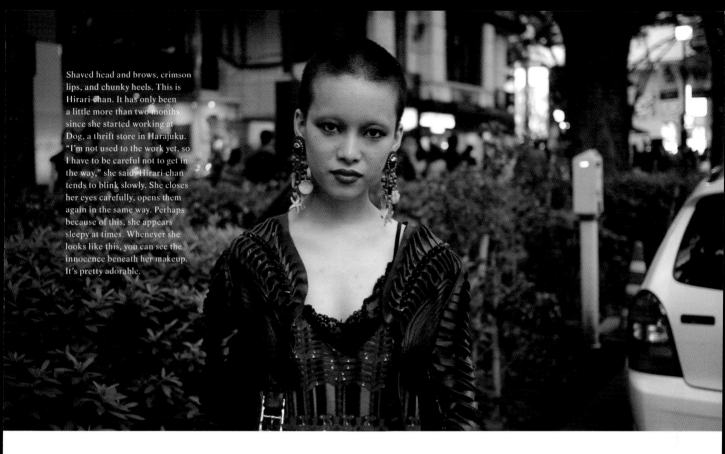

Shaved head and brows, crimson
lips, and chunky heels. This is
Hirari-chan. It has only been
a little more than two months
since she started working at
Dog, a thrift store in Harajuku.
"I'm not used to the work yet, so
I have to be careful not to get in
the way," she said. Hirari-chan
tends to blink slowly. She closes
her eyes carefully, opens them
again in the same way. Perhaps
because of this, she appears
sleepy at times. Whenever she
looks like this, you can see the
innocence beneath her makeup.
It's pretty adorable.

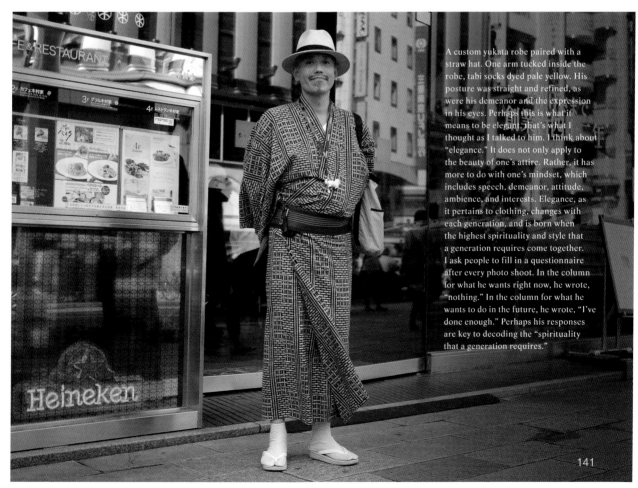

A custom yukata robe paired with a
straw hat. One arm tucked inside the
robe, tabi socks dyed pale yellow. His
posture was straight and refined, as
were his demeanor and the expression
in his eyes. Perhaps this is what it
means to be elegant, that's what I
thought as I talked to him. I think about
"elegance." It does not only apply to
the beauty of one's attire. Rather, it has
more to do with one's mindset, which
includes speech, demeanor, attitude,
ambience, and interests. Elegance, as
it pertains to clothing, changes with
each generation, and is born when
the highest spirituality and style that
a generation requires come together.
I ask people to fill in a questionnaire
after every photo shoot. In the column
for what he wants right now, he wrote,
"nothing." In the column for what he
wants to do in the future, he wrote, "I've
done enough." Perhaps his responses
are key to decoding the "spirituality
that a generation requires."

141

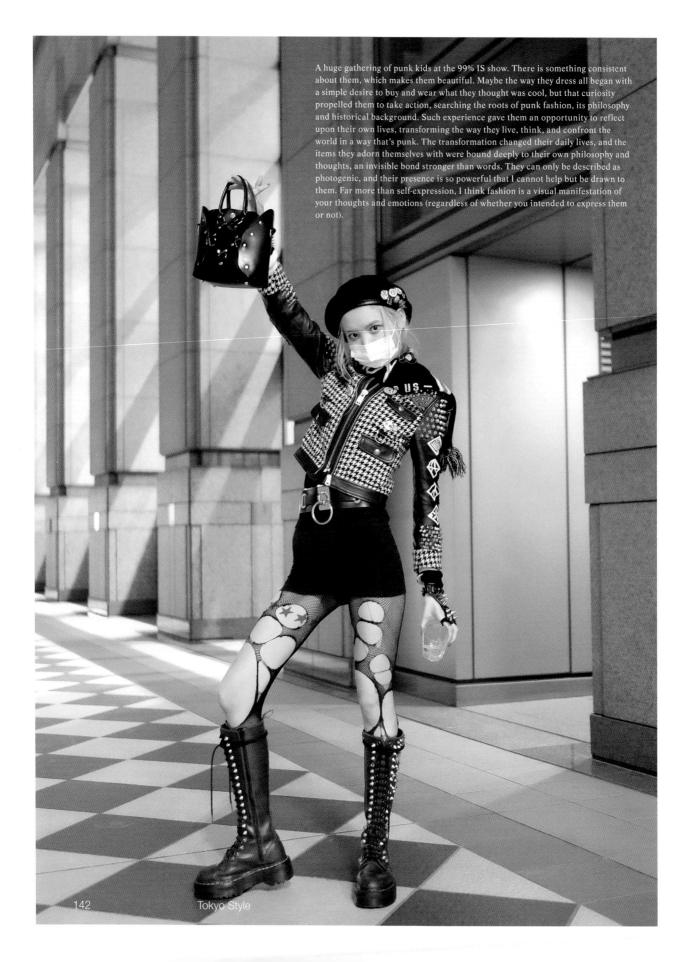

A huge gathering of punk kids at the 99% IS show. There is something consistent about them, which makes them beautiful. Maybe the way they dress all began with a simple desire to buy and wear what they thought was cool, but that curiosity propelled them to take action, searching the roots of punk fashion, its philosophy and historical background. Such experience gave them an opportunity to reflect upon their own lives, transforming the way they live, think, and confront the world in a way that's punk. The transformation changed their daily lives, and the items they adorn themselves with were bound deeply to their own philosophy and thoughts, an invisible bond stronger than words. They can only be described as photogenic, and their presence is so powerful that I cannot help but be drawn to them. Far more than self-expression, I think fashion is a visual manifestation of your thoughts and emotions (regardless of whether you intended to express them or not).

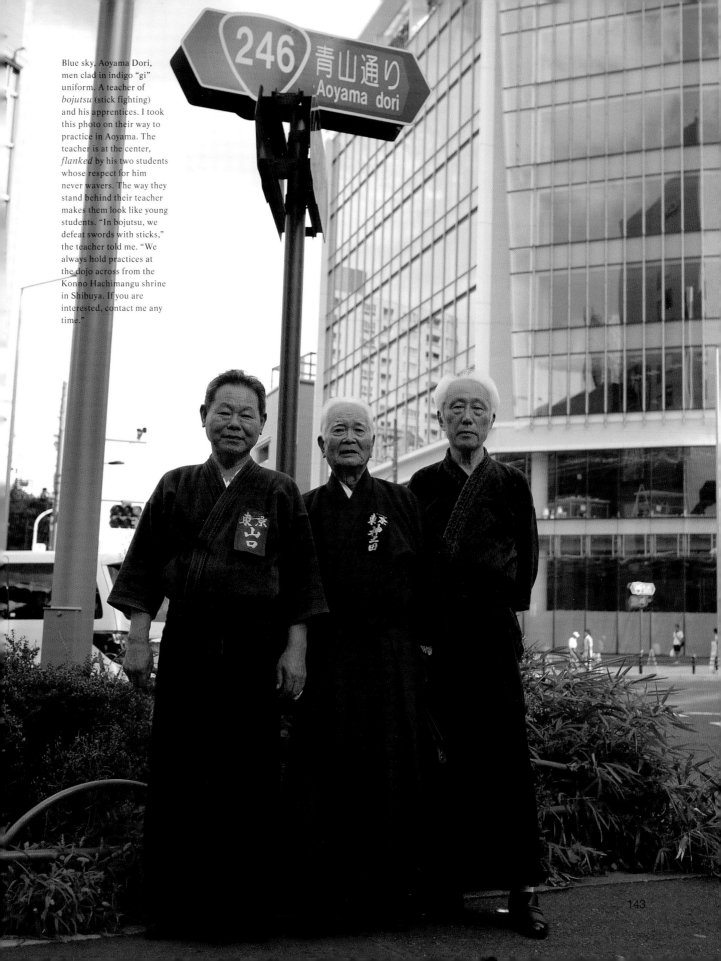

Blue sky, Aoyama Dori, men clad in indigo "gi" uniform. A teacher of *bojutsu* (stick fighting) and his apprentices. I took this photo on their way to practice in Aoyama. The teacher is at the center, *flanked* by his two students whose respect for him never wavers. The way they stand behind their teacher makes them look like young students. "In bojutsu, we defeat swords with sticks," the teacher told me. "We always hold practices at the dojo across from the Konno Hachimangu shrine in Shibuya. If you are interested, contact me any time."

143

A kebab shop on Meiji Dori. I found him ambling through the city, clutching a cane with a skull. It took a bit of courage to stop and talk to him, but I did. Contrary to how he looks, he was a very nice guy. His nickname? Demon King. "What do you want to do in the future?" I asked. "Take over the world." "You are the king, after all." "True."

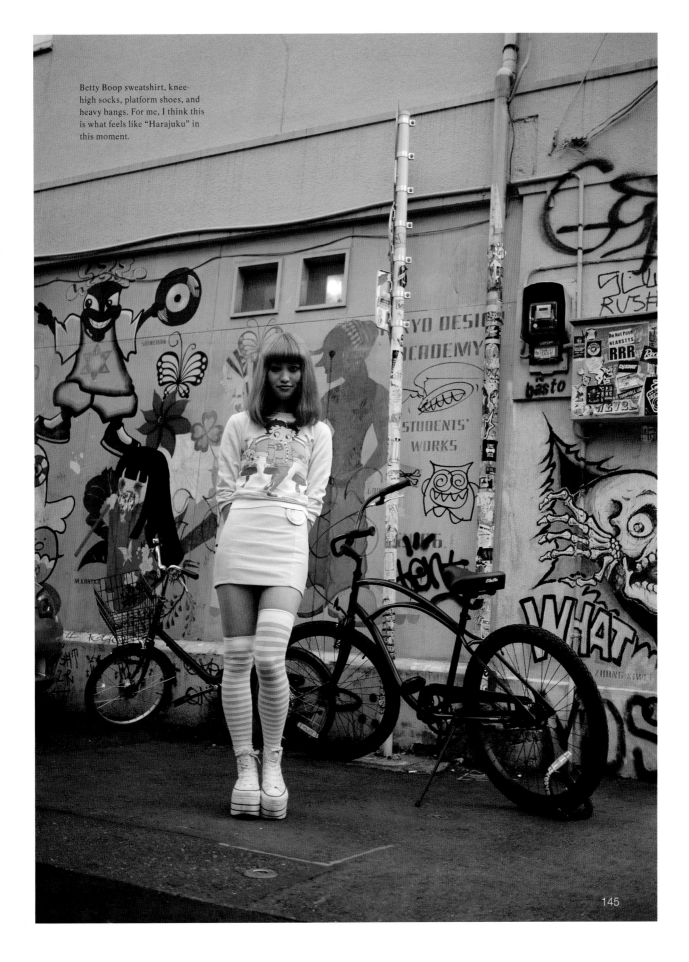

Betty Boop sweatshirt, knee-high socks, platform shoes, and heavy bangs. For me, I think this is what feels like "Harajuku" in this moment.

145

SHINY ITEMS, VIVID COLORS

Good news for anyone who thinks gold and silver are too flashy and therefore avoids them! Here, I apply the technique of *zurashi* (shifting) to color saturation.

First break down the colors you want to wear into their elements. When silver loses its luster, it leaves behind a grayish hue. Gray is a neutral color that goes with anything.

In the same way, gold without luster becomes a kind of beige. Beige, like gray, is a neutral color that complements everything.

When you shift the saturation of gold and silver and treat them as neutral colors, they become much easier to incorporate into your outfit.

Try coordinating gold and silver with other neutral colors such as white, navy, brown, and beige. If you want to challenge yourself a little more, try combining them with colorful items and you'll instantly upgrade your style.

The same idea applies to neon colors. Shift the intensity of neon yellow or neon green and simply match them with colors that go well with yellow or green!

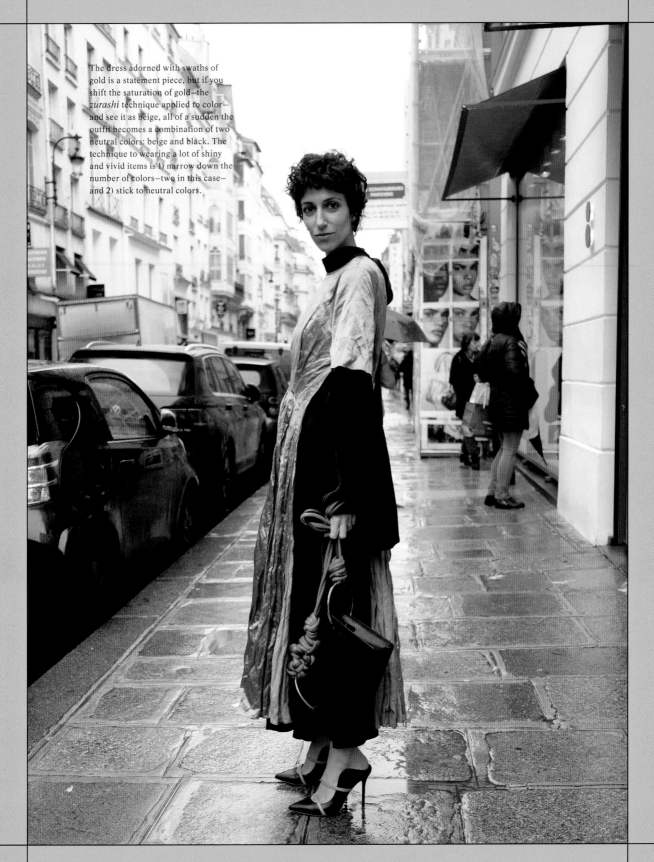

The dress adorned with swaths of gold is a statement piece, but if you shift the saturation of gold—the *zurashi* technique applied to color—and see it as beige, all of a sudden the outfit becomes a combination of two neutral colors: beige and black. The technique to wearing a lot of shiny and vivid items is 1) narrow down the number of colors—two in this case—and 2) stick to neutral colors.

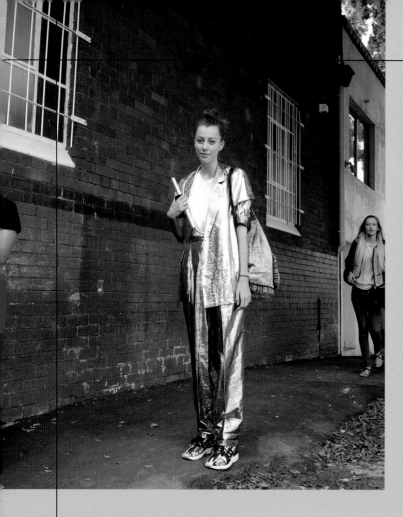

An eye-catching gold ensemble is paired with a classic white T-shirt. Statement pieces are easier to pull off when neutralized with a staple item.

The gold-toned skirt with a mode feel makes a big impact, but a well-worn vintage T-shirt neutralizes it so that the ensemble looks effortless and comfortable enough to wear every day. It's the same logic as how a great yakitori restaurant always serves shaved radish as an appetizer—it's all about modulation.

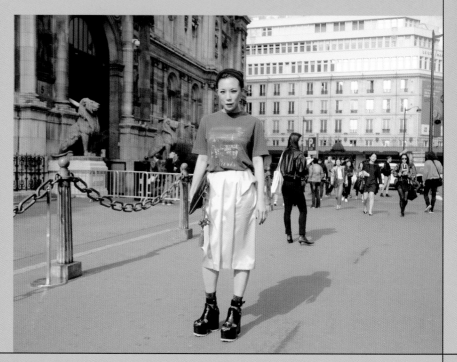

Four different ways of wearing silver. You might hesitate to reference these looks at first but take a closer look at the combination of colors. The colors are all neutrals and the items are wardrobe staples, something you might even find in your own closet. Doesn't that make you feel better about wearing shiny and vivid pieces? If so, go ahead and try wearing them yourself!

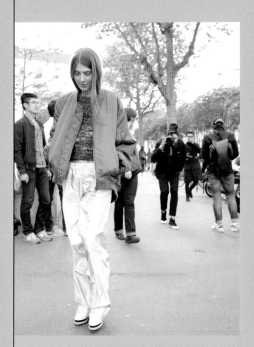
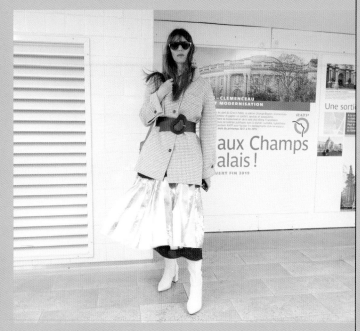
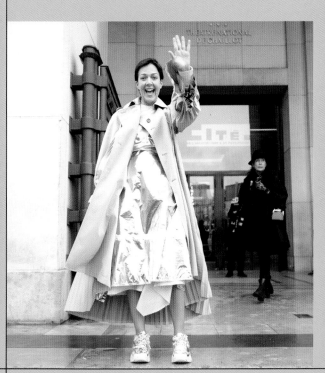
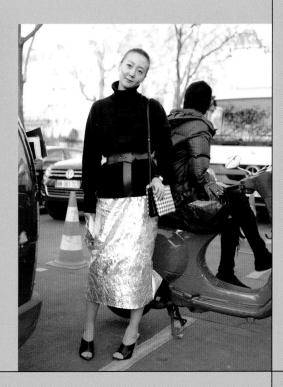

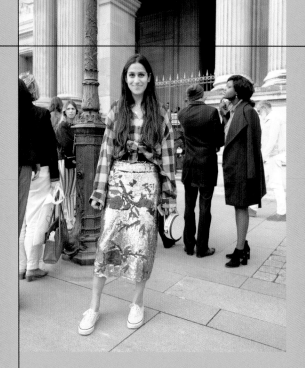

Here is the *zurashi* technique with color at its best. All it takes is a single silver skirt to turn a seemingly ordinary ensemble into a casual style with a twist.

Silver skirt and a pop of color on top. Shift the saturation of silver so that the skirt becomes more of a light gray. The *zurashi* technique with color makes it easier to pair vivid colors with shiny pieces.

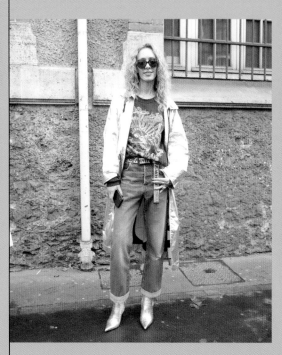

A simple jeans and T-shirt ensemble is elevated when worn with silver jacket and shoes. It's all about calibrating the amount of silver you incorporate!

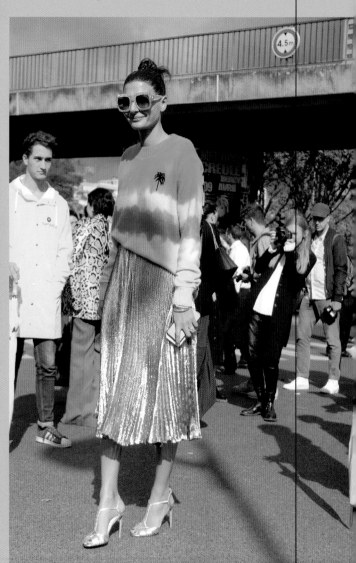

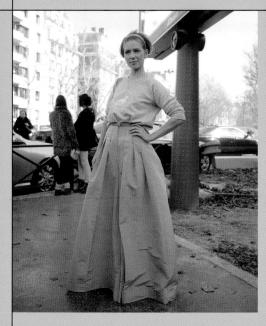

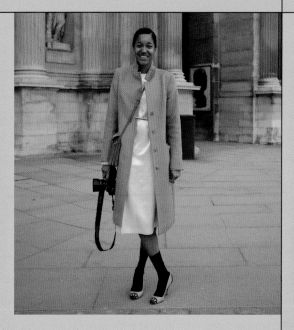

Neon colors pierce the monochromatic ensemble like arrows. Neon colors stand out all the more with subtle accessories like hairbands and belts that don't take up a lot of real estate. A simple yet powerful style.

Apply the *zurashi* technique to neon yellow and it becomes a simple yellow. Here, the ensemble is expertly tied together using tones similar to the beige of the coat, while bag and shoes add a pop of color.

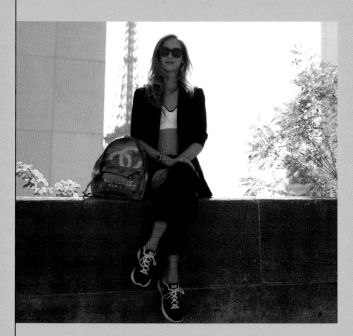

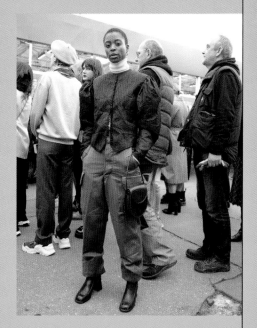

An all-black outfit with a neon yellow sports bra. Limiting to just two hues makes the yellow pop, and the glimpse of neon is a witty touch.

A Victorian top paired with authentic military pants. The weight of vintage and heritage pieces is counterbalanced with the neon yellow at the collar. An enlightened style that mixes genres.

COLOR COMBINATIONS

One of the things I learned while taking photos around the world is that you can see a country's character in the way its people combine colors. For example, I always love taking photos of Italian women because they come up with color combinations that soar far beyond my imagination! The way they combine colors is inspiring—it's bold, vivid, and playful with an unexpected twist. (It's interesting because I feel that the Japanese, on the other hand, are skilled at using subdued colors.)

There are two methods of incorporating vibrant colors.

1) Surface
2) Scatter

Let's take a look as some examples.

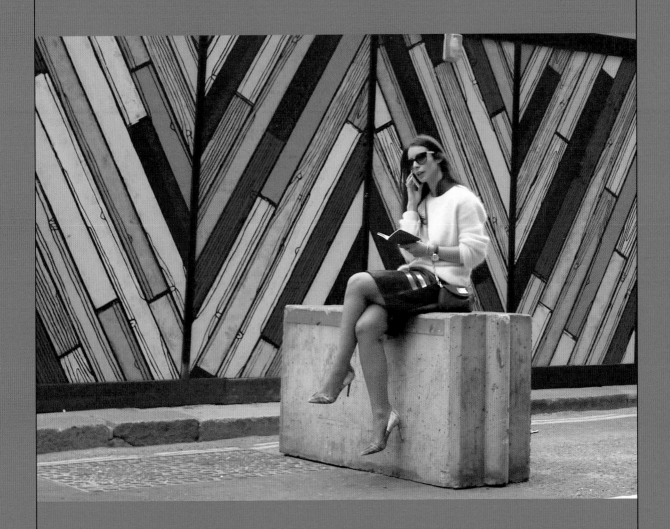

Here I look at parts 1) and 2) to explain the methods of combining vivid colors. She first incorporates a large surface 1) of vivid color with a statement top. The key to this ensemble is how she narrows down the number of items she wears. Since the color combination is on the flashier side, it's best to keep the outfit simple. Then, she scatters 2) vivid colors throughout with shoes and a bag. I love how you can catch glimpses of her fashionista spirit that declares, "Even if your style is simple, always leave a mark!"

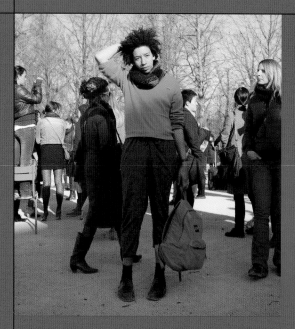

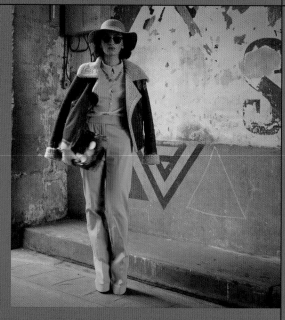

Vibrant green, navy, blue—a vivid combination of tones. Since the combination packs a punch, keep the silhouette simple.

Top and bottom featuring gorgeous greens. The jacket thrown over her shoulder tones down the flashy colors, letting them settle more casually. It's amazing how the colors of her jacket and hat work in concert with each other, too.

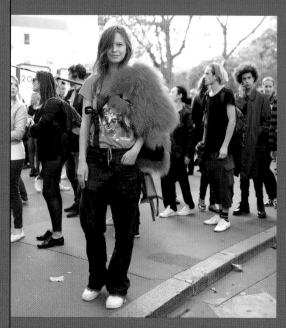

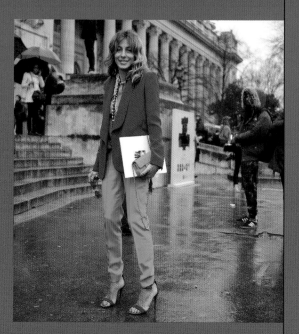

Who would have thought that a vivid and gorgeous fur shawl could be worn so casually? I love the contrast of the street-style items, which are polar opposites of the fur in both color and genre.

Here is another brilliant green and blue combination. The jewelry over her heart (which is also in harmony with her hair color!) adds spice. The key to making bright color combinations work is to keep the silhouette streamlined.

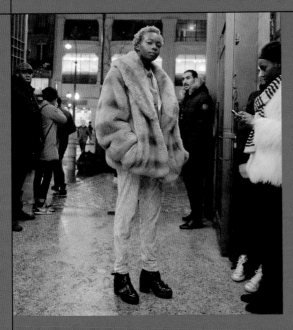

This color combination may seem flashy at first, but the fabric softens the ensemble into more nuanced tones.

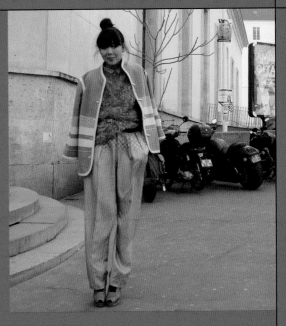

The gradient of colors around the hip deserves attention. The subdued colors evoke the beach just before dawn. The jacket is the perfect touch that "cools down" the overall styling.

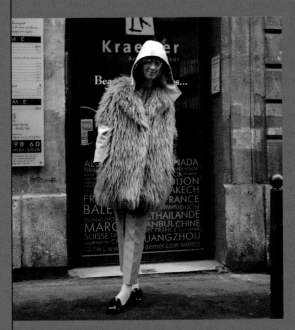

A pastel yellow-green fur and vivid green pants. Since the ensemble features a strong combination of similar shades, the white hoodie worn as an inner layer keeps things loose and casual.

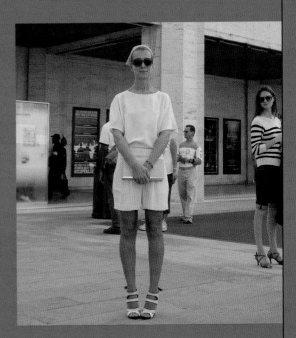

Pastel color combinations can quickly become saccharine (and the makings of a typical "flirty and girly" outfit often seen in Japan) but the way she ties her scarf around her head manages to turn the entire concept around! These clothes aren't styled to fit anyone else's ideals; they are worn for her own enjoyment. A pastel style for a grown-up, independent woman.

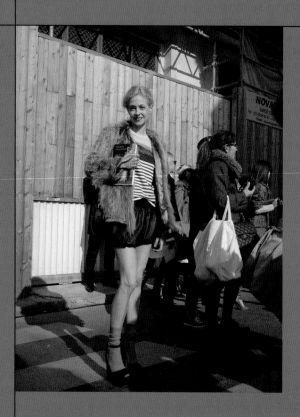

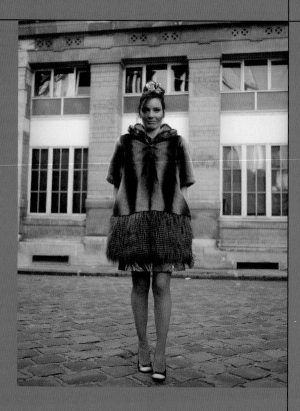

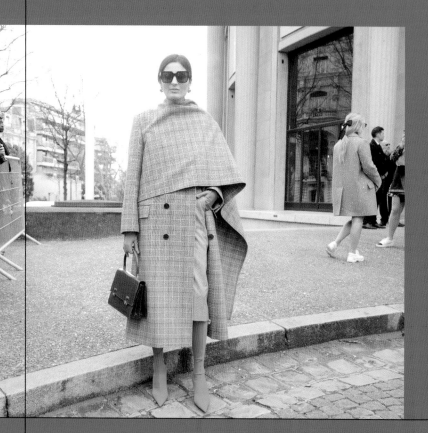

A selection of three combinations that "scatter" vivid colors. The pop of color peering out at the sleeves, the hem, and from beneath the coat.... The smaller the real estate, the stronger the impression that vivid colors make. Since it's just a small part, make it as bright as you want, be colorful and playful! (The bonus is that even if you step out of the house and you're not feeling your style, you can easily fix it. Worst case scenario, you can take it off or hide it with an outer layer!)

Elisa Nalin's style

I don't care what anyone says. The indomitable queen of styling colors is Elisa Nalin! Warm colors, cold colors, subdued colors, crisp bright colors—she can wear them across vast surfaces or scatter them around. No matter how she wears colors, she'll surprise you every time and make you think, "Oh, that's a way to incorporate color I've never thought of before!" I believe her sense of color is unparalleled.

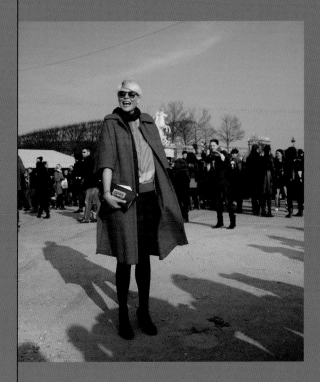

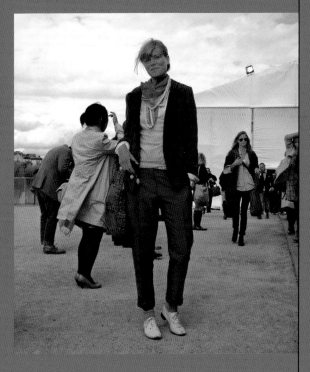

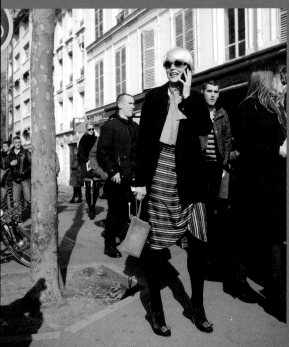

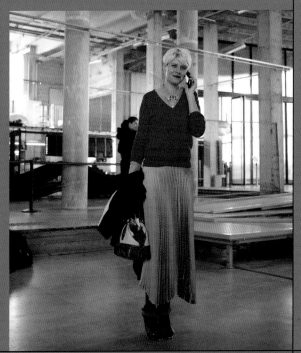

SIMILAR COLORS, MONOCHROMATIC STYLE

When you want to dress head to toe in similar colors, you must first decide your stance! Begin by having a clear idea of what you want to do and how you want to be.

There are two ways you can wear monochromatic style.

1) Bold
As you might guess, this is when you dress to clearly express what you love with your whole body and soul. There's a refreshing frankness to this method. The downside is that it can feel a little too perfect.

2) Nuanced
This is a tried-and-true method that we Japanese people have mastered. It is expression through obfuscation, where you express the vague idea of what you like with nuance and range. There is softness and depth to this expression, but it lacks decisiveness.

By the way, Buddhism begins by understanding that life does not always go your way, but I feel that fashion might be a rare exception. We only live once—I don't think you'll be punished for wearing what you like the way you like. Yet it's hard to disregard how you want other people to think about you. Even if you go out in your favorite outfit, if your date seems put off by it, you can't help but feel disappointed, right? (The earthly desire to please others is hard to renounce.)

Balancing your sense of self and your relationship to society on a scale and making the decision to dress "the way you want to, right now" is difficult. The conflict between the two is something we have to keep in mind as a member of society (Of course, the exception is when you're still at an age when you're relatively free from constraints, like when you are a student, or when you are enjoying a personal moment at home. In such situations, you should enjoy wearing whatever your heart desires.)

What's important is not to be forced into making a choice, but to think for yourself before choosing a style.

This is what it means to wear color boldly!
She expresses what she loves with her whole
being through fashion. I love her candid and
carefree self-expression!

Five crisp and bright looks

A selection of five styles that exemplify bold monochromatic style. The more intense the color of your ensemble, the bolder you should be in your attitude. Yes, attitude is part of fashion, too!

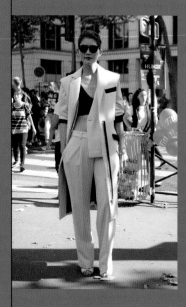
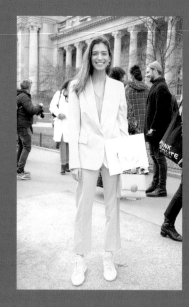
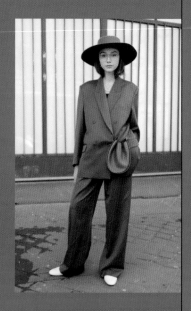
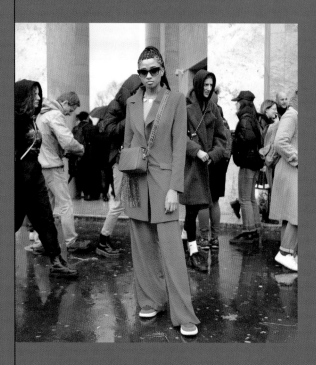
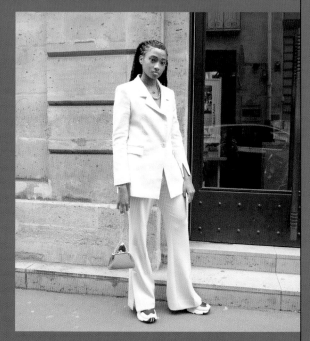

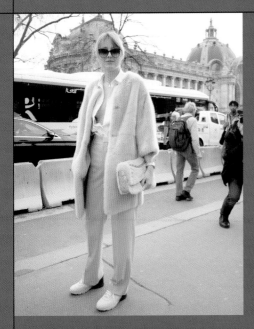

A gradient of subdued colors from pastel green to mint green. Since the colors are soft, the fabric should be soft, too.

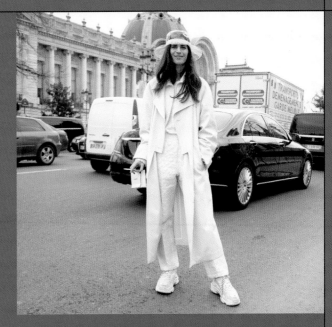

The subtle white gradient is a mark of a true expert!

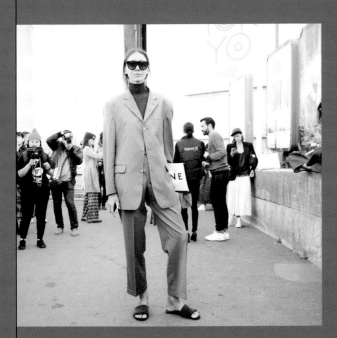

Gradient styling with shades of brown. The sandals add an effortless touch.

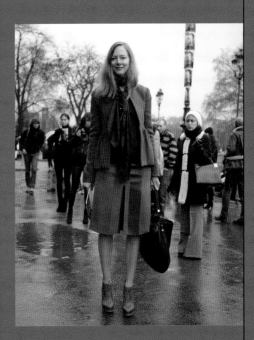

A combination of subtle shades of brown, green, and blue. Only a virtuoso can make her hair color a part of the palette.

Styling Tip #14

PATTERN ON PATTERN

Checks, florals, stripes, geometrics—the world is filled with a variety of patterns. When you master how to wear pattern-on-pattern, you'll step up your fashion game in no time. Pattern-on-pattern is surprisingly easy to incorporate. Here are two theories to keep in mind!

1) Unify patterns by color.
2) Scatter different scales of patterns.

Let's talk about the first theory. When patterns share a single color, they look unified even if the designs are different. Here, I express this idea through a simple formula.

For example, let's work with four colors: red, blue, white, and yellow.

Let's say there is a red-and-blue striped top and a bottom with white and yellow polka dots.

The formula looks like this:
$(R+B)(W+Y)$

This expands to
$RW + RY + BW + BY$

This looks a bit disorganized, doesn't it? We can do better!

Now, let's try adding a common denominator (a common color) to the equation.

There is a red-and-blue striped top and a bottom with red and yellow polka dots.

The formula is like this:
$(R+B)(R+Y)$

This expands to:
$R^2+R(Y+B)+BY$

Doesn't it look a bit simpler than before?

Break down different patterns into colors—ask yourself "which colors are found in this pattern?"—and if they share a color, they can be mixed together without clashing. This creates a sense of harmony like magic!

Let's move on to the second theory: scatter different scales of patterns. If you want to wear pattern-on-pattern in a way that feels mode, you want to pay attention to scale!

When selecting patterns, first choose the main pattern, then add patterns that are slightly bigger or smaller, so that you scatter different sizes of patterns throughout your ensemble.
 If you want a coordinated look when you are styling a suit or going for a neat, and more feminine style, combine patterns that are smaller or similar in scale.

Mixing patterns with stripes and checks. Pattern-on-pattern style requires an advanced technique, but since the patterns on both items are basic, they look natural together. It's a tricky style that seems ordinary at first but looks stylish on closer inspection.

Here, both the stripes and the checkered coat share the color navy. The idea of unifying patterns with the same color is applied here, too.

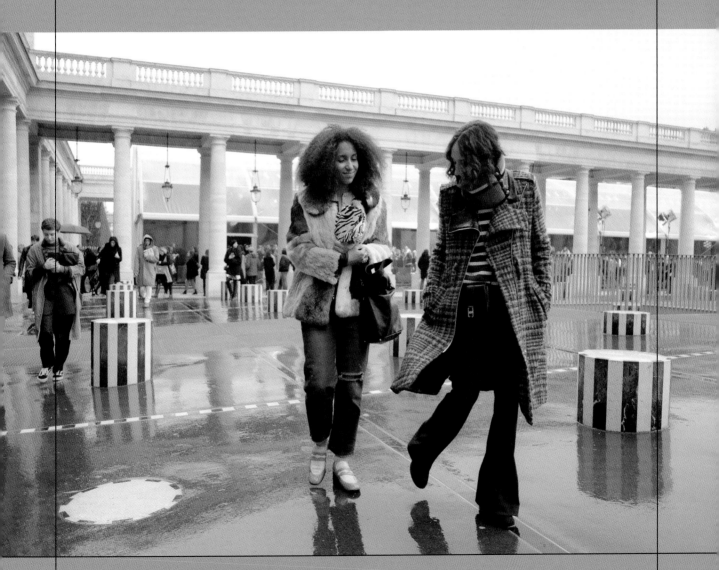

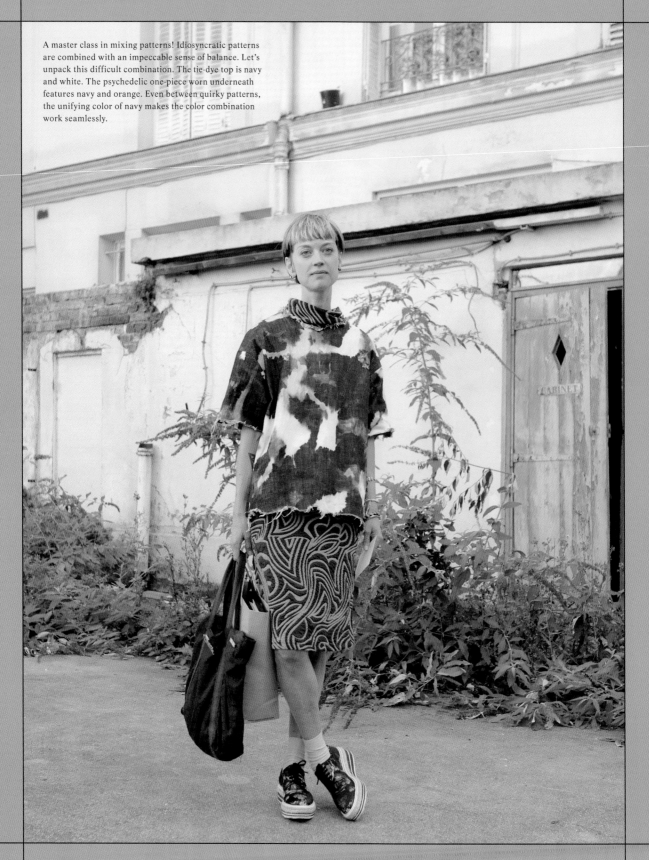

A master class in mixing patterns! Idiosyncratic patterns are combined with an impeccable sense of balance. Let's unpack this difficult combination. The tie-dye top is navy and white. The psychedelic one-piece worn underneath features navy and orange. Even between quirky patterns, the unifying color of navy makes the color combination work seamlessly.

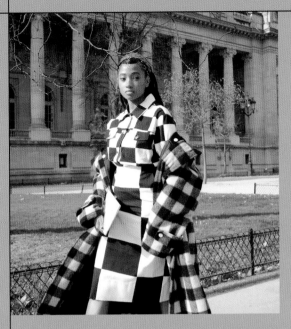

Coat, shirt, and skirt ensemble with a checkered flag pattern. The scales of the pattern—big, medium, small—are varied for each item. The wider the contrast between the patterns, the more mode the outfit looks.

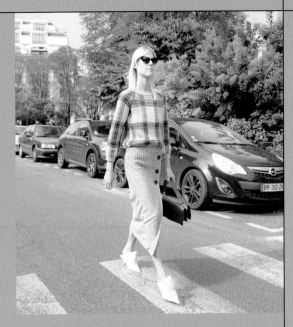

A knitted top with oversized checks and a skirt with tiny checks. The pattern-on-pattern, which becomes evident when seen up close, is a testament to her stylistic prowess.

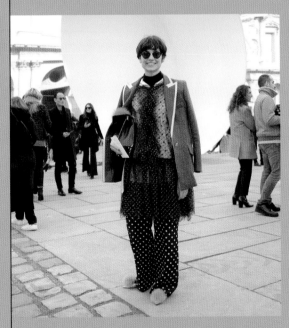

Polka dots styled with polka dots. Not only are polka dots a familiar pattern, the sizes of the dots she wears are all the same, so the style is sophisticated yet down to earth. A good example of an outfit that reveals its stylishness when you look at it closely.

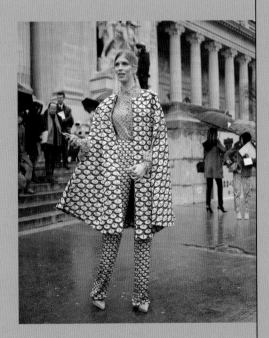

Another shirt, coat, and pants ensemble that makes a big impression with the same pattern scaled differently.

Selection of eight check-on-check styles!
Pay close attention to 1) the shared color and 2) the scale of the pattern.

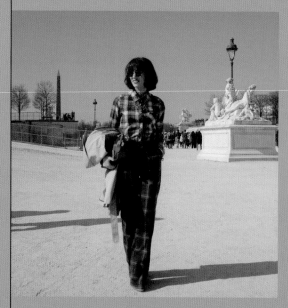

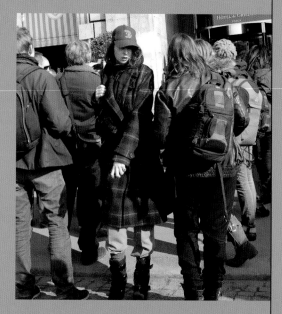

A navy, white, and brown plaid shirt and navy, green, and yellow plaid pants. Once again, the shared color, navy, keeps the ensemble cohesive.

A navy, green, and yellow scarf paired with a red, yellow, and green coat. Thanks to the shared colors yellow and green, what first appears like a hodgepodge looks thoughtfully put together when seen up close. Style *par excellence*.

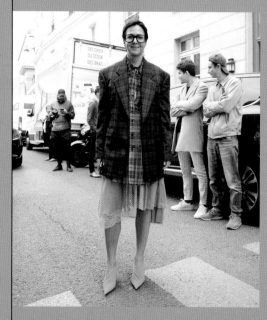

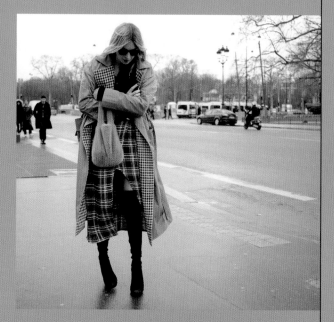

Checkered patterns on both the jacket and shirt. The shared colors are green and navy. The jacket features rich, deep colors, so you might not notice that it has a pattern at first glance. A skillful styling that reveals its stylishness up close.

The lining of the coat and the checkered skirt create a check-on-check. The shared color is brown. If you find mixing prints difficult, why not try it out with a lining, as she did here? (If you get too self-conscious you can always hide the lining by buttoning the coat!)

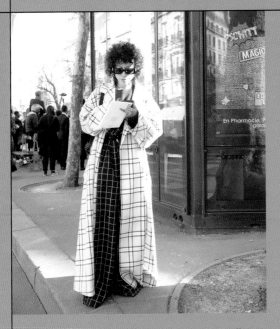

The elemental colors in the windowpane coat are yellow, white, and navy. The colors in the windowpane pants are navy and white. The shared colors harmonize the look, while the different scales add a mode vibe.

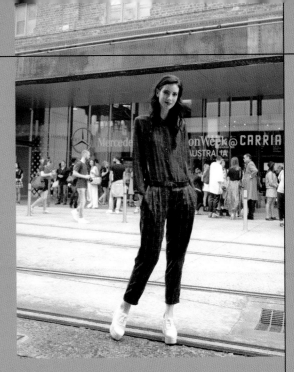

The top and bottom repeat the same pattern, but the different textures give the ensemble more depth. The white pair of shoes brings an easy vibe.

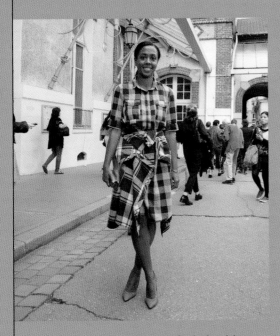

A plaid shirt tied around the waist of a checkered dress. Even though both items are staples, the way they are worn gives the ensemble a fresh spin. Once again, it's not what you wear but how you wear it.

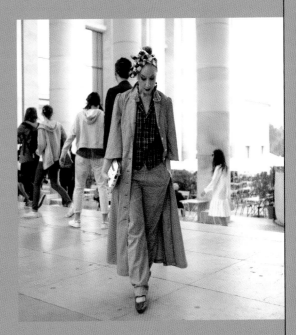

The checkered turban wrapped around the head, plus checkered shirt and pants. The shared colors are white and black.

A selection of eight leopard print styles.
Leopard prints make a strong impression on their own, but when you incorporate another pattern, they create an unexpectedly cool combination (or a fashionable chemical reaction).

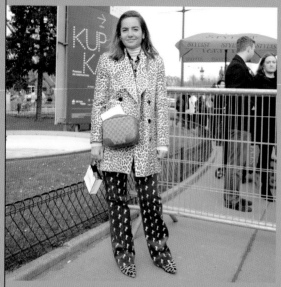

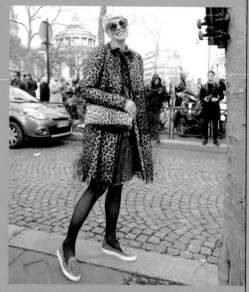

1) Leopard coat, 2) leopard shirt, 3) Gucci-patterned bag, 4) horse print pants, and 5) leopard shoes. Even with a parade of patterns, what deserves attention is the shared color. The shared color between 1) and 4), which take up the most surface, is white. This creates the foundation of the ensemble. Then, let's take a look at the playful details (shoes and bags): 1), 2), 3), and 5) all feature the color brown. This is an expertly styled ensemble that uses the same technique—unify different prints with a shared color—twice.

Leopard, leopard, leopard, and more leopard. A repeat style that almost causes a gestaltzerfall with the word leopard. Even though the patterns look similar in design and color, the technique of scattering varying scales of the same pattern creates an illusion of depth.

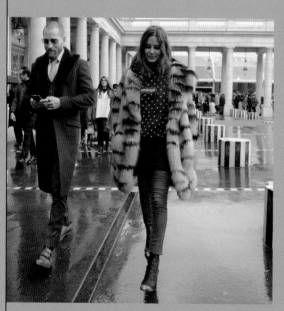

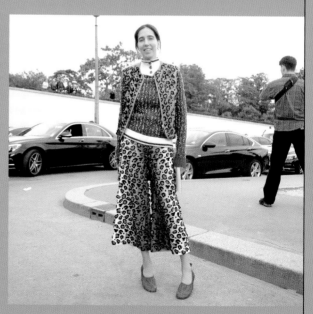

A leopard print coat meets a polka dot hoodie. The shared color is black.

1) A leopard jacket, 2) a top with a dewy pattern and 3) wide-legged pants in a leopard print. 1) and 3) are both leopard prints, but the colors are inverted. The whole ensemble feels cohesive because the different prints all share a common color.

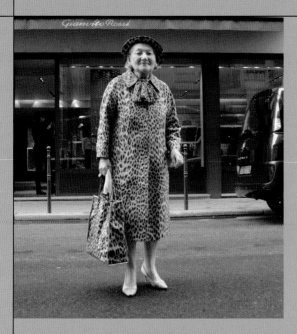

This woman's outfit seems to shout, "Leopard prints forever!" I love fashion that's outspoken about what you love.

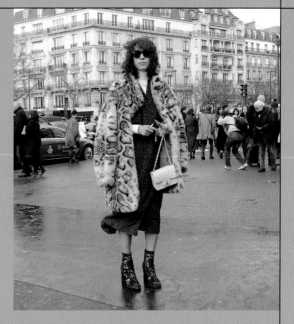

Leopard (coat), polka dots dress, and floral (boots)—a lively style featuring a trifecta of patterns. The white turtleneck worn underneath breaks up the patterns. Intentionally undoing a part of a busy ensemble like this gives it a more relaxed impression. Design your outfit with an idea of how you would like to be perceived!

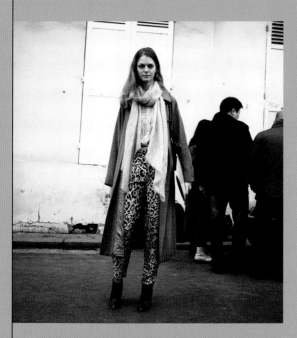

Leopard print plus checkered shirt. The coat and scarf complement the ensemble with shades of brown.

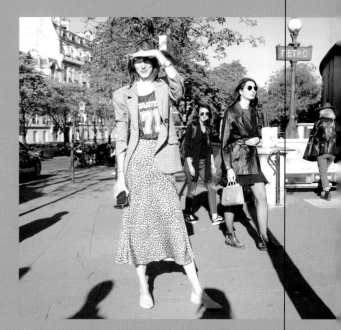

A vivid and gorgeous leopard print skirt plus a casual athletic striped top. Opposite genres, when mixed together, create a playful style.

Various pattern-on-pattern

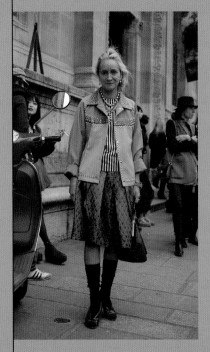

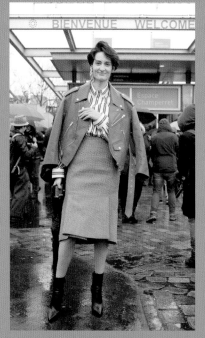

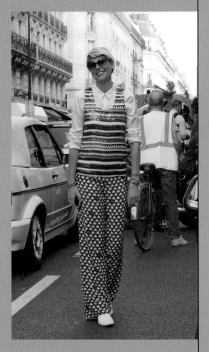

The colors, the shapes, and the fabrics are all different, but why does her ensemble look so harmonized? The key is the beige color in her jacket, which acts as a cushion. The beige falls in between the white striped top and the brown skirt, creating a smooth gradient.

A striped shirt and a skirt with a tiny checkered pattern. The pieces both feature the colors red and white.

White is the unifying color of the striped top and the polka dot pants. The red dots scattered along the pants echo the colors of the top.

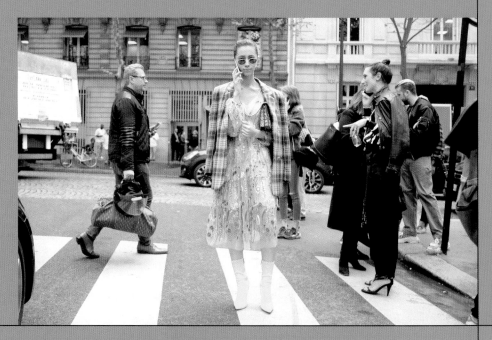

A tailored brown jacket worn over a soft floral dress. The unifying colors include beige and brown. The yellow boots create an effective shift in color!

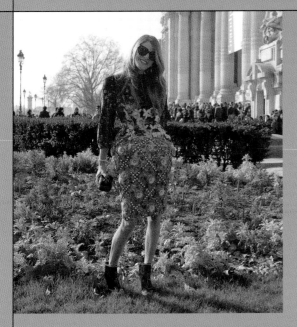

A floral top and a floral skirt—and she even has a floral landscape behind her. Only a true fashionista can direct the mise-en-scène when having her photo taken!

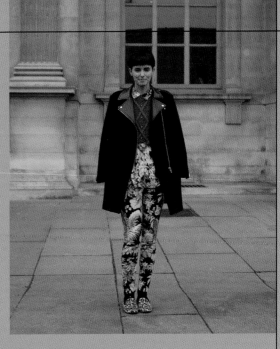

Floral pants and a floral shirt worn beneath a sweater. Floral patterns belong to the same genre, but the whole ensemble comes together because they share the same black shade.

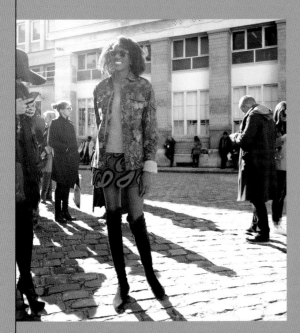

Military jacket paired with African print. The different patterns may seem to clash at first, but the shared colors—brown and green—keep them together.

A checkered military jacket and black-and-white stripes peeking out at the collar and the midsection. The prints in the ensemble are all undeniably vibrant, but the more you look at them, the more the paired combinations of colors (black unifies the jacket and the shirt while green unifies the jacket and pants) reveal the work of a true virtuoso.

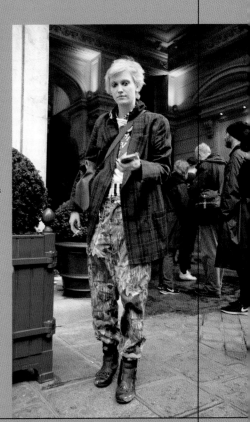

Styling Tip #15

BALANCE

You need to first acquire form before you break it; if there is no form there is no shape.
These are the famous words of the kabuki actor, Nakamura Kanzaburō XVIII.

In kabuki theater, you first need to learn the form (foundational movements) before you can find an original way to deconstruct it. When you try to deconstruct without mastering the form, the result you get is "shapeless." I think the same thing can be said about fashion.

There are silhouettes in fashion that are considered universal and classic (the equivalent of form in kabuki). There are also established rules when wearing clothes.

Fashion should be free—I agree with this wholeheartedly! And yet: Freedom exists under strict rules. The absence of rules and discipline is not freedom but disorder. (I've forgotten whose quote this is.)

I believe that you feel the joy of freedom when you break loose from rules and established values.

A journey of a thousand miles begins with a single step. If you want to enjoy fashion in the truest sense, there are no shortcuts. You have to first learn the standard "forms," try them out, then make them your own.

Here's how the kabuki adage can be applied to fashion: To deconstruct means to first learn the classic silhouettes and rules, then step away from them and wear what you want freely. The result becomes "shapeless" when you wear whatever you want without first learning the fundamentals of fashion.

Here are a few people who dress with an exquisite sense of balance.

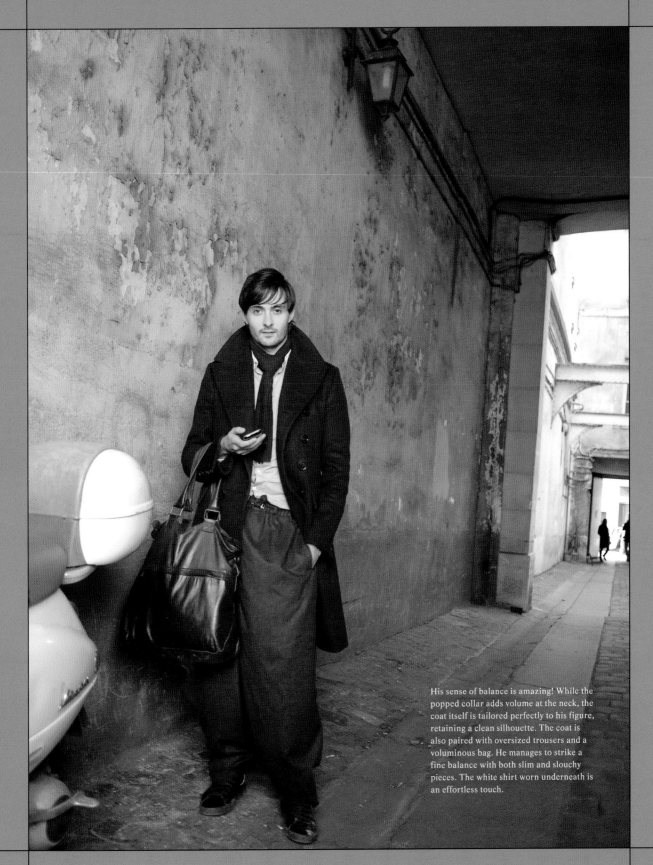

His sense of balance is amazing! While the popped collar adds volume at the neck, the coat itself is tailored perfectly to his figure, retaining a clean silhouette. The coat is also paired with oversized trousers and a voluminous bag. He manages to strike a fine balance with both slim and slouchy pieces. The white shirt worn underneath is an effortless touch.

Intentionally slouchy silhouettes!

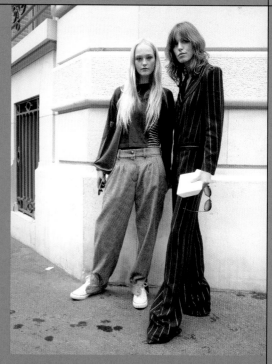

Take a look at the figure on the left. She wears oversized knickerbocker pants low on her hips. The unbuttoned hem also adds to her chill vibe.

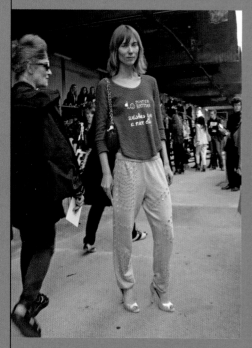

A cozy ensemble of sweatshirts and sweatpants turn chic with a pair of heels.

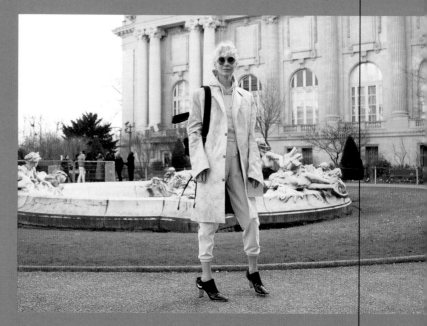

Another slouchy pair of sweats elevated by a pair of heels.

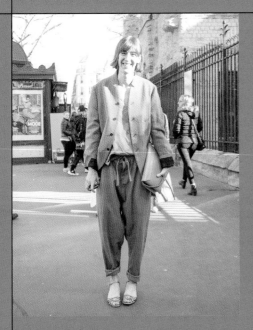

Loose trousers lend a relaxed feel to the coordinated outfit.

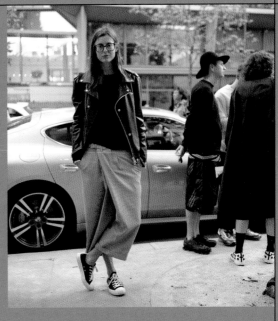

Her keen eye for balance is evident in the wide pair of baggy pants, worn low on the hips.

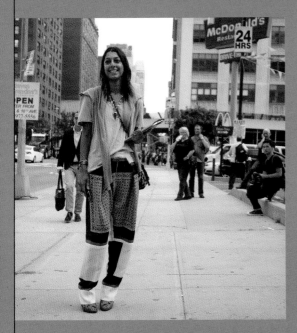

I love the way she balances out this loose-fitting silhouette! The pants are worn low on the hips and the T-shirt is half tucked in. The pair of heels keeps the look feminine.

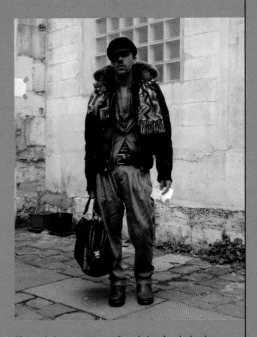

This style is one step away from being dowdy, but he makes it work because he is "decidedly" dowdy. The secret is his attention to detail, from the way he wraps his scarf to how he leaves his shirt open.

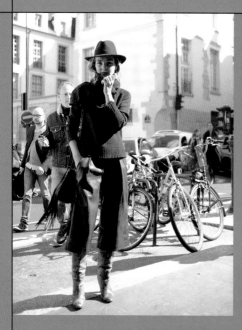

Cropped pants that fall below the knee can often look off balance. Coordinate with tall boots to keep the outfit cohesive.

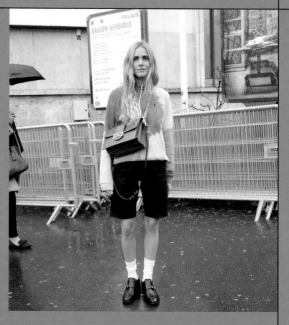

The silhouette of her shorts and leather shoes reminds me of a young aristocrat. Crossbody bags, by the way, look more balanced when worn high on the body as she does here.

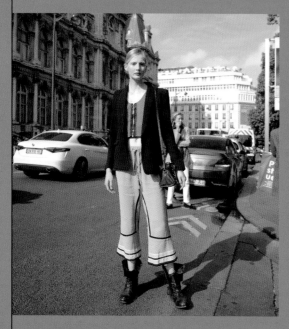

The cropped flared pants and lace-up boots (I love how she wears them rugged!) are effortlessly paired. Her style is proof that there is no need to be constrained by a silhouette that "flatters your figure."

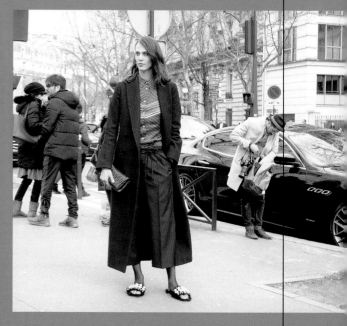

The silhouette of the long coat and wide pants are on the heavier side, so she keeps her footwear easy and light. Sandals complement her exposed ankles.

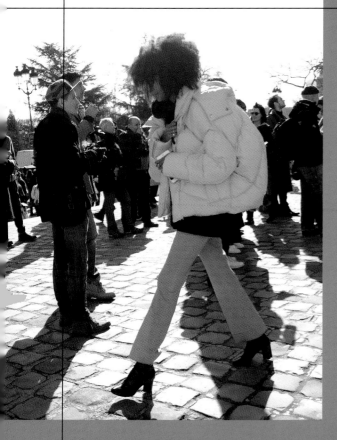

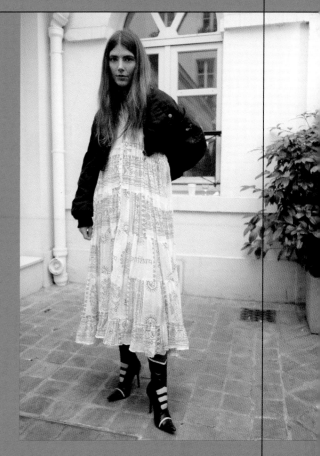

What a silhouette! A super big top balanced by a slender bottom. The unique silhouette emphasizes her stylishness.

A short MA-1 bomber jacket and maxi skirt. Once again, the short length of the top elongates the silhouette.

The collar of the down jacket is pulled back, making the jacket appear more like a cropped top. This elongates your legs and creates a lean silhouette.

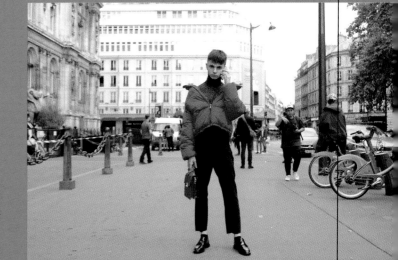

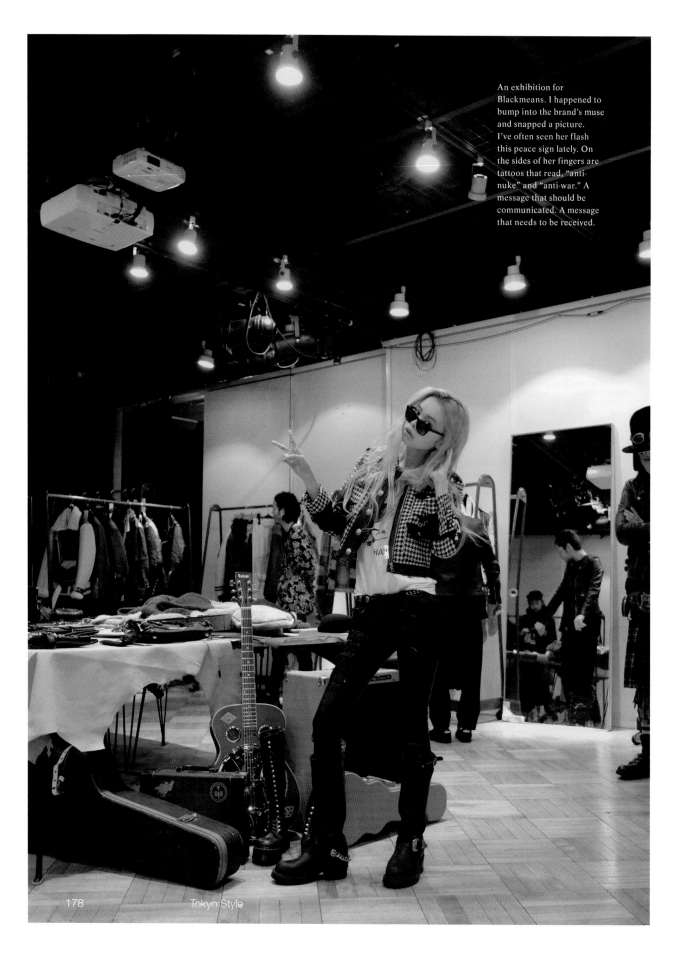

An exhibition for Blackmeans. I happened to bump into the brand's muse and snapped a picture. I've often seen her flash this peace sign lately. On the sides of her fingers are tattoos that read, "anti-nuke" and "anti-war." A message that should be communicated. A message that needs to be received.

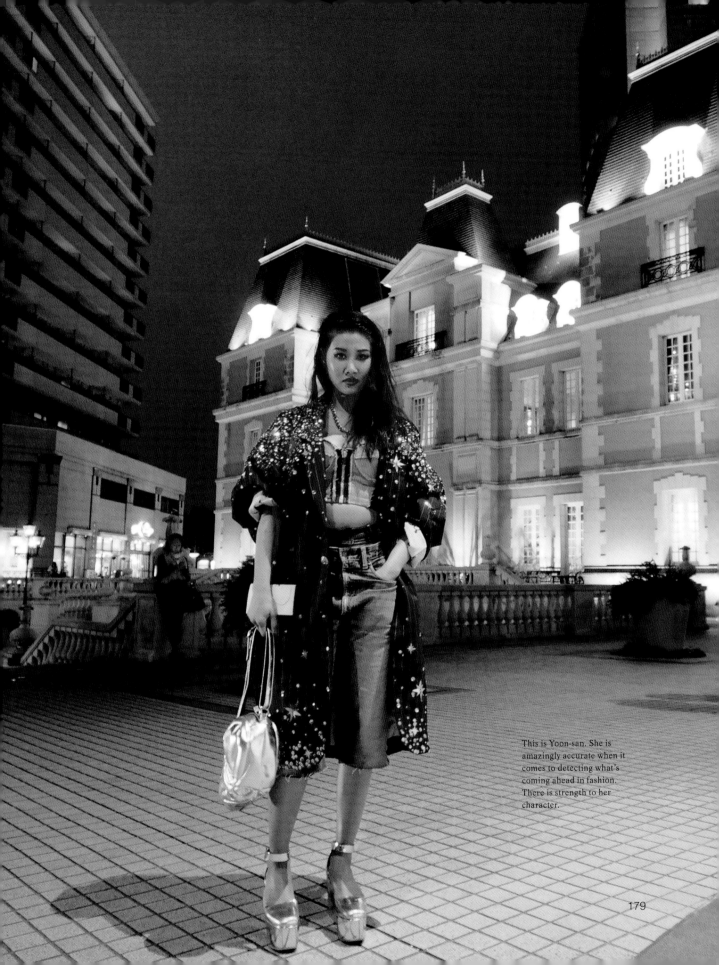

This is Yoon-san. She is amazingly accurate when it comes to detecting what's coming ahead in fashion. There is strength to her character.

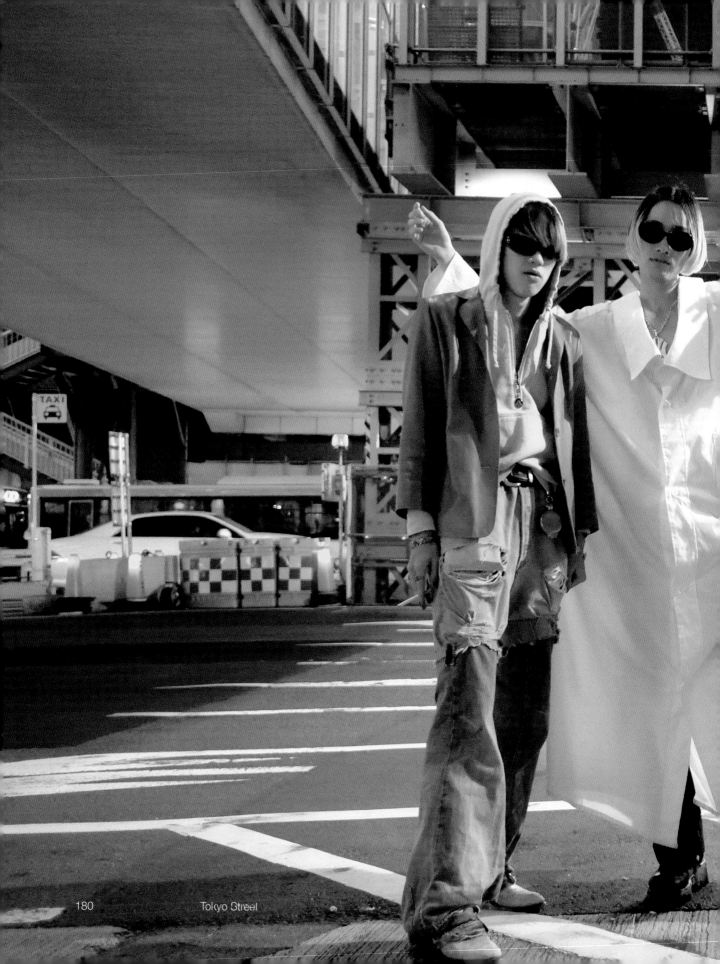

Tokyo Street

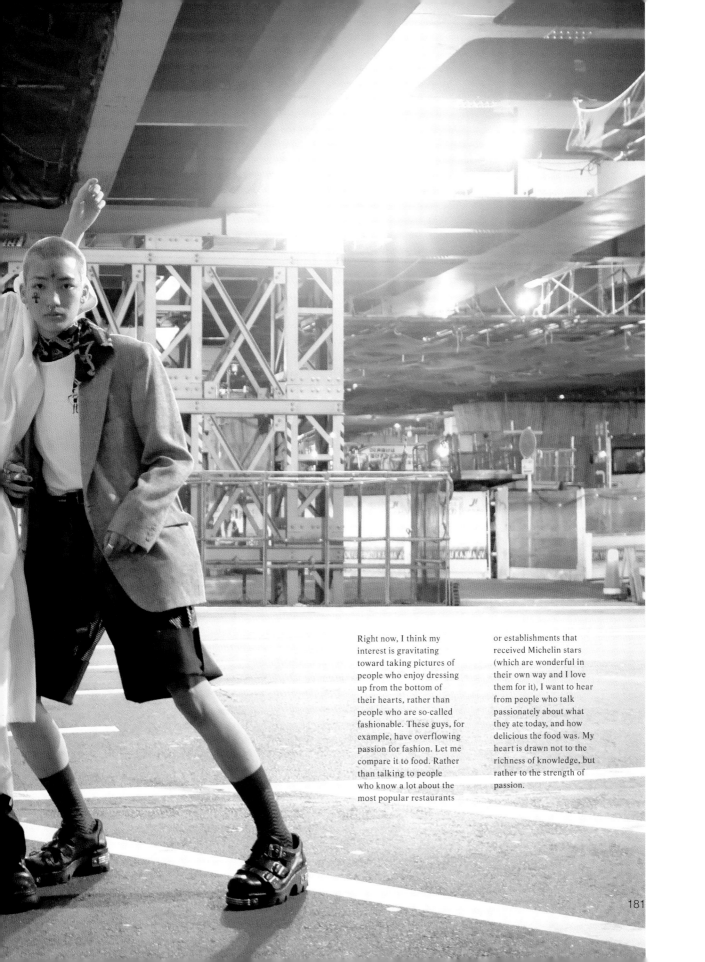

Right now, I think my interest is gravitating toward taking pictures of people who enjoy dressing up from the bottom of their hearts, rather than people who are so-called fashionable. These guys, for example, have overflowing passion for fashion. Let me compare it to food. Rather than talking to people who know a lot about the most popular restaurants or establishments that received Michelin stars (which are wonderful in their own way and I love them for it), I want to hear from people who talk passionately about what they ate today, and how delicious the food was. My heart is drawn not to the richness of knowledge, but rather to the strength of passion.

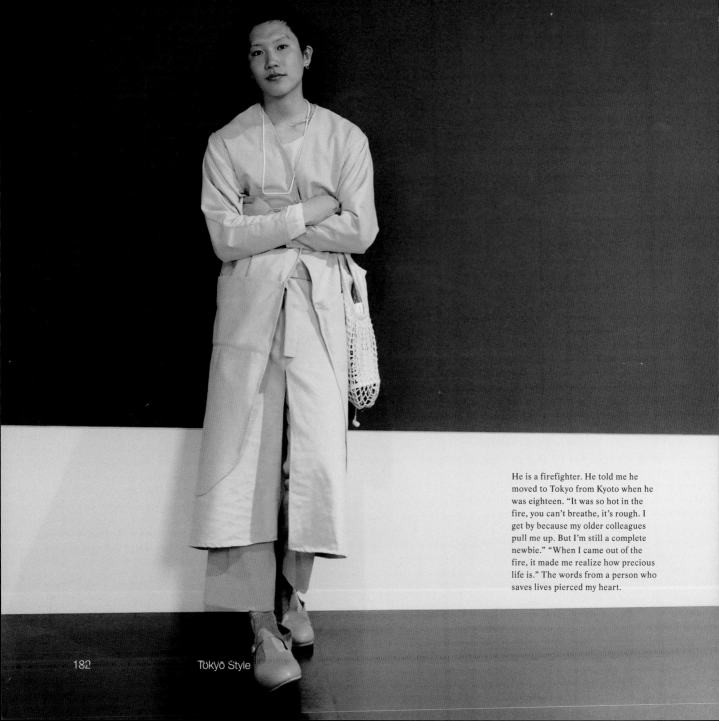

He is a firefighter. He told me he moved to Tokyo from Kyoto when he was eighteen. "It was so hot in the fire, you can't breathe, it's rough. I get by because my older colleagues pull me up. But I'm still a complete newbie." "When I came out of the fire, it made me realize how precious life is." The words from a person who saves lives pierced my heart.

The employees of the Thom Browne store. I never fail to admire the way they see their customers off. They accompany their customers outside, carefully placing their purchases in their hands. The two of them bend their bodies 90 degrees in unison, and say carefully and respectfully, "Thank you very much." The customers, shopping bags in hand, return to the neighborhood of Aoyama. The two employees slowly straighten their postures. They fold their hands in front of them once again, their backs held straight, watching as their customers walk away. Straight as an arrow. Still watching. Their valued customers walk all the way to the end of a long path, where they disappear around the corner. Once the employees see this, they signal with their eyes and nod to each other, then return inside the store through the silver doors. This series of actions is so dramatic. Every time I visit the store, I perch where I can see the front of the store and wait in anticipation for it to begin again, as if I'm waiting for a dramatic story to take place. It's something I now look forward to each time I visit Aoyama.

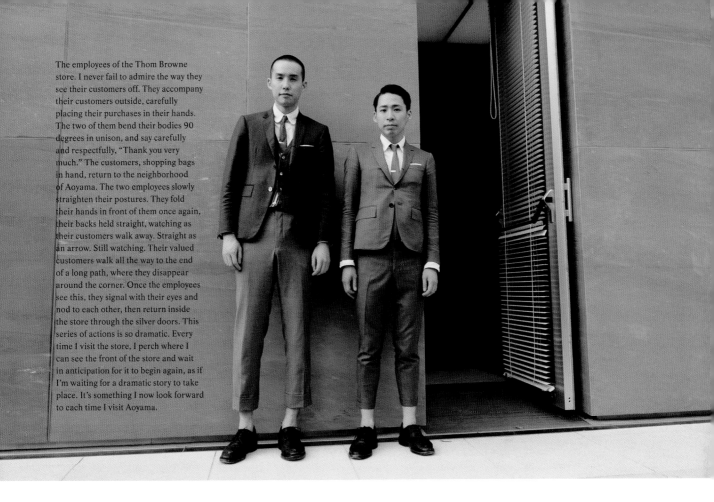

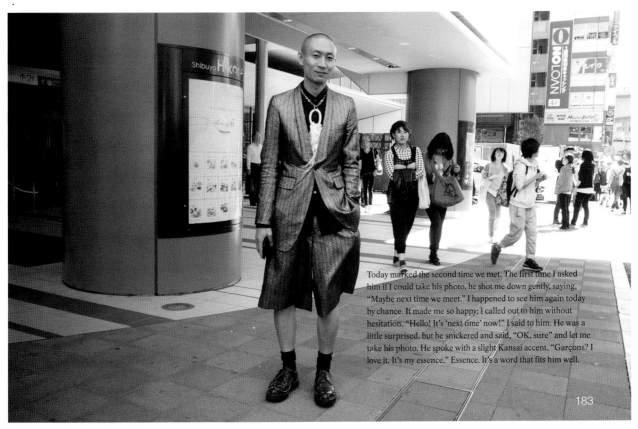

Today marked the second time we met. The first time I asked him if I could take his photo, he shot me down gently, saying, "Maybe next time we meet." I happened to see him again today by chance. It made me so happy; I called out to him without hesitation. "Hello! It's 'next time' now!" I said to him. He was a little surprised, but he snickered and said, "OK, sure" and let me take his photo. He spoke with a slight Kansai accent, "Garçons? I love it. It's my essence." Essence. It's a word that fits him well.

183

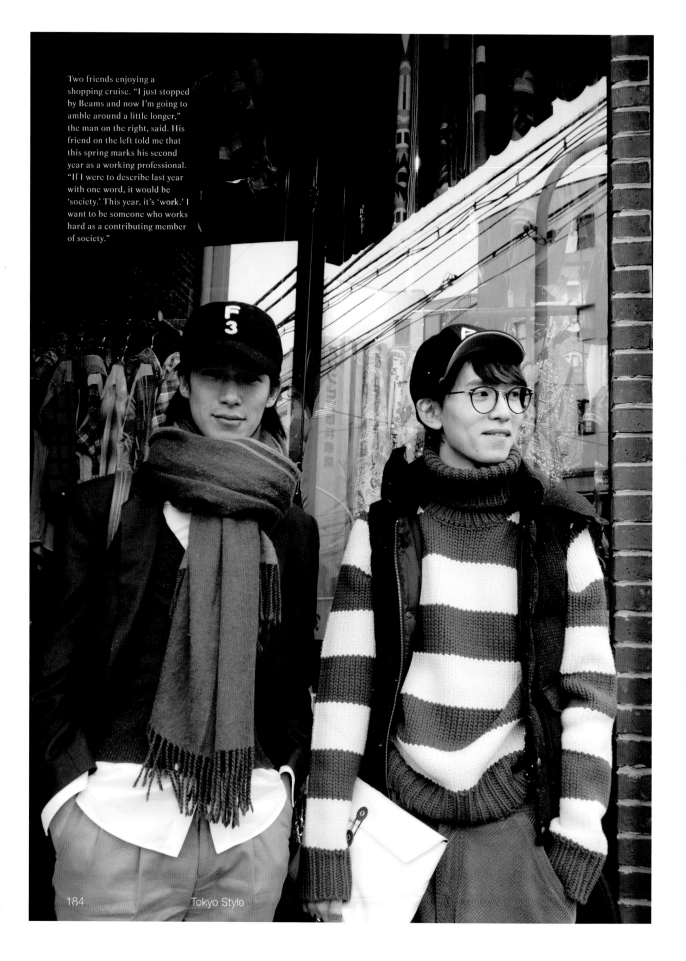

Two friends enjoying a shopping cruise. "I just stopped by Beams and now I'm going to amble around a little longer," the man on the right, said. His friend on the left told me that this spring marks his second year as a working professional. "If I were to describe last year with one word, it would be 'society.' This year, it's 'work.' I want to be someone who works hard as a contributing member of society."

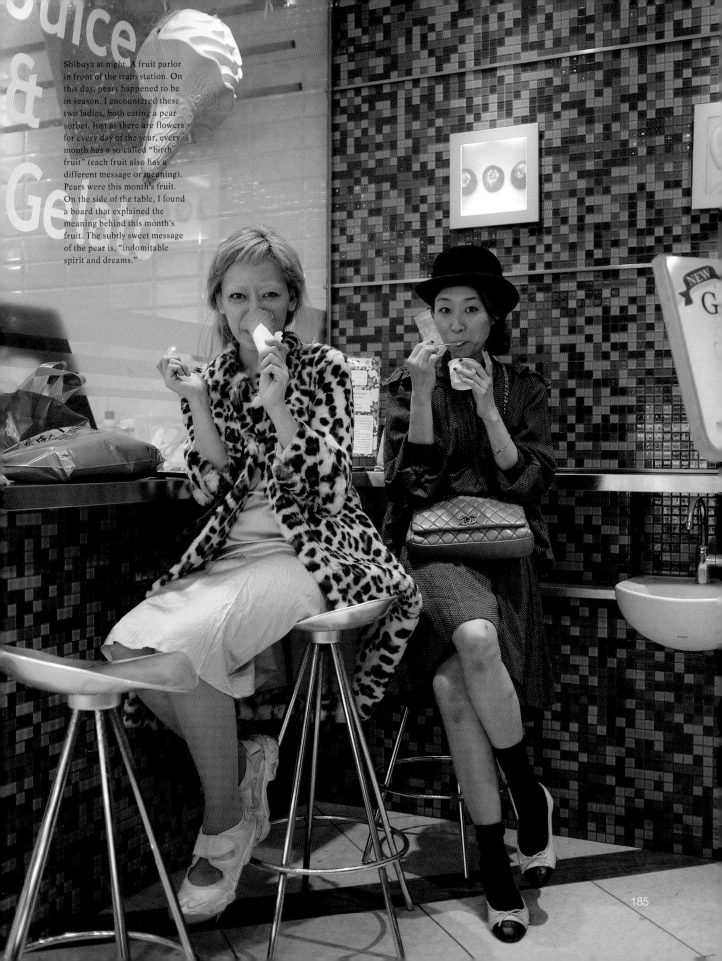

Shibuya at night. A fruit parlor in front of the train station. On this day, pears happened to be in season. I encountered these two ladies, both eating a pear sorbet. Just as there are flowers for every day of the year, every month has a so-called "birth fruit" (each fruit also has a different message or meaning). Pears were this month's fruit. On the side of the table, I found a board that explained the meaning behind this month's fruit. The subtly sweet message of the pear is, "indomitable spirit and dreams."

185

Platform shoes, sarouel pants, coral necklaces. A woman I found in Aosando. She's clothed in frothy pastels, yet she looks confident and elegant. I have never seen a woman more beautiful. Who she is, what she has done in her life? There were so many things I wanted to ask her, but I decided not to. I wanted to save it so that I have something to look forward to when we meet next time.

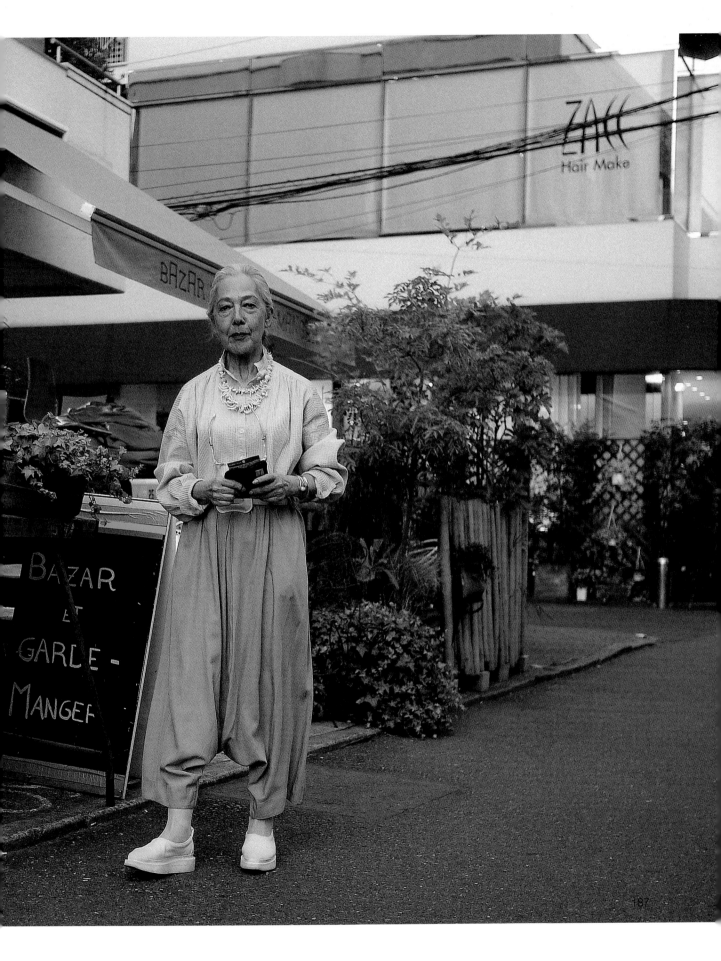

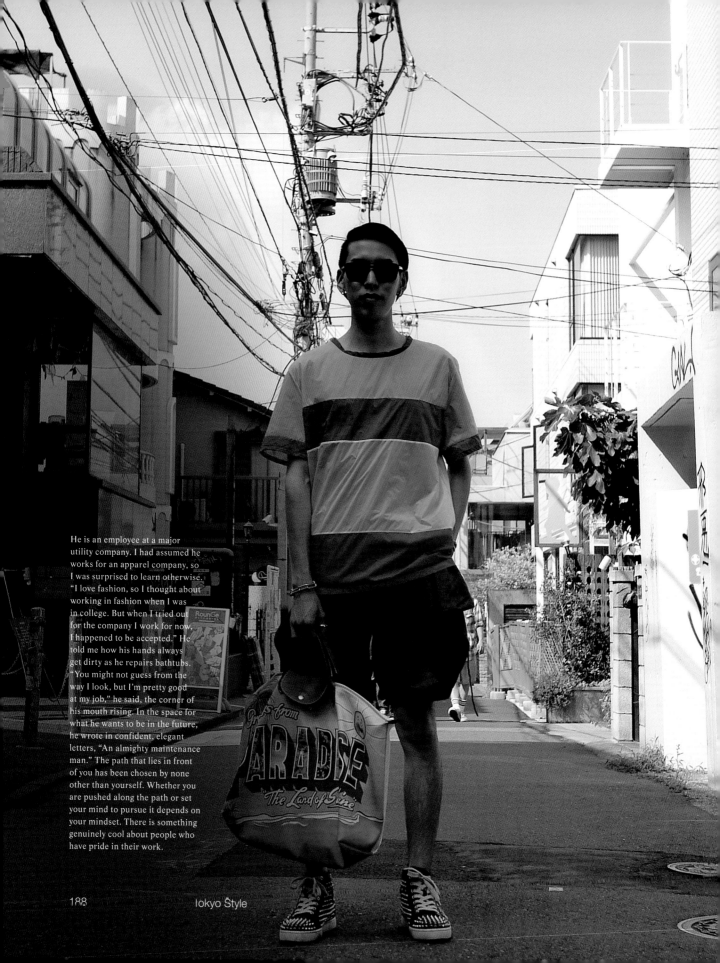

He is an employee at a major utility company. I had assumed he works for an apparel company, so I was surprised to learn otherwise. "I love fashion, so I thought about working in fashion when I was in college. But when I tried out for the company I work for now, I happened to be accepted." He told me how his hands always get dirty as he repairs bathtubs. "You might not guess from the way I look, but I'm pretty good at my job," he said, the corner of his mouth rising. In the space for what he wants to be in the future, he wrote in confident, elegant letters, "An almighty maintenance man." The path that lies in front of you has been chosen by none other than yourself. Whether you are pushed along the path or set your mind to pursue it depends on your mindset. There is something genuinely cool about people who have pride in their work.

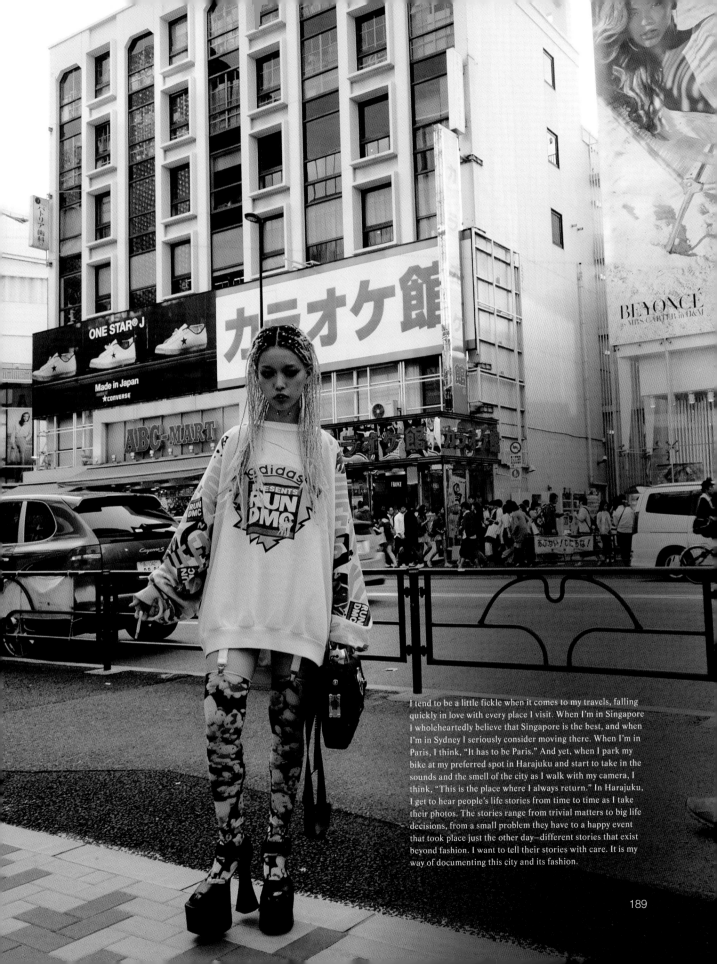

I tend to be a little fickle when it comes to my travels, falling quickly in love with every place I visit. When I'm in Singapore I wholeheartedly believe that Singapore is the best, and when I'm in Sydney I seriously consider moving there. When I'm in Paris, I think, "It has to be Paris." And yet, when I park my bike at my preferred spot in Harajuku and start to take in the sounds and the smell of the city as I walk with my camera, I think, "This is the place where I always return." In Harajuku, I get to hear people's life stories from time to time as I take their photos. The stories range from trivial matters to big life decisions, from a small problem they have to a happy event that took place just the other day–different stories that exist beyond fashion. I want to tell their stories with care. It is my way of documenting this city and its fashion.

189

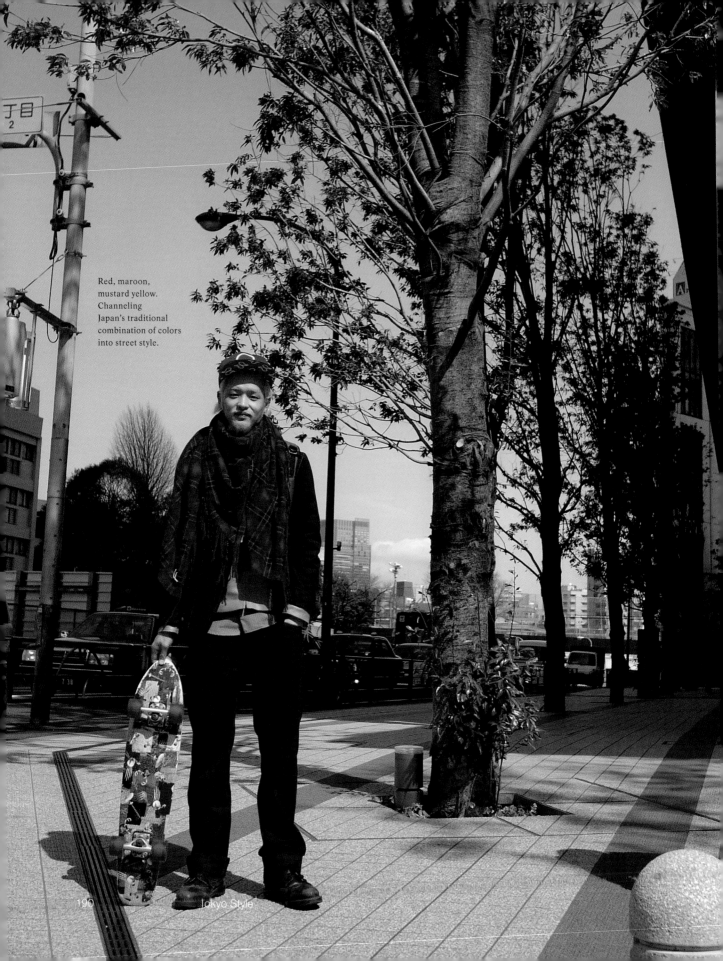

Red, maroon,
mustard yellow.
Channeling
Japan's traditional
combination of colors
into street style.

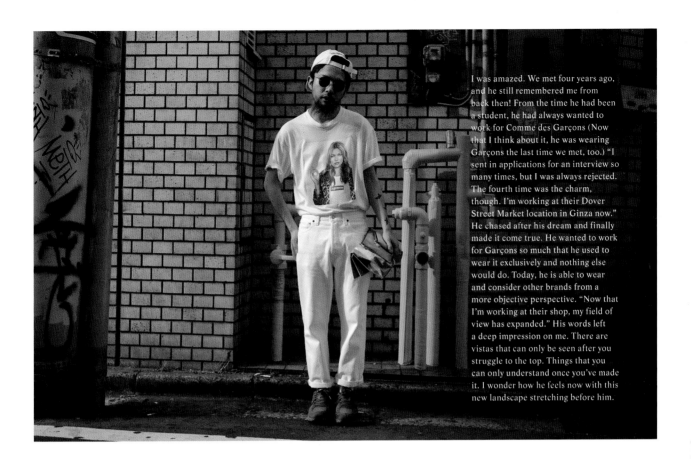

I was amazed. We met four years ago, and he still remembered me from back then! From the time he had been a student, he had always wanted to work for Comme des Garçons (Now that I think about it, he was wearing Garçons the last time we met, too.) "I sent in applications for an interview so many times, but I was always rejected. The fourth time was the charm, though. I'm working at their Dover Street Market location in Ginza now." He chased after his dream and finally made it come true. He wanted to work for Garçons so much that he used to wear it exclusively and nothing else would do. Today, he is able to wear and consider other brands from a more objective perspective. "Now that I'm working at their shop, my field of view has expanded." His words left a deep impression on me. There are vistas that can only be seen after you struggle to the top. Things that you can only understand once you've made it. I wonder how he feels now with this new landscape stretching before him.

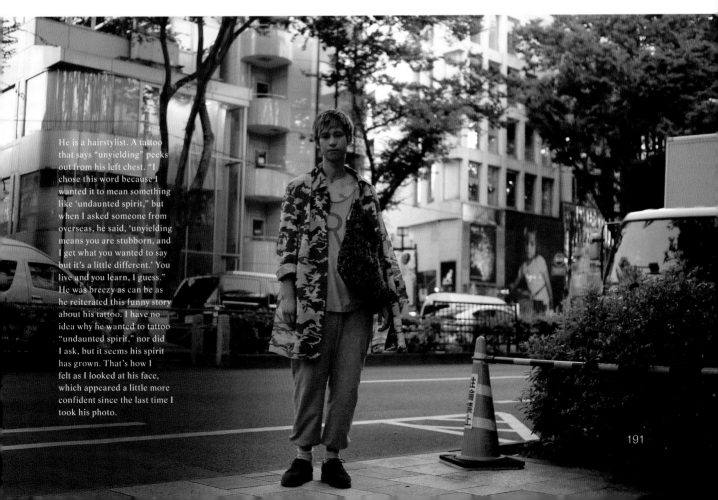

He is a hairstylist. A tattoo that says "unyielding" peeks out from his left chest. "I chose this word because I wanted it to mean something like 'undaunted spirit,' but when I asked someone from overseas, he said, 'unyielding means you are stubborn, and I get what you wanted to say but it's a little different.' You live and you learn, I guess." He was breezy as can be as he reiterated this funny story about his tattoo. I have no idea why he wanted to tattoo "undaunted spirit," nor did I ask, but it seems his spirit has grown. That's how I felt as I looked at his face, which appeared a little more confident since the last time I took his photo.

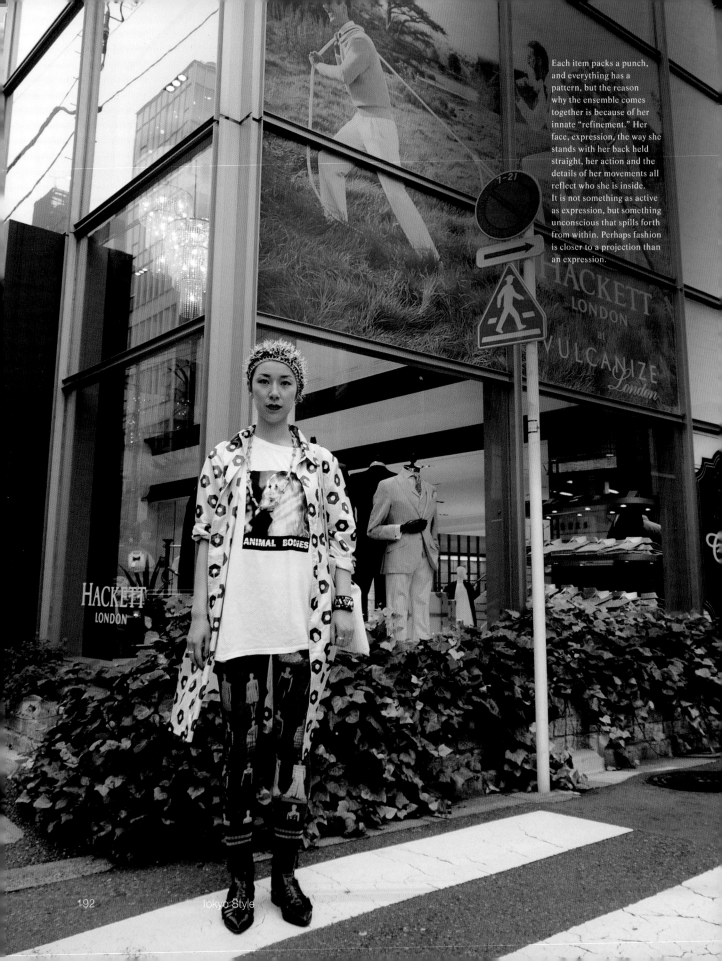

Each item packs a punch, and everything has a pattern, but the reason why the ensemble comes together is because of her innate "refinement." Her face, expression, the way she stands with her back held straight, her action and the details of her movements all reflect who she is inside. It is not something as active as expression, but something unconscious that spills forth from within. Perhaps fashion is closer to a projection than an expression.

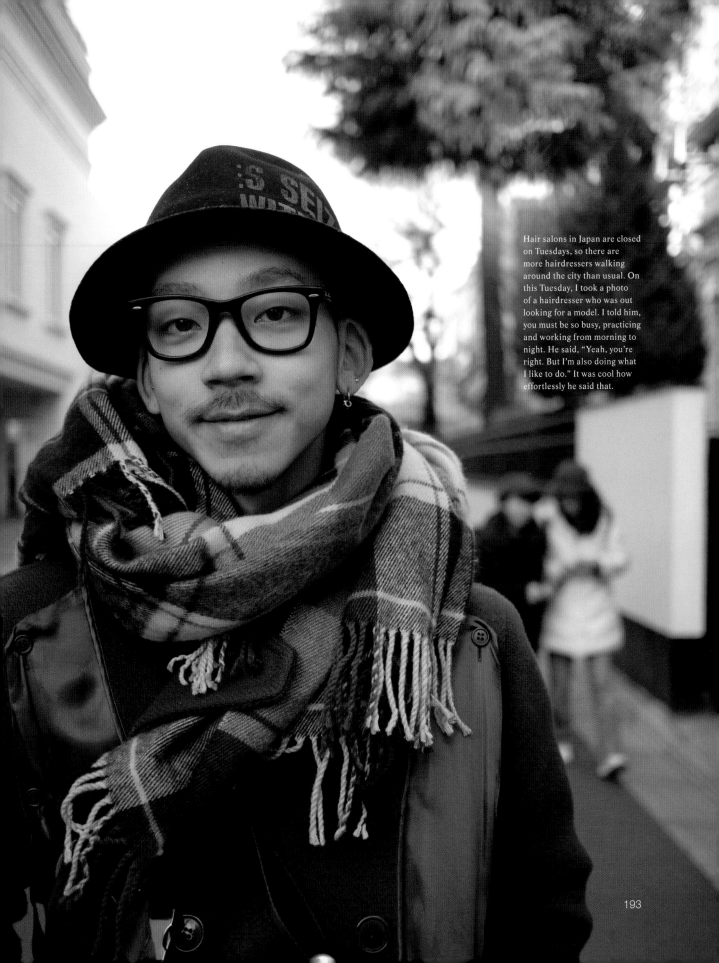

Hair salons in Japan are closed on Tuesdays, so there are more hairdressers walking around the city than usual. On this Tuesday, I took a photo of a hairdresser who was out looking for a model. I told him, you must be so busy, practicing and working from morning to night. He said, "Yeah, you're right. But I'm also doing what I like to do." It was cool how effortlessly he said that.

193

He works for Solakzade. Pictured here with him is his beloved daughter, Ma-chan. Looking at her, I think she must be the definition of a tomboy. Her big round eyes dart back and forth as she zips around (look at her feet, she's kicked off her shoe!), not a tinge of shyness as she talks to me. "Ma-chan, look at the camera." When her father instructed her, she flashed the biggest smile. I can't think of anything sweeter.

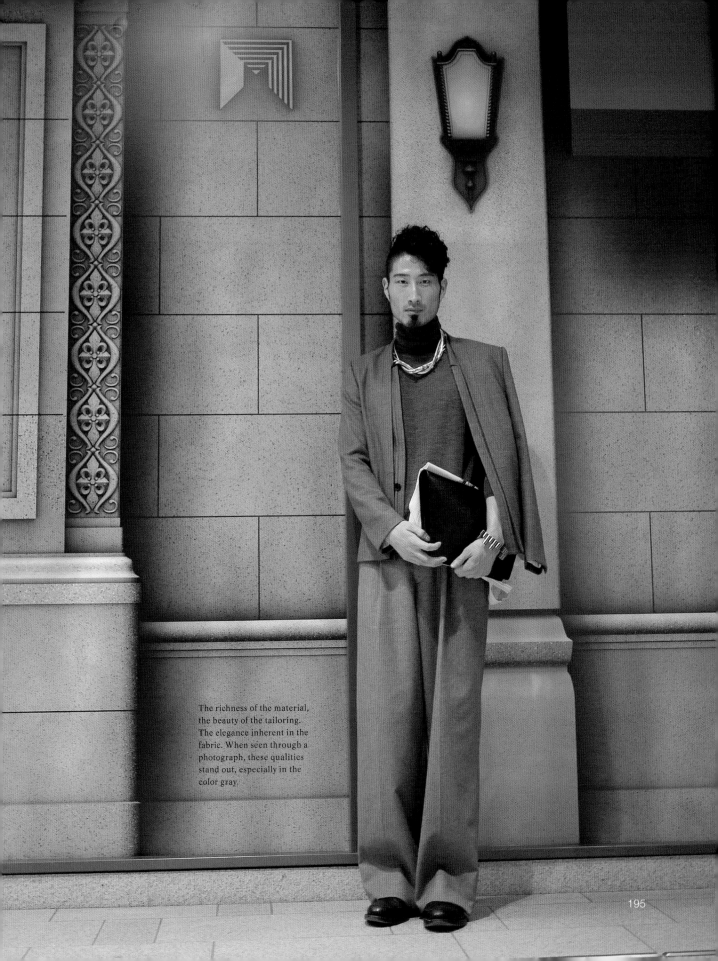

The richness of the material,
the beauty of the tailoring.
The elegance inherent in the
fabric. When seen through a
photograph, these qualities
stand out, especially in the
color gray.

195

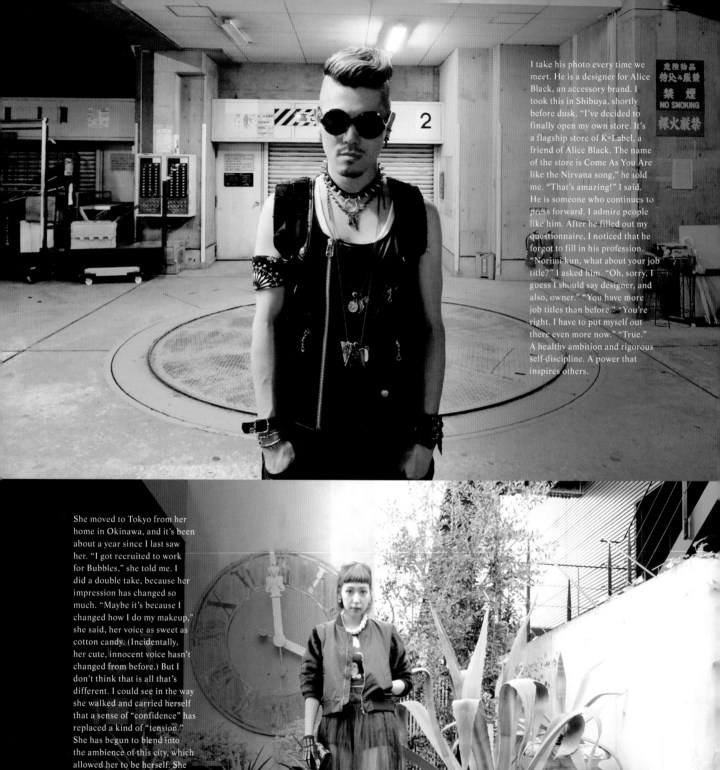

I take his photo every time we meet. He is a designer for Alice Black, an accessory brand. I took this in Shibuya, shortly before dusk. "I've decided to finally open my own store. It's a flagship store of K=Label, a friend of Alice Black. The name of the store is Come As You Are like the Nirvana song," he told me. "That's amazing!" I said. He is someone who continues to press forward. I admire people like him. After he filled out my questionnaire, I noticed that he forgot to fill in his profession. "Norimi-kun, what about your job title?" I asked him. "Oh, sorry. I guess I should say designer, and also, owner." "You have more job titles than before." "You're right. I have to put myself out there even more now." "True." A healthy ambition and rigorous self-discipline. A power that inspires others.

She moved to Tokyo from her home in Okinawa, and it's been about a year since I last saw her. "I got recruited to work for Bubbles," she told me. I did a double take, because her impression has changed so much. "Maybe it's because I changed how I do my makeup," she said, her voice as sweet as cotton candy. (Incidentally, her cute, innocent voice hasn't changed from before.) But I don't think that is all that's different. I could see in the way she walked and carried herself that a sense of "confidence" has replaced a kind of "tension." She has begun to blend into the ambience of this city, which allowed her to be herself. She was on her break from work, so we chatted for a little while and went our separate ways. Seasons change, cities change, people change. Things that change and things that remain the same.

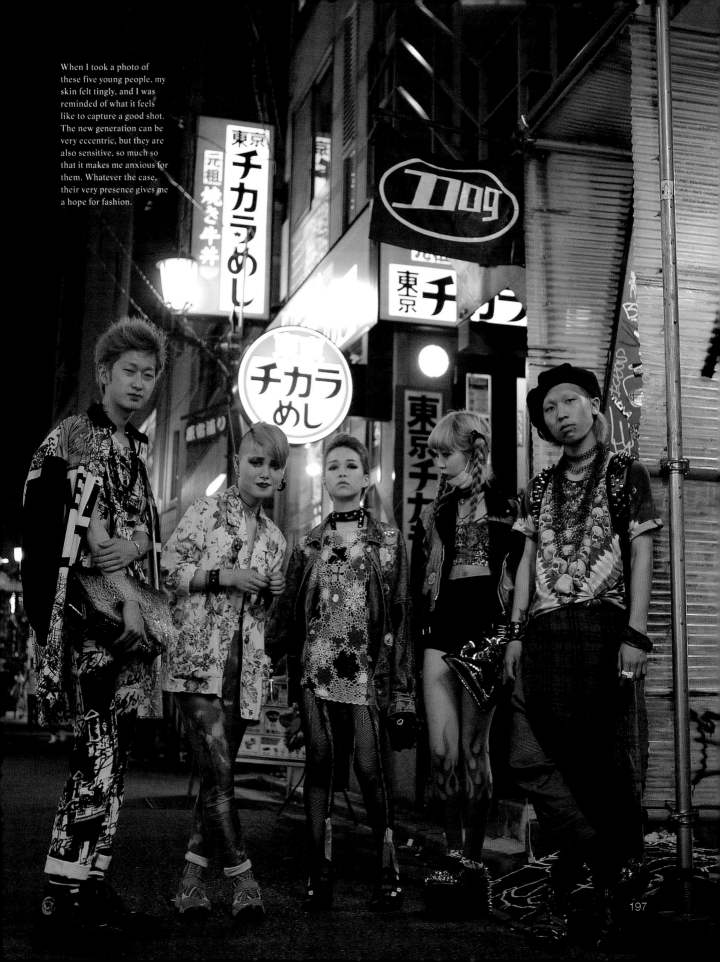

When I took a photo of these five young people, my skin felt tingly, and I was reminded of what it feels like to capture a good shot. The new generation can be very eccentric, but they are also sensitive, so much so that it makes me anxious for them. Whatever the case, their very presence gives me a hope for fashion.

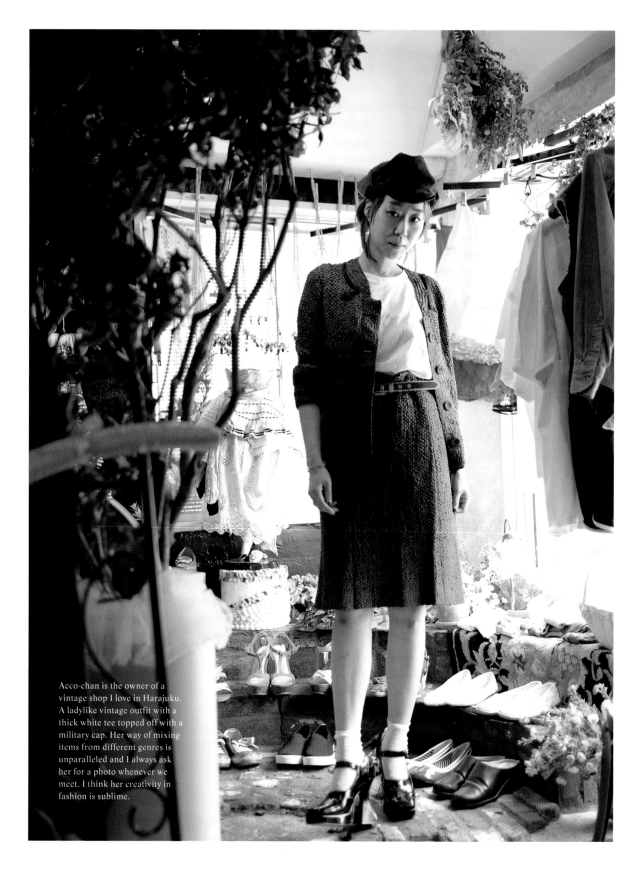

Acco-chan is the owner of a vintage shop I love in Harajuku. A ladylike vintage outfit with a thick white tee topped off with a military cap. Her way of mixing items from different genres is unparalleled and I always ask her for a photo whenever we meet. I think her creativity in fashion is sublime.

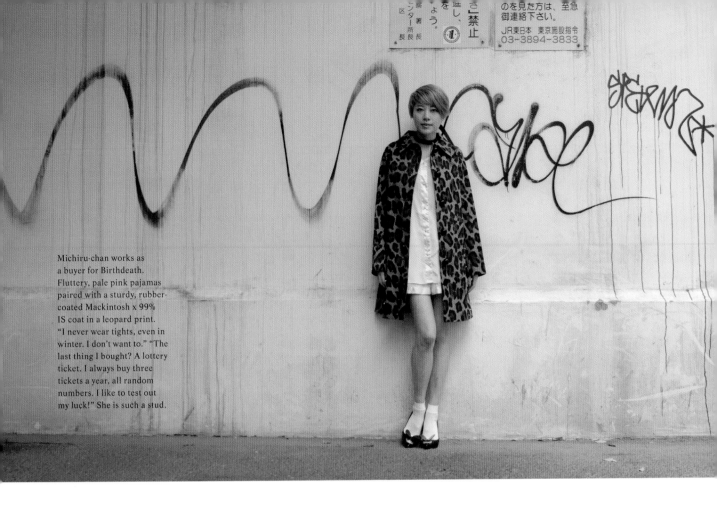

Michiru-chan works as a buyer for Birthdeath. Fluttery, pale pink pajamas paired with a sturdy, rubber-coated Mackintosh x 99% IS coat in a leopard print. "I never wear tights, even in winter. I don't want to." "The last thing I bought? A lottery ticket. I always buy three tickets a year, all random numbers. I like to test out my luck!" She is such a stud.

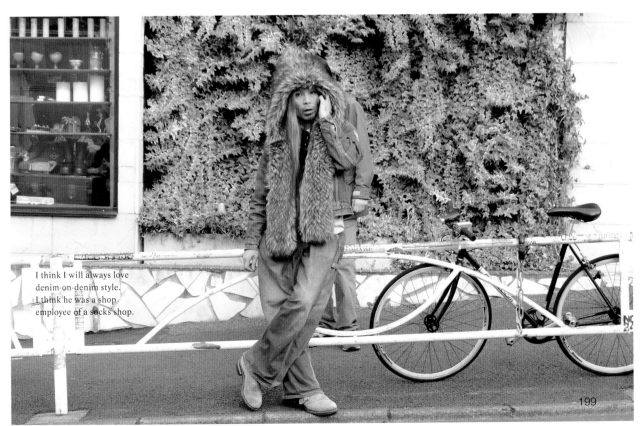

I think I will always love denim-on-denim style. I think he was a shop employee of a socks shop.

199

Styling Tip #16

MANNISH AND BOYISH

The multifaceted charm of mannish and boyish women.

The way she styles her jacket is mannish, yet the subtle frills and florals scattered all around add a tricky twist!

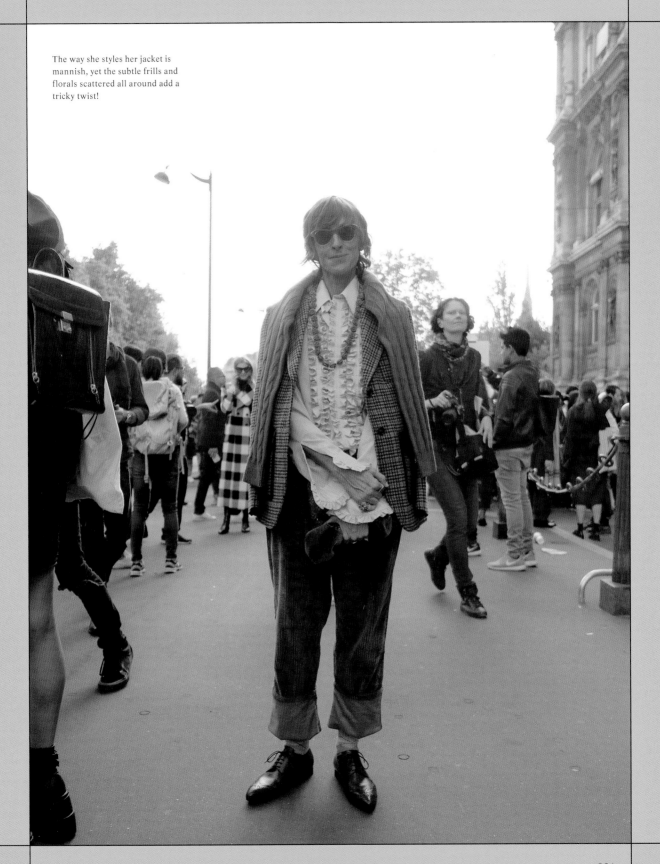

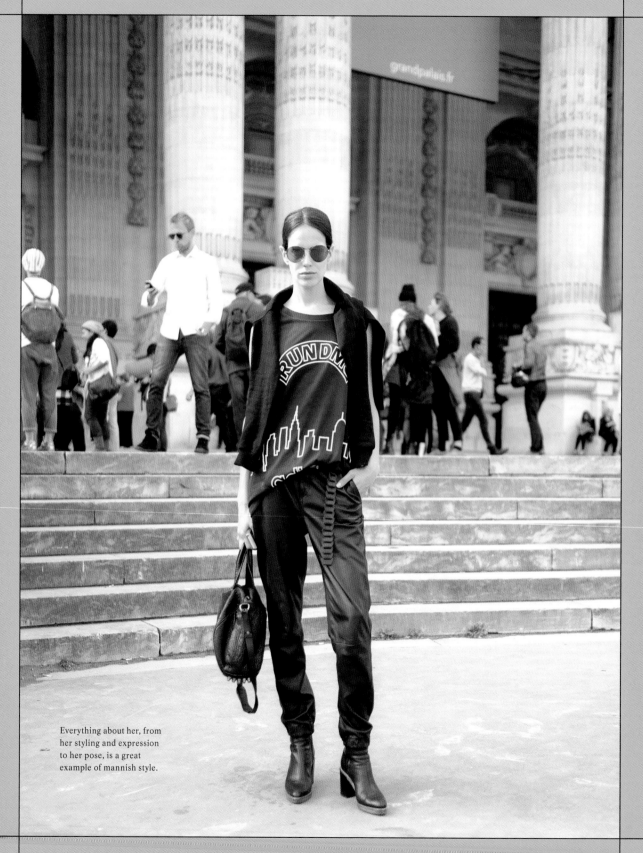

Everything about her, from
her styling and expression
to her pose, is a great
example of mannish style.

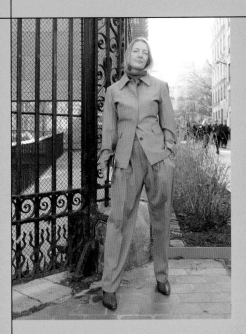

A gentlelady in a fitted jacket and wide trousers combo. Though her outfit is composed of basic items, the subtle sizing draws attention.

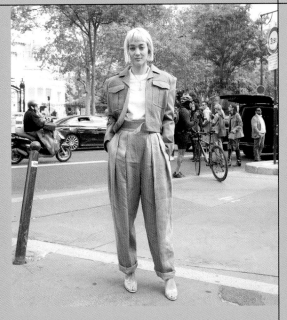

Another menswear-inspired styling. The pastel colors soften the masculine impression.

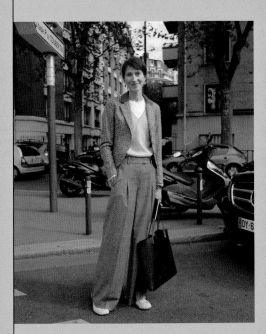

Her head-to-toe mannish style gives this woman with a sophisticated look.

Her handsome features complement her mannish outfit. The frills at her neck provide an indescribably lovely contrast to this mannish outfit.

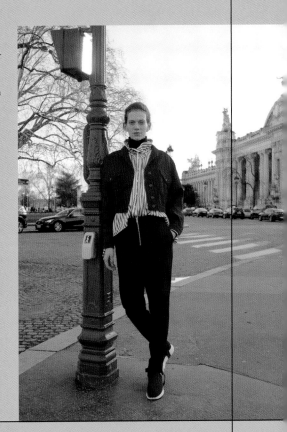

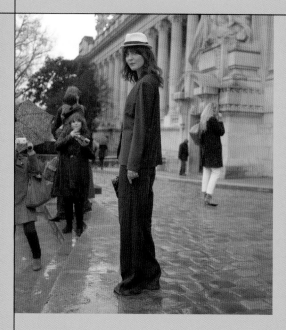

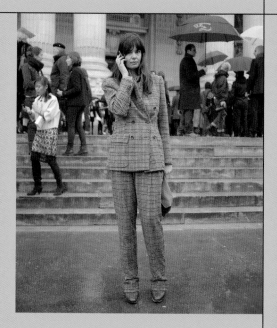

These two ladies have perfected the art of styling a pantsuit.
They wear their suits formally instead of dressing them down,
a choice that brings out their inherent femininity all the more.

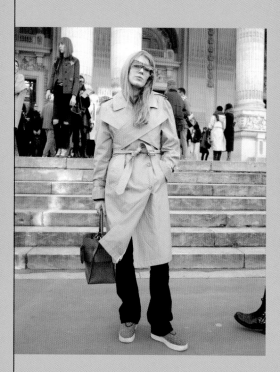

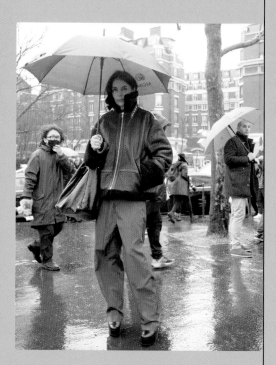

A selection of two boyish styles. They flaunt a "borrowed
from the cool boys" look with not only their clothes but
their mannerism and pose, the way they stick their hands
in their pockets.

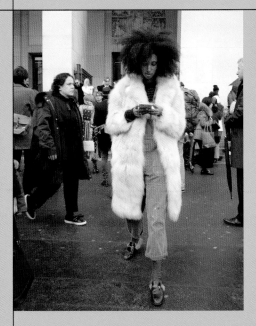

A voluminous fur coat over a casual outfit. The socks provide a pop of color and she keeps it easy with slip-on shoes.

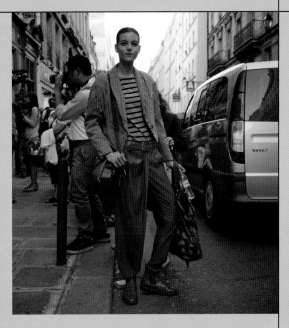

A relaxed and casual ensemble with vintage-inspired pieces. Pants that hang from the hip channel the boys.

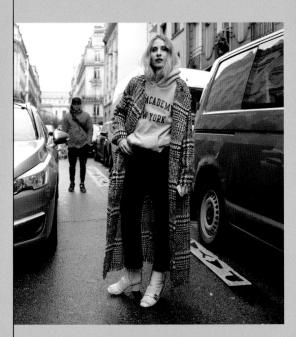

A fashionable long coat and a casual hoodie. I love the way she casually tucks her hair inside the hoodie.

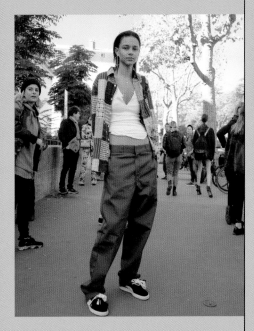

At first glance she looks as if she stepped out of the house wearing her boyfriend's clothes. Her street-style inspired look is boyish and mischievous, yet the flashes of skin around her chest and midriff elevates the look in a uniquely feminine manner.

Styling Tip #17

1+1=∞

Enjoying fashion on your own is always exciting, but it's much more fun when you have people to share it with! Try wearing clothes with a common theme, matching colors, or a paired look with coordinated items. Here are groups of people whose styles exude a nice groove.

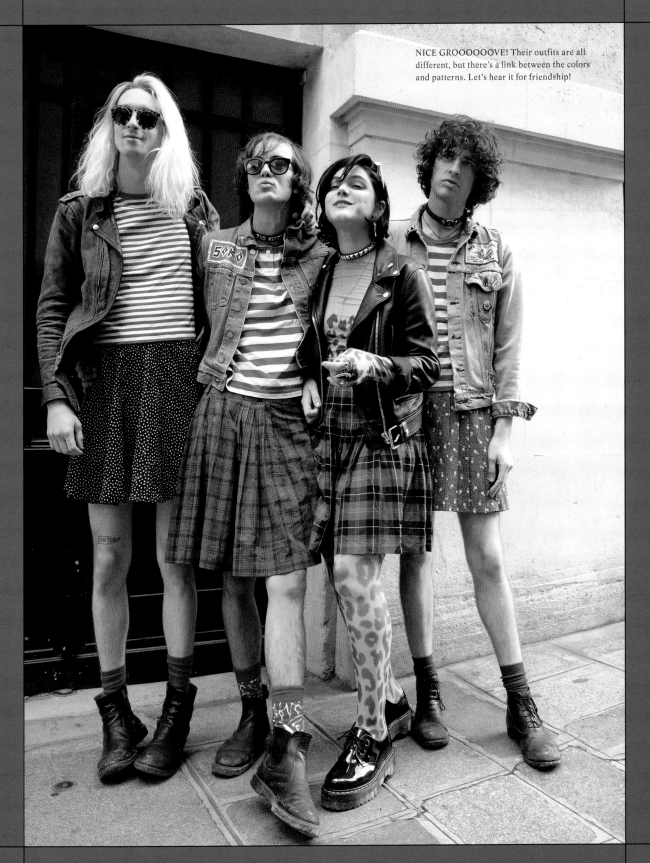

NICE GROOOOOOVE! Their outfits are all different, but there's a link between the colors and patterns. Let's hear it for friendship!

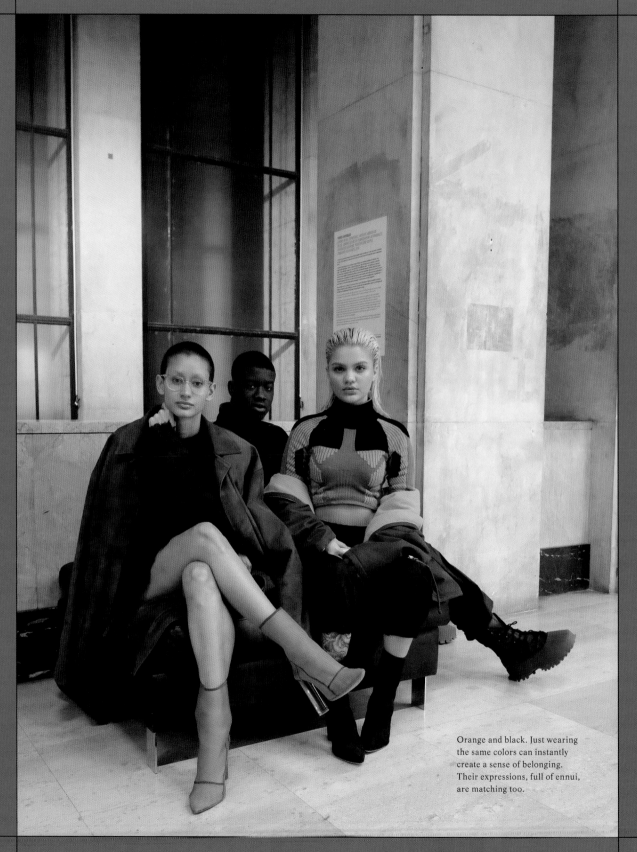

Orange and black. Just wearing
the same colors can instantly
create a sense of belonging.
Their expressions, full of ennui,
are matching too.

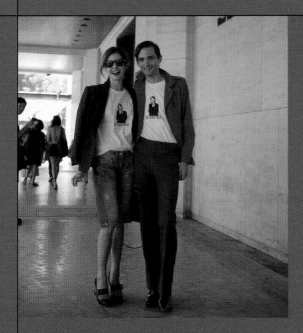

A couple in matching T-shirts! The matching outfit is breezy
and purely fun—I love that it doesn't take fashion too seriously!

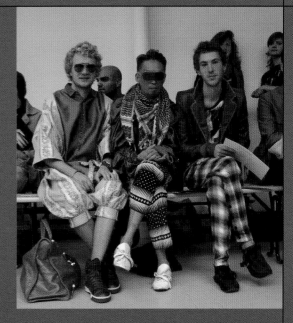

The colors they are wearing overlapped by accident, grouping
them together as a result.

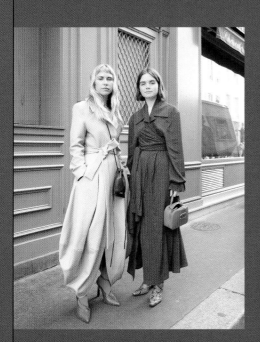

A paired look in long coats. Twin silhouettes!

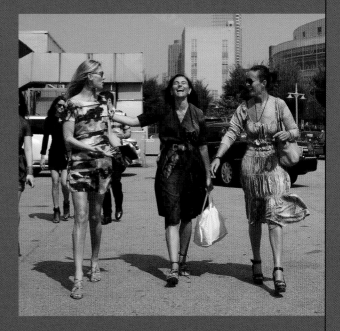

Three women head for the collections, each stylish in her own way. They all
stand out individually, but together their presence and happiness amplify!

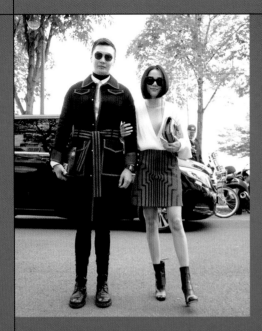

Comrades in the same designer. Even if they are strangers, they look like they could be instant friends.

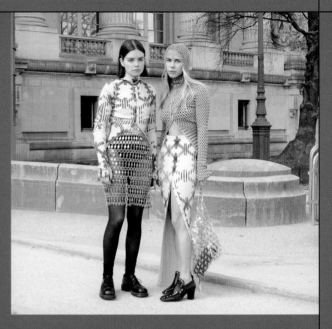

Each person is fashionable, but together their stylishness is doubled! They complement and elevate each other.

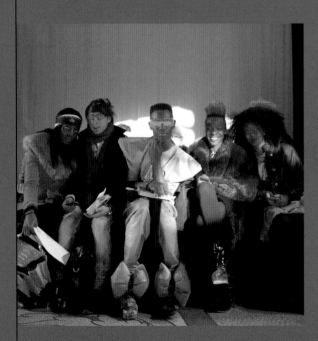

A photo that illustrates their deep bond, with the five of them all casually decked out in coordinated colors.

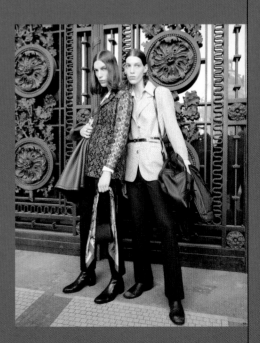

There are no common traits in their clothes, but the pair shares a taste in '90s fashion.

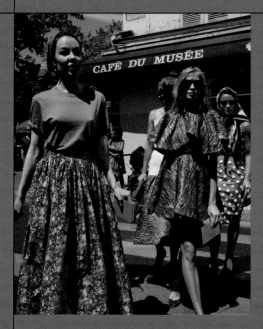

Though walking along separate paths, they still look like they belong in the same group. A great example of how simply wearing similar colors can create a sense of togetherness.

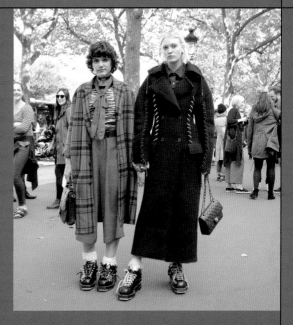

At first glance their outfits may look different but take a closer look at their matching footwear (shoes and socks). I feel their bond in their firmly clasped hands. What a great couple!

Two women in a nice groove! Hats and scarves, jackets and accessories all matching for their afternoon tea. The best!

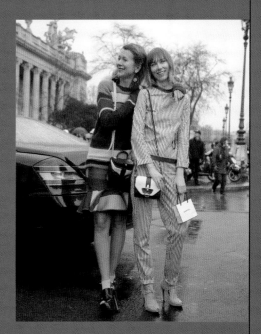

Even dressed in completely different tastes and colors, their shared love for the same brand (JW Anderson in this case) brings the two closer together.

Styling Tip #18

GENDERLESS

Now that we finally live in an age where being a part
of the LGBTQ community is embraced as a part of
one's identity, I feel that we are moving from a time
when a person's individuality is hidden away in our
hearts to a time when we express it openly through
our fashion. Our hearts and bodies are connected. I
hope for all of us to wear clothes whichever way our
hearts desire. Fashion should be free, after all!

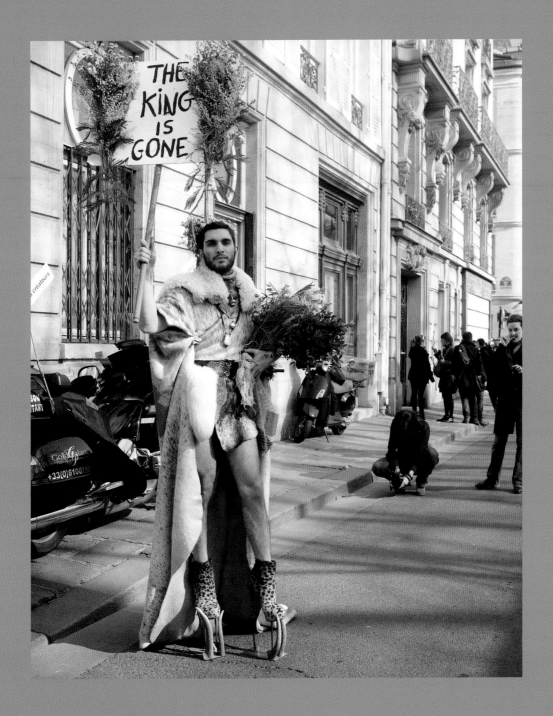

He appeared at the show venue just as
John Galliano left Dior. The way he
expresses himself passionately from the
heart moved me.

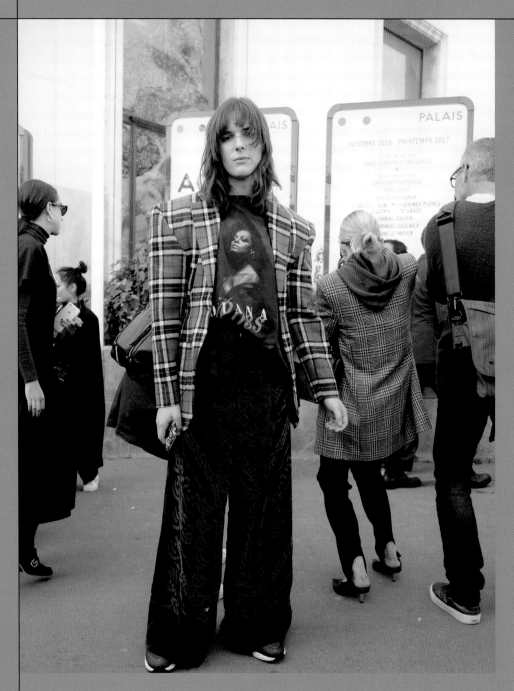

The pairing of the oversized jacket and wide leg pants is heavy and idiosyncratic, but the look is softened somehow.

Another styling that transcends gender.
The practice of dividing clothes into binary
gender-specific categories is passé, a vestige
of a bygone era.

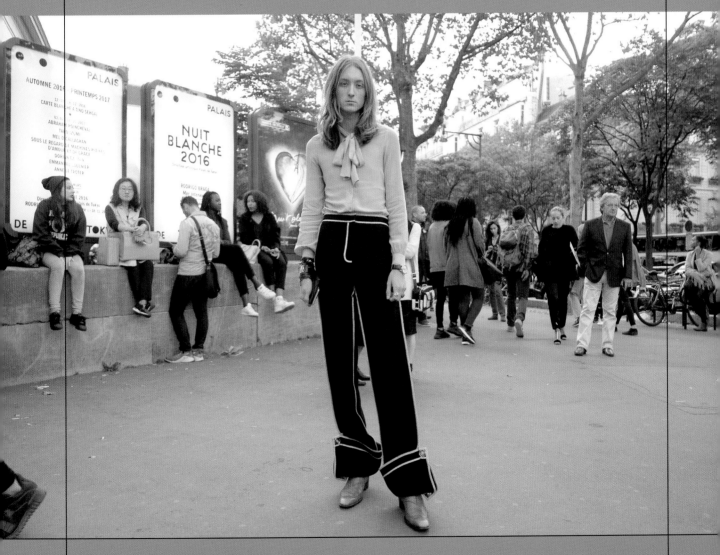

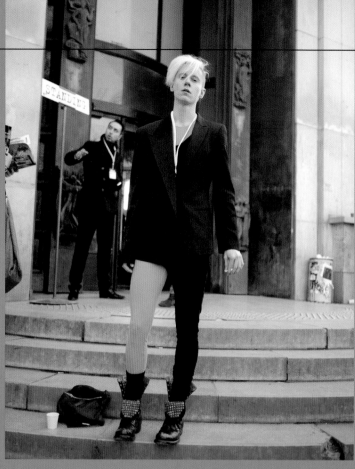

His androgynous features emphasize his nonconformist attitude.

I love the way the jacket is nonchalantly fastened at the top with the arm through only one sleeve!

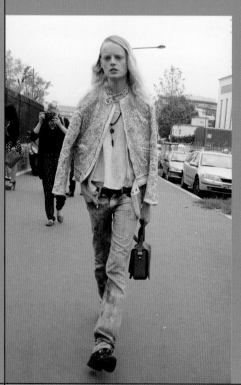

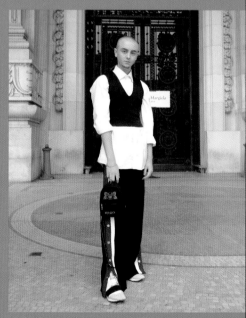

No matter how eccentric the clothes, you can pull it off so long as you have confidence in your unique character!

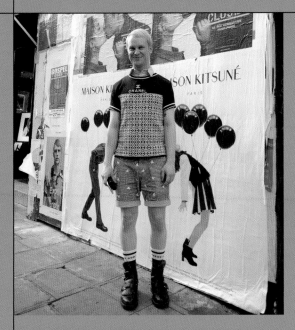

The "young aristocratic" look.

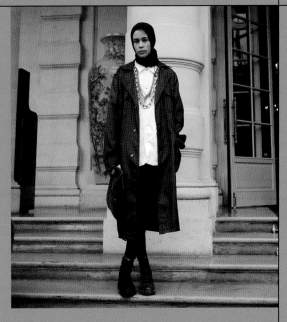

With a fashionable and monochromatic style, he shows a deep knowledge of what works best for him.

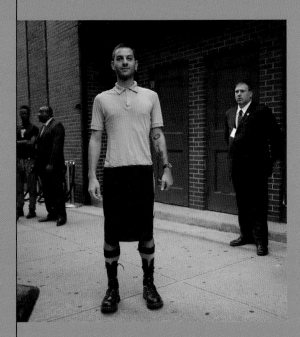

I can't believe someone can style a tight skirt in a way that's so masculine, rugged, and yet elegant!

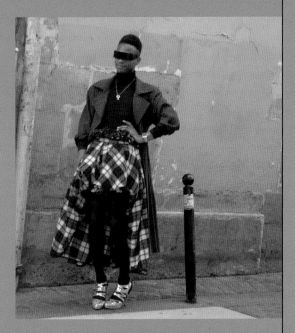

He wears what he likes in a way that he likes. His carefree spirit is infectious and makes even the viewer (the photographer) happy.

Styling Tip #19

MY FAVORITES!

Genres, balance, colors, and patterns. Here are styles that defy categorizations and are bursting with various elements. The reason they work despite containing so many elements is because of the individual character of each dresser. It's hard not to take a photo when someone has a strong sense of self. To say that your clothes look good so long as you are attractive as a human being might contradict the point of this fashion lecture, but it's true in the end.

Ragged jeans layered with a wrap skirt—
take a look at how she wraps the skirt
part of the way, showing off a glimpse
of the jeans beneath!—layers of large
ethnic necklaces, silver shoes on her
feet. Street, ethnic, vintage—a wide array
of elements mixed together to create a
combination with plenty of highlights.
Since this is a lot of information to take
in, she lets the outfit breathe with a
simple white baseball cap.

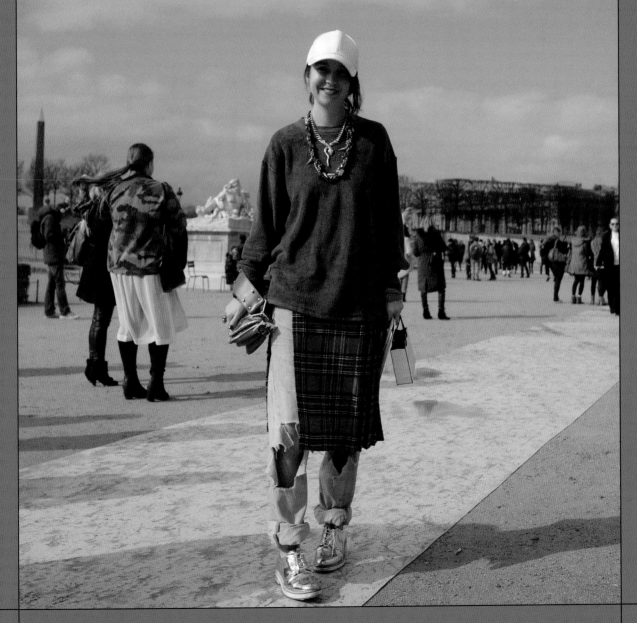

A pattern-on-pattern style with a classic plaid jacket and floral dress...or, so I thought. Look closer and you'll notice that she is wearing a sporty pair of leggings, which provide a dash of vivid color! She also wears a belt bag across her body and a pair of sunglasses with a futuristic vibe. This style is brimming with many tastes—classic, sporty, futuristic, and street—but the cool woman pulls it off like it's nothing. She stole my heart!

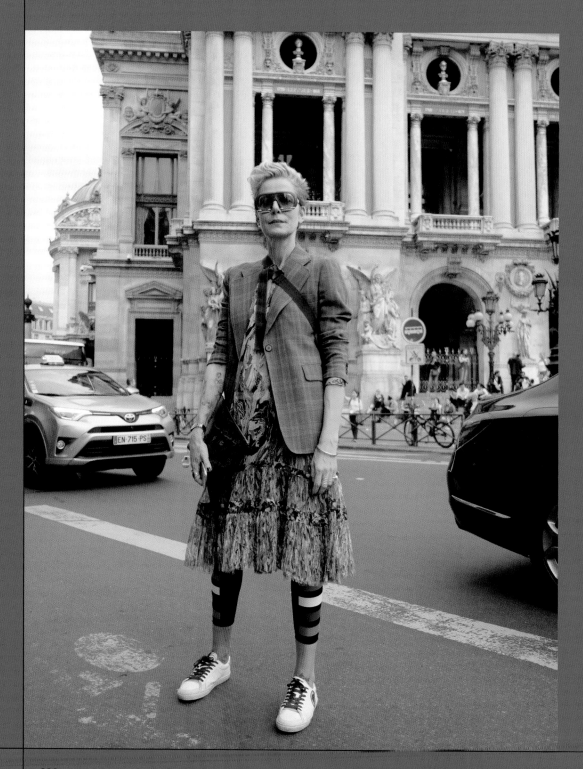

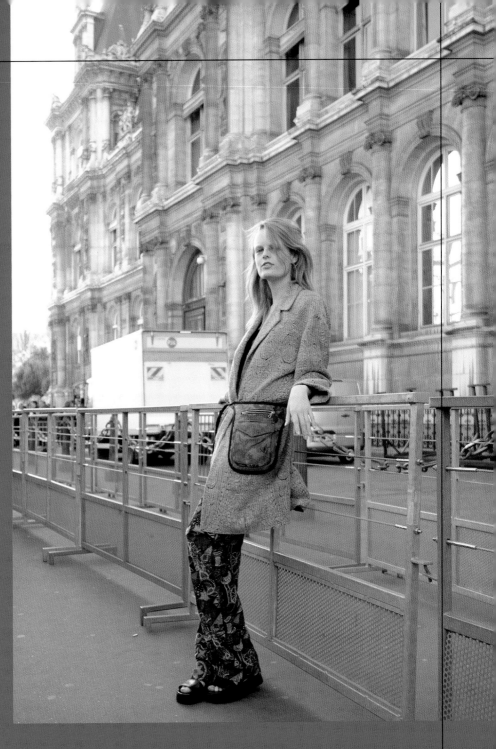

I ask to take a photo of the model Hanne Gaby Odiele whenever I see her because her styling is always creative and unrivaled. A coat worn directly on bare skin is paired with pants whose pattern almost compels you to ask if she purchased it in the Sugamo district of Tokyo (known as Grandma's Harajuku.) Over it she slings a mysterious (tooled?) belt bag, and her choice of footwear in the middle of winter is a pair of sandals. I believe that people who walk the precarious boundary of what's acceptable and what's not in fashion are truly stylish. After all, fashion is about presenting new values and progressing through constant renovation. Hanne doesn't just enjoy fashion—she is one of its creators.

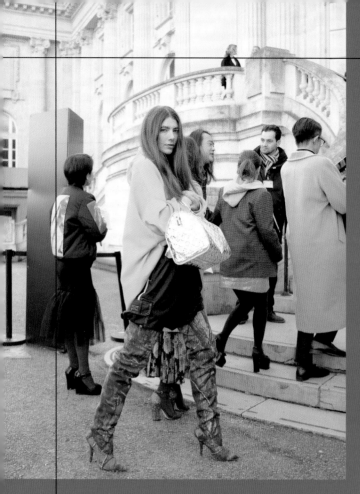

Fashion is about presenting new values and progressing through constant renovation.

Observing street-style through this perspective, I feel that these two ladies are firmly on the side of those who create fashion rather than those who simply enjoy it.

On the left is the stylist Ursina. Below is Hanne, whom I introduced earlier.

Let's take a look at Ursina first. She chose a bright street-style hoodie that's slightly oversized, a luxurious silver Vuitton bag, and wide-leg pants forcefully tucked into her camouflage knee-high boots! The way she creates her silhouette is unique and her mix of different genres is unprecedented. She enjoys fashion with a liberated sensibility!

Now let's look at Hanne.
She wears a distressed vintage hoodie and an ethnic-inspired coat, a long heavy skirt and platform shoes with a '90s vibe. Since the silhouette of this style is large and voluminous, she chose a white hoodie to lighten its image. Each item has such a strong character, but she pulls it off with her inherent originality and fierce sense of style.

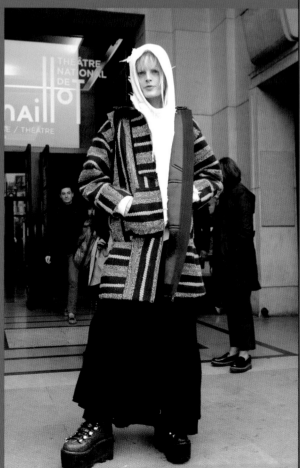

The ease with which she sports a corset-style top already marks her as an expert dresser, but she also incorporates a variety of other techniques! First, her pinstriped top and checkered pants are coordinated in a pattern-on-pattern style. Moreover, when you look closely, you'll see that she layered her sheer pants over a pair of shorts. She also dresses down her outfit by partially untucking the hem of her shirt. Her technical prowess is easy to miss on a quick glance, but her styling is full of noteworthy points. She embodies the philosophy, "It's not what you wear, but how you wear it."

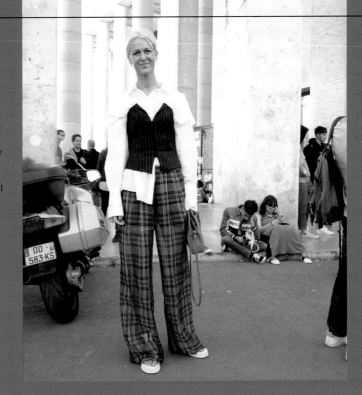

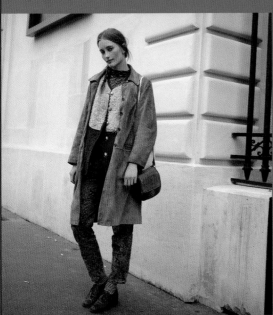

It takes a skillful dresser to pull off this mixed print style (with striped socks no less), which had me wondering if it really works or not. The styling feels carelessly arranged at first, as if she pulled together pieces that were randomly scattered around. Yet these colors and fabrics can only be the result of a meticulous calculation.

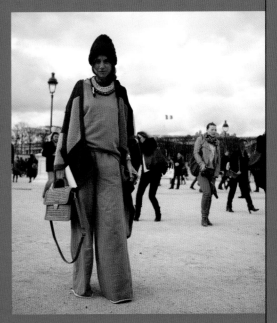

A pair of sweatpants and not just any sweats but a wide-legged pair!, a fluffy knitted cap, and a gorgeous chunky necklace. Her bag, on the other hand, is classic and formal. The style is casual yet gorgeous, relaxed yet finicky about the details—it stirs a sense of adventure with its offers of endless discoveries. I love this stuff!

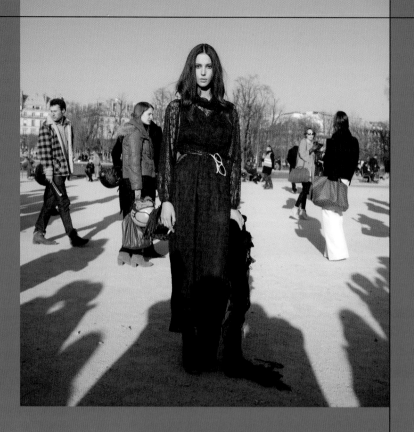

Their transfixing gaze is full
of both ennui and strength.
Their mysterious allure
makes dark colors and slightly
decadent style (the one on the
bottom even drags the hem of
her coat!) look indescribably
cool. They compel people to
stop and stare.

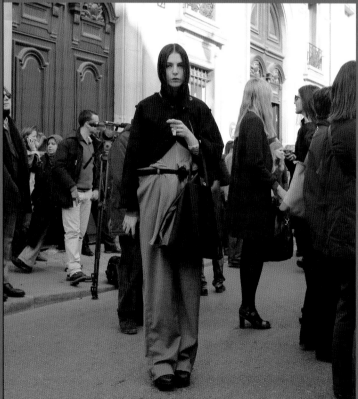

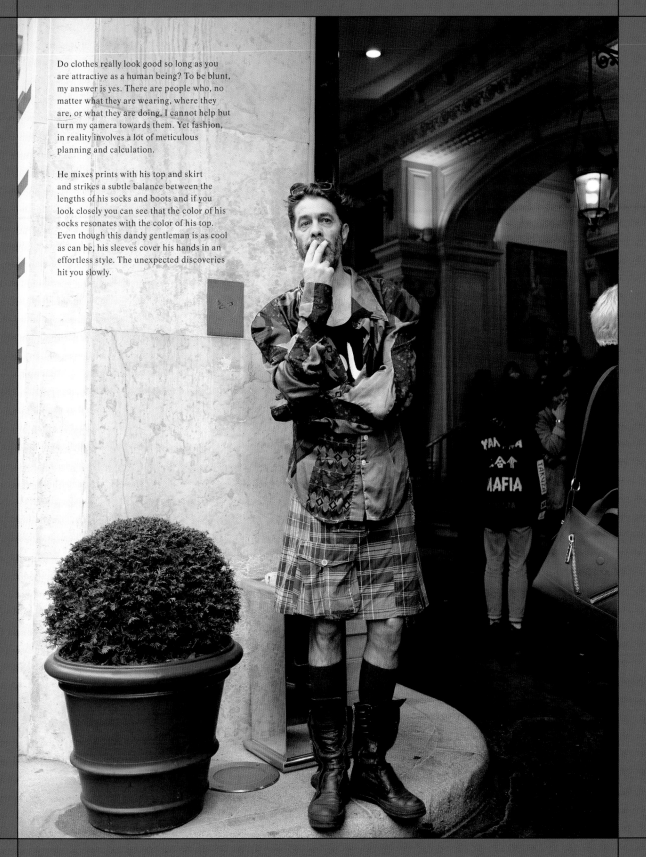

Do clothes really look good so long as you are attractive as a human being? To be blunt, my answer is yes. There are people who, no matter what they are wearing, where they are, or what they are doing, I cannot help but turn my camera towards them. Yet fashion, in reality involves a lot of meticulous planning and calculation.

He mixes prints with his top and skirt and strikes a subtle balance between the lengths of his socks and boots and if you look closely you can see that the color of his socks resonates with the color of his top. Even though this dandy gentleman is as cool as can be, his sleeves cover his hands in an effortless style. The unexpected discoveries hit you slowly.

This is what it means to have a
winning character. His charming
style is full of mischievousness
that plays up his quirks.

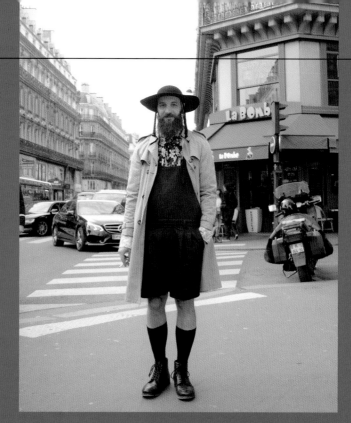

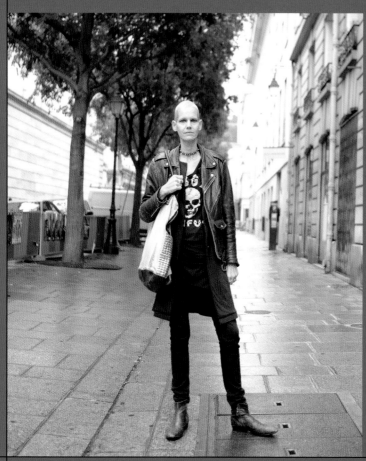

Her shaved head is a sign that
she knows her best features well.
Her slender rock-and-roll style
maximizes her appeal.

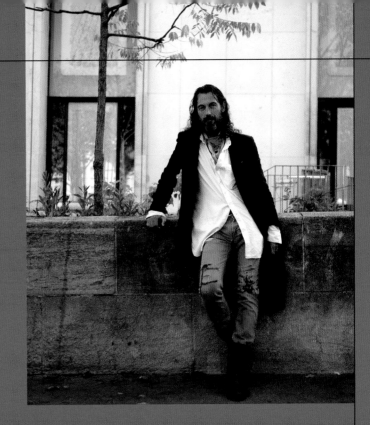

Even if you are no longer at the height of your youth, as long as you acquire a "mature sophistication," you can continue your way into the future fearlessly! There's no doubt he can make any clothes look good and be a star anywhere he goes. The key is how he complements his maturity with a fresh white T-shirt.

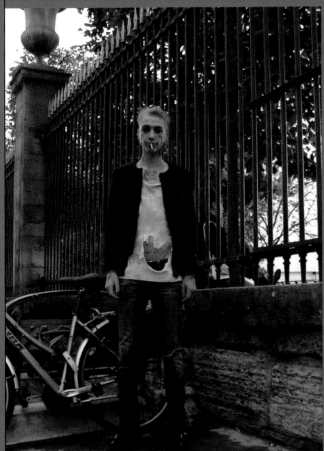

A body full of tattoos! And on his face too! He also has a distinctive character, so no matter what he's wearing, I would take his photo. If it was between clean and dirty, his ragged T-shirt would fall on the side of the latter. When opting for an intentionally rugged style, the same principle as the style of the gentleman above applies here. Keeping a sense of neat "freshness" is important.

Styling Tip #20

VERSATILITY

Of course, we can't simply conclude by saying that
fashion is all about a person's humanity. Here, I
introduce techniques to help you think on your
feet and improvise like a true professional. ENJOY
FASHION!

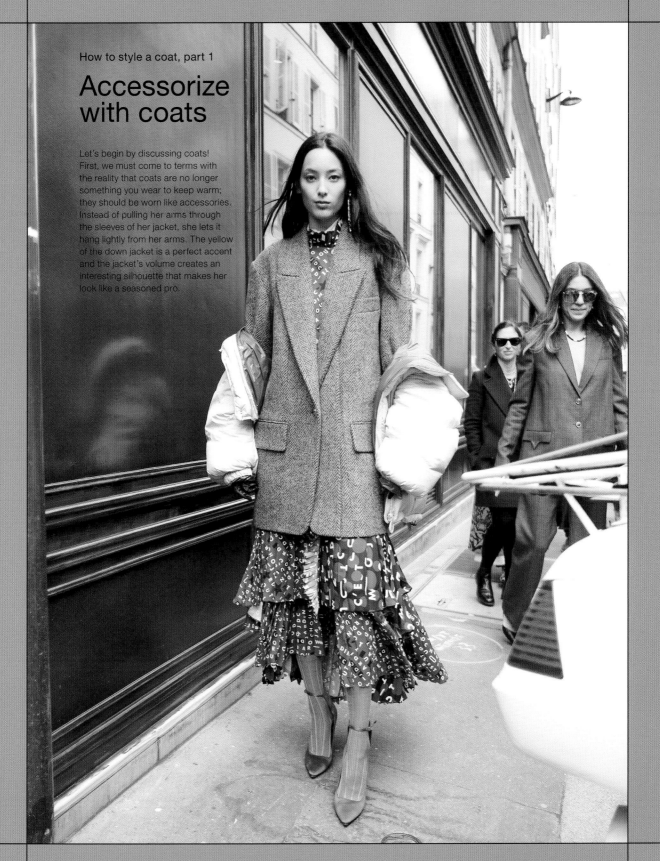

How to style a coat, part 1

Accessorize
with coats

Let's begin by discussing coats!
First, we must come to terms with
the reality that coats are no longer
something you wear to keep warm;
they should be worn like accessories.
Instead of pulling her arms through
the sleeves of her jacket, she lets it
hang lightly from her arms. The yellow
of the down jacket is a perfect accent
and the jacket's volume creates an
interesting silhouette that makes her
look like a seasoned pro.

How to style a coat, part 2

The one-shoulder slip

I wrote that coats are no longer something you wear to keep warm; they should be worn like accessories. Of course, that's hard to accept when it's cold out. The "one-shoulder slip" is a technique that allows you to keep warm while also dressing like a pro. Instead of being obvious, apply this technique in a nonchalant way, as if to say, "my coat slipped down one shoulder, but I couldn't be bothered to fix it…"

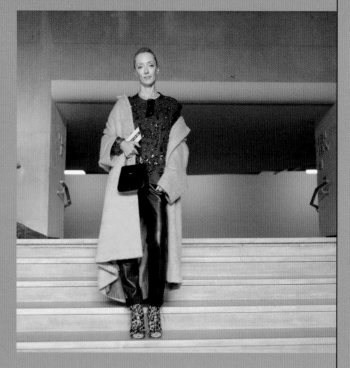

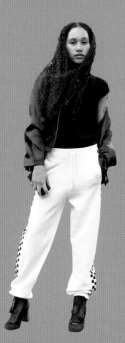

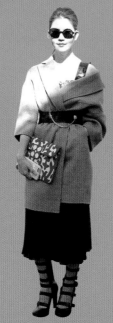

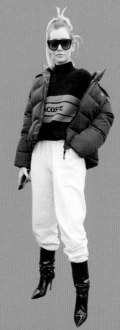

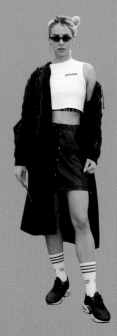

Another one shoulder slip. Notice how she also pulled back the lapels of her coat.

By letting her upper arm show a little bit with the one shoulder slip technique, she's added a hint of sexiness.

The one shoulder slip technique works with any genre from sporty to mode, like this one.

The sporty style looks healthy and energetic with the shoulder and midriff exposed.

How to style a coat, part 3

The belt!

Coats tend to have a lot of volume, and once you
have them on, there aren't ways to style them
other than with what you wear on the inside.
What comes handy in this situation is something
everyone has at least one of at home: a belt!
Simply tying a belt around a coat or a jacket can
easily change its silhouette. The width of the belt,
its position, whether you tie it tightly or loosely—
you'll be surprised how much the impression of
your outfit changes according to the way you
tie your belt, so find your own "golden ratio" by
trying out a variety of positions.

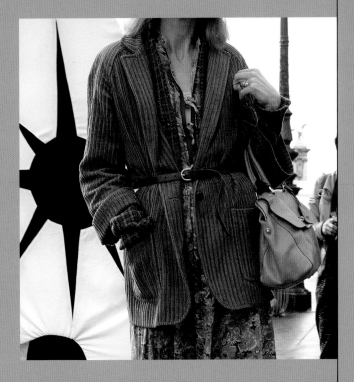

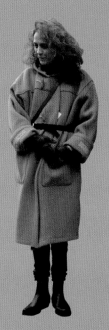

An update of a classic with a
belted duffel coat.

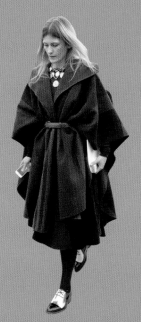

Even a poncho gets a new
silhouette when tied with
a belt. The draping is an
effective touch.

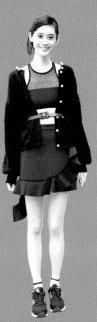

A belt tied over a cardigan.
Tying a belt over an exposed
midriff is a unique style that
someone should have thought
of but I had never seen done
before.

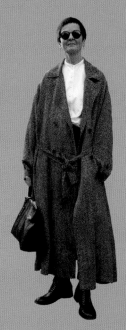

A big coat worn loosely.
The belt is tied loosely as
well, giving the ensemble a
seasoned touch. The crisp
white shirt counterbalances
the unconstricted silhouette.

How to style tops like a pro, part 1

The tiny tuck!

The method is simple and involves only three steps!
1) Pinch the front section of your top around your bellybutton, or slightly to the side of it.
2) Tuck it in.
3) Pull out a little on each side (the third step is key!).

The tiny tuck creates draping and a more rounded shape to the silhouette of your top, giving it a more seasoned look. It also raises your waistline and lengthens your legs. Try it out by tucking the middle section of your top or slightly to the right or left of it and see what works for you!

Depending on your height, figure, or the fabric of your top (thin or thick), the position that "feels right" will change, so in the eternal words of Bruce Lee, "Don't think. Feel!" Have fun experimenting!

Just as there is always a goal to a maze, there is always a goal to the journey of finding your best style! I hope you will experience fashion in a way that allows you to enjoy the journey itself.

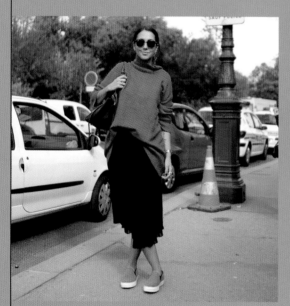
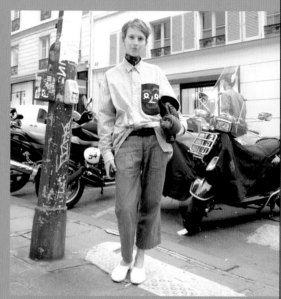
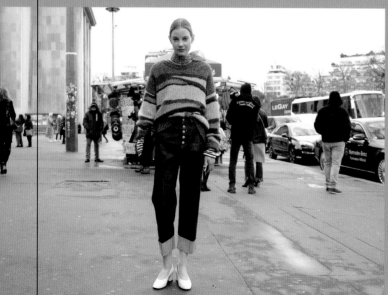
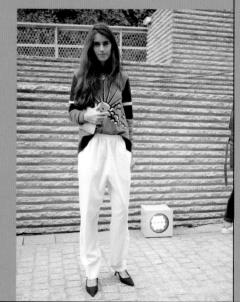

How to style tops
like a pro, part 2

The half-tuck

Here is a problem with the shirt hems: we tend to take a do-or-die, all-or-nothing approach when it comes to tucking them in. Tucking in half of your shirt creates a gray zone, an "effortlessness" that makes you look like a pro. In the end, dressing like a pro comes down to how you incorporate "inconsistencies" into your style in a smart and effortless way.

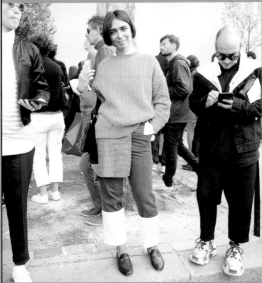

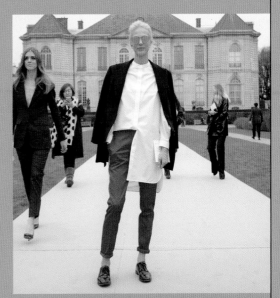

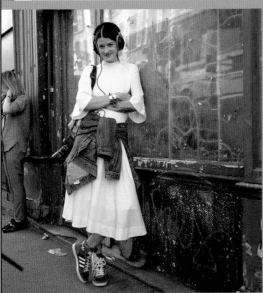

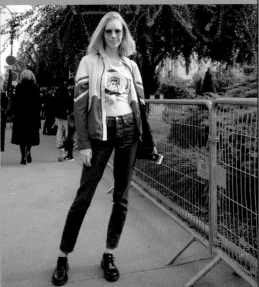

Tying a jacket around your waist is less a styling technique than common sense.... Yet the more you learn about this technique, the more you'll see that it goes much deeper than meets the eye. Tie your jacket around the hip bone for a casual look or tie it higher around your ribs for a more creative, high fashion silhouette. I know it's hard to tie but you can do it with determination!

She changes the silhouette of her slouchy T-shirt to fit her proportion by rolling the hem and tying it into a knot. Tying the shirt allows you to create a body-conscious silhouette or a look that exposes the midriff. A casual T-shirt worn on its own is great, but I recommend this technique when you're in the mood for a little change. Tie your tee into a knot in the front or the back—the position of the knot changes the overall impression, so choose a spot that fits your mood.

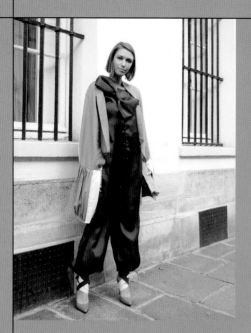

Control of the silhouette.

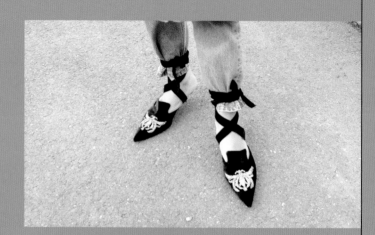

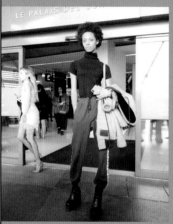

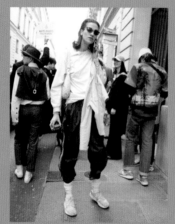

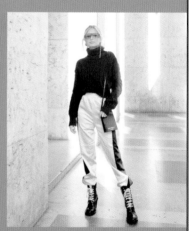

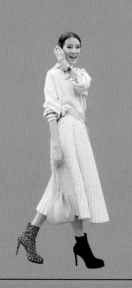

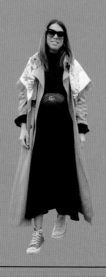

To style your footwear like a pro, take control of the silhouette! The shape of your pants can change depending on how you style your footwear, from tying the laces of your lace-up heels over your pants to tucking in the hem of your pants into your boots. Both methods add volume to the ankles, changing a straight silhouette so that your pants look more like a knickerbocker. It's a subtle and small technique that can be implemented immediately. The applications of an item can unfold limitlessly when you learn new techniques!

Take a close look at their feet. The colors and patterns of their shoes are mismatched. Shoes only take up minimal space—compared to a coat or a long skirt, shoes are such diminutive accessories!—so I think it's fine to go big and be mischievous! Fashion is about taking on a challenge; the key to enjoying it is to be playful at heart.

Styling clothes like a professional is about how much you understand the techniques that create a sense of "effortlessness" and element of "surprise." A seasoned style is not about sensibility—it is possible to cultivate it to a certain extent with the right technique! The last photo I want to introduce is this one. Take a look at the hip area. Instead of wearing pants at her natural waistline, she wears them intentionally lower so that they hang from slightly above her hip. This dresses down the familiar "jogger pants" silhouette a little, loosening the pants and letting them fall more naturally. The second point is how she lets the drawstrings hang out instead of tucking them into her pants. The presence of the drawstrings adds a relaxed, comforting vibe to the otherwise sleek and stylish ensemble.

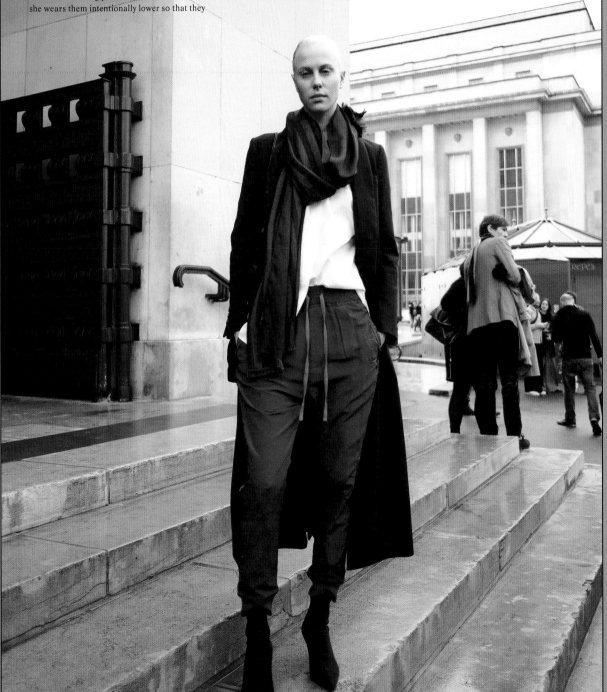

Small Stories #3

think my motto is just keep going, like it's a marathon. You just have to keep going.

——You are considered the pioneer of street-fashion snap. You always seem to enjoy photo shoots. What are tips to stay motivated?

Thank you. Well, I think the thing that helps keep me motivated is that I keep challenging myself. Doing a book on India and then coming back and doing a book about menswear was really a change. It is a marathon. It's something you're going to do for a long time. You've got to challenge yourself and challenge the audience, too. I think the audience gets bored when they figure out who you are and what you usually do, especially on Instagram or on social media. You have to keep them curious and keep them wondering. All of a sudden if I start posting photographs from India and then from Fashion Week and then from Copenhagen, trying to keep the audience interested is like a relationship.

——What inspires your creativity, especially for the street snap?

I look at my own photographs and say "No. What can I do better? What can I do differently? If I'm creating this kind of a dream catalogue, what could be something I haven't done yet?" So I add a fresh nuance to the shooting. Right now I'm getting ready for this Fashion Week and I want to experiment with the flash a little bit more. So I've been studying that. It's a subtle difference, but it is a difference in the way the photographs work and the fact that you can shoot indoors or at night. So for me, I don't really look at other people. I look at some historical photographers. But for the most part it's just me kind of looking at my own work. What do I want to do better? What can I do differently?

——How often do you take photographs on the street during non–Fashion Week or off-season?

I try to shoot every day, but when I get a crunch of books or something like that, I don't get out every day. But I like going out. That's the part of my job I like the most. I shot last night and hope to shoot more by the end of the day. I'll get to go out and shoot a little bit so, yes, almost every day.

——Do you always bring your camera?

No. I decide when I want to take photographs because, as I said, since I don't have to shoot to make anybody else happy or turn it in to an editor I shoot when I'm in the right frame of mind. It requires me to be in the right frame of mind to see the world I want to see, to imagine, to be present. I don't feel that way all the time. So if I'm not feeling the right way, I don't shoot. But more often than not, I do feel that way. I can go out and shoot and enjoy the romance of the moment and be in the present, let all that happen. How lucky I am to have a job like that. So for me, it's not very hard to do.

——I like your expressions such as "romance of the moment" and "be in the present."

Yeah. It's from being with my two teenage daughters. Plus I work with a lot of young women. So you hear a lot of, like, "being in the present," "being in the moment," and "oat milk"! You hear a lot of those kinds of catchphrases. Yeah, I am basically an 18-year-old girl trapped in a 50-year-old man's body. That's why Rei and I get along so well. We are both young people, young spirits.

—— In which city do you most like to photograph? Rei thinks you would choose Milan.

Yeah. I love shooting in Milan. I love being in Milan. I love being anywhere in Italy. I just returned from a vacation there. I like Milan. But I like how the fashion circuit works, that you go from one city to another city that is very different. The style, food, streets, furniture—everything looks very different. I like constant change. You know what's fun but really exhausting is when I work during Fashion Week and then go to India to work on my book, because it's very different going from Paris to India. So I like all the cities in which I shoot. But Milan is probably the most comfortable, I would say, because Milan is more narrow in types of style but very deep whereas New York is more broad and wide, but shallow in terms of style. There might be some people who are wearing vintage— not many people—but some people wearing vintage in a very interesting way. There's a lot more variation of style in New York, whereas in Milan, there are two or three styles and, for the most part, everybody does one of those kinds of styles. So it's very deep and there are many variations of those different kinds of style.

——You've been to Tokyo several times. What do you think of Tokyo street style?

The style is very good. I think you know that the hard part for me is that being in New York makes it more difficult to get to Tokyo. It takes me much longer to get there than to get to Europe. Therefore my expectation builds up. When I get there I'm expecting to see crazy things and it's good, but it's not as surprising. I think the thing that really put Japan on the map was when Rei Kawakubo, Commes des Garçons and Yohji (Yamamoto) really created a Japanese style that

nobody was doing anywhere else and I really respect that. When I see people wearing that style, that's something Japan can do unlike anyone else. It can be surprising because they created the idea and it catches you off guard because they really understand that look. Whereas when I see someone in Tokyo dressed in an Italian style or an English style, they are so precise that it's not as surprising because it's too perfect. There's no surprise to it. And so I think it's when the Japanese wear something in their own kind of style they put more of their take on it. That's what they do really well.

—— How about Tokyo street kids? Rei often takes pictures of them in Tokyo.

Yeah, I tried a couple that I thought were pretty cool. But I think even in New York I don't shoot them very much. I'm very picky, so maybe there's a different way of photographing them. Someone like Bill Cunningham, for example, documented what was out there. He wanted to tell you what was out there. And that's a little bit more like a documentary photographer, and Rei is a little bit like that. I think a lot of people who do street photography want to tell you what's out there, whereas I approach it in a little bit more romantic way. I only shoot what I like. I never care if it's a full picture of an area. Like my book on India, it's not an encyclopedic tour of India. You're not going to get an idea of everything that's there, all the different styles, everything. I put myself in position and I shot what I liked, but I do have a very open eye to a lot of different things. I think one of the things makes my photography strong is that I don't really look for certain kind of subjects. So if I shoot someone kind of old who has a really great style, it's because I like who they are as a person. They just happen to be old. Or if I see street kids, it's not because "Oh look

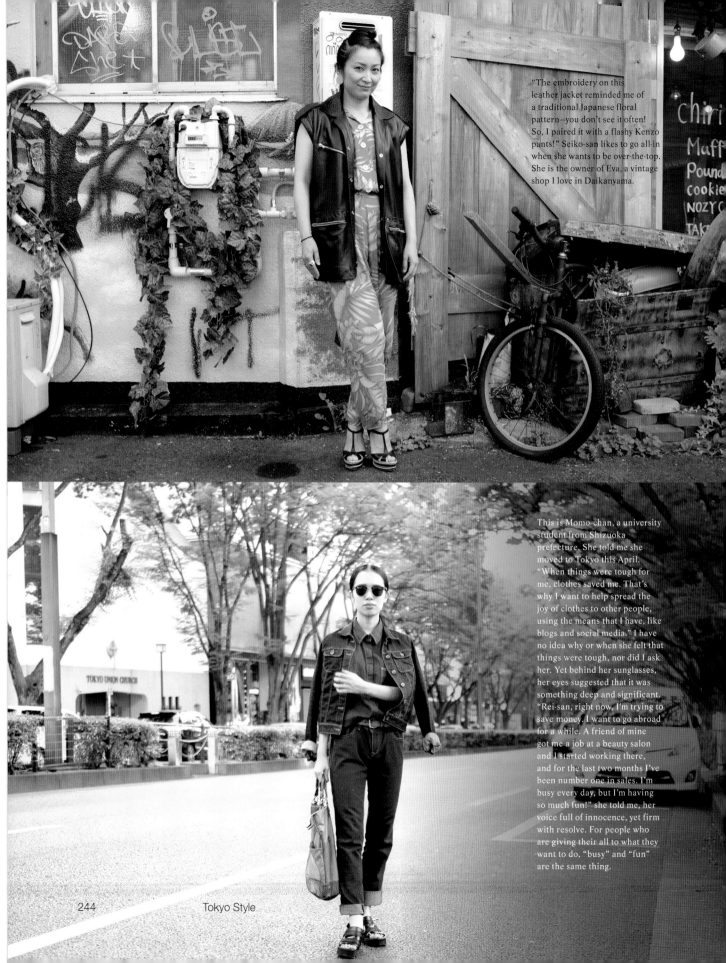

"The embroidery on this leather jacket reminded me of a traditional Japanese floral pattern—you don't see it often! So, I paired it with a flashy Kenzo pants!" Seiko-san likes to go all-in when she wants to be over-the-top. She is the owner of Eva, a vintage shop I love in Daikanyama.

This is Momo-chan, a university student from Shizuoka prefecture. She told me she moved to Tokyo this April. "When things were tough for me, clothes saved me. That's why I want to help spread the joy of clothes to other people, using the means that I have, like blogs and social media." I have no idea why or when she felt that things were tough, nor did I ask her. Yet behind her sunglasses, her eyes suggested that it was something deep and significant. "Rei-san, right now, I'm trying to save money. I want to go abroad for a while. A friend of mine got me a job at a beauty salon and I started working there, and for the last two months I've been number one in sales. I'm busy every day, but I'm having so much fun!" she told me, her voice full of innocence, yet firm with resolve. For people who are giving their all to what they want to do, "busy" and "fun" are the same thing.

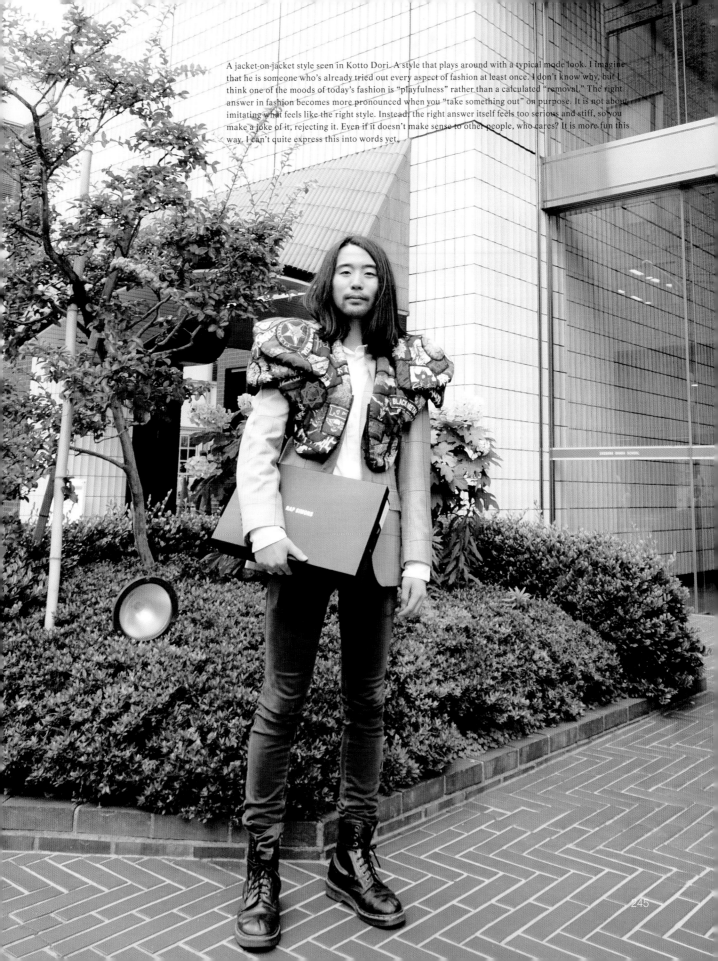

A jacket-on-jacket style seen in Kotto Dori. A style that plays around with a typical mode look. I imagine that he is someone who's already tried out every aspect of fashion at least once. I don't know why, but I think one of the moods of today's fashion is "playfulness" rather than a calculated "removal." The right answer in fashion becomes more pronounced when you "take something out" on purpose. It is not about imitating what feels like the right style. Instead, the right answer itself feels too serious and stiff, so you make a joke of it, rejecting it. Even if it doesn't make sense to other people, who cares? It is more fun this way. I can't quite express this into words yet.

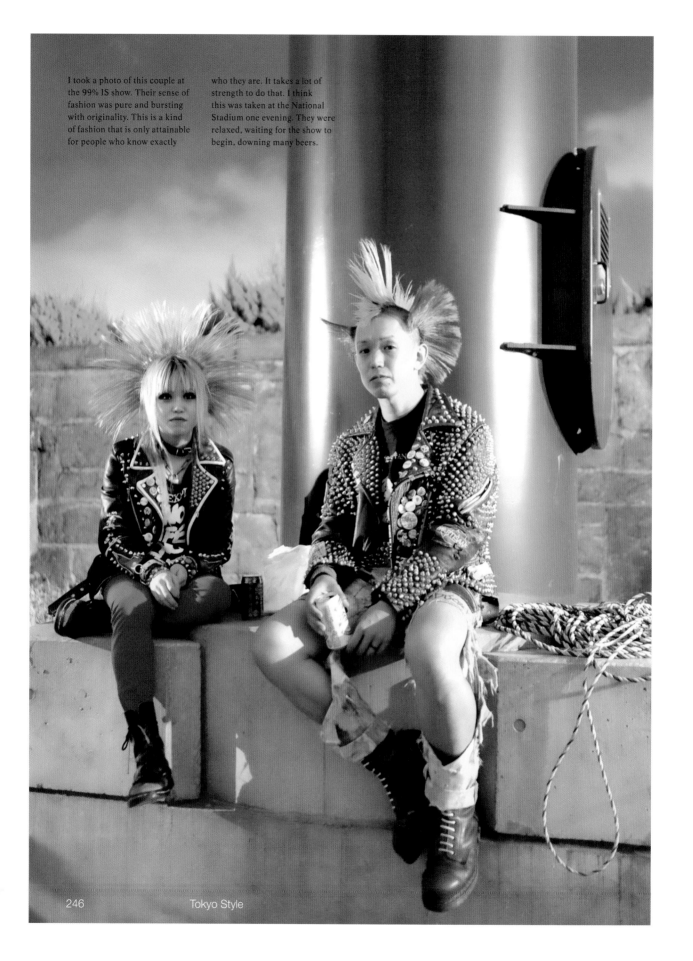

I took a photo of this couple at the 99% IS show. Their sense of fashion was pure and bursting with originality. This is a kind of fashion that is only attainable for people who know exactly who they are. It takes a lot of strength to do that. I think this was taken at the National Stadium one evening. They were relaxed, waiting for the show to begin, downing many beers.

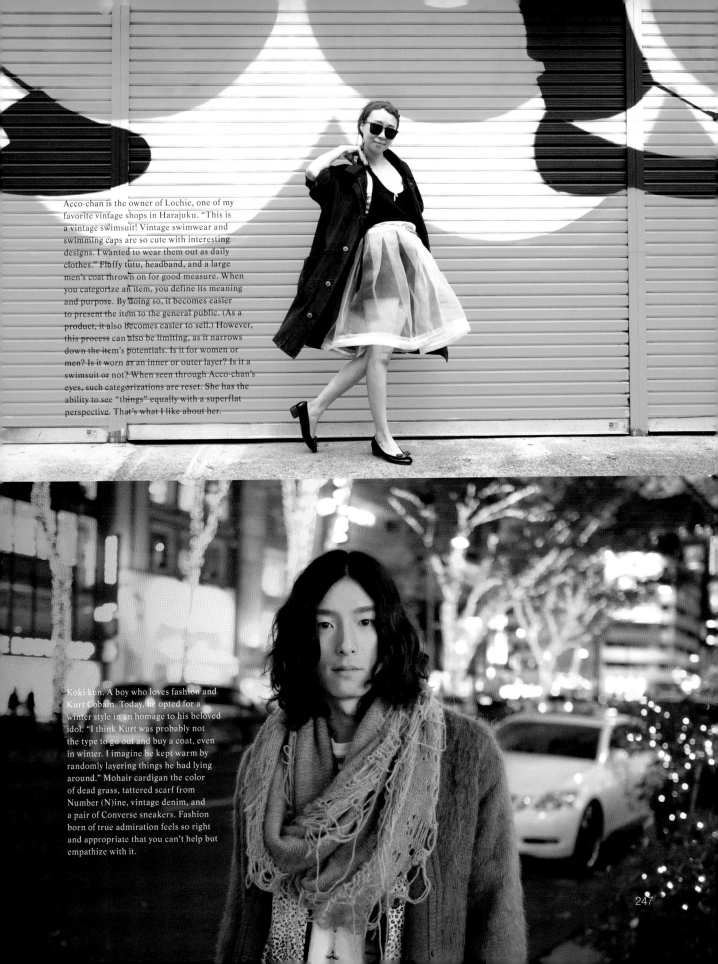

Acco-chan is the owner of Lochie, one of my favorite vintage shops in Harajuku. "This is a vintage swimsuit! Vintage swimwear and swimming caps are so cute with interesting designs. I wanted to wear them out as daily clothes." Fluffy tutu, headband, and a large men's coat thrown on for good measure. When you categorize an item, you define its meaning and purpose. By doing so, it becomes easier to present the item to the general public. (As a product, it also becomes easier to sell.) However, this process can also be limiting, as it narrows down the item's potentials. Is it for women or men? Is it worn as an inner or outer layer? Is it a swimsuit or not? When seen through Acco-chan's eyes, such categorizations are reset. She has the ability to see "things" equally with a superflat perspective. That's what I like about her.

Koki-kun. A boy who loves fashion and Kurt Cobain. Today, he opted for a winter style in an homage to his beloved idol. "I think Kurt was probably not the type to go out and buy a coat, even in winter. I imagine he kept warm by randomly layering things he had lying around." Mohair cardigan the color of dead grass, tattered scarf from Number (N)ine, vintage denim, and a pair of Converse sneakers. Fashion born of true admiration feels so right and appropriate that you can't help but empathize with it.

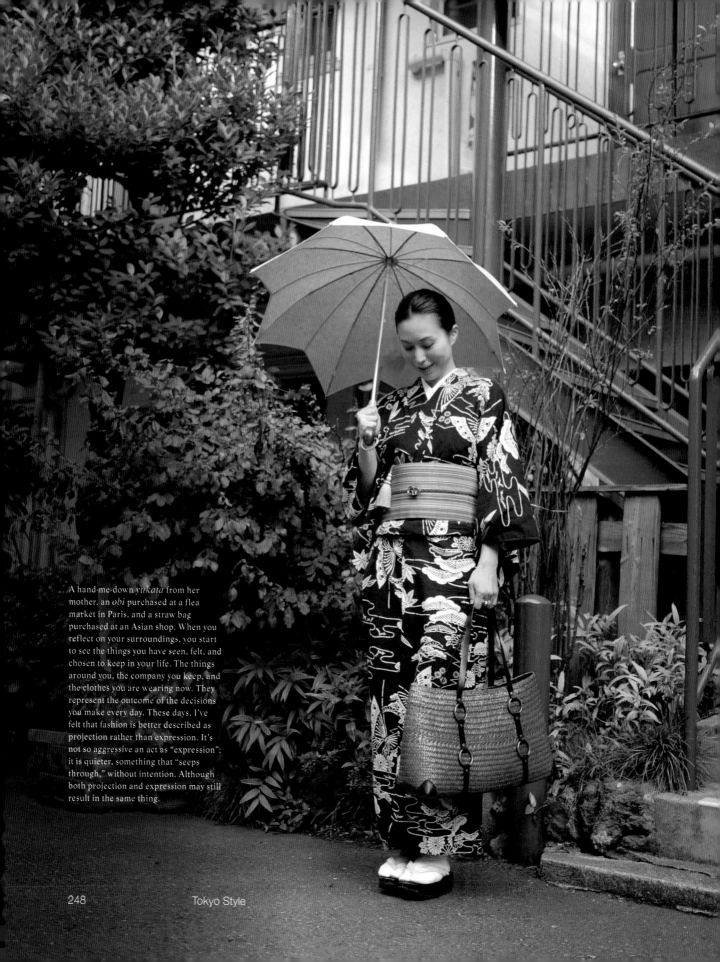

A hand-me-down *yukata* from her mother, an *obi* purchased at a flea market in Paris, and a straw bag purchased at an Asian shop. When you reflect on your surroundings, you start to see the things you have seen, felt, and chosen to keep in your life. The things around you, the company you keep, and the clothes you are wearing now. They represent the outcome of the decisions you make every day. These days, I've felt that fashion is better described as projection rather than expression. It's not so aggressive an act as "expression"; it is quieter, something that "seeps through," without intention. Although both projection and expression may still result in the same thing.

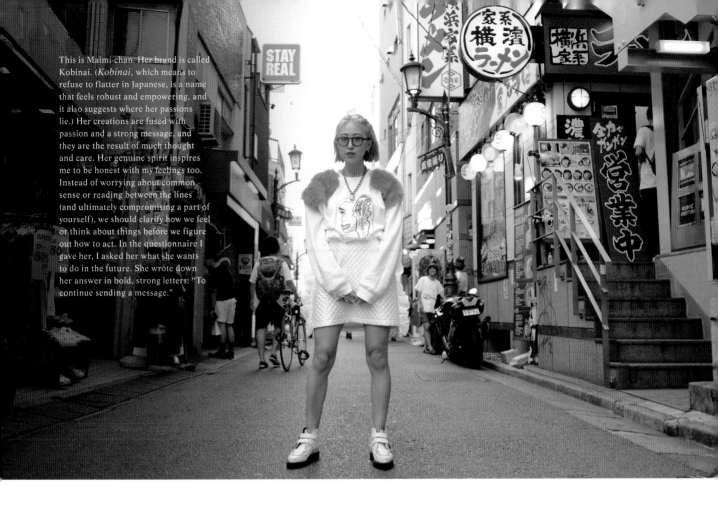

This is Maimi-chan. Her brand is called Kobinai. (*Kobinai*, which means to refuse to flatter in Japanese, is a name that feels robust and empowering, and it also suggests where her passions lie.) Her creations are fused with passion and a strong message, and they are the result of much thought and care. Her genuine spirit inspires me to be honest with my feelings too. Instead of worrying about common sense or reading between the lines (and ultimately compromising a part of yourself), we should clarify how we feel or think about things before we figure out how to act. In the questionnaire I gave her, I asked her what she wants to do in the future. She wrote down her answer in bold, strong letters: "To continue sending a message."

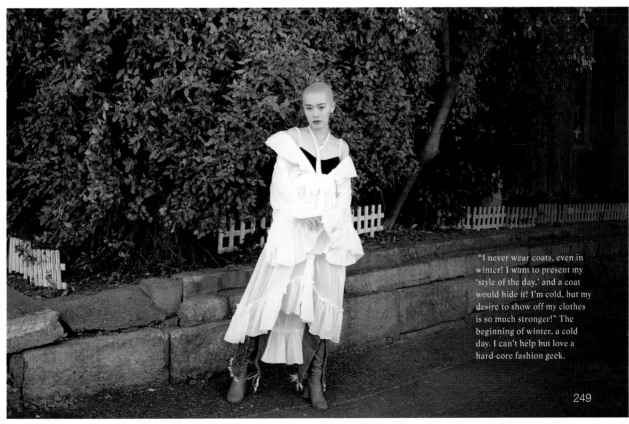

"I never wear coats, even in winter! I want to present my 'style of the day,' and a coat would hide it! I'm cold, but my desire to show off my clothes is so much stronger!" The beginning of winter, a cold day. I can't help but love a hard-core fashion geek.

249

This is Enna-chan, the designer of Clane. I quite like the way Enna-chan talks, with hints of Kansai dialect. "Rei-san, my social circle is pretty small; I don't actually come to Omotesandō all that much. But my shop is opening for the first time at Omotesandō Hills, so I think I'm going to be making new memories in this area." That's what she told me, her eyes looking ahead into the future.

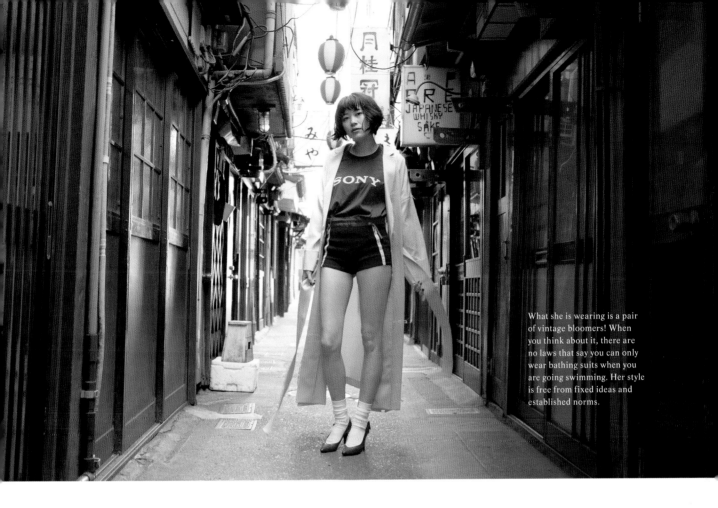

What she is wearing is a pair of vintage bloomers! When you think about it, there are no laws that say you can only wear bathing suits when you are going swimming. Her style is free from fixed ideas and established norms.

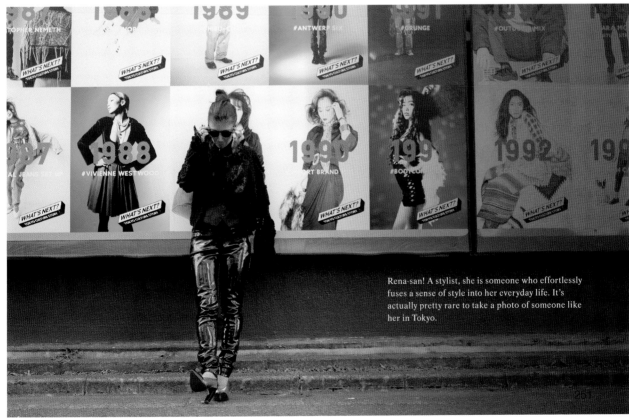

Rena-san! A stylist, she is someone who effortlessly fuses a sense of style into her everyday life. It's actually pretty rare to take a photo of someone like her in Tokyo.

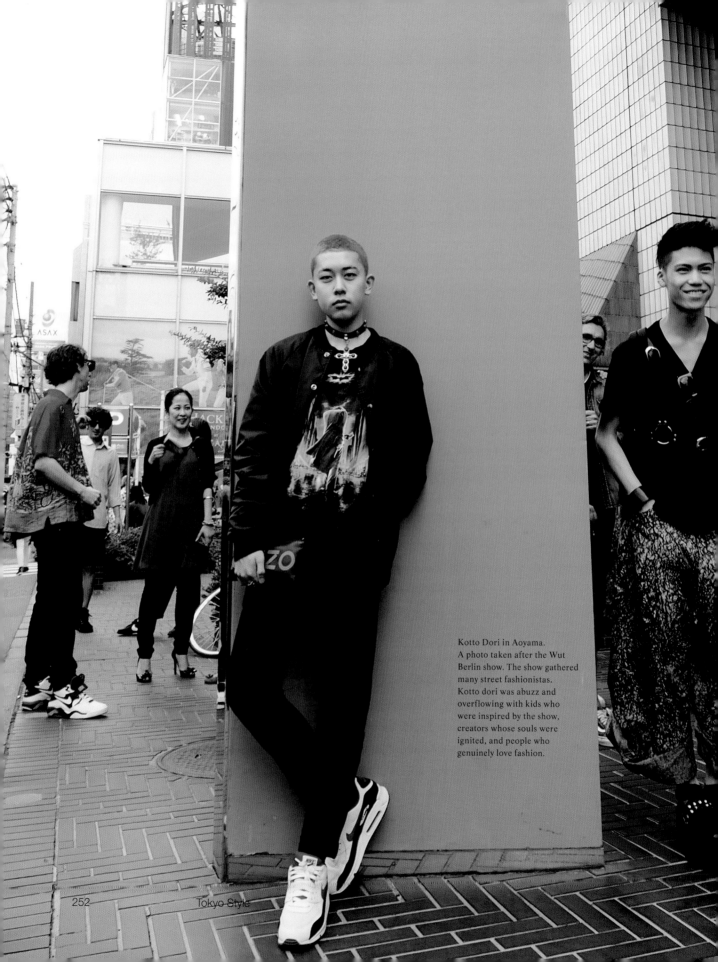

Kotto Dori in Aoyama.
A photo taken after the Wut
Berlin show. The show gathered
many street fashionistas.
Kotto dori was abuzz and
overflowing with kids who
were inspired by the show,
creators whose souls were
ignited, and people who
genuinely love fashion.

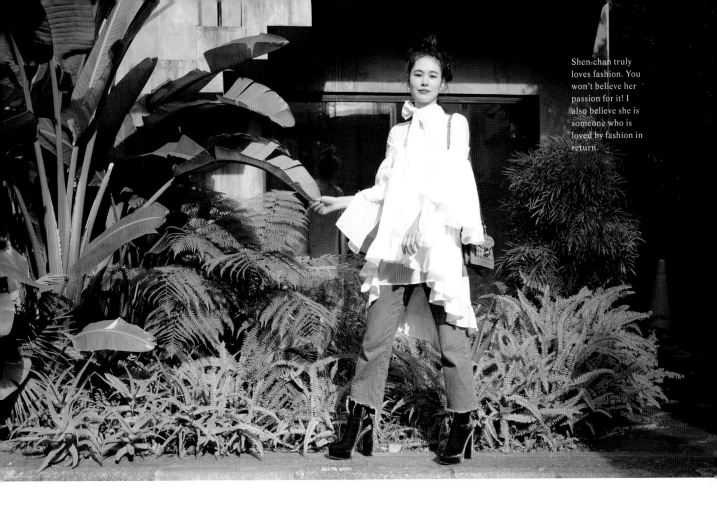

Shen-chan truly loves fashion. You won't believe her passion for it! I also believe she is someone who is loved by fashion in return.

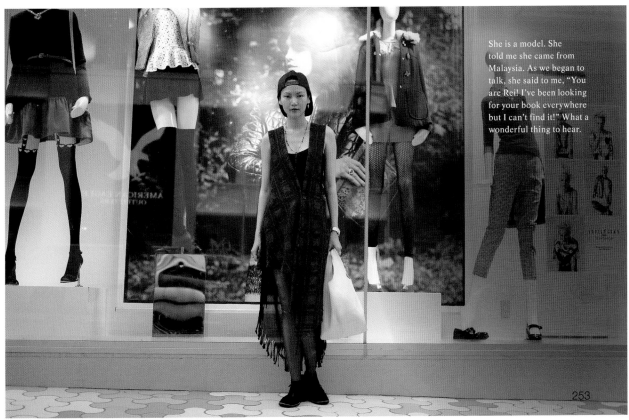

She is a model. She told me she came from Malaysia. As we began to talk, she said to me, "You are Rei! I've been looking for your book everywhere but I can't find it!" What a wonderful thing to hear.

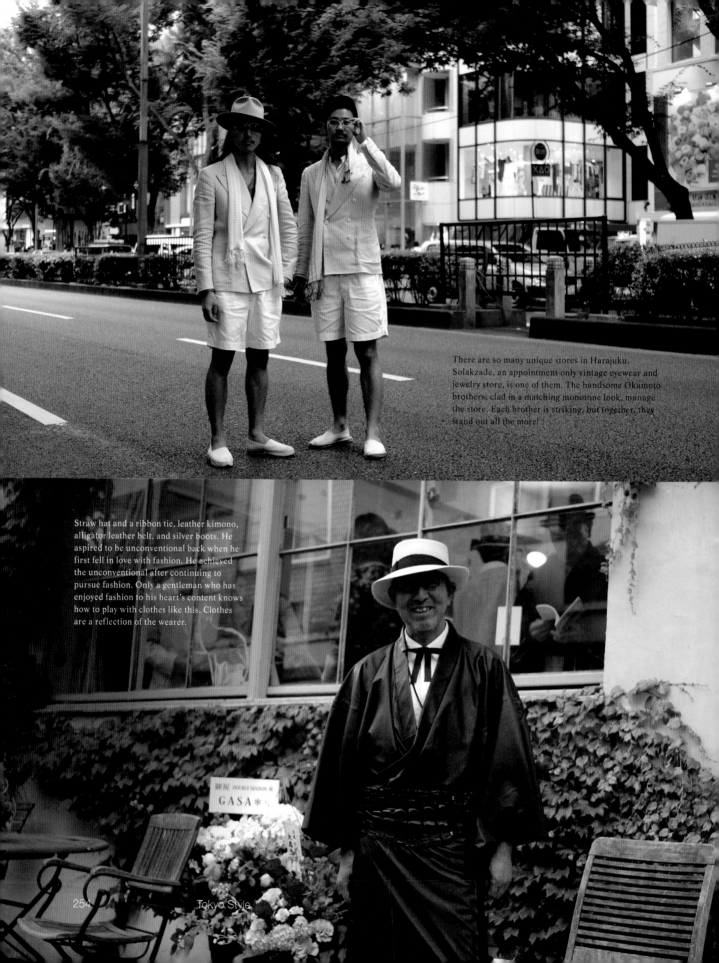

There are so many unique stores in Harajuku. Solakzade, an appointment-only vintage eyewear and jewelry store, is one of them. The handsome Okamoto brothers, clad in a matching monotone look, manage the store. Each brother is striking, but together, they stand out all the more!

Straw hat and a ribbon tie, leather kimono, alligator leather belt, and silver boots. He aspired to be unconventional back when he first fell in love with fashion. He achieved the unconventional after continuing to pursue fashion. Only a gentleman who has enjoyed fashion to his heart's content knows how to play with clothes like this. Clothes are a reflection of the wearer.

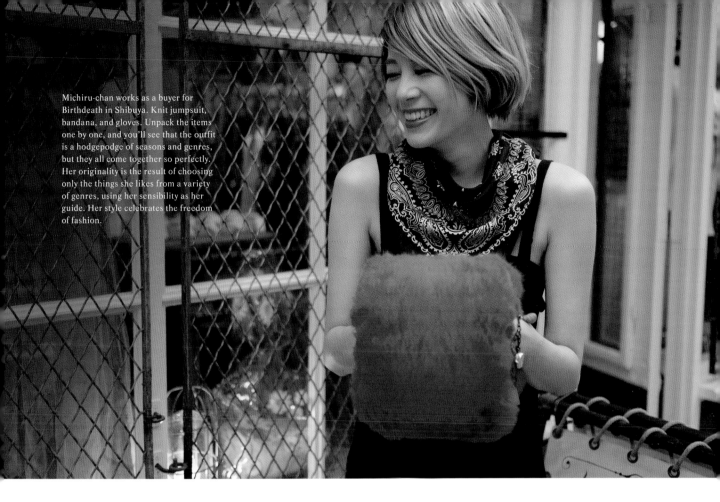

Michiru-chan works as a buyer for Birthdeath in Shibuya. Knit jumpsuit, bandana, and gloves. Unpack the items one by one, and you'll see that the outfit is a hodgepodge of seasons and genres, but they all come together so perfectly. Her originality is the result of choosing only the things she likes from a variety of genres, using her sensibility as her guide. Her style celebrates the freedom of fashion.

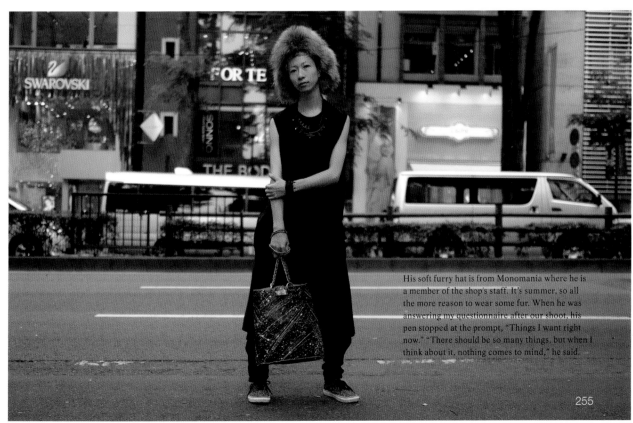

His soft furry hat is from Monomania where he is a member of the shop's staff. It's summer, so all the more reason to wear some fur. When he was answering my questionnaire after our shoot, his pen stopped at the prompt, "Things I want right now." "There should be so many things, but when I think about it, nothing comes to mind," he said.

255

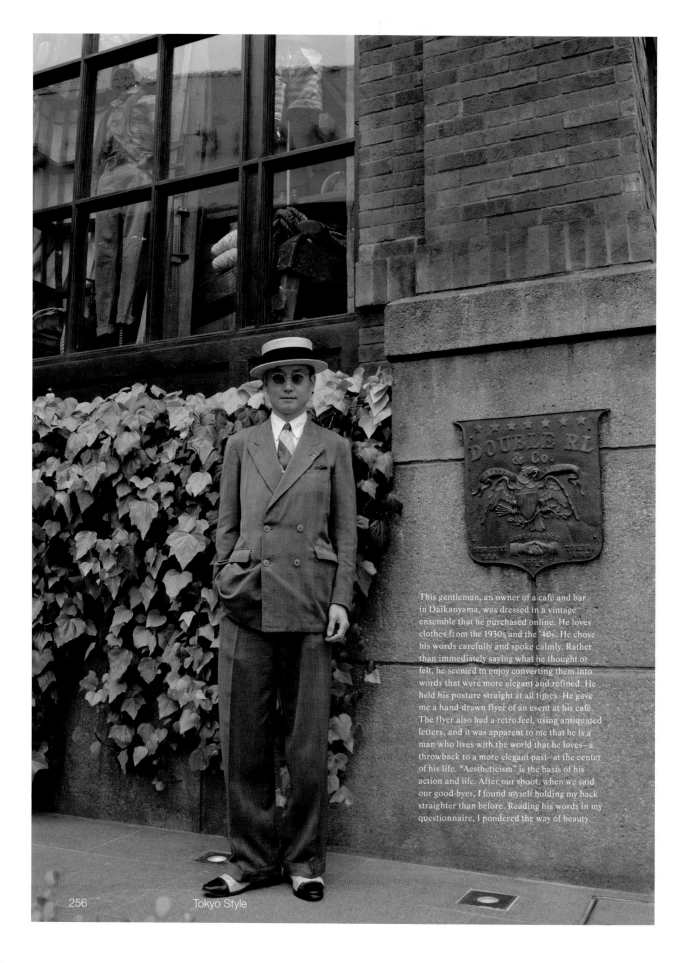

This gentleman, an owner of a café and bar in Daikanyama, was dressed in a vintage ensemble that he purchased online. He loves clothes from the 1930s and the '40s. He chose his words carefully and spoke calmly. Rather than immediately saying what he thought or felt, he seemed to enjoy converting them into words that were more elegant and refined. He held his posture straight at all times. He gave me a hand-drawn flyer of an event at his café. The flyer also had a retro feel, using antiquated letters, and it was apparent to me that he is a man who lives with the world that he loves—a throwback to a more elegant past—at the center of his life. "Aestheticism" is the basis of his action and life. After our shoot, when we said our good-byes, I found myself holding my back straighter than before. Reading his words in my questionnaire, I pondered the way of beauty.

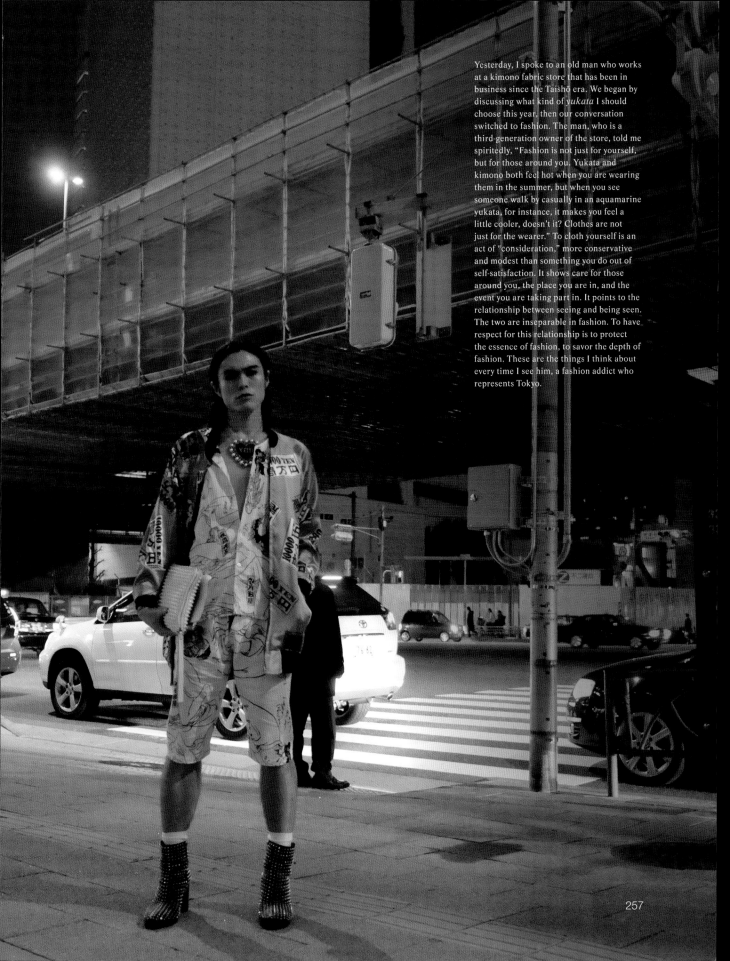

Yesterday, I spoke to an old man who works at a kimono fabric store that has been in business since the Taishō era. We began by discussing what kind of *yukata* I should choose this year, then our conversation switched to fashion. The man, who is a third-generation owner of the store, told me spiritedly, "Fashion is not just for yourself, but for those around you. Yukata and kimono both feel hot when you are wearing them in the summer, but when you see someone walk by casually in an aquamarine yukata, for instance, it makes you feel a little cooler, doesn't it? Clothes are not just for the wearer." To cloth yourself is an act of "consideration," more conservative and modest than something you do out of self-satisfaction. It shows care for those around you, the place you are in, and the event you are taking part in. It points to the relationship between seeing and being seen. The two are inseparable in fashion. To have respect for this relationship is to protect the essence of fashion, to savor the depth of fashion. These are the things I think about every time I see him, a fashion addict who represents Tokyo.

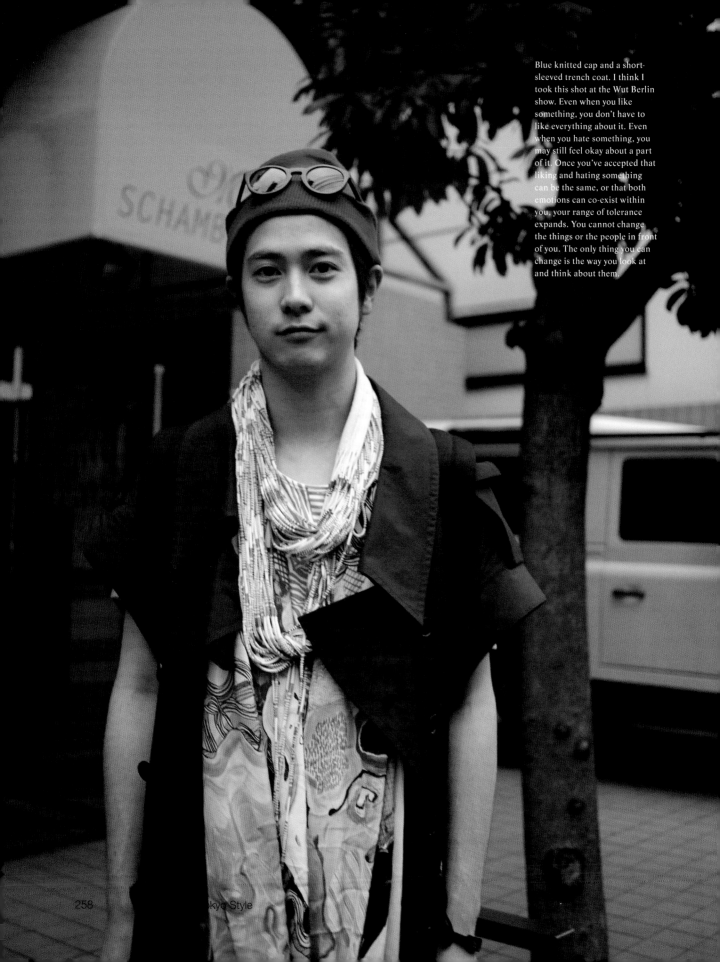

Blue knitted cap and a short-sleeved trench coat. I think I took this shot at the Wut Berlin show. Even when you like something, you don't have to like everything about it. Even when you hate something, you may still feel okay about a part of it. Once you've accepted that liking and hating something can be the same, or that both emotions can co-exist within you, your range of tolerance expands. You cannot change the things or the people in front of you. The only thing you can change is the way you look at and think about them.

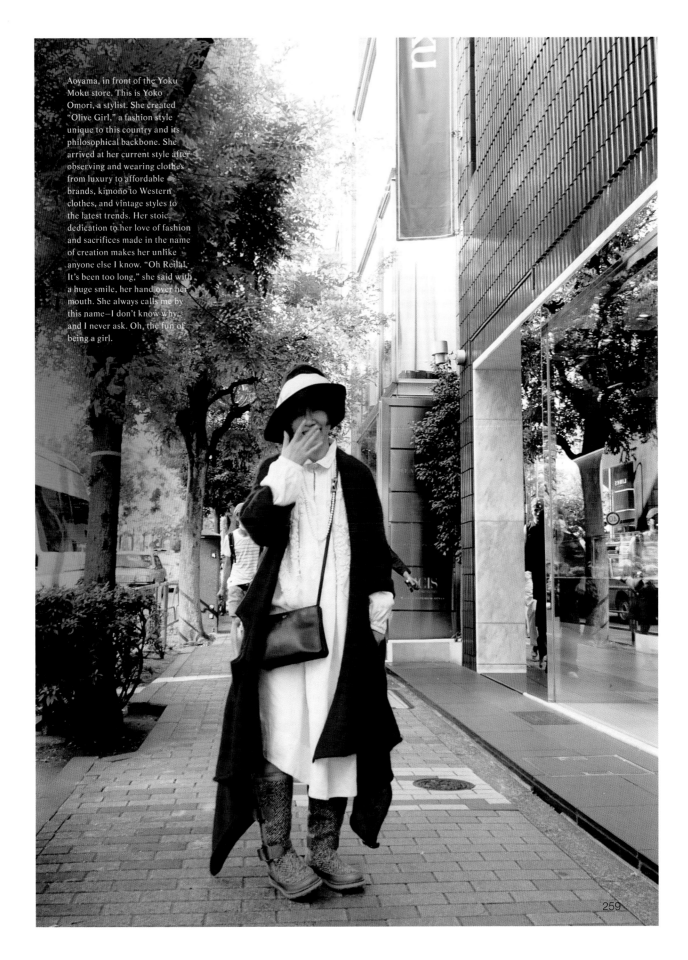

Aoyama, in front of the Yoku Moku store. This is Yoko Omori, a stylist. She created "Olive Girl," a fashion style unique to this country and its philosophical backbone. She arrived at her current style after observing and wearing clothes from luxury to affordable brands, kimono to Western clothes, and vintage styles to the latest trends. Her stoic dedication to her love of fashion and sacrifices made in the name of creation makes her unlike anyone else I know. "Oh Reila! It's been too long," she said with a huge smile, her hand over her mouth. She always calls me by this name—I don't know why, and I never ask. Oh, the fun of being a girl.

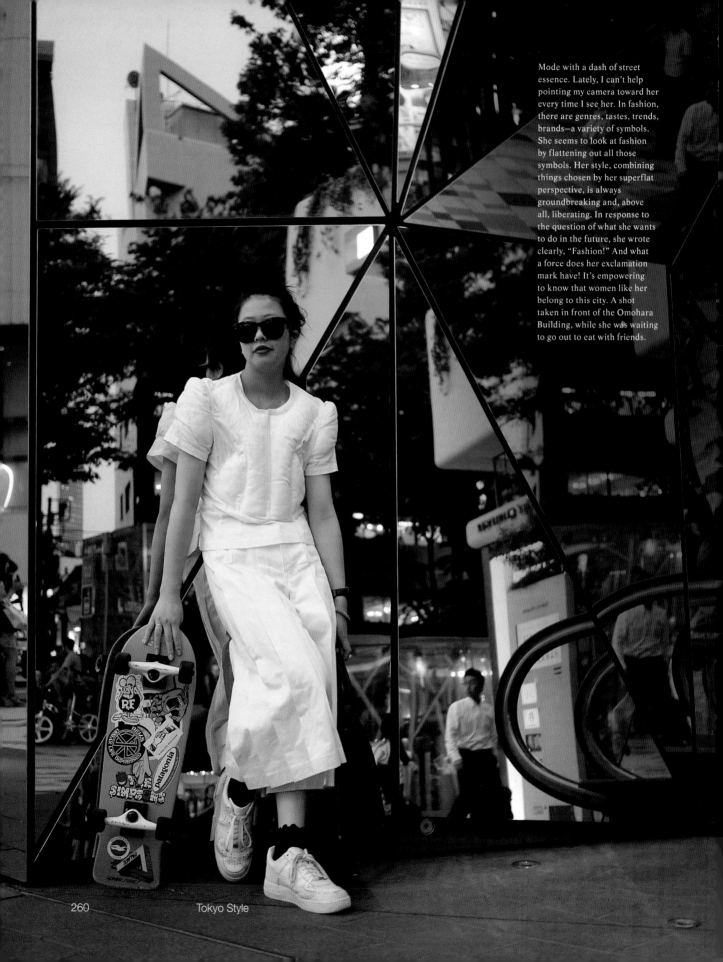

Mode with a dash of street essence. Lately, I can't help pointing my camera toward her every time I see her. In fashion, there are genres, tastes, trends, brands—a variety of symbols. She seems to look at fashion by flattening out all those symbols. Her style, combining things chosen by her superflat perspective, is always groundbreaking and, above all, liberating. In response to the question of what she wants to do in the future, she wrote clearly, "Fashion!" And what a force does her exclamation mark have! It's empowering to know that women like her belong to this city. A shot taken in front of the Omohara Building, while she was waiting to go out to eat with friends.

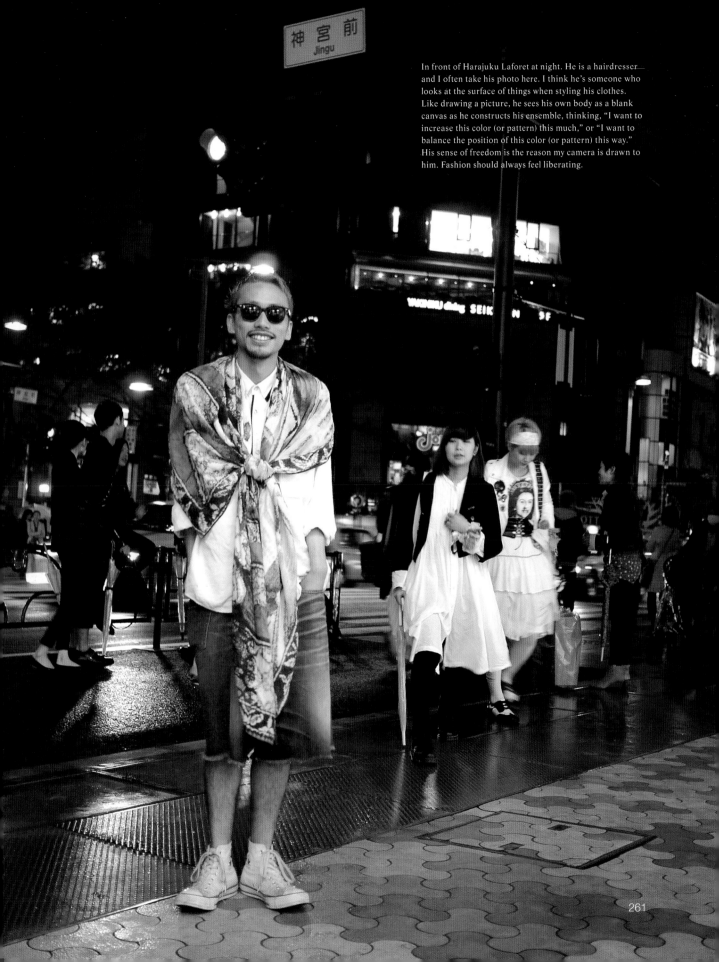

神宮前
Jingu

In front of Harajuku Laforet at night. He is a hairdresser
and I often take his photo here. I think he's someone who
looks at the surface of things when styling his clothes.
Like drawing a picture, he sees his own body as a blank
canvas as he constructs his ensemble, thinking, "I want to
increase this color (or pattern) this much," or "I want to
balance the position of this color (or pattern) this way."
His sense of freedom is the reason my camera is drawn to
him. Fashion should always feel liberating.

A Smile,
a Snap,
and the Streets

By Toshiko Nakashima

When I first met Rei Shito, she was a sweet young woman who was good at taking photos, before she had donned the aura of a photographer that she has now. Yet even then, the way she would smile brightly like a flower at her subjects as she took their photos hinted at something special about her ability as a photographer.

When Rei started taking photos in 2004, the world of high fashion was still skeptical of street snaps. It was a transitional period when the grand narrative of trends in fashion had come to an end and the concept of "annual trends" had started to ring hollow. On the other hand, Tokyo was alive with the simultaneous emergence of a variety of fashions, from celebrity casual to Lolita. It was also during this chaotic period when luxury brands began to descend in droves upon the avenue of Omotesandō. Back then, the coexistence of street and haute couture was considered heresy; the two ignored each other, at times even disliking each other. However, the street culture of Tokyo continued to evolve, expanding its reach with music, graffiti, and skateboard cultures as its catalysts. For a long time, the *maisons* failed, or maybe never even tried, to capture the hearts of young people representing such cultures. The mood of the streets could not be further removed from the fashion envisioned by the professionals working inside their white cyc studios. The eclectic mixture of styles (sports mix, sweet & hard, high & low, etc.) that Tokyo became known for could not be generated from inside a studio. Out on the streets, fashion was "what looked good against the backdrop of the city"—fashion was effective insofar as it served as a tool for communication, existing because of the city, worn because of the community of likeminded friends. I believe that Rei was someone who had intuited such a movement in Tokyo.

Rei's sensibility never wavered no matter where she went, from Tokyo to Paris and other cities around the world, and it continued to develop. Just as she had done with the fashion kids of Tokyo, she pointed her camera with no hesitation toward international celebrities, always with a big smile on her face. Her confidence and aura as a photographer began to flourish and glimmer. From the back streets of Harajuku to the show venues of Paris Fashion Week, she never failed to grab whoever caught her eye and click away, all while standing on the same

Afterword

level as her subject. She doesn't choose her subject based on which brand he or she is wearing; rather, it depends on the overall balance of the outfit, whether it looks good on her subject and if her subject exudes an original philosophy of fashion. She never takes photos just because someone is a celebrity. It always comes down to whether her subject "embodies fashion."

It is a wonder how Rei always manages to draw out such cute expressions from her subjects in the chaotic scenes in front of the show venues. How does she portray the clothes so beautifully at such perfect angles amidst such a crowd of people? That remains a mystery to me, even when I watch her at work. The only thing that clearly sets her apart from other photographers may be the indescribable innocence of her smile. When she releases the shutter, standing on the asphalt, she and the person she is shooting are transported into a tranquil space, as if they are momentarily removed from the outside world, as if they alone stand in complete silence. For anyone who has seen the film *Ping Pong*, you may recall the iconic scene in that beautiful white space. The space vanishes as soon as Rei finishes taking photos, checks

her work, and calls out "thank you!", and the subject of her work returns to normal life, feeling a bit tickled and enchanted by the experience.

After holding her own and sharpening her skills among the fashion luminaries of the world, Rei soon became not only someone who photographs other people but someone who other people wanted to photograph. In the bustling splendor of the stages in Paris and Milan, Rei, alone with her camera, is a delicate figure, an icon of snap photographers who stand apart from the typical paparazzi. Just as the designers of luxury brands expend enormous talent and money to showcase their greatest work on the runway, her photos have also reached the apex of street fashion.

Times have changed, and now high fashion and street fashion cannot live without each other. The *maisons* actively look for the next big thing in street culture in search of new horizons, and tastes of the streets have been incorporated into *maisons*. The last decade or so that Rei has spent taking photos coincides with the rise of street snaps in the fashion magazines of Tokyo. A time

when a feature on street snaps regardless of genre—
men's, women's, haute couture, or casual—could
guarantee a sold-out issue soon arrived. The readers
and even the apparel makers began to refer not to
communiqués from Paris Fashion Week but street snaps
to foretell what people would be wearing tomorrow.
What emerged from that movement was not some ivory
tower high-end brand but suggestions of fashion that
mixed street and high end. Rei's photos, insisting on the
freedom of fashion and the idea that the best fashion
was one that looked good on its wearer, began to be
recognized everywhere. The era's growing passion for
street snaps and the time she has spent taking photos
linked together like a miracle. If her beloved idol Bill
Cunningham could be described as an author of a
profound picture scroll depicting the history of fashion,
then she is a vivid photographer chronicling an equally
vivid time, a smiling warrior fighting at the forefront of
contemporary fashion. I'm sure she has had more than
her fair share of trials while traveling the world alone, but
Rei is never one to complain; she only talks joyfully of the
latest street fashion, always with that bubbly smile that
illuminates everyone around her.

Contained within these pages are serendipitous
encounters and scintillating moments shared between
Rei Shito and the people she has photographed around
the world, and the glimpses into their lives that their
fashion styles offer.

This book is a precious accumulation of her records.

Toshiko Nakashima
After graduating from university, Toshiko Nakashima worked for Recruit before
joining Magazine House, one of Japan's premier fashion and lifestyle publishing
companies. She covered art and fashion at *Brutus* for about seven years before
joining the editorial division of *Tarzan*. She also developed a passion for martial
arts and began studying karate; she is now a Nidan. She worked on a variety of
features on street cultures to fashion as the deputy editor at *Relax*. In 2011, she
became the Editor-in-Chief of *Ginza*, overseeing its rebranding into a highly original
publication that fuses fashion and culture. In 2018, she left the company to become
independent and currently works as a freelance producer and editor.

Rei Shito

Photographer

Rei Shito is a renowned Japanese street-style photographer and journalist. Born and raised in Ishikawa prefecture, Shito graduated from Waseda University. Weaving together photos and words to capture the unique appeal of her subjects, her signature style has captivated many fans in Japan and beyond. With her experience as a street-style photographer under her belt, she currently works in various fields including TV and radio, as well as writing and hosting lectures and fashion seminars.

Instagram:@reishito

P4

ファッションは一つの哲学である。これは私がストリートフォトグラファー・ジャーナリストとして世界中を撮っていて感じた事の一つです。ストリートファッションに向き合う過程を通じて、私は人生における大事なこと(生き方における哲学のようなもの)を学んできました。一つは、ファッションには正解はない。ということ。誰が何を、いつ、どのように、どういう風に着てたとしても、そこに正解も間違いもないし、良いも悪いもない。ジャッジの基準はあくまで「自分が好きか、そうではないか」。この基準はあくまでパーソナルなものであって、他人にそれを押しつけるものではない、というリベラルなものである、ということ。たとえ人と趣味嗜好が違ってても「でも私はこれが好き!」って思うなら、それを貫くのが一番だということ。他の人の意見はあくまでその人の意見でしかないから、自分の着る服を決めるイニシアチブは自分が持つのが一番だ、ということ。イニシアチブが自分にある、ということが自覚できると「生き方」は180度変わります。受け身の消極的な生き方から、能動的かつ、ポジティブな生き方へと。ファッションは、あなたの生き方を変える「力」になる。もう一つは、ファッションを極めることは、自己肯定につながると同時に、他者への寛容をうながすものだということです。外見に気を付けることは、自分自身を労ることでもあると思います。そして、自分自身を労ることは、自分へ愛情を向けることであり自分へのケアであると言えます。自己愛や自己ケアを自分自身に施すことは、自ずから自己肯定につながって、人は自分に対して自身が持つようになるし同時に自分に自信が出るとゆとりがもてて、他者にも優しくできるから。とかく他者との比較で、もしくは表面的なものとして語られがちなファッションですが本質はというと、自分自身を肯定した理想的な生き方のきっかけになるものであり、つまり自分自身を見つめるものであり、それは一つの哲学といえるのではないかな、と。これが、私にとってファッションの『本質』です。ジャーナリストは、「真実を切り取り、伝える」ということが大原則にあります。この本では、大先輩であるビル(カニンガム)や、私をこの世界に導いてくれた青木正一(ストリート編集部)のスタンスをそのまま引き継いだ形で、総ての写真は撮られています。つまり、美しい写真を撮ることや、クールな瞬間を切り取るのが目的なのではなくて、リアルなファッションの「そのまま」を切り取ることをスタンスとし、ポリシーとしています。エディトリアルされたファンタジーの世界のファッションではなく、市井のリアルなスタイルやファッションは、自身のファッションをもう一歩先に進めるにおいての、今すぐにでも取り入れやすいコツやヒントに溢れています。「何を着るか、ではなくどう着るか」のノウハウを、今回は系統立ててご紹介もしています。この本が、手に取ってくれているあなたの毎日を、豊かに心地よく、笑って楽しく過ごす一つのきっかけになりますように。Enjoy Fashion!

P10

東京的スタイリング。手前味噌ながらすいません、世界中でストリートを撮っているなかで、やはり市井におけるファッションにおいて、東京は頭一つ抜けているな、と思います。色合わせや、素材の合わせ方、異なったテイストのミクスチャー、ディテールにおけるこだわり等など。東京的スタイリングとは? いくつかの要素をひもといてみたいと思います。

P11

ベニちゃん。見事にきれいな謙譲語を使う女の子。謙虚で、相対する人に対して総じてみんなに丁寧な彼女には「アーティストになる」という目標があってそれに向かってもがいている最中。いい事、そうでない事が波のようにやってくるし根拠のない自信や漲(みなぎ)るエネルギーは急に心から湧き上がり、そうかと思えば急に不安も襲ってくる。彼女を手放しで応援したくなるのは、時折キューッって抱きしめたくなるのは夢に向かって真っすぐに立ち向かっているところ。しっかり苦しんでいるところ、でも諦めないでいるところ。尊くて、美しい。そしてかっこいいこの街の女の子。

P12

ビックシルエットのセットアップ、そしてシャツ。注目すべきはベルト、その使い方。ベルトホールを完全無視して、好きな位置でウエストを絞るその方法は服をどう着るかは着る側の自由だってことを、服を着る際のイニシアチブの持ち主は自分自身だってことを改めて教えてくれる。「何を着るか、ではなくどう着るか」、その「どう」の部分が軽やかで自由な着こなしはいつも私を感動させる。

P13

原宿の奥にあるランジェリーショップ、il felinoの菜月ちゃん。彼女が愛するランジェリーの魅力を今の時代に即したやり方でクールに、なおかつセンシュアルに発信してる。撮影のあと、立ち話をしていて感じたのは、会話のキャッチボールがとにかく絶妙。間の取り方、選ぶ言葉、うなずき方や話す内容に知性の一端を垣間見る。彼女はコミュニケーションのスタンスとして「寄り添う」形の人だと思う。

「初めての転職です」って井上さんは話し出す。穏やかな口調、物腰のやわらかさ、彼の人との距離の取り方は近すぎず遠すぎず「ちょうどいい」距離感を微調整しながら話す人。曰く長い間続けていたファッションの仕事を離れ新しいチャレンジをするという。彼の次の場所はスポーツの業界。「自分がパーソナルトレーニングに通ってるときに気が付いたんです。トレーナーって、究極の接客だなって。僕多分、接客がすごい好きなんです。それを極めるためにインストラクターになろうって決めて。今まではファッションで人が変わる瞬間に立ち会ってて、それが僕の生きがいだったんですけど今度からは、体づくりで人の変わる瞬間に立ち会えたら、って。インストラクターになるために、今は毎日勉強中です。久しぶりに教科書開いて勉強してるんですよ、学生ぶりかも! 大変だけど、うん、楽しいです」向上しようとしている人は美しい。チャレンジし続ける、学び続けるその姿勢。

P14

青山、コムデギャルソンの前はお気に入りの撮影場所。小さな神社が隣にあって、時々にお参りをする人が立ち寄る。彼らはとってもカジュアルに、まるでテイクアウトのコーヒーでも買いにいく位のカジュアルに鳥居をくぐりお参りする。ここ青山における住人を見るにつけ私は日本の持つ、本質的な丁寧に感じ入ったりしてしまう。さて、青山のこの場所は、いい意味で「違和感」に囲まれている。モードと、伝統。沢山の海外からの観光客の人たちと、昔ながらの住人。つつしみ深さとアヴァンギャルド。変わりつつある街並みと、(おそらく多分)時代を凌駕して残るであろうこの神社。

P16

原宿通りに新しく古着屋さんが出来た。PIN NAPって名前の店でもうちはとても心をくすぐる古着屋さん。オーナーのボブさん。多分あたしは彼のファッションの経験値が、好きなのだと思う。何かを始める時はいつでも躊躇をしてしまいがちだ。例えば自信がなかったり、それにタイミングが悪そうだったり、そうそう、準備が整ってなかったりだったり、色々デメリットがわいてくる。そんな時に何かを始めなかった時のデメリットをその時考える。未来に「こんなはずじゃなかった」や「やっとけばよかった」ってとんでもないダサい後悔をする。そうだ、まず今現在、けじめのつかない自分自身に嫌気がさす。一番怖いのは、自分自身の成長がこれで止まる。始め

P17

原宿にある古着屋さん、S△NK△KUで働く彼女。ヴィンテージのスカーフをアレンジして巻いてトップスにして。しっかりひいた赤い口紅とバギーパンツ。さながら昔の映画の女優さんみたいなスタイル。古い映画や本や音楽で得たスタイルに、すぐに果敢にチャレンジしてるってその姿や気持ち。私はとても愛しく思う。いろんなスタイルにあこがれ、真似してトライして。そのトライ&エラーの連続が自分自身のオリジナリティを形作っていくのだ。

P18

赤色のリップにイヤリング。背筋をすらり、しとやかに歩く女の子。「クラシックバレエを8年やってたから、ですかねぇ。ありがとうございます」歩き方の美しさを伝えると赤色のくちびるはそう小さく動く、しっとりと。仙台からきたという彼女は最近進路がやっと決まった、と。「AO入試だったんですけど、東京の大学の建築学科に進路が決まって」。しっとりとした見た目とその学科のギャップは、ある意味彼女らしいのかもしれない、とも思ったり。ミステリアス、というのは自分の中の様々な引き出しがあるということを想起させる事でもあるから。撮影のあと、少し話してサヨナラをする。彼女はきれいな背筋でもってまた青山に向かって歩き出す。

P19

もちうる自分自身のすべてを使って、ファッションにおけるパッションを表現している人たちを心の底から尊敬している。

ふゆりちゃん。彼女も会う度撮らせてもらう人。「レイさん、私将来、いつか大切な人がみんな集える場所をつくりたいんですよね。サロンというかお店というか」。撮影中てくてく歩きながら、彼女はそう話してくれた。

P20

「トム・ブラウンで、なくてはならない」ファッションにおける美学なるものが彼の中には確固たるパーセンテージを占めていて。美しい体躯と、なによりも「上から釣り糸かなにかで持ち上げられているような」立ち姿は見ているあたしの気持ちと背筋をシャッキリ、と正す。ファッションは立ち振る舞いに変化を及ぼす。立ち振る舞いの変化は毎日のささいな行動に変化をもたらす。ファッションが好きだな、知りたいなっていうその好奇心(向上心)は、毎日を変える。少なくともあたしの場合、人生の経験で得たいくつかの確認のある事実はここに帰着する。(行動の変化と同時にマインドを今一度彫り深め、考察をもたらす。「外面を磨くことの意味および意義」が再定義される)行動が変わると、習慣が変わる。習慣が変わると、生き方が変わる。生き方が変わると、人生が変わる。ファッションは、人生を変える。

モデルの二人組。男子二人で原宿をぶらぶら、お店をみたり、知り合いに挨拶にいったり。Berberjinは毎回立ち寄ってしまうお店らしく。出てきたところをパチリ。

P21

ギャルソンのジャケット、アンチの軍パン、渋谷の雑居ビル、7階。初流乃というお店を営む彼はファッションで自らの「思想」をしっかり表す、臆さず真面目に表現をする。骨太で、そして誠実で。ポッセ(曰く、彼の仲間達のことだ)を大事にする人だった。古風で、この人はちょっと素敵だ。

P22

モデルのチアキ。彼女は会うたびだんだんに、逞しい人

になっている。それは愛する子どもを守りぬく、という母親としての自覚であったりインディペンデントで仕事をしている自負であったり色々な要因が彼女を逞しく、美しくさせてるのだと思う。これはミハラヤスヒロのショーの後。モデル仕事が終わってすぐあと。「早く戻って子どもをピックアップしなきゃ!」って言ってポーズを決めるやニーハイブーツで猛ダッシュ。

P23
透明感のある男の子。21歳、フリーターの彼。将来やりたい事の欄は空白で。「わかんないっす」って笑ってるような、ちょっと困ってるようなそんな言い方で答えてた。彼と同じ年だった時あたしは、何を考えてたのかな、とふと考える。未来が希望でキラキラして見えたと同時に先の分からない束縛さ、深い深い井戸を覗く時みたいな不安もあった事を今思い出した。先の分からない不安が消えたのは一体いつ頃だっただろう。やりたい事を見つけて、そこに向かって走り出して。前だけみて進んでいたら、あたしは、あたしの中の井戸のある場所をすっかり解らなくなってしまっていた。

P24
久々にシェンちゃんに会う。彼女は今、海外で活躍する女優さんになるという新しい目標があって、実現に向け、そこから逆算をし今やるべきことをチャレンジしている。それは演技であったり、語学(中国語)であったり。「レイちゃん、演技ってすごい面白いの。自分自身と向き合う感じ! 見たくない自分を、心のフタを空けて見つめるっていうか、えぐる? 作業というか。」「最近、めっちゃ頑張ってる」ってキッパリと言う。そのキッパリのあまりの清々しさはちょっとまぶしくて、うん、気持ちよくうらやましい。

P25
原宿の交差点。梅雨の始まりに撮らせてもらった彼女。原宿、この街の魅力は(少なくともファッションに関して)「誰が、何を、いつ、どのように、どんなスタンスを持って着るか」そういったTPO的な文脈を一切合切飛び越えてファッションを自分が好きなように謳歌できる所、なのだとおもう。

スキンヘッドに赤い口紅、両腕のタトゥー、繊細な手首。確かスタイリストをしてるって言ってた。

P26
Banal Chic Bizarreのショー会場。このブランドを通じてしりあった5人。住んでる所も職業もバラバラ、「バナル」という共通項が5人を強く結びつけた。ファッションを一緒に楽しめる仲間がいる。熱く語って刺激し合って。それってすごい幸せな事。

P27
渋谷の新しくできた古着屋さん、BOYのトミー。いつかは古着屋さんやりたいって言ってたけどいつかがこんな早くに来るなんて! おめでとう、トミー。できたてホヤホヤのお店で撮らせてもらった一枚。

P28
原宿にいたら偶然SITAに会う。(一瞬誰だかわからなかった!)好きなものを好きな風に好きな時に着る。それは勿論自分のために。誰かに評価されるためじゃなく。誰が何を言おうとも「これが素敵だ、かっこいいと思う」を自分の言葉で責任で、断言できる気持ちの強さがファッションなのだ。ファッションは自分で自分を肯定するための道具でもある。

P29
美容師の彼。まっ青な髪は丁度昨日染めたばかりだと言ってた。将来やりたい事の欄。「信頼される美容師に

なる」って。

P30
竹下通りと明治通りの交差点。白い星マークをモチーフにしたオニツカタイガーのワンピース、ヒョウ柄バックとヒョウ柄ブーツ、トラの大判ストールとネコ科(わりと強め系)つながりでの組み合わせ。

「次は世界のモードの王道に挑戦しに行く」と明言してるFACETASMの落合さんはミラノでショーをやった時感じた事を話してくれて。「今なんかファッション日本ブームとか言ってるじゃん? 日本デザイナーが注目されてたりファッショニスタでも日本びいきな人多いし、とか。でもミラノで気づいたんだけどさ、多分それは本当に一部の人だけ(のブーム)の話で日本のイメージで言えばいまだに「芸者! 富士山!」みたいなもんなんだなぁ。極東で何が行われてるなんか、どんなデザイナーかなんてほぼ知らないっていうのがすごく良く分かった、自分も含めて。」実際現場を踏んだ人しか、ショーという舞台を体験した人でしかわからないリアルな言葉。私が思っていたものをまたそれは違って聞いていて面白い。落合さん曰く「完全アウェイ」のその状況だから余計に兆戦心をくすぐられるのだろう。FACETASMの挑戦が今から始まる。「腹くくんなきゃね」って彼はそう言う。

P31
「じゃあ外苑前で!」と、待ち合わせをしてあったツインズはおそろいのキャッツアイのサングラス、(ちなみにサングラスの奥の瞳に丁寧に引いたアイラインも目尻がピョンとキャッツアイだ)鼻にかかった声、その極まりない頼りなさはとても愛しさを喚起するもので。「子猫のような可愛らしさ」というのは正にまさしく二人の事だ、と心の中で首肯する。なんとなく、撮らせてもらいながら話しながら感じたのは「AMI AYAちゃん」と聞いて誰もが思い浮かべるイメージは二人を温かく優しく守り、確立させていると同時に彼女たちを、今この段階で「もがかせている」のだろうな、と。なんというか、「踊り場」にいる人ってやっぱりちょっと独特な空気がある。(それが、もしもわれわれ魅力でもあったりもするのだけれど)二人にもそれを感じたり。たぶんこれは、AMI AYAちゃんの2回目の「孵化前」の写真たち。

P33
「何を着るかではなく、どう着るか」これは私がストリートファッション一番大事にしている考え方です。「どう」の部分、その工夫の仕方や思ってもみないアイデアで着こなしている人を見ると、心の底から感動してしまいます。「どう」の部分こそが「センス」と呼ばれるモノだと私はおもうけど、センスって先天的な要素も勿論関係はあるとは思うのだけど(天才的におしゃれな人というのは少なからず存在する)、ある程度、センスはテクニックでカバーできるんです。ここではその「センス」の部分のテクニックをご紹介します。

P34
見立て
日本には「見立て」という文化があります。例えば枯山水。日本庭園では、砂で「海」を表したり、砂に線を描いて「波」を表現してみたり、岩を「山」に見立てて自然の景色を表現したりしています。こんな風に日本人は古くから「見立て」というものを暮らしの中に取り入れてきました。ファッションもしかり、例えばニットセーターをマフラーに、ジャケットをシャツとして、コートをワンピースに、スカートをワンピースに「見立て」てスタイリングをしてみる、ということ。よく考えたらマフラーもコートもスカートも元を正せば単に一枚の布でしかないんですよね。洋服を機能や用法を外して単なる「布」としてとら

えると、ファッションはもっともっと幅が広がって楽しめるんじゃないかなって思います。

P35
彼女は子供サイズのバーバリーのコートをワンピースとして見立てて着る。子供が着たら普通に膝下丈のコートだけど、彼女が着ることでミニワンピになって、袖も7分丈になってる。その丈感の絶妙さといったら!

P36
フィッシャーマンセーターをマフラーに見立ててスタイリング。冬のアイテムを夏の時期にも使っちゃう、その季節感の「ズレ」を楽しんでる所も自由で素敵だな、と。

P37
これもニットをストールに見立ててふんわり身体を覆ってる。「見立て」の着方はおおいに玄人感が醸し出されるので、色味は彼女のように同系色で控えめにすると取り入れやすいかと。

彼女もニットをマフラーに見立てて首元にグルりと。首元にボリューム感があるので小顔効果も期待できる着こなし。

これもニットをマフラー風に。結び目の位置がポイント。

ボリュームがあるファーのコートをカーディガンにお見立ててプロデューサー巻きに。袖のが長さが足りない分は、手で持つことで補って! コートの新しい活用の仕方。

P38
下着のコルセットをブラトップに見立ててて着こなし。「機能や用法を外して単なる「布」としてとらえる」その自由さ、発想の柔軟さが存分に発揮された着こなし!

迷彩のアーミージャケットをシャツと見立てた着こなし。結果ジャケット・オン・ジャケットと同じアイテムを重ね着するという面白いレイヤードになっている。下に着たジャケットの裾の出し方もポイント。ジャケットをシャツとして見立てた着こなし。

ジャケットをパンツにインする着こなしで一気に上級者感! まさに「何を着るか、ではなくどう着るか」。

P39
パジャマをセットアップとして見立てた着こなし2選。寝間着まで、おめかし着として使っちゃえると、クローゼットにあるお洋服の着こなしのバリエーションは、もっともっと広がります。なんだかそう考えるとワクワクしますね!

P40
はずし
お洒落する場合「おぬし、やるな…!」とか衆人に刮目されるテクニックとして「はずし」もしくは「ずらし」というものがあります。つまり異なる要素だったりをあえて混在させることにより、「既視感はあるんだけれど違和感も感じる」スタイルを作ることができるんです。個々でのポイントは「違和感」のさじ加減。(奇をてらったドヤッとした違和感は「なんだかトリッキーな方ね…」になってしまうので注意)「しれっとした違和感」がお洒落における「上級者感」を喚起するんです。さて具体的に見ていきましょう。

①アイテム
一つだけテイストだったり、色あいのマッチングに違和感がでてしまうアイテムを投入すると、とたんに「はずし」、

「ずらし」が完成します。これとこれって合うかな？ 合わないかな？って考える前に、これとこれって組み合わせたことあるかな（やったことあるかな）？って考えてみる。組み合わせたことがなかったとしたら、秒の早さでレッツトライ！ 合う合わないは考えないでも全く全っ然大丈夫。だってそもそも「あわせ」ないことが「はずし」もしくは「ずらし」におけるコツだから！

②テイスト
モード、スポーツ、ガーリー、エレガント…。ファッションは色んなジャンルにカテゴライズされています。一つのカテゴライズのアイテム同士でまとめると、そつのない無難なスタイリングになるけれど、playfulなスタイルをしたいときはあえて違うジャンル同士をミックスするのが肝要です。これも合う合わないとか考えないでもムニャムニャ…（同じ話だから割愛ね！）

③バランス
あえて「（身体が）綺麗に見える」バランスを崩してみる。ちょっと大きめなアイテム、逆に寸足らずなアイテムをあえてチョイスしたり。服を着るときはとかく「自分自身（の身体）」が綺麗に見える、つまりプロポーションが綺麗に見えるシルエット」にこだわりがちですが（それってある意味呪縛でしかない）、そこから解き放たれることができると、ファッションはよりPlayfulになるかなって思います。

P41
紳士のトラッドな背広スタイルをニューヨークヤンキースのベースボールキャップで軽妙に「はずし」て。シャツとタイとキャップの色を合わせているのがポイント。

この、自分の趣味を投影しちゃったスタイル（おそらくヤンキースのファンであろう）は、チャーミングさを感じさせます。かわいいおじさん。

P42
クラシカルなセットアップとコートに、こちらはストリート感あふれるキャップとTシャツのアイテムを投入することで、テイストを「ずらし」た着こなしに。

ラグジュアリーなジャケットに白のキャップを投入することで全体的な抜け感が出て、ラグジュアリーなテイストから少し「はずし」たスタイルに。

P43
この2人は足元に注目！ 左はチェックのスカートを基調としたスタイル（もうこれだけで完成しているとも言えるスタイリング）に、合えてもう一発レオパードタイツを追加、右の彼女はピンクを基調としたストライプジャケットが効いた完成度の高いスタイルにあえての網タイツの追加。これによりこの完成されたスタイリングに人さじの違和感をトッピングしています。料理で言う追鰹、追マヨみたいなものでしょうか。所謂「追タイツ」！

こちら2人はニットキャップのアイテムで外してる。左の彼女は緑のキャップでかっちりしたスタイルをカジュアルに「はずし」、右の彼女は首から下のモードテイストなスタイルに紺×赤のボーダーのニットキャップで「色」と「テイスト」において「違和感」を感じさせている、「はずし」の上級者！ 全体的に柄がおおい組み合わせですが、上手くまとめているところが巧者。

P44
コチラはスポーツテイストなスタイルに、モードなヒールで足元で「はずし」を。

カジュアルなスエットにモードなフリンジスカートとテイストを「ずらし」多岐こなし。

スポーツテイストなインナーに、ボリューム感＆ラグジュアリー感があるファーコートで「ずらし」。

P45
カジュアル＆スポーティなスエットにあわせたのはラグジュアリーなシャネルのツイード。合わせるテイストのイメージに開きがあればあるほど「ずらし」レベルは上がっていきます。

こちらもスポーティなフーディにレディライクなフリルのついたロングスカートで「ずらし」てる。

スポーツテイストに、ちょっと野暮ったいおじさんテイストを投入することで全体に違和感を感じさせる着こなし。このあえての野暮ったさがキモ！

清楚なイメージのコットン調のワンピースを「はずす」際に選んだアイテムは、オラオラ感（強めなモード感）あふれる蛇柄ブーツ。一筋縄ではいかない巧者。

P46
着こなしにおいて、スマートにまとめるのがキレイなファッションの定石ですが、それは知りつつ、あえてのやりすぎトゥーマッチなスタイルに仕上げる。ファッションを遊び尽くしたプロの「はずし」方、7選。

トゥーマッチなバランス感でのずらし。あえて大きすぎるジャケットと、ミニマムなバイシクルショーツのコントラストがポイント。

ボリュームのあるロングコートの上に、さらにボリュームを持たせたファーのロングコート。このトゥーマッチなボリューム感がはずしになってる。

ダウンベストに注目。このアリなんだかナシなんだか判断つきかねるバランス感が絶妙なはずしになってる。

オールチェックのクレイジーパターン。このチェック・オン・チェック・オン・チェック・オン（以下省略）の「やり過ぎですがな感」が上級者風はずしになっている。

P47
柄オン柄の賑々（にぎにぎ）しさに輪をかけて、何層も巻き付けた布のレイヤードが生み出す独特のシルエットのトゥーマッチ感というはずし。

チェック、しましま、パッチワーク、柄の洪水のトゥーマッチ感！ 上級者!!

なんだかベルト2個も巻いてるし（しかも長過ぎだし）、パンツもなんだか長すぎるし、ウエストにあしらったアクセサリーもなんだかでかいし、、、アイテムの大きさをトゥーマッチにしあげたスタイル。

P48
露出
女子における露出における概念ほど、日本と海外の違いを感じるコンテンツはないなって私は思ってます。源氏物語から、童話の鶴の恩返し、谷崎潤一郎に出てくる女性像まで、日本の女性は「隠す」ことに重きをいているんです。「露出」なのに「隠す」?? 一見矛盾しているかのように聞こえますが、みなさんティーンエイジャーの時代を思い出してください。タバコやお酒を禁止されたらされるほど興味津々になってしまう、「見ちゃダメだよ」っていわれると途端に何故か見たくなる。こういった禁止されるほどやってみたくなる心理現象のことを「カ

リギュラ効果」というのですが、日本女性における露出の本質はズバリ「カリギュラ」！ また、とかく日本の女性はおおよそにおいて「恥じらう」ことが美徳とされてきた文化背景もありまして、「ドヤドヤヤ！ 私の魅力をみろみろみろ」ってアピールは品位にかけて、むしろ興ざめ、野暮な態度にうつりかねない。と、そういう文化背景の中育まれた露出はチラリズム。つまり「（図らずも）見えてしまった」という体（てい）で見せる露出方法です。ある意味エロスの極みとも言えるこの露出ですが、「無意識下である」という強烈至極なオブラートによって露出を品良くさせている。一方海外における露出は「見せる」方向が多いなという印象です。つまり「これが私の魅力です」とスパッと堂々と衒（てら）いの「て」の字もなく見せる。こういう「あっけらかんさ」がたとえ露出が過度に多度であっても「あっけらかん」という、小賢しい計算皆無の「素でやってる感じ」がヘルシーさにつながって、爽やかな露出につながっている。ということで女子の露出に関して、いの一番に大事なのは、「スタンスを決めること」！ つまり①見えた（見えてしまった）でいくのか（ばっくりいえばたおやかな女性像）②見せたでいくのか。（ばっくりでいうとパワフルな女性像）なりたい女性像を思い描いて、果たして自分はどのスタンスで行くべきかをチョイスしファッションを楽しんでもらえたらと思います。まず重要は自分自身が「どうありたいか」。ファッションは「自己」表現、自分自身に問いかけ、潜在的な望みをみつけていくことから、ファッションは、そして人生は始まるのだと思います。

P49
このブラが脇から見えちゃっているチラリズム最高！

P50
こちらのブラはチラリズム。腕を動かす毎にチラリとみえるブラの露出に目が離せない。

こちらのブラは「見るなら見ろ！」露出。髪型をオールバックにマニッシュにまとめている、そのツンデレ感もポイント。

こちらのブラは「見るなら見ろ！」なスタンスの露出。堂々としているのがポイント。

P51
透け感というのも露出を語るにおいて欠かせないコンテンツです。ということでここではレース3選。「見えそうで見えない、とはいえ見えなさそうで見えそうな」その事がカリギュラ効果を生み出し、我々は自然とチラリと目が向いてしまうのです。目が向く＝魅力的な証。効果的にカリギュラを、そして透け感を使っていきましょう！

P52
手持ちの服でも効果的な露出は出来る！ ここでは着こなしのご紹介です。その名も「片肩はずし」！ なんだか柔道の技みたいな名前になっていますが……。ズバリポイントは肩！ こんな風に片肩をあえて外した着こなしは、一気にお洒落レベルを上げてくれます。これぞ「何をきるか、ではなくどう着るか」。

P53
ボリューム多めに片肩外しをするとリラックスした雰囲気が出てきます。

ジャケットをパンツにイン、かつ片肩外しのダブルテクニックを用いた着こなし。上級者！

P54
脚を開くとわりとパッサー！と切り込みの入ったスカート達。歩く度にチラチラのぞく脚のチラリズムがたまり

ません。

フリンジから垣間見える太もものこのチラリズム！

P55
胸元パッカーン！「見るなら見ろ！」の露出。やはり堂々感が「見せる露出」におけるポイント。

背中パッカーンご開帳！出すならチマチマださずにガッツリいっちゃいましょう！

胸元の開き方、そしてパンツの透け感。露出におけるダブルコンボなテクニックのきこなしだけど、堂々＆サバサバしているのでヘルシーに見えます。

P56
レイヤード
平安時代の十二一重の時代から、日本人はファッションとして「レイヤード」「重ね」がカルチャーとして根付いています。和装においては重ね着をしたときの襟元の色合わせなんかに妙味を見いだすカルチャーがあったり（源氏物語の時代においては十二一重がマックスお洒落の最高潮スタイルだったのもそういったことが理由です）。レイヤードってわりと日本のお家芸。さてレイヤードのコツはズバリ丈！大まかにいって①袖、②裾の2点をつかんでおけばある程度なんとかなります。ポイントはズバリ「上は短く下長く」。一番上に着るものの丈感を短めに、その下に着るものの丈感をそれよりも長目にしておくと「レイヤードしてる感」は簡単に作れる！ロシアのお土産といえばマトリョーシカ。あれは表面の人形が一番大きくて、開くにつれて段々小さくなっていきますが、その逆張りだと思ってもらえたら！

P57
袖に注目！インナーの袖をコートの袖からあえて長目に出してレイヤード感を表現、かつコートの上にベージュのポンチョ型コートを重ねてコート・オン・コート。重ね着において「同じアイテムを重ねる」というのはテクニックとして是非覚えておきたいところ。一気に玄人感が出ます！レイヤード、かつロングスカートでボリューム感がある重めなシルエットになっている分、首元のスカーフと足元のブーツを白色にすることで抜け感を出しています。

P58
コート・オン・コート。これも「上は短く下長く」のセオリーに則って。

こちらのムッシュもコート・オン・コート。ベージュのコートもチェックのコートもベーシックアイテムなのに、「上は短く下長く」のセオリーに従って着ると、お洒落レベルが一段上がって見えます。

P59
ファーのコートの上にミニタリージャケット。前身ごろの部分を多めにはだけることで重ね着感をより強調しています。

ツイードのジャケットの上にミニタリーのキルトのライナー。ライナーという元々はインナーとして着ていたものをアウターに用いるのも、既存の価値観や常識の転換が見られて面白い。

「上は短く下長く」のセオリー＆「同じアイテムレイヤード」のダブルテクニック。一番上のトップスが短くボリュームがある分スタイルがよく見えます。

P60
こちらもグレーのフレアスカートの上にレースのスカートを合わせて。これも「上は短く下長く」のセオリーが効いています。

シャツワンピースの上に透け感のある巻きスカートを合わせた、ボトムスにおける「スカート・オン・スカート」のレイヤードスタイル。

P61
薄手の花柄スカート、花柄のシャツ、ジャケットは張りのある素材、おまけにふわふわのファーベスト。沢山の色、柄、素材を重ねて情報量が多いスタイルなのですが、絶妙なサイズ＆カラー・バランスでまとめています。

パーカーのスエットの上に、タートルネックのスエットのレイヤード。特筆すべきは首元のボリューム感！見たことありそうでない着こなし方法。

細身のパンツの上にチェックのスカートを合わせて。大きめの柄物バック、ポンチョのボリューム感ともあいまって、情報量がおおいけれどバランス良くまとめています。

コットンのドレープの沢山あしらわれたワンピース、ニットのコート、そして手にもったファーコートと、レイヤードをするときは素材感を散らすと重ね着に奥行きが出ます。

P62
禅的ミニマリズム
禅的精神といえば、ミニマリズム。瞑想、断捨離、シンプルな暮らし。いらないモノをそぎ取って大事なモノだけ残しましょう的な精神はまことに日本的とも言えます。さて、ファッションにおいてもミニマリズムはありますが、ここで紹介するのはfun!ミニマリズム。ミニマムなんだけど楽しさがあるスタイルをいくつか紹介します。

P63
シルエットもサイズ感も自分の身体にフィットしたジャストサイズ。アイテムも必要最低限のものだけにそぎ落としたミニマムスタイルですが、ヴィヴィッドな色使いでもって遊び心があるミニマムスタイルになっています。ミニマムスタイルはシルエットがシンプルな分、ストイック（場合によってはつまらない）な印象になりがちだからこそ、色使いに「fun!」さ表現するととたんにシンプルなんだけど印象的な着こなしになります。ミニマリズムなスタイルはごまかしが聞かない分、自分自身の似合う色やシルエットをよく知る事が大事。ミニマリズムに向き合うことは自分自身に向き合うこと。

P64
モノトーンな着こなし7選
ミニマムなスタイルといえば当然モノトーン、それは定石で外せません（知ってる）。というわけでおすすめモノトーンミニマムもご紹介します、7選！

モノトーンだけど、シルエットをガーリーなフレアのミニスカートにすることで、シンプルなんだけどラブリーなスタイルに。

モノトーンと色を省いたスタイルだけに、肝要になるのはシルエット。タイトなトップスにボトムスの微妙なボリューム感がポイント。パンツのシルエットの美しさを最大限に活かしたスタイル。

アシンメトリーな簾のようなスカートは。動く毎にフサフサ揺れるその点がチャームポイント。最大限にそれを活かすには色調はモノトーンでミニマムにまとめて。

ニットやファー、コットンなど異素材のハイブリッドで黒という色の奥行きを表現したスタイリング。

P65
張りのある素材でのミニマリズムスタイルは、自然と背筋が凛と伸びます。着るものは、自分の心にも影響を与えてくれます。

リラックス感があるミニマムスタイルに大事なのは素材感。彼女のような柔らかさのある素材を選ぶと良いかと。

モノトーンの着こなしといえばケイト・ラインフィア。彼女のモノトーンの着こなしはいつもパンチが効いてる。

P66
アイテムは総てベーシックなのに合わせる色合いで一つ格上のベーシックに。

ミニマムスタイルを語るにおいて、シルエットのバランスは取っても重要！彼女のサイズ感はとても参考になります。

素材感を合わせる、というのもミニマムスタイルに大事なこと。やわらかで薄手の素材のトップスには、同様に薄手のパンツで。

やっぱりミニマムスタイルに「fun!」をいれるのは色味というのは絶対切っても切り離せない！

P67
Brune Buonomano's style
ミニマリズムスタイルの女王といえば彼女、ブルネfromマスターマインドマガジン！アイテムそれぞれはベーシックなのに、レンズを向けないではいられない理由は秀逸なサイズのチョイスと、シルエットにおけるバランスの取り方。

P68
Small Stories #1
Chitose Abe
Designer of sacai

―デザイナーとして、クリエイションはどういうものからインスピレーションを受けていますか？

レディース、メンズ、プレシーズンと一年を通して多くの服を作っているので、その為に旅行したり映画を観て、インスピレーションを受けるということはありません。刺激を受けているとしたら、もっと身近で日常的にあるもの。海外に行く機会も多いので、そこで見た街や景色、出会った人などがクリエイションに影響していることはあるかもしれません。

―毎シーズンのテーマはどのように決めていますか？

私たちの仕事は洋服を作ることなので、直接的に大きな言葉で声高らかにメッセージを宣言し、こうあるべきだということはしていません。〈サカイ〉にとっては、シーズンテーマというのは夢のような話ではありません。「このテーマでいきましょう」と最初に固めて作るのではなく、私やスタッフが着たいもの、世の中の情勢、伝えたいメッセージのバランスが、混ざり合い最終的に完成します。もちろん女性なので素敵な服を作ろうという発想もありますが、これだけ世の中にたくさん洋服がある中、あの約10分間のランウェイで私たちは何ができるか、何を伝えられるかということも両方考えていきます。あとは自分が作るものに共感し、着てくださる方に自由に解釈してもらいたいと思っています。

―「日常の上に成り立つデザイン」をメインコンセプトに掲げていますが、立ち上げから21年が経った今もそれは変わっていませんか？

〈サカイ〉の服のベースは、生活の中で着られる服。生活というのも人によって異なるので、例えばある場面では〈サカイ〉の服を着ていたら目立つかもしれないけど、私は私が見ている世界や環境で日々を過ごす人々の生活に溶け込み、着られる服を作っていて、普段着、という意味での日常着を作っているわけではないです。そもそも洋服をアートだとは思っていなくて、洋服は洋服。ある人から見たら、「これはアートじゃないの？」と思うような服でも、実際の生活の中に私の服を着る場面のある人はいると思っていて、その差がとても大切だと思っています。世界中でいろいろな日常があるといいますが、私の中で、自分自身や私が目にする人々の生活に落とし込んだ上での「日常の上に成り立つデザイン」です。ですから、子供ができた21年前とは作るものも変わってきているとは思います。自分の日常が変わっているので、それが少しずつ変化しているだけで、〈サカイ〉のフィロソフィーは変わっていません。

―スタンダードな物にエレガントを加える、ベーシックなアイテムに捻りを加える、というのも阿部さんのクリエイションの核にあると思いますが、阿部さんが考えるエレガントとは何でしょう？

素材の気持ちよさやパターンの美しさ、着心地。全てにおいて完成度が高くないと、捻りを利かせた服はただのエキセントリックな服になってしまう。奇をてらったものになりがちな物を、奇抜になる一歩手前のギリギリのところで留めて、エレガンスを保った服に仕上げたいと思っています。〈サカイ〉の服は日常の中で着られるものに落とし込んでいると思いますし、これからもそうでありたいからです。その「奇抜」と「エレガンス」の線引きは私の感覚でしかなく、言語化が難しいのですが、ビジネスも同じ考えです。自分の中でここまでだったら格好いいだろうと思うところでバランスを見てやっています。そのバランスが、〈サカイ〉らしさかもしれません。

―クリエイションをする際に、トレンドは意識しますか？

意識しません。私はこの仕事を長年やっているのでたくさんの衝撃を見てきました。だから新しいものが出てきても、「どこかで見たことある」と感じ、あまり気になりません。ただこれだけ世界がグローバルに繋がっていて同じ世界に生きているので、「何となく今はリラックスしたいよね」や「もう少し攻めたいよね」という気持ちが揃うときはあると思います。そのムードが揃うことを否定はしませんし、そうしないと洋服は売れないと思っています。それはあくまでムードの話であって、アイテムであるべきではない。例えば今はこのシルエットのあのデザインが流行っているからと、その真似をしてしまったらブランドはダメになってしまう。表面上だけ変えたとしても、作り手にもお客さまにも分かってしまいます。流行に振り回されると、ブランドとしてはブレてしまうと思います。

―〈サカイ〉はさまざまなブランドとコラボレーションをされていますが、どういった観点で相手を決めているのでしょうか。またコラボレーションにおいて、大事にしている点を教えてください。

私が好きかどうか、やりたいかどうか。あとは〈サカイ〉にないものを持っている人がいたら、やってみたいと思います。もちろんすべてが受け身ではなくて、こちらからお願いすることもあります。大事にしていることは、両方の良さが出て、お客さまにもコラボレーションした相手にも、

イメージ的にも、ビジネスとしても満足してもらえること。イメージというのは、世間にインパクトを与えられるもの。高額すぎてあまり売れないものでも、イメージが良いものもあれば、イメージが良くたくさん売れるものもある。色んな意味で満足していただけるようにしたいと思っています。コラボレーション相手によって目的が違うので、よく話し合い、意図を理解し合えればクリエイションは任せてもらうことが多いです。

―東京をベースにしている阿部さんですが、阿部さんから見て東京のファッションと世界の都市との違いはありますか？

東京は、他の都市と比べて、様々な要素がよりミックスされている街だと捉えています。高級ブランドのバッグを持った方がファストフードに行ったり、300円で食事のできる飲食店の隣に、ラグジュアリーブランドのショップが軒を連ねている特異な街です。その意外性のあるものが融合している感覚は、日本の特徴であり面白さだと思います。あと日本は、トレンドの服に遊びや外しを効かせてスマートに着ている方が多いと感じます。外しすぎてはダメというバランスを重視する風潮もある。その点ではパリやNYと比べると、日本だけ違うかもしれません。

―東京のファッションは阿部さんのクリエイションに影響を及ぼしているのでしょうか？

海外の人は仕事が終わったら、一度家に向かうことが多いですけれど、日本人は電車に乗って会社に行き、その服でそのままディナーに行きます。それは日本の良さなので、〈サカイ〉を立ち上げた当初は、そのように一日を通して着れる服を作ろうと思っていました。ただし、最近は世界もどんどん変わってきていて、オンとオフがフラットになってきました。〈サカイ〉が初めて海外でプレゼンテーションを行った際、「なぜこの服が好評なのだろう」と疑問だったのですが、「あ、そういうことか」と納得しました。そういうところも含めて、やはり東京に住んでいるので少なからず影響を受けていて、きっと海外に住んでいたら、違う服を作っていたと思います。シンプルにリボンが付いたドレスも、東京へ向けると捻りたくなる。少し捻りがあるのが〈サカイ〉の良さでもあり、日本の良さなのかなと感じます。割と遊びや外しが効かない街は世界に多いけれど、日本はそういう遊びや捻りを受け入れてくれます。

―日本のモードを牽引し続ける阿部さんにとって、ファッションとは何でしょうか？

このようなこと言ったら怒られるかもしれませんが、洋服はなくてはならないものですが、ファッションは所詮ファッションなので、なくても困らないものです。人の命を教える訳でもないですし、今日着たら少し勇気が湧いた、一日幸せだったなど、人の気持ちを少し上げるくらいの影響しか与えられません。ただこの仕事をさせてもらっているからには、大事にしている部分はきちんとあります。ショートケーキは苺がないと寂しい。さらに私は中の苺も大事にしたい。ジャムではなく本物の苺がいい。表面上で真似ることはいくらでもできますが、そこはとても大事なことでお客さまにもきちんと伝わると思います。

―〈サカイ〉として、もしくは阿部さん自身が将来やりたいこと、トライしてみたいことがあれば聞かせてください。

やりたいことがあるというよりも、自分やブランドがどうなっていくのかが楽しみで仕方ないです。その楽しみに向かうために、今何をやるべきということを日々考えて

います。〈サカイ〉は本物ではあると信じていますが、まだ一流への途上だと思います。私にできないことをできている人がいると、「どうやっているんだろう」と気になって仕方がなくて、その景色や状況を見たくなってしまいます。「なるほど、私に足りなかったのはこれか」という試行錯誤をずっと続けています。そうやって一流になりたいと思っていますし、本物でありたいと思っています。大きな目標があるというよりも、日々起こる色々なことが楽しくて仕方がないので、色々なことが起きるように、そして自分自身もアップグレードできるように、毎日進化していきたいと思っています。

―最後に、阿部さんにとって〈サカイ〉とはずばり何でしょう？

私自身です。

阿部千登勢
1965年、岐阜県生まれ。数社でパタンナーや企画を担当した後、1997年に結婚、出産を機に退社。1999年に子育ての傍ら、5型のニットウェアを自宅の一室で発表するかたちで〈サカイ〉を立ち上げる。2006年にはメンズコレクションを発表。2009年からは発表の場をパリに移し、11年秋冬からショー形式でコレクション発表を続ける。〈サカイ〉立ち上げから21年が経った今もなお、世界のモード界を牽引し続ける、日本が誇るファッションデザイナーである。

P72
表参道ヒルズさんでやってる写真展のおかげであたしは藤原ヒロシさんを撮影することになり。（ここ最近、表参道ヒルズにまつわる幾人かの人たちに声をかけ、あたしはこの数週間撮り下ろしをしていたのだ）驚くほどヒロシさんは、なんていうか「そのまんま」だ。自分を誇示することもなければ謙遜するもなく、壁を作ることもなければ反対に立ち入ってくるでもなく、そのまんまの距離で、そのまんまに話をする。そのいい感じの距離感に、あたしは大好きだったあたしのおじいちゃんを思い出す。夕方、暇を持て余した小学生のあたしはリビングのテレビでお相撲を見る彼に近寄る。目があうと「いーちゃん、一緒に見るか」って相手してくれてあたしは彼のあぐらの上でゴロゴロする。（とはいえ子供の私は相撲なぞに興味がサッパリないので）5分くらいすると「ねぇ、つまらんからどっか行っていい？」っていう。「ほうか、気をつけるんやぞー」って、彼はまたクフクフとお相撲観戦に戻る。付かず離れずの、ちょっと面白い距離だったかと思う。こういうのは、ちょっと気持ちがいい。ヒロシさんは、「そのまんま」の人だ。

P73
銀座のドーバーストリートマーケットでイベントの後、「折角だから送って行きましょう」ってミスター・ドーバー（わたなべさん）は私を新橋まで連れてってくれる。銀座から新橋に向かう道は温かみのある夜のネオン。静かなトーンで話す彼の声は耳に心地いい。わりとプライベートなことまで話せてしまうのは、彼の人柄なのか、この街の、夜の雰囲気故なのか。「着きましたよ、ここがSL広場です。じゃあ、またね」と言って彼は銀座に戻ってく。泰然自若の空気と一緒に。

下北沢の美容師さん。今日は休みで原宿に。アンケートを書いてもらってる時に彼の働く街について、ぽつぽつ話を。「今シモキタは開発中で、なんていうか『らしく』なくなっちゃってるんですけどね〜。あの雑多な感じが良かったんですけど」って。いつまで経っても開かない踏切はなくなって待ち続けるそのストレスは消えたけれど駅前のクリーンさにはどこか違和感を覚えたりもしたり。

P74
アッシュなブルーのヘアスタイルに総スパンコール。しゅんくんは語彙だったり言葉の選び方が独特な人。私はそれを結構好きで言葉を紡ぐときにわりと参考にしてたりする。

P75
NOZOMI ISHIRUGOのショー会場。最近よく会うAlice Blackのデザイナーの彼。

P76
この街の「ファッションシーン」の真ん中にいる一人(特にストリートのシーンにおいて)Tokyodandy、Joeくん。「ぼく自分の八の字眉があんま気に入ってなくて。だから撮られる時、いつも眉間に力をいれるんだけど、それって少しでも眉をまっすぐにしたいからなんですよねー。だから何か『いつも機嫌悪い人』みたいな見え方になっちゃって」ってのんびりおっとりそう話す。

ミスター＆ミス・トーキョーポッパー＠お店の前で。変化の早いこの街で、こんなに長くお店を続けてお客様に愛されてるって、これはものすごく稀有なこと。時代を見る目、次の時代の空気を読み取る感覚。続ける才能は、日々のたえまない努力から。

P77
もうこの人のセンスには実際全くかなわない、と気持ちよく白旗あげちゃう人がいる。Blocの美容師さん。ファッションにおけるスタンスやスタイルにおいて彼女は、「トウキョウ」そのもの。バーバリーチェックにレオパード。柄×柄。実際最高だと思う。

P78
TWEEDRUNで撮らせてもらった紳士達。「ツイード」というドレスコードで紳士がそれぞれのおめかしをする。日常の中でのお洒落、ではなくてハレの席でのお洒落、いわゆるドレスアップ。あたしたちはお祭りだったり(特にハロウィン!)日常を離れた装いで歌舞くのが案外好きなそしてとことんまで積極的にのめり込む国民性だとあたしは思うのだけど、ツイードランでみる紳士の凝り様にもそれは通じるものがある。いつもは照れ屋な紳士達も今日はレンズをむけると堂々とポーズ。イエーイ。

切りっぱなしのザクザクとしたフリルをひるがえし歩く背中が颯爽として思わず追いかけて声をかけたのはあゆみちゃん。17歳の女の子。今自分のブランドをはじめたばかりだという。「パターンとかも、もっともっと拘ってやりたいんですけど、お金のこととかもあるから今はまだ」って言いながら、Billion(彼女のブランドだ)のサイトを見せてくれる。パッションだけで走っちゃった、すこぶる付きのフレッシュさがありつつも、(こういうの個人的にはすごいラブリーで大好き)同時に客観的な視点でもって、クールダウンさせ、抑えて表現しようとしているそれはまだ未完成だしラフなものだけど私をちょっとわくわくさせる。覚束ないし、確定も何もないかもだけど、不安と自信の両軸の行ったり来たりを繰り返しながら自分の将来を手探りで自分自身で切り開こうと努力する人を、私は心から、心の底から尊敬をする。

P79
原宿の脇道のその少しまた奥、美容室と美容室に挟まれた小道にある階段付近。ここは原宿キッズが自然と集まってくる場所。この日もなんとなく人がたまってて、あたしも一緒に缶コーヒーとか飲みながら、たわいもない話をしてたりした。幸せというのは、日々の何気ないこんな時間。些細な幸せを、一つ一つ丁寧に掬いとることができたなら、人生はきっとただしく豊かになる

んだと思う。

P80
伊勢丹×シトウレイコラボレーション。3つのバックと4つの靴をつくらせてもらって。実のところバックの中でも一番個性の強いアイテムがこのトライアングルバック。ユリアちゃんは、自分で自分の「今、着たい服」を選べる人。自分で自分のスタイルだったり、(パーソナルな)トレンドを生み出す力のある女の人。自分の中から沸き起こるクリエイションを、とても繊細にしてると思う。クセの強いアイテムだからこそサンプルチェックの打ち合わせでこのバックを見た時「ユリアちゃんならどういうふうに着こなすんだろ?!」って最初にパッと頭に浮かんで、今回声をかけた人。私が撮りたくなってしまう人の共通点。スタイルがある人。そしてなおかついつもそのスタイルを絶えず「更新」している人。ユリアちゃんが、行くその向こう、目指すその先、掴むべき未来。

P81
洋服、髪型、ネイルにコロン、身に着いたすべてがファッションである(そういう意味では立ち方、ふるまい、声のトーンに教養、すべてがファッションだとも言える)。ファッションにおいて、一番大事になるものは自分が何を価値基準として一番においているかということだと思う。「おしゃれだね!」って言われたその時もしくは「今日ステキだね!」って言われたその時。ほめられた単語の意味するものは、カワイイ、のかセクシーなのか、筋骨隆々なカッコイイ、なのか一緒にいて感じる気兼ねなさを演出できるものなのか、美しいのか愛らしいのか。最新を熟知しているということを表現できるモードであか、綿々と続く歴史を学んだトラディショナルか、「あなたならでは」な所謂「個性的」なのか、他の人は「違う」ことなのか、誰がみても「ちゃんとしてる」という信頼感(もしくは安心感)があることなのか、大人っぽく見えるということなのか。人類誕生から先人達が命題にしてきた問題、「自分というこの生き物は、何なんだろう、どうあるべきであるのだろうか」という問題。「どうあるべきか」はつまり「どうありたいか」と表裏一体で「どう思われたら自分自身の一番望むことなのか」という事なのだ。今一度。「おしゃれだね!」、「今日ステキだね!」って言われたときに、どんな理由でその言葉をもらったらあたしたちは嬉しくなるのか今一度自分自身に問いただす。その質問を考える中で価値観が少しづつ、少しづつ浮かび上がってくる。今の自分を客観的に輪郭化するキーワード。

渋谷の隠れたセレクトショップ、GARDENさわむらさん。あたしの知る中で東京メンズファッションシーンの目利きは何人かいるのだけど、彼はその筆頭株主。アップカミングなブランドやデザイナー、今の街の流れなんかは彼と情報交換をすることが多い。

P82
ブルーの髪の毛、おっぱい(!)Tシャツ、プラスチックのネックレス。すくすく伸びた長い脚、その先にかまえているのはドクターマーチン。多分あたしの場合カメラが自然に向いてしまうのは、透明感とか清楚感、そういったものが「ファッション」の後ろに垣間見える人。

P84
可愛いヘビースモーカーのお気に入りは、黒い煙草。今日もお店の前で休憩中、ちょこんと座ってプカプカふかす。「なんか今お店の方向性が変わってきてて、自分のやりたい方向性とずれ始めてて、だから今迷ってるんです」っていって溜息と一緒にけむりをふぅっと長くはき出す。けむりは曖昧に空気を漂い雲散霧消に空に溶けてく。「そろそろお店戻らなきゃ」「あ、そうだね、撮らせてくれてありがとう」バイバイまたねをした後も、どうしたらいいのか、何だかあたしまで悩みこんでしまった。

やわらかなベージュトーンの組合せ。最近よく街で出会う美容師さん。ゆっくりと優しい話し方。青山のサロンで働いているって言ってた。ナチュラルで自然体でいるには、起こる出来事と、自分の感情を意識的に切り離しておく必要がある。

P85
外苑前、銀杏並木。ツイードランが東京でも開催されるこの日、朝早くから「ツイード」というドレスコードを基にドレスアップして紳士達が集まってて。パーフェクトにドレスアップしてる彼はT-MICHAEL。穏やかで凪いだ人だった。

P86
真っ白のポインテッドとシルバーの靴。トレンドに時差を感じる長閑な時代は何時の間にやら何処かに行ってしまったのだ。早さが価値になるというファッションの固定概念もいずれか何処かに行ってしまうのだ。

P87
プレッピースタイルは、おおよそにおいて風通しがいい。大学時代tomorrow landでバイトをしてた彼。最初はモードスタイルが好きだったけど、お店に合わせるため、(最初の頃は妥協して)プレッピーを着てたって言ってた。先輩たちに色々教えてもらっていくうちに、プレッピースタイルの面白さ、徐々にわかるようになっていって。「プレッピーって奥が深いですよね、モードとかストリートとは、また全然違った世界があるし」って。ファッションを深めていく、楽しさ。

P88
デビル君、この街を代表する男の子。彼と一緒に原宿をてくてく、偶然お友達(韓国からきた女の子)にあった時。彼ときたら自然に韓国語でおしゃべりしてて。「僕中国と韓国になんだかやたら友達多いんですよ、だから語学勉強しようって思って。最初中国語やってたんだけど、難しくって難しくって! ムリなーって思ったから韓国語に切り替えたんです。こっちの方が文法とか日本語と同じだからまだ大丈夫でした」って。凡そにつけ、そつなく見える彼だけどやるべき努力をこつこつと積み重ねてるからこそのこの場所にいる。

お店のパーティーが夜にあるから、その準備中にばったり遭遇、Falineの二人。赤、黒、白。二人一緒の統一感。「会わない時は全然会わないけど、会う時はほんと良く合うねー」って。なんとなく立ち続けに会う時はその人の事を思ってたり、考えたりしてる事が多い。この日も然り。「偶然は必然と必然が重なり合って出来たもの」結構お気に入りのフレーズで、確かどこかで見聞きしたのだけど、誰の言葉か忘れてしまった。

P89
たしか彼女にあったのは、去年の夏くらい。その時の彼女はくりくりの丸坊主で、あどけなさが残りつつ、大人びようとしたのが可愛くて。あの時と今では彼女を取り巻く状況はガラリと変わった。顔つきも引き締まって、「見られる」という役割を引き受けた人の顔になってる。彼女の乗っかったボートは想像以上に大きくて、向かう先も自分には見えてこない。期待と不安が交差して、自信が出たと思ったらべしゃんこに潰(つい)えてしまったりもして、その不安定さにへとへとになってしまうかも、だけど。神様は、それを乗り越えられる資質のある人に試練を与える。あなたが、乗り越えられますように。

P90
スタンダードスタイル
「お洒落をする際に方向性って2種類あるな」ということはストリートで撮っている中で、私の気づきの一つです。

273

ひとつは①センスがあること。特に特別な服をきている
わけじゃないのに、なんだかお洒落感が全身から漂う人。
センスってある種運動能力みたいというか、持って生ま
れた才能的なものとして認識されているきらいがある
なと感じてます（その真偽の如何は別として）。つまり誰
もが持つわけでもないから、その「選ばれし人感」が
かっこよさにつながっている。もう一つは、②トレンド感
があること。これはキャッチーというか時代感をはらん
だ着こなし。私は時代を見る目をもっている、時代を知
っているんだよってことを表現するスタイルですね。その
「知り得し人感」、それがかっこよい。

これはどっちがいいとか悪いとかの話ではないので、「自
分がどうありたいか」ってところで自分のスタイルを選
んだらいいのかな、と思います。「お洒落だね」って言わ
れたいって時、その「お洒落」の意味する所は前者なの
か後者の意味なのか、今一度自分はどっちの意味を
求めてるのか自問自答してみると、自分のファッショ
ンの方向性、つまりスタイルですね、それが定まってくる
のかな、と。（ちなみに私は全取り派です。よくばりだか
ら！）で、翻って①の方向性の場合、キーになるのが「エ
ターナルなものをどう自分自身のスタイルに落とし込ん
でいくか、そして（ここ重要！）日々常々にUPDATEして
いくか」だと思います。「自分らしいスタイル」というのを
見つけるのも勿論大事なのだけれど、もっと大事なの
はそれを日々UPDATEしていくこと。科学技術の進化
によって都市も生活様式も、私たちを取り巻く環境は
日々スクラップ＆ビルド、めまぐるしい早さでUPDATE
がされてる。ところで、日本には16世紀から続く虎屋さ
んという和菓子屋さんがあります。（赤坂のカフェは私
のお気に入りのスポットです）時代を凌駕して何百年
も続いてきたその秘訣は「本質は変えず、その時代ごと
に本質を世の中にフィットさせた方向に進化させる」所
だということをどこかで聞いたことがあります。エターナ
ルなスタイルにも同じようなことが言えるのだと思います。
本質はかえず時代に応じて、自分の気持ちや状況に
おいてアップデートしていくことがエターナルにおいては
大事なことになるのかな、と。

P92
白T
老若男女、世代も国も凌駕して大抵の人のクローゼッ
トの中に必ず一枚あるではあろう白T。シンプルでエタ
ーナルなアイテムだからこそ、どんなスタイル、どんなテ
イストにあわせてもフィットする使い勝手の良いアイテ
ム。麻雀でいえばオールマイティ牌みたいなもんですね！
ここではとびきりのラブリーな白Tの着こなしをご紹介
します。

P93
コレクション会場でフォトグラファーに囲まれてた彼女。
ぱっと背を向けると白Tの後ろに「もう撮った？」なんて
ウイットに富んだメッセージが。白Tを通じて撮る人、撮
られる人の会話がうまれてた。

P94
くたびれ感のあるヴィンテージのレザージャケットにク
ラッシュ感抜群の網タイツ。白Tを合わせる事によって
クリーンさが加わり、ゴリゴリでハードな印象がありつ
つも清潔感を感じさせる着こなしに。

sacaiのモードなワイドパンツには、ゆったり気味の柔
らかい素材の白Tを合わせる事でリラックスした印象に。

P95
大胆にクラッシュしたデニムパンツにもクリーンな白T
を合わせる事で清潔感が加わります。クラッシュだっ
たりヴィンテージを着る場合、清潔感をどう保つかが重

要になるのですが、白Tはその解決策の一つ。おろした
て、洗い立ての真っ白な白Tをチョイスしてください。

P96
モードな着こなしに抜け感をだすべく白Tを合わせて。
赤のリップとヒールもアクセントになっています。

P97
ゴージャスなファーのコートのインパクトを中和させる
べく白Tをあわせる。白Tは着こなしにおける「引き算」
的な役割でつかうのがおすすめ。

デコラティブでボリューム感があるスカートを主役にし
た着こなしにはやはり「引き算」として白Tをチョイス。
主役であるスカートを際立たせてくれます。

P98
ボーダー
ボーダーって、多分世界で一番愛されている柄なんで
しょうか（シトウ調べ）。そのままベーシックにシンプル
に着てもいいし、ちょっと挑戦して柄×柄の組み合わせ
をしてもよし、モードなアイテムに合わせても、「なんと
なくまとまる」懐の深さがある。母の愛情さながらの「受
け止め力」がボーダーにはあるんです。

P99
このシルエットといい、色味具合といい、時代を凌駕し
たボーダーの着こなし。

P100
ボーダーのカットソー×レオパードのマフラー＆グロー
ブと柄×柄の着こなし。

ボーダーカットソー×レオパードのジャケット＆スカート
（もしくはキュロット？）、柄トリプルな着こなし！

こちらもボーダーのカットソー×レオパード。

P101
ボーダーカットソー×花柄のパンツ。定番同士のアイテ
ムでも、組み合わせ次第で新鮮さだったり新しさは作
ることが出来る。

P102
ボーダートップス×ボーダーロングのスカートと、ボー
ダー×ボーダーの着こなし。白Tシャツの襟と裾が抜け感
を出しています。

P103
このようにファーアイテムや女優帽など主張の強い（ク
セの強いともいえる）アイテムを「和ませる（中和させる）」
意味でボーダーはとっても良い仕事してくれます。

P104
デニム
デニムは私自身も一番大好きなアイテム！ デニムこそ
誰でも取り入れやすく、とはいえ同時に気の抜けないア
イテムはないんじゃないかと思います。トレンドの方向
性であったり、自分の置かれた立場や環境に応じて似
合うサイズ感やバランスは日々移ろいでいくもの。つい
この間まで気に入ってきてた一本が、久しぶりに着て
みると「何か違う…」と感じたりするのはそれ故です。デ
ニムこそ定期的に見直して「今の自分に相応しい一枚」
を選んでみる事が大事。つまりデニムは自分自身の「映
し鏡」だとも言えます。

P105
デニムシャツ、デニムジャケット、デニムパンツとデニム

3つ巴！ ポイントはシルエット。全体的に直線的かつシ
ャープでシュッとしたシルエットが、カジュアルなデニム
素材とはいえフォーマルな感じに。また、「着崩し」を一
切せずにシャツのボタンは上まできっちりとめ、かっち
り感を演出しています。デニムをシャープなイメージで
着こなしたい時には、こんな風に「直線的なシルエット」
を意識すると良いかと。

P106
これもバランス感の秀逸なスタイル。パンツの太さがポ
イントです。同時にストリート（帽子）、ヴィンテージシック
（コート）、トラッド（Aジャケット）、カントリー（デニム）
にモード（ヒール）……、異なるテイストをミクスチャー
して一つにまとめ上げたそのスタイリングの手腕にも
注目。

モードでかっちりしたジャケットには少しオーバーサイ
ズなダメージデニム。短めトップスと腰履きしたデニム
の奏でる、全体におけるシルエットのバランス感が秀逸。

P107
カジュアルにふりがちなデニム・オン・デニムスタイルを
エレガントに着こなしています。そのポイントはこのラグ
ジュアリー溢れるコート！

普段使いするには若干ハードルの高いサテンのドレー
プ感がエレガントなスカートも、デニムシャツを合わせ
る事でカジュアルダウン。ブルーで色味を統一させた
所も全体のまとまり感につながっています。

P108
ダメージデニム。ここまで潔くバッカーン！ とご開帳さ
れたのであれば、あとはひるまず堂々と着る以外の選
択肢はない。ファッションは度胸！

ニュアンスカラーの色使いが美しいトップスの重ね着を、
ダメージデニムでカジュアルに着崩す。エレガントだけ
ど肩の力が抜けたスタイル。

どんなにクセがあるアイテムであろうとも、デニムと合わ
せればなんとかなる、という好例。

P109
特筆すべきはデニムのサイジング、そして履き方！ ちょ
っとワイド目でボリュームのあるパンツを腰骨にひっか
けるようにして履いてます。このサイズバランスは上級
者ならでは。

「白T＋デニム＝爽やか！」という概念を気持ちよく打ち
破ってくれるのがこの一枚。サイズが大きめなダメージ
デニムを腰ばきにして、対照的にピッタリとしたトップス
をチョイス、丈感が短め故にお腹もしっかりみえてます。
やはりここでも重要なのはサイズ感。サイズ感を制す
る者がデニムを制する！

P110
デニムをスカートで取り入れてみたスタイル。パッチワー
クにリメイク風に、セットアップにしてみたりと、それぞれ
の着こなし。

P111
こちらもデニムオンデニム。彼女はポンチョで取り入れ
て少しガーリーな仕上がりに。男前マダムのデニム・オ
ン・デニム！ 特筆すべきは腰回りのあしらい方。少しオ
ーバーサイズ気味のデニムを腰に穿きつつ、これまた
大きめのシャツは無造作にパンツイン。この「ゆるっと」
感が「こなれ」につながっています。なのにだらしなく見
えないのは、足元に（見えないけれど）ヒールを履いて

いるから。

P112
ミリタリー
ミリタリーといえばそもそも軍人さんが着る服からスタートしたこともあり、その機能性であったり歴史背景といった蘊蓄を語られる事がおおいですが、今回ご紹介する着こなしはそんな総てをすっとばした、ザッツ・ファッション！な着こなし。自由奔放な発想でミリタリーを着こなしています。

P113
ミリタリーのライナージャケットは、本来ならば防寒時にコートの下に重ね着するものでしたが、彼女はそれをアウターに見立てて、サラッと一枚で。大きめサイズのコートで上がボリュームがあるので、足元もボリュームのあるスニーカーでバランスをとって。

P114
ミリタリーって無骨さだったりワイルドさがその魅力だったりするのですが、大人のマダムが着ることで、より彼女の女性性であったり、大人としての深みがコントラストになり魅力を引き立たせてる。

P115
ミリタリーシャツにフレアスカートで「アーミー×ガーリー」なテイストミックススタイル。茶色で色味をそろえているのでテイストをミックスしていても全体的にまとまりがある。

パステルカラーのボウタイ×ミリタリーテイストのジャケットとテイストをずらしたスタイル。ミリタリーにパステルを組み合わせる、その色合わせは新鮮。

P116
無骨さ、質実剛健さが魅力のミリタリー。何も足さない、何も引かないで、そのまま素直に着る。着る人の個性が問われる着こなし。

ミリタリーのセットアップにラグジュアリーなファーコートを合わせてテイストミックス無きこなし。

P117
ミリタリージャケットにシルクの華やかな柄物スカーフと柄×柄の着こなし。かつスカーフと靴のエレガントさと、ミリタリージャケットの無骨さのコントラストが見事。着ているアイテムは別段普通のアイテムなのに、組み合わせの妙でここまでお洒落に持っていけるとは！まさに「何を着るか、ではなくどう着るか」！上級者のお洒落。

P118
ヴィンテージ
古い映画の中からそのまま飛び出てきたようなレトロでクラシックなスタイルを着こなす時のコツは、映画の世界にそのままダイブ、ある意味コスプレのように「歌舞く」かなと。そう、自分が映画の主人公になったかのような気持ちで着るとよいかと！レトロでクラシックなスタイルは「人生の主役は自分！」という人生の真理の一つを呼び覚ましてくれます。

P119
ヴィンテージはトレンドを超えて時代を凌駕する着こなしになる。茶色ベースでまとめた着こなしに、黒のボウタイ（ボウタイ！これもクラシカルにおけるティピカル（代表的な）アイテム！）でキリッと引き締めて。

P120
レトロな柄（しかも柄×柄！）、身体に沿わせたシルエッ

ト、夜会巻きのヘアスタイル、ストラップヒール靴とヴィンテージ要素を頭の先からつま先まで精到させたスタイル。歌舞きっきてる！

ヴィンテージスタイルはクラシカルなイメージがあるからこそ、落ち着いた色合いでまとめがち。だからこそのヴィヴィッドの差し色を入れることによって、一つUPDATEしたヴィンテージスタイルに。

P121
こちらはパステルカラーで取り入れたヴィンテージシックなスタイル。ところでクラシカルスタイルにおいて彼女のような「靴下＋ストラップ付ヒール」というのは金科玉条、鉄板です。

こちらもヴィヴィッドカラーのヴィンテージスタイル。シルエットがクラシカルだからこそ、色で遊ぶという好例。

P122
はずしません、ずらしません。頭の先からつま先までヴィンテージ。深い！

トレンチ、靴下、ストラップヒール。クラシカルなスタイリングで、真逆であるストリートキッズ系アイテム、スラッシャーのパーカーをミクスチャーさせちゃう、そのイタズラ心に思わずシャッターを押してしまいました。

P123
ニットもパンツも形も色もベーシックでエターナルアイテム。そこにスカーフを一枚巻いただけでぐっと①洗練と、②エレガントが醸し出されたヴィンテージスタイルに。理由はやはりスカーフの巻き方（まちこ巻き！）、そして（スクリーンの女優然とした）ふっくらとした赤いリップの存在感。

P124
Small Stories #2
Motofumi "Poggy" Kogi
Fashion Curator

—ユナイテッドアローズを離れてからは、どのような仕事をしていますか？

引き続きコンセプトストア〈ユナイテッドアローズ＆サンズ〉をアドバイザーとして続けながら、〈NANZUKA〉によるアートと〈MEDICOM TOY〉のアートトイ、そして自分がセレクトを手がけるファッションを融合したスタジオ〈2G〉のファッションディレクターや、芸能プロダクションやブランドのファッションコンサルティング、東京を代表するインターナショナルブランドになる可能性を持つブランドを選出する「ファッション プライズ オブ トウキョウ」の審査員などを務めています。

—ファッションアイコンとして世界から注目を集めていますが、自身のスタイルを形容するとしたら何でしょうか？また影響を受けた物はありますか？

スーツにストリートから産まれたアイテムをMIXするスタイルで、自分では"サルトリアルストリートスタイル"と呼んでいます。高校生の時に〈グッドイナフ〉や〈ア ベイシング エイプ〉などの裏原ファッションにハマって、20歳でユナイテッドアローズに入社し、スーツやトラッドスタイルを学びました。PRを務めていた2000年代初頭は、エディ・スリマンが〈ディオール オム〉を手がけていて、日本は細身のロックファッション全盛期。そんな中初めて行ったニューヨークで衝撃を受けたのが、ヒップホップの人達のファッションだったんです。カニエ・ウェストやファレル・ウィリアムスがいわゆる"ダボダボ"フ

ァッションではなく〈ラルフローレン〉などトラッドな服をラフに着崩しているのを見て、「これ、めちゃくちゃかっこいい！」って思って。

—そのニューヨークでの体験があって、"サルトリアルストリートスタイル"が確立されたんですね。

そうですね。先輩から、"男はスタイルを身に着けて、女性はモードを身に着けるべき"と教わりました。女性は半年ごとに移り変わるモード＝ファッションを楽しむ。男性は何を着てどこへ行く、何に乗るかなど、そういうことを考えて繰り返すと、Tシャツを着てもスーツを着てもその人になる。ファッションはお金で買えるけど、スタイルはお金では買えない、個から滲み出るものがスタイルと言われて。当時はよく分からなかったんですけど、自分が好きなサルトリアルストリートスタイルを続けてきたら、ハットに髭、さらにジャケットにストリートアイテムをMIXしないといけないという使命感が湧いてきて、少し分かった気がします（笑）。

—変わらないスタイルの中でも、マイブームはありますか？

最近は〈イッセイミヤケ〉のプリーツプリーズシリーズや、ブランドでいうと〈キャピタル〉をよく着ています。どちらも海外の方が着ていて、いいなと思って。日本だとイメージが固まっているブランドも、海外の人がモードに着こなしていると、その魅力や日本の良さに改めて気付かされることは多いですね。あと最近は鳶職人がはく寅壱にもハマっています。

—ポギーさんから見て、東京ファッションの特徴とは？

とにかくみんな、ファッションを楽しんでいますよね。ファッションって平和だから成り立つものだと思っているので、これだけ様々なジャンルが存在する日本はとても平和だと感じます。あと海外だと、レッドカーペットで着るカクテルドレスは引きずることが当たり前じゃないですか。でも日本だったらきっと引きずらない丈にすると思うんです。洋服で用途を考えた時点でファッションじゃなくて日常着になるのですが、日本は文化的に非日常のシーンが少ないので、日常着が多いかもしれません。だから洗えるタキシード、みたいな発想も生まれてくるのかなと。今は海外のデザイナーもその考えを取り入れて、日常で着やすい洋服を作っている流れもあります。日本の気質が世界のファッションに影響を与えているかもしれません。

—世界を飛び回るポギーさんですが、東京と世界の都市とで違いを感じることはありますか？ 東京の長所・短所があれば教えてください。

日本の東京みたいに数百メートル歩いただけで、こんなに多くの洋服のジャンルに出会える国って他にはないですよね。加えて日本人はファッションに関する知識が多い。日本人は戦後アメリカに憧れて、アメリカのファッションを徹底的に研究しましたから。"格好いいデニムの穿き方"や"アイビースタイルとは？"などといったHOW TO本が多く世に出て、今もその手法の雑誌はたくさんある。そんな環境だから、シャツの襟を見ただけでこれはイタリアっぽい、アメリカっぽいと分かるくらいファッションに関する知識はマニアックなほど高いと思うんです。ただルールを理解しているが故に新しいスタイルが受け入れられなかったり、生まれなかったりという弱点もあると思います。

—ファッションシーンにおいて、今気になっているコンテンツはありますか？

日本が1990年代〜2000年代初頭にやっていた、ファッションブランド×ストリートアートといった流れがまた来ているのが気になっています。当時〈ヘクティク〉と交流があったグラフィティアーティストのスタッシュが、KAWSやフューチュラを彼らに紹介したり、スタッシュがフューチュラと洋服を作り始めたりして、ファッションとアートを結びつけた流れです。その時の日本のブームを今アメリカのブランドが吸収して、世界に発信しているという印象を受けています。〈ディオール〉のキム・ジョーンズが空山基さんやKAWSとコラボレーションしたり、〈ルイ・ヴィトン〉のショーでフューチュラがライブペイントを行ったり。ファッションとストリートアートが強く交差している気がしているんです。

——最近ボギーさんがアートに興味関心が広がっているのを感じていました。きっかけは何だったんですか?

もともと好きだったんですが、〈2G〉をオープンさせてもらったことが大きいですね。香港のアート・バーゼルで開催されたサザビーズのトークショーに行った時に、そこで近年ストリート初のアートの勢いがすごくて、バイヤーもストリートファッションに精通している人を雇っているという話を聞きました。さらにNIGOさんが私物をオークションにかけてKAWSの絵が最高額で落札されたことがニュースになった年で、アート界もストリートに寄ってきていると感じ、より身近に感じました。そしてストリートアートが盛り上がったのは、スケーターが重要だと考えました。スケーターの世界では、デッキという板状のキャンバスがあって、若い才能を探してフックアップするという土壌が昔からあります。さらにスケーターは、僕たちが普通に歩いている道を「ここでトリックしたら面白そう」とか「誰々のステッカーが張ってある」といった"スケータービュー"という視点で観察しながら歩いていたりするんです。そういうアーティスティックな視点があったからこそ、ストリート発のアートがここまで大きくなったのかなと思います。

——ボギーさんがファッションやアートを語るには、やはりストリートは切り離せないですね。ストリートファッションのどこに魅力を感じていますか?

昔、お世話になっている方に"誰もがやっていない方法で、新しい道を作るのがストリート"と教えていただいたことがあります。近年はなんでもストリートファッションと呼ばれてしまって、定義が曖昧になっている気がします。もともとストリートは答えはあってないようなものだと思いますが、僕はその方に教えていただいたことが一番心に響いています。それでいうと、NIGOさんはファッションだけでなく新しい道=価値観も作ったと思うんですよね。Tシャツとキャップで高級車に乗ったり、高級ホテルに行ったり。昔はそんな人いませんでしたから。賛否両論はあると思いますが、新しい価値観を創出して、見たこともなかったスタイルを作れるポテンシャルがあるところが、ストリートの最大の魅力ですね。それに本来ファッションって自由なものだけど、特に日本だとコンプライアンスやルールが厳しくて、自由が利かない側面もあります。でもストリートファッションやアートはまだ自由さを持っている。そういうところにも惹かれています。

——今後やりたいこと・挑戦したいことがあれば教えてください。

ファッションにはこれから新たな付加価値が必要になるだろうと思っています。音楽は今1曲数百円で買えるけど、LAのコーチェラフェスなどのVIPチケットは数十万円しても売れますよね。高いお金払っても、その場で音楽を含めて体感したいってことだと思うんです。

ファッションも同じように、ただ着るだけでなく、アートや食といった他ジャンルも融合して一緒に楽しめる何かができないかと考えています。また将来的なことだと、音楽で言うインストールが洋服だとどうなるのかが気になっています。服型デバイスみたいなものを纏えば、3Dグラフィックでスーツになったりシーンによって入れ替わったり……みたいな未来も訪れると思っていて、最近ではIT業界の方たちとの交流も増えてきました。彼らはルールに則るのではなくどうしたらもっと面白くなるかを常に考えていて、ストリートの精神と共通していることも多く、話していて面白いです。また昔から夢見ているのが、無重力の中でのファッション。ファッションは重力があるから成り立っているもので、無重力だったらどうやって楽しむのかを知りたいんです。ハット、かぶれないですからね(笑)。観客も浮くし、服も浮く。そんなショーをやったら楽しいかなと、構想を練っています。

小木"POGGY"基史
1997年にユナイテッドアローズに入社。販売員、PRを経て、2006年にストリートとラグジュアリーを融合させたセレクトショップ、「リカー、ウーマン&ティアーズ」を立ち上げる。2010年には「ユナイテッドアローズ&サンズ」のディレクターに。2018年に独立し、渋谷PARCO内の「2G」ファッションディレクターや、その他アドバイザーとしても活躍している。ハットと髭、スーツとストリートをMIXしたスタイルがトレードマークで、世界的に注目を浴びる日本を代表するファッションアイコンでもある。

P128
この間、ファッションをよく知る一人の紳士と話をする事があって、私たちは二人、東京のファッション(特にストリートに於ける)についてあれこれと思う事などを。紳士曰く東京のファッションを描写するのによく言われるのが「階級(ヒエラルキー)がない事」そして「ジェンダーレスである」という事。これが東京のユニークネスの源になってると言っていて、ここ近頃は後者においてよりより加速している気がする。それはメンタリティの表現、というよりもあくまで表面上のファッションにおけるジェンダーレスであるという事もまた一つ興味深いところ。ジェンダーレスというメンタルを表すための装いではなく(つまりスタイルとも言える)単純に好みのシルエット、見た目、テイストであるだけ、という事(これがつまりファッションだ)。

P130
東京。私は世界で一番好きな街。いくつかの魅力を備えていると思うけど(清潔さであったり、食だったり、ホスピタリティーその他いろいろ)私にとっては、ファッションを動かしているのが(もしくは中心軸にいるのが)ストリートであるという事それに尽きる、と思う。帰ってくる場所がこの「東京」であるというのはあたしにとっての「誇り」。

P131
Unaちゃん。彼女とは原宿で初めて会って撮らせてもらって以来、会うたびにシャッターを切り、小さな話をしたりして。毎回書いてもらうアンケート、「将来やりたいこと」の欄には毎回同じ文言が書いてあったのだ。久々に会った彼女は、「やりたいこと」を実現させてて。アーティストになって夢をかなえた彼女の顔には「自覚」が見える。覚悟ともいえる類の、ある種のけじめ。バックの中にはレッスン道具。「これからまたレッスンなんです、スタジオ、原宿にあるから相変わらず今まで通りいつも原宿!」って。夢をかなえることが出来るのはかなえる努力を続けているから。

ムロさん。背が高いのでちょっと迫力がある彼は遠くから見ても良く目立つ。22歳までプロボクサーをやっ

ていて、色々あって最近転職、今はイタリアンレストランでシェフをしてるって言った。いつも書いてもらってるアンケートには「将来やりたい事の欄」がある。「うーん……どうしよっかな」ムロさんは筆がなかなか進まない。ちなみにこの欄は特に、スラスラ書いちゃう人と、そうでない人にはっきり分かれる項目。思いっ切り考え込んでしまう人もいる(それは生真面目なのだと思う)。

P132
「東京はヘアサロンのレベルが高い」って海外から友達が来るたびに口を揃えてそんなことを言う。「この街で髪を切ってもらうとしたら?」って質問には、当然私は毎回彼の名前をあげる。SHIMA原宿を統括するアートディレクター、奈良くん。私の髪は彼にずーっと預けっぱなしでサロンに行くにも毎回ノーアイデア。身体一つでフラッと行って、彼の「こうしよう!」に「うん!」と答えるだけでいい。おおよそファッションしかり、全てを誰かに委ねるっていうのは(もちろんチャレンジングだから、委ねる相手に関しては充分に精査すべきだ)自分の想像以外、所謂「斜め上」の自分を見出すことができる。こだわってないつもりでも、固定概念は常にどこかしら付きまとうので(この髪型は似合う、この色は似合わない、このスタイルは自分ぽくない、とか)そういうのを一網打尽に吹き飛ばすのは、プロに委ねるのが一番、あたしはそう思う。ところでこの日は「髪を赤色にしたい!」って言われて何年かぶりにあたしは髪の色が変わったのだ。似合う洋服もちょっとレンジが広がるし、着たい服のアイデアもどんどん出てきて思いがけない提案は、ルーティーン気味な毎日を、ちょっと変えてくれたりしたり。

P133
渋谷、ヒカリエ。誰かを待ってる所の一枚。緑の黒髪、色鮮やかなプリーツスカート、遠くを見つめるその眼差しの涼やかにシャッター切るのを少し忘れて思わず見とれる。

P134
縦じまの背広、ペイズリーネクタイ、茶色と白のウイングチップ。ユナイテッドアローズの展示会にて。ファッション+その人自身の個性やあり方=スタイル。

P135
ささこくん。会う度撮らせてもらう男の子。今日は青山ギャルソンの立ち上がりなので今から顔出しに行くところ。「仲いいスタッフがいるんです」って。彼とときたら会う度にタトゥーが増えている。ハトの平和のモチーフだったりどこかの見知らぬ異国の一節だったり。モチーフはいろいろ。「今日またタトゥー入れに行くんです。今度はフリーハンドで書いてもらおうと思って」「どんなの?」って聞いたら「それは次あった時に」と教えてくれない。「ふーん」とあたしもアッサリ引き下がる。次会うその時の楽しみのために。東京、ストリートの撮影で何度も撮らせてもらううちに顔見知りになる人達がいる。街でばったり彼ら彼女らと会うその偶然を、あたしは愛しているのだと思う。会う度にアップデートするささいな日常、気持ちの変化、そしてファッション、その移ろい。そのいちいちに感動する。
Nicolla Formechettiが手がけるPop icon projectが産んだ新しいミューズがこの彼女。時代を纏う人やアイテムには同じ空気が流れてる。輪郭が、どこかきりりと浮かび上がってて(見た目のエッジーである、というのとはまた少し違った、街の背景から「抜け出た」というか「浮かび上がった」その感じ)彼女も、このMACKINTOSH×99%IS-のコートも同様そういう「空気」を孕んでる、と私は感じる。

P136
「レイさん、あたし今恋してるんです」開口一番、ハスキ

ーな声はそう話す。ちょっと照れながら、でも嬉しそうに。「彼って、私と感性とか、言葉の使い方とかが似てるんです。この間初めて連絡先交換して。あぁもう！ レイさん。大人になって初めて恋がわかったんだともう、あたし」一緒に階段に腰かける。キラキラした目は恋してる目で、目の奥には例の彼がいる。ステキ。「連絡ちょっと途絶えるだけでチーンってなったり、でもまた一個メールが来ただけで急に全部晴れちゃって、嬉しくなったり、気持ちが毎日ぶんぶん揺れ動いちゃってしんどいけど、でも、恋って楽しいね」女の子は、恋をしてるとかわいくなれる、成長できる。

見た瞬間、手に取った瞬間「わぁ、これ着たい！」「何これ？！ 絶対欲しい」って一気にテンションが上がる服。ハードルが高ければ高いほど「絶対、絶対着こなしてやる！」って盛り上がる服。これこそ、ファッションの醍醐味。着こなして、ドアをあけ、お外に出るときのワクワクとドキドキ。誰かに「いいじゃん」って言われた時の心の中でのガッツポーズ。ファッションはいつもの平坦な毎日のところどころにちょっとしたハイライトな瞬間を作り出す道具ともいえる。ファッションを楽しめると日々が華やぐ、楽しくなる。

P137

クレイジーな残酷さだったり、小狡さだったり、どんなに純粋無垢な女の子でもそういう側面は持っている。丁度彼女の持ってるmagmaのバックの下の方、（黒地にお花や果物なんかがプリントされてるのだ）全体のバランスにおいて、そこだけの「何かしらの違和感」がつまりそういう事なんだろうな、と。で、パステルの淡さとかわいらしさを引き立たせるのもまたこの「違和感」とも言える。お刺身には、すりたて山葵のツンとくる辛味が必要なのと豆大福に入ってるかすかな塩気に味わいを感じるのと同様の原理。ファッションも人も食べ物も幾分パンチの効かせてあるのが多分あたしにとっては魅力的なもの。

P138

AVANGARDEのももちゃん。今はお店の休憩中で、BEAMSをチェックしに行くところ。「Ashishの総スパンコールのキラキラ靴下が出るっていったからチェックしにきちゃったんです、入荷連絡がくるようにお願いしてるんだけど、でも、何か待ちきれなくて」って。ちょっと恥ずかしそうに話す。「大好き」を待ってる、そのそわそわ感。これはもう、間違いなく「可愛い」としか形容できない。

P139

柄、柄、柄の組合せ。DOGのコンボイ君。ちょうどオーガナイズしているイベント「吟味」まであと3日、といったタイミングで撮らせてもらった一枚。アンケート欄。「今欲しい物：本気」「本気って？」「ほら、芸人さんとか24時間お笑いの事ばっかり考えてるじゃないですか、俺も店の事と吟味の事だけ24時間ずーーーーーーっと考えて本気で全部本気でやってたいんです。でもまだ他の事とか考えちゃって。なんか人間関係とか。意外と繊細なんすよー」って笑う。

P140

美容師一年目の彼は青山のやや少しコンサバティブなヘアサロンで働いてる。「勤務中も着る服は決まってて、ファッションって感じじゃあまりないんだけど、でも今のこのサロン、技術がスゲーいいって聞いて。『学べる』から、ここで働くの決めたんです」将来やりたい事の欄には「Bigに。」って書いてある。その言葉自体は曖昧だけど、じゃあどうやったら、望むべく「Bigに」なれるかの具体的対策やアクションを考え抜いて、起こしてるその彼を、ちょっと眩しく思う。将来から逆算して、今やるべ

き事を淡々と、そして着実に積み重ねる。感情や好き嫌いに流されず。

P141

丸坊主、そり落とした眉、真っ赤な口紅、厚底のヒール、ひらりちゃん。原宿の古着屋さんDOGで働き始めてまだ2ヶ月とちょっと。「まだ仕事、ついてけないから迷惑かけないようにしないと」って。ひらりちゃんは、まばたきのスピードがゆっくりだ。ゆっくり閉じて、ゆっくり開く。なので時々、眠た気な表情になる。メイクの後ろに隠れたbabyな感じがその眠た気に見え隠れする。ちょっと可愛いらしい。

あつらえ物の浴衣に麦わら、懐中に差し込む片腕、うす卵色に染められた足袋、すっと伸ばした首筋や目線、佇まい。「エレガンス」というのはこういう事かも、と彼と話しててそう思った。「エレガンス」について考える。曰く「エレガンスは言葉づかい、しぐさ、態度、雰囲気、趣味まで含めた精神的要素の強いもので、服装の優美さだけをさすものではない。服装におけるエレガンスは、時代によって常に変化し、時代の求める最高の精神性と服装が一体化したときに生まれるもの」とある。撮影の後書いてもらういつものアンケート。「今欲しいものは？」の欄には「いらない」、「将来やりたい事は？」には「もう充分」って書いてある。おそらく多分、この答えたちが「時代の求める精神性」を読み解くキーワード。

P142

99%IS-のショーに集いに集ったパンクス、彼らはなにより筋が通っていてとても見ていて美しい。彼らの着こなしは最初は単に「ファッション（＝これカッコイイ！ 着たい！ 欲しい！）」から始まった好奇心かもしれないけれど、ちょっとしたきっかけがパンクスのファッションのルーツを掘る、というアクションにつながり、彼らの思想だったりそれが生まれた背景だったりを知る契機になる。それは自分自身の生き方を見直す機会になり、彼らの生き方や考え方、世の中に対しての向き合い方にパンクな変化を及ぼしていく。それを受けての毎日を生きる気持ちに変化は訪れて、改めて身に着けたそれらのアイテムは自分の思想や考え方と深く結び付きそれはとても目に見えない、言葉には出来ない「フォトジェニック」としか言えない雰囲気、もしくは迫力があり私は心を奪われないではいられない。ファッションは自己表現というよりも、自分の今感じている思想や考えが（表現しようとしなくても）見た目に漏れ出たもの、なのだ、と改めて思う。

P143

真っ青な空、青山通り、藍染胴着のおじいさん。棒術の先生と生徒さん。丁度青山でやった稽古の途中の一枚。真ん中が先生で、二人はいつも敬いを欠かさない。先生をたててるのやり方が何だか学生さんみたいで、何だかいいなぁ、と。『棒術』はねぇ、刀使いを棒で倒す術の事ですよ。いつもは渋谷の金剛八幡向かいの道場で稽古をやってるねぇ。興味があれば連絡しなさい。」って先生が言う。

P144

明治通り、ケバブのお店。瓢簞のステッキを片手に悠々と街を歩いてた彼。声をかけるのは少し勇気がいったけど思い切って声かけてみた。見た目と違って話すと普通にいい人。ニックネームは「魔王」。「将来やりたい事は？」「じゃ、世界征服で。」「そだね、魔王だしね。」「ね。」

P145

ベティーのスエット、ニーハイソックス、厚底の靴、たっぷりボリューム厚め前髪。私にとって、今この瞬間の「原宿っぽい」って言うものはおそらく多分こういう感じ。

P146

ひかりもの
ゴールドやシルバーを「私には派手がすぎる…」と敬遠している方、朗報！ ここでは「彩度ずらし」というテクニックのご紹介です。ポイントはまず、着こなしにおける「色」を因数分解して見ること。「銀」はピカピカした光沢をなくすとグレーっぽい色になる。つまり、「シルバー＝グレー」って考えてもらってもいいかなと思います。グレーって、何にでも合わせやすいベーシックカラー。同様に金色も光沢をなくすとベージュっぽい色になるかなと思います。ベージュもまたグレー同様、何にでもあわせやすいベーシックカラー。ゴールドもシルバーも彩度を変えてベーシックカラーとしてとらえると取り入れる際のハードルも、ググググンと下がるかと思います。ゴールド＆シルバー。最初は白、紺、ブラウン、ベージュといったベーシックカラー同士と合わせると綺麗にまとまります。もう少しチャレンジしたいなって言うときは、色物アイテムと組み合わせてみると上級者っぽい仕上がりになります。蛍光カラーに関して言えば、これも蛍光イエローは彩度をずらした黄色、蛍光グリーンもたんなる緑。合わせる色は、黄色に似合う色、緑に合う色をチョイスしたら間違いなし！

P147

ゴールドがふんだんにあしらわれたインパクトの強いワンピースドレスだけど、ゴールドを「彩度ずらし」でベージュに見立てると、途端に「ベージュ×黒」のベーシックカラーの組み合わせ。このように大きな分量でヒカリモノアイテムを取り入れるコツは、①合わせる色の数を抑える（今回は2色）&ベーシックカラーに絞り込むこと。

P148

セットアップのゴールドというインパクトがあるアイテムだからこそ、合わせるアイテムはエターナルな白Tをチョイス。アクの強いアイテムはエターナルアイテムで中和させると着こなしやすくなります。

モード感ある、存在感濃いめのゴールドのスカートだからこそ、着古した古着のTシャツでその「濃ゆさ」を中和し、デイリーな着こなしに着地させてる。良い焼き鳥屋さんでは大根おろしが必ず先付で出てくる感覚とここら辺は似てると思います。

P149

シルバーの着こなし4選。どれもぱっと見、参考にするには躊躇してしまいそうな着こなしですが、よくよく色合わせに着目して見てください。合わせてるアイテムの総てはベーシックカラー&エターナルアイテム。そう、ほとんどがあなたの家にあるアイテムです。おっ!? ヒカリモノ、今ハードルちょっと下がりました？ だったら速攻その気持ちのままレッツトライ&チャレンジ！

P150

シルバーのスカートにヴィヴィッドカラーのトップス。彩度ずらしのテクニックでこのシルバースカートをライトグレーのスカートととらえると、「ヒカリモノ×ヴィヴィッド」もトライしやすくなります。

これぞ彩度ずらしのテクニックの魅力が真骨頂に溢れた一枚かと。何気ない着こなしでも、スカートのこのシルバーが一点入るだけで、途端に「一癖のある」カジュアルスタイルに。

何気ないデニムとTシャツのカジュアルスタイルにも、シルバーアイテムをジャケットと靴で差し込むことで一気にワンランク上の着こなしに。シルバーの差し込むボリューム感がこの場合キモになってくるかと！

P151

全身同色にあかたも吹き矢のようにネオンカラーを差し色として投入する。カチューシャやベルトなどそれほど面積は取らないささやかなアイテムを着ても、蛍光色のインパクトはいやが応にも存在感を発揮します。シンプルながら強いスタイル。

蛍光イエローも「彩度ずらし」のテクニックを用いれば単なる黄色に置き換えられる。ベージュのコートと同系色で服はまとめつつ、小物のバックや靴で差し色要素をさらに追加と上級テクニック。

黒のセットアップにはネオンイエローのスポブラ。トーンを2色に限定させた分、ネオンイエローが効いています。チラリズム的要素にネオンカラーを入れるウイット。

ヴィクトリアンのトップスにわりと本気目なミニタリーパンツ。ヴィンテージやヘリテージの重さを感じさせるスタイルだからこそ、首元にはあえてのネオンイエローを差し込んで「外し」を加えて見る。テイストミックスの妙が光るスタイル。

P152
配色問題

「色合わせ」というのもお国柄が出るなぁ、というのが世界中で撮っていて感じたことの一つです。こと配色問題においては私の中ではイタリアのマダムのそれは、私の想像の斜め上いく配色具合だから撮っていてすごく面白い！竹をわったようにパキッと鮮やかでPlayfulで、かつ捻りがきいた色合いは、見ていてすごく参考になる。（日本はニュアンスカラーの色使いをわりと得意としているということもあって、私にとってはイタリアの色使いはある意味真逆で面白い。鮮やかな色合いを取り入れる時には2種類あります。それは①「面」でいれるか、②「ちらし」で使うか。個々の着こなしを見てみましょう。

P153

こちらは①、②両方のコンテンツでもって配色のコツを取り入れています。まずはヴィヴィッドなトップスを大胆に①面でとりいれている。この場合洋服のアイテムの点数をできるだけ絞っていることがポイント。配色が派手な分できるだけシンプルにして「派手み」のバランスを調整します。彼女の場合その上で②ちらし要素を入れるべく、バックや靴にヴィヴィな色合いを追加しています。「シンプルとはいえ、爪痕のこしたスタイリングを！」というファッショニスタの気概が垣間見えて素晴らしい。

P154

鮮やかな緑、ネイビー、ブルーの同系色のヴィヴィッド配色。配色がインパクトがある分シルエットはベーシックに。

鮮やかなグリーンの色合いの上下。その派手さを沈静化させカジュアルに落とし込んでいるのはこの肩にひっかけたジャケット故。よくみるとジャケットと帽子の色合いも呼応させているのが流石。

ヴィヴィッドでゴージャスなファーの巻物を、ここまでカジュアルダウンして着こなせるなんて！ファーの色味と正反対な色味、かつ正反対なストリートテイストとミクスチャーさせているところがもう！

こちらも鮮やかな緑×ブルーの配色。胸元にイエロー（髪色とも呼応している！）をスパイス的にあしらって。鮮やかな色合いの組み合わせにおいては、シルエットはシンプルにするのがポイント。

P155

一見ビビッドな色合いだけど、素材の力でニュアンスカラーに昇華させるその力量。

特筆すべきはこの腰元のグラデーション。夜明け前の海辺のようなニュアンスカラー。ジャケットが丁度いい「差し水」になって全体のスタイリングを落ち着かせている。

パステル黄緑のファーと、ヴィヴィッドな緑のパンツの同系色の押しの強い色合いの着こなしだからこそ、このカジュアルなインナーに着た白のパーカが抜け感としてとっても良い役割を果たしてる。

パステル配色ってえてしてラブリーー辺倒（日本で言う「モテ系スタイル」）なりがちだけど、この頭にあしらうスカーフのクラシカル具合がその総ての文脈を覆してる！誰かの理想に合わせるスタイルではなく、自分自身の今を楽しむために服を着ている。自立して大人の女性のパステルスタイル。

P156

「ちらし」で使ったヴィヴィッド配色3選。袖、足元、コートから出たチラリズム的配色……面積が小さな場所であればあるほど、そのヴィヴィッド具合は色濃く心に刻まれます。小さな部分だからこそ、思いっきりヴィヴィッドに、カラフルにプレイフルに！（最悪「あー、今日の着こなし間違えた」って思ったとしても、すぐ取り替えがつくという利点もあります。最悪脱げばいい＆アウターか何かで隠せばOK！）

P157
Elisa Nalin's style

誰がなんと言おうと、着こなしにおける色使いのクイーンは彼女、エリザ（Elisa Nalin）！暖色、寒色、ニュアンスカラーの色使いでも、はたまた竹を割ったようなパッキリハッキリしたい色使いでも、はたまた「面」での着こなしで「ちらし」でも、どんなスタンスであっても「ああ、そういう色使いもあったのね！」という驚きを毎回提示してくれる人です。色使いにおいては彼女のセンスは飛び抜けていると私は思う。

P158
同系色

頭の先からつま先まで同じ色味でそろえる着こなし！これに関してはまずスタンスを決めることから始まります。つまり「自分がどうしたいか、どうありたいか」を最初に考え、決めることが肝要です。スタンスとしてはこの場合も2種類。①バッキリ系。文字通りオンマイウェイな「オレの『好き』はコレ！」と全身全霊、全力投球で表現をするスタイルです。その率直さは清々しい。ただスキがないのが難点といえば難点。②ニュアンス系。これは我々日本人のお家芸なのですが、物事の境をぼかしてニュアンスだけで表現する「何ていうか、私の『好き』って感じはばっくりこういう系っていうか」と、レンジをもたせた表現。柔らかく深みが出ますが、潔さは若干かける。さて、仏教の出発点は「一切皆苦（人生は思い通りにならない）」と知ることから始まりますが、ファッションだけは例外じゃないし、と私は結構とらえてます。人生一回きりのもの、自分が着るモノくらいは自分の好きに思い通りにしてもバチがあたらないんじゃないかと思っています。と、は、いえ！「相手にどう思われたいか」ってのもやっぱり捨ててはおけなかったり。だって好きな服着てデートとか行って、相手に引かれたりすると、やっぱりへこまないではいられないし（←ここらへんが煩悩との戦い）。自我と自身の社会性を秤にかけた上で、「今、自分がやりたいスタイル」を選択するということ。一社会人としてこれは頭の隅に置いておくと良いかと

P159

思います。（もちろんしがらみのない学生時代とか、あとは大人であっても家でくつろぐなんかのプライベートな時間においてはその範疇外。「好き」の気持ちの赴くままに好きな服を着て楽しむのが日々を楽しむ秘訣です）。大事なのは、単純に流された上でのチョイスではなく、自己責任で考えた上でスタイルを選択すると言うこと。

これぞ①バッキリ系の最骨頂！「私はこれが好き！」ってことがファッションを通じて全身から表現されています。この忖度皆無な自己表現のすがすがしさ！

P160

ハッキリ＆バッキリ5選。ハッキリ＆バッキリの同色系でまとめた着こなし5選。服の色味のインパクトが強いからこそ、威風堂々と態度で着こなすのがコツ。そう、態度もファッション！

P161

ニュアンス系配色。パステルグリーンからミントブルーの柔らかな色味のグラデーション。柔らかな色味だからこそ素材感も同じ柔らかなものにして。

白のグラデーションが絶妙な人って上級者って感じしますね！

ブラウンベースのグラデーション系スタイリング。足元のサンダルで抜け感を作って。

茶色～グリーン～ブルーのニュアンス系配色。髪の色まで加味してグラデーションをつけている所が上級者。

P162
柄×柄

チェックに花柄、ストライプ、幾何学柄に世の中に柄物は百花繚乱。柄×柄の着こなしをマスターできれば、とたんにお洒落レベルは格段にUP間違いなし。とはいえ実はこれ、わりと簡単に取り入れられるんです。押さえておくべきセオリーは2つ！①共通項の色。ず①色における共通カラーを持たせると、柄はバラバラでもまとまって見える。今回は数式で表現してみることにします。例えば赤（red）、青（blue）、白（white）、黄（Yellow）、4つの色。赤・青のストライプのトップスがあるとします。白×黄の水玉のボトムスがあるとします。数式で表すとこうなります（R＋B）（W＋Y）。展開するとRW＋RY＋BW＋BY。少しガチャついた数式ですね、残念！さて、そこに共通項（共通カラー）を一つだけ持たせるとします。赤×青のストライプのトップスがあります。赤×黄色の水玉のボトムスがあるとします。数式で表すとコチラ。（R＋B）（R＋Y）。展開するとR²＋R（Y＋B）＋BY。先ほどの数式よりも若干スッキリしていませんか？（これ色味を数式化したイラストみたいなのがあるといいかと）そう、柄を一旦「色」という要素で因数分解し（「何色がこの柄には入っているのだろう？」と考えてみる）、それぞれのアイテムにおける共通カラーが見つかれば、その柄同士はミックスしてもガチャつかず、不思議と調和がうまれるんです！次に②の大きさ散らし。柄×柄の着こなしをモードにきめる際、留意ポイントは大きさ！柄をチョイスする場合は、まずメインで使いたい柄を決め、それより大きめのパターンの柄、小さめのパターンの柄などと大きさを散らすのがポイントです。対照的に「落ち着き性」を表現したい場合（例えばソレはスーツの着こなしであったり、女性であれば楚々としたイメージでいきたい場合）、その時は似た大きさの柄や、細かめの柄あわせを選ぶと良いかと。

P163

ボーダー×チェックの柄×柄の組み合わせ。柄×柄とい

う上級者のテクニックですが、使っている柄がベーシックな柄なのでナチュラルな印象。「一見普通、でもよく見るとお洒落」という一番「子ニクい」スタイリング。ポイントはボーダーの紺、そしてコートのチェックに入り込んだ紺その共通カラー。柄×柄のくみあわせにおけるセオリーがここでは活かされています。

P164

これぞ柄×柄マスター！クセの強い柄同士の組み合わせを絶妙なバランスで組み合わせています。この難しい柄あわせを紐解いてみましょう。タイダイ柄の色構成は「紺×白」。その下に着たサイケデリックな柄のワンピースの色構成は「紺×オレンジ」「紺」という共通カラーがあるからこそ、クセのある柄もの同士の色合わせでもまとまりがうまれています。

P165

フラッグ柄のコート、シャツ、スカートの柄。アイテム毎に柄の大きさを大、中、小と散らしています。柄の大きさのコントラストがあればあるほどモード感は強調されます。

大きめのチェックのニットにとっても細かなチェックのスカート。近づいて初めて解る柄×柄のスタイリングに巧者の貫禄を感じさせます。

水玉×水玉のスタイリング。水玉の柄の大きさが揃っている、かつ定番柄なので、上級者の着こなしなのだけど、落ち着いた印象に。「よく見るととってもお洒落」な良例。

こちらもシャツ、コート、パンツと3アイテムに同じ柄、だけど違う大きさの柄を組み合わせてインパクトのある着こなし。

P166

チェック・オン・チェックの着こなし8選！①共通項の色、そして②柄の大きさに注目。

紺×白×茶で構成されたチェックのシャツに、紺×緑×黄色で構成されたチェックのパンツ。やはりここでもまとまりを産むのは紺という共通カラー。

紺×緑×黄色のマフラーに、赤×黄色×緑のコート。共通カラーの黄色と緑があることによって、一見ちぐはぐに見えつつも、よく見たらきっちり「(キモは)押さえてる」感がある。秀逸。

チェックのジャケットにチェックのシャツ。共通カラーはグリーンとネイビー。ジャケットの色味が深いこともあって、一見柄物に見えないけれどよく見ると柄×柄になっている。近くに寄るとお洒落具合が伝わるという、「巧み」スタイリング。

コートの裏地のチェックに、チェックのスカートのチェック・オン・チェック。茶色が共通カラーになっています。柄×柄にハードルの高さを感じる人は彼女のようにまずは裏地から取り入れてみては？（気恥ずかしくなったら最悪コート閉じちゃえばいいし！）

P167

格子チェックのコートの色の要素は「黄色×白×紺」。そして格子チェックのパンツの色要素は「紺×白」。共通カラーによってまとまりをだしつつ、格子柄の大きさの違いを持たせる事でスタイリングにモード感をプラス。

上下同じ柄なんだけど、素材を変えることによって着こなしに奥行きが。靴を白にして抜け感を出している所もポイント。

チェックのシャツワンピースにチェックのシャツを腰に巻いて、着ている物は定番なのに、着こなしで新鮮さを演出している。そう、大事なのは「何を着るか」ではなくてどう着るか」

頭に巻いたチェックのターバン、チェックのシャツにチェックのパンツ。共通カラーは白と黒。

P168

「レオパードx○○」の着こなし8選！
一枚で着てもインパクトがあって様になるレオパードだけど、さらに柄物を投下することによって、思いもかけない組み合わせの妙（＝ファッションにおける科学反応）がうまれています。

①レオパードコート×②レオパードシャツ、③GUCCI柄バック、④馬柄パンツに⑤レオパードの靴。この柄オンパレードなスタイリングにもやはり着目すべきは「共通カラー」。まず面積としてボリューム感がおおい①と④の共通カラーは白。まずここで土台を整えておきます。そして遊びの部分のディテール（靴やバックアド）に次は注目。①、②、③、⑤の共通カラーにブラウンを。「柄×柄における共通カラーテクニック」をダブル使いした非常に高難度なテクニックです。

レオパード×レオパード×レオパード×レオパード……。もはやレオパートという単語にゲシュタルト崩壊を感じてしまいそうな反復スタイリングですが、やはりここでも絶妙に「大きさ散らし」というテクニックが効いているので、同色単一柄とはいえ奥行きを感じさせるスタイリングに。

レオパードのコート×水玉のパーカー。共通項は黒。

①レオパードジャケット、②五月雨柄（？）のインナー、そして③レオパードのワイドパンツ。①と③は同じレオパードですが、土台となる色が反転している所がポイント。また総てのアイテムに関して、柄は違えど色味は同じ、共通カラーが効いているので全体的にまとまりがうまれてる。

P169

「私はずっとずっとずっとずっとレオパードが好きよ！」って気持ちがほとばしったマダム。問答無用にこういう「好き」をストレートに表現したファッションを愛しています。

レオパード（コート）×水玉（ワンピース）×花柄（ブーツ）のトリプル柄の賑やかなスタイリング。インナーに着た白のカットソーがいい「抜け感」を作っています。賑やかなスタイリングの場合は、こんな風にどこかに抜け感を作ると、相対する人に与える印象に「ゆとり」がでます。「どう見られたいか」をデザインして服をきこなして！

レオパードパンツ×チェックシャツ。そして合わせたコートやマフラーも全体的に同系色の茶色でまとめているので、統一感が出ている。

強めでゴージャスな印相のレオパード柄のスカート×ポップでカジュアルなスポーツテイストのストライプのトップス。真逆のテイストをミックスした、ファッションを「遊んでる！」感があふれるスタイリング。

P170

柄×柄、バリエーションあれこれ。
色も形も素材もバラバラなのに、何故このマダムの着こなしは調和しているのか。トップスのジャケットの「ベージュ」この色合いがポイント。これが緩衝材になってる。つまりトップスのストライプ入った白と、スカートのブラ

ウン。その中間色のベージュをジャケットに入れ込むことで白〜茶のグラデーションを全体で作り出している。

ストライプシャツX細かいチェックスカート。共通カラーは赤と白。

マルチストライプ×水玉。共通カラーは白。そして水玉のパンツに所々にあしらわれた赤い水玉が、トップスとの色の呼応を助長させてる。

茶色ベースのかっちりとしたジャケットのインナーに、柔らかな小花柄のワンピース。共通カラーとしてベージュやブラウン。黄色のブーツの彩度はずしが実に効いてる！

P171

花柄のトップスに花柄のスカート。さらには背景にまで花柄を盛って。撮られる場合は背景含めてディレクションする、ファッショニスタの心意気！

セーターの下の花柄のシャツと、花柄パンツ。同じテイストの花柄だけど、やはり共通項として「黒」の色みがあるからこそ全体的にまとまりが出てる。

ミニタリージャケットにアフリカンな柄の柄×柄。やはりここでも共通項の茶色、緑があることで、一見相容れない柄に見えてもハーモニーを生み出してる。

ジャケットのチェック、首元及びお腹周りにちょっとだけはみ出てる黒白ストライプ、ミニタリージャケットなど、柄の賑やかさ極まりない着こなしなんですが、ダブルに色合わせ（ジャケットとインナーは黒の共通項、ジャケットとパンツは緑の共通項がある）が盛り込まれてる、見れば見るほど上級者的きこなし。

P172

バランス
歌舞伎役者の十八代目中村勘三郎（五代目中村勘九郎）さんの名言「型があるから型破り、型がなければ形無し」。歌舞伎の「型（基本となる動き）」を身につけ、そこから自分のオリジナリティを見つけて崩すのが「型破り」。型も習得せずに崩そうとして出来たものは「形無し」、そういうことを意図した言葉なんですが、ファッションにおいても同じことが言えると思います。ファッションにおける普遍的で王道のシルエットというものは存在します（歌舞伎でいう型のようなもの）。同様に服を着る際におけるルールもしかり。「ファッションは自由！」異論皆無で勿の論です！とはいえ「自由とは厳しいルールの下に存在するもの。ルールや規律が存在しないのは、自由ではなく無秩序である」。（誰の格言かは忘れました）。そう、自由って、ルールや既存の価値観から抜け出したときにその自由の幸せを感じるモノだと思います。千里の道も一歩から。ファッションを真の意味で自由に楽しむためにはそこに近道はなく、まずは王道の「型」を知って、着てみて、身につけることが重要です。歌舞伎の名言になぞらえますと王道シルエットやルールを知った上で、そこから一端都度自由に服を着ることを『着崩し』、そういったモノを知らずに自由に服をきると、それは単なる『着崩れ』といったことが言えるのではないかと思います。ここでは絶妙なバランスを持って服を着こなしている人をご紹介します。

P173

この彼のバランス感最高ですね！襟を立てて首のまわりにボリュームをもたせつつも、コート自体はジャストサイズなのですっきりシルエットになっている。そしてパンツはあえての少し大きめサイズのシルエット。それに加えてボリューム感があるバックをあわせ、スッキリ感

とボリューム感が同居したバランス感が絶妙。インナーの白シャツを加える事で抜け感を出してます。

P174
あえてのゆるめのバランス感！

スエットのコージーでゆるめなスタイルだけど、ヒールを履くことでモード感のあるバランスに仕上がってます。

左の彼女に注目。ちょっとサイズ大きめのニッカポッカ風パンツを、ゆるめのバランスで着こなして。腰ばき＆裾のボタンもはずして「ゆるさ」を演出してる。

こちらもカットソー＆ゆるめスエットのコージーバランスだけど、ヒールを履くことでモードバランスに昇華されてる。

P175
セットアップだけれど、ゆるめのパンツのシルエットなのでリラックス感があるバランスに。

ワイドなラップパンツを腰にひっかけるようにして履いた、絶妙なバランス感。

このゆるシルエットのバランス感秀逸！パンツの腰ではいている具合、Tシャツを少しだけパンツインしている具合がポイント。ヒール靴をはいて「ゆるいんだけど、女性らしさ」のあるバランス感にしあげている。

一歩間違えたら「ただのもっさりした人」になるところが、彼の場合は「確信犯的もっさり」に。その秘密はマフラーのかけ方、シャツのはだけ具合などディテールに凝ってる所にある。

P176
バランスの取りにくい6分丈パンツは、彼女のように長目のブーツをあわせるとまとまりやすくなります。

五分丈パンツと革靴で「良家の男の子」シルエット。ちなみに斜めがけバックは、彼女のように上目にかけた方が全体のバランスがよく見えます。

8分丈のフレアパンツに編み上げブーツ（この無造作な履き方！）を合わせるこのバランス感。「プロポーションを綺麗に見せるシルエット」に拘る必要は無い、ということが彼女を見ていると改めて感じます。

ロングコートにワイドパンツと全体的に重くてボリュームがあるシルエットだからこそ、足元に抜け感を出して軽やかに。8分丈パンツで足首を見せ、かつサンダルをチョイスして。

P177
この全体のシルエット！上半身をスーパービックにして、足元は細身に。ユニークなシルエットがモード感を強調している。

短め丈のMA-1にロングスカート。こちらもトップスが短いのでスタイルアップしてみえます。

ダウンジャケットはあえて襟を抜き、短めトップス丈の見え方にして。その分足が長く見え、スタイルがよく見えるシルエットに。

P178
Blackmeansの展示会。このブランドのミューズの彼女にたまたま出会う。撮らせてもらう。最近彼女がよくやるこのピースサイン。指の内側には「反核」「反戦」っ

てタトゥーが入ってて。伝えるべきメッセージ。受け止めるべき、メッセージ。

P179
ファッションにおけるupcomingが何かを嗅ぎ取るという意味合いに置いて彼女の鼻はとにかく豊かで確かだと思う。強さがある。

P180
多分私いま、お洒落な人を撮りたいっていうよりも、お洒落を心の底から楽しんでいる人を撮ることに興味関心が移っているんだと思う。ちょうど彼らみたいに、溢れちゃう位のファッションにおけるパッションを。なんていうか、ご飯で言うと話題のお店とかミシュランで星をとったお店をよく知る人と話したいというよりも（それはそれで素敵だと思うし、好きですが）「今日これ食べてね、すっごく美味しくってね！」って熱弁する人の話を聞きたいというか。知識の豊富さではなくて、情熱の強さに心が惹かれてる。

P182
消防士の彼。18歳で京都から上京してきたっていった。「火の中、めっちゃ熱いし息出来ないし、大変です。先輩に引っ張ってもらって、ようやくやれてる感じです。まだ全然ぺぇぺぇで」「火から出てきたら、命、やっぱ大事にせなあかんなって思った」命を救う人からのこの言葉。心にクッと入り込む。

P183
トム・ブラウンのスタッフの人達。このお店のお客さんのお見送り方は、毎度毎度にほれぼれする。お客さんとお外まで一緒に出て行って、買ったバックを相手に丁寧に手渡し、二人でそろって「ありがとうございました」って丁寧に90度にお辞儀をする、とてもゆっくりに敬意を込めて。お客様はバック片手にまた青山の街へと戻って。二人はゆっくり背を正す。改めて手を組み背筋をはってお客様の背中をずっと見守る。直立不動。見守る、見守る。それなりに距離のあるこの道程をずーっとずーっと見守って愛するお客様は通りを曲がって見えなくなる。それをしっかり見届けて、目をくばせ頷いて、二人はシルバーのドアの中に戻る。この一連はあまりにもドラマティックなので行く度にお店の対面にちょこんと腰かけまた始まらないかな、とかドラマを待ってるような気分で通りをきょろきょろしたりしている。私の最近の青山の楽しみ。

彼を見かけたのは今日が2回目。一回目、声をかけた時に「じゃあ、次あった時に…」とか言われてやんわり断られてた。で、たまたま偶然彼を見かけて。嬉しくなって、もちろんあたしは声をかける。「こんにちは！今が、『次会った時』です！」少し驚いてたけど、苦笑しつつ「じゃあ」って言って撮らせてくれた。関西弁まじりの話し方。「ギャルソンは、好きですねぇ。真髄です」って、そう言っていた。「真髄」。またすばらしく彼らしい言葉だと思う。

P184
今日は友達と一緒にショップクルーズ。「さっきBEAMSちょっと見て、これからもうちょっとブラブラするつもり」って。左の彼はこの春に社会人2年目に。「去年を一言で表すなら『社会』。今年は、『仕事』です。ちゃんと社会人としてしっかり仕事出来るようになりたいんです」って。

P185
渋谷、夜。駅前のフルーツパーラー。丁度この日は洋梨の季節。二人して洋梨のソルベを食べる所にばったり遭遇。1年365日にそれぞれの花があるように、それぞれの月に「誕生果」なるものがあるらしく、（各々の果物には異なるメッセージや意味が込められている）ちょ

うどこの月は洋梨だった。机の脇にちょこんとあった今月の誕生果の説明ボード。ほのかに甘い洋梨のくれたメッセージは「不屈の精神、夢」。

P186
厚底靴にサルエルパンツ、さんごの貝のネックレス。青参道で見つけたマダム。あわあわとしたパステルカラー、なのに強くてエレガント。こんな綺麗な女の人をあたしは今までに見た事がない。何をしてる人なのか、何をしてきた人なのか、興味津々、聞いてみたい事は沢山あったけどあえて聞かないことにした。次に会えるときの楽しみにとっておくために。

P188
大手ガス会社で働いている彼。アパレルの人かな、と思っていたら予想外のお仕事だった。「ファッション好きだし、将来はアパレルいこうかなーって学生時代は漠然と考えてたんですけど、記念に今の会社を受けたら受かっちゃって」いつもは手を真っ黒にしてお風呂の修理をしてるという。「こうみえても結構直せます」って言って口の端を上げる。将来やりたい事の欄に「最強メンテマン」達筆な文字。自分の目の前にある道を、選んだのは他ならぬ自分自身で流されながら進むのも、いっそ切り替えて追及するのも自分の気持ち一つの問題だ。自分の仕事に誇りをもって仕事をしている人は、それはもう本当に格好が良い。

P189
あたしはわりかし浮気な方なので世界のいく土地どちを大好きになると心から思うし、シンガポールにいればシンガポールが一番だと心から思うし、シドニーにいたらここに住みたい！って本気で考えだしちゃう、パリにいたらいたで「やっぱパリよね」なんて行く先々の街に浮気する。とはいえ原宿、自転車でいつもの定位置にのりつけて、街の喧騒と匂いを肌になじませるべくカメラをもって歩き出すとやっぱりこの街があたしの「帰る場所」なのだな、と思う。原宿では撮らせてもらう彼ら彼女らの人生におけるストーリーを撮影を通して時折に聴かせてもらう事がある。それは、日々の些細な事から大きな決断、ちょっとした悩みやこないだ起きたハピネスだったり。ファッションの、その奥にある人それぞれのストーリー。丁寧に紡いでいきたいな、と思う。この街の、ファッションのドキュメント。

P190
赤色、えび茶、からし色。日本古来の伝統的な色合わせをストリートなスタイルに昇華する。

P191
本当に驚いた。あたしたちは4年前に会っていて、彼はちゃんとその時の事を覚えてくれてた！学生の頃から、ずっとずっとコムデギャルソンで働きたかった。（そうり前にあった時も、ギャルソンの服を着ていたのだった）「何回も面接の書類を出してて、でもずっと落ちっぱなしで。でも4度目の正直。今銀座のドーバー（ストリートマーケット）にいます」追いかけて、追いかけて、追いかけてやっと勝ち取った夢。今までずっとギャルソンに入りたくて、そのブランドしか目に入らなかったし、それしか着れなかったけどやっと今落ち着いて他のブランドも見れるようになって、着るようになって。「お店に入った事で、今までよりも視野が広がった」って言葉が耳の奥に残る。もがいて、もがいて勝ち取ったからこそ、見える景色がある。解る事がある。新しい景色を目の前に広げ、彼は今、何を感じているんだろう。

美容師の彼。左の胸からは「unyierlding」ってタトゥーがのぞく。「『不屈の精神』みたいな意味を入れたくてこの単語にしたんだけど、外人さんに聞いたら、『この単

語は『頑固』とかみたいな意味で大体わかるけど、ちょっと違う』って言われて。ま、これも経験です。」ってタトゥーにまつわるちょっとおかしな失敗談をサラッと話す。「不屈の精神」って入れたかった彼のその理由が何だったのかは解らないし、聞かないけれど彼のその「不屈の精神」は培われてきているんだろうな、と以前より少し凛々しくなった顔立ちを見てそう思う。

P192
一つ一つパンチのあるアイテム、もしくは柄物だけど、何となくすんなりまとまってるのは彼女のもつ「上品さ」が中心にあるから。顔立ち、表情、それに背筋の伸びた立ち方、行動やしぐさのディテールがその人自身の内側の部分を映し出す。それは「表現」という能動的なものというより「漏れ出てくる」ような、無意識のものだと思う。ファッションは表現というより投影に、近いのかもしれない。

P193
火曜日はサロンがお休みだから、街にはいつもより多く美容師さんがいる。この日も火曜日、モデル探しに来た美容師さんを撮らせてもらう。朝から晩まで練習とかお仕事とかで大変そうだね、とかそんな話をしたら、「まぁ、そうですね。でも自分の好きなことやってますからね」ってサラッと応える。かっこいい。

P194
SOLAKZADEのお兄さん、愛する彼の女の子、まーちゃんと一緒に。「おきゃん」ってこういう子なんだろうなぁ、大きな丸い目はくるくるよく動いて(まーちゃんのこの元気な脚!もう靴だって脱げちゃってるし!)人見知り皆無で話してくれる。「はい、まーちゃん、カメラカメラ」てパパが言うとイーってにっこり顔になる。文句なしにカワイイ。

P195
素材の豊かさ、仕立ての美しさ、それに生地そのものの持つ気品。特に写真に落とし込んだ場合グレーで見るのが一番クリアに見える気がする。

P196
会う度に撮らせてもらう彼はアクセサリーブランドAlice Blackのデザイナー。夜の帳が下りる少し前、渋谷にて。「ついにお店、出すんです。Alice Blackと友達のK=labelのフラッグシップショップ。名前はニルバーナの曲にちなんで『come as you are』、ありのままで、って意味なんですけど」「すごいね!」どんどん前に進んでる。ちょっとそういうのは見てて惚れ惚れする。アンケートの後。「うっかり肩書きを書き忘れてて。「のりみくん肩書きどうする?」「あ、すいません。デザイナーと、あ、あとオーナーですかね」「肩書き増えたねぇ」「ね、これからもっと外に飛び出していかないと」「だねぇ」健全な野心、溢れるほどの克己心。それは周りを巻き込む力。

沖縄から上京してきたという彼女に約一年ぶりに会う。「今は、声かけてもらってバブルスで働いてるんです」前会ったときとすごく印象が変わってて、見違える。「メイク変わったからかなぁ」って飴細工みたいな声で話してくれたけど(声は以前に変わらない。可愛らしい、あどけない音だ)多分それだけじゃない。歩き方、振る舞いに「自信」が見えて「張ってた」何かがとれたというか。この街の空気に馴染んできて、「自然体」でいられる余裕が見える。ちょうどお店の休憩中。少し話して「じゃぁまたね!」ってあたしたちは別れる。季節の移り変わり、街の移り変わり、人の移り変わり。変わるものと、かわらないもの。

P197
5人を撮らせてもらった時実際全身の肌が一瞬ふわぁっと泡立ったりして。何て言うのか、「手ごたえ」というのはつまりこういう事かと。ニュージェネレーションはとても破天荒、と同時にちょっと不安になる位に繊細で。いずれにせよ私は彼らの存在そのものに、ファッションの希望を感じているのだと思う。

P198
原宿の大好きなヴィンテージショップのオーナー、ACCOちゃん。レディライクなヴィンテージのセットアップに、厚手の白T、頭の上にはミニタリーキャップ。彼女もぜんぜん違うテイストやアイテムをミックスするスタイルが唯一無二で会うたびに撮らせてもらってる。ファッションにおける、彼女のクリエイティブは実際最高だと思う。

P199
birthdeathのバイヤー、みちるちゃん。ひらひらと、薄いピンクのパジャマに頑丈なゴム引きのマッキントッシュ、ヒョウ柄の。「冬でも絶対タイツ穿かない。イヤだから」「最近買ったもの?あ、宝くじっすかね。毎年バラで3枚買ってんすよね、運だめし運だめし!」ほれぼれする、この男前女子。

デニムオンデニムのスタイルを私は一生好きだと思う。確か靴下やさんのお兄さん。

P200
男前女子
マニッシュだったりボーイッシュな女性には多面性という魅力がある。

P201
マニッシュなジャケットの着こなしに、さりげなくフリルや花柄があしらわれている所も心憎い!

P202
着こなしと良い、表情、ポーズの取り方すべてがすべて男前。

P203
紳士女子。ベーシックなのに目を引くのはやはり絶妙なサイズ感。ジャストサイズなジャケットとワイドなパンツのコンビネーション。

こちらも紳士的着こなし。パステルカラーだから紳士的ではあると同時に、柔らかな印象に。

上から下までマニッシュな着こなしだからこそ、逆に彼女の知的で聡明な女性的イメージが引き立って見えます。

だからこそ首元にあしらわれたフリルがなんともいえない素敵なコントラストを生んでいます。

P204
背広の上手に着こなした女性2人。きっちり着崩さず王道スタイルに着ているからこそ、元々持つ女性らしさというのが引き出されて見えます。

ボーイッシュな男の子の着こなし2選。洋服というよりも佇まいや、この片手を無造作に突っ込んだポーズに「かっこいい男性」性を感じてしまいます。

P205
カジュアルなセットアップにボリューム感のあるファーコート。足元は靴下で差し色をいれつつ、スリッパで抜け感を出す。

全身古着っぽいカジュアルでリラックスした着こなし。腰ではいたパンツの具合がボーイッシュ。

モードな長目のロングコートとカジュアルなパーカーの組み合わせ。さりげなく髪をパーカーにインしているところもポイント。

一見ボーイフレンドの服をそのまま着てきました的な、ストリート感があるボーイッシュでやんちゃな着こなしなんだけど、胸元やお腹の露出によって「女性ならでは」なストリートな着こなしに昇華されてる。

P206
1+1=∞
一人でファッション楽しむのも勿論ワクワクするけれど、仲間がいたらもっともっともっと楽しい!テーマに沿って着こなしてみたり、色をおそろいにしてみたり、アイテムをそろえてペアルックにしてみたり。NICE GROOOOVEな人達の着こなしのご紹介です。

P207
NICE GROOOOOOVE!着ている物はバラバラだけど、色味だったり柄だったりがそれぞれにリンクしてて。仲良し万歳!

P208
オレンジと黒。色味を統一させただけでも途端にグループ感がでます。アンニュイな表情もおそろいで。

P209
おそろいのTシャツを二人で!この街いも無いペアルック、ファッションを楽しんで(いや、ふざけてて)最高!

狙った訳ではないのだけれど、図らずも色味がかぶって結果グループ感がでて。

同じアイテム(ロングのコート)でのペアルック。シルエットがおそろい!

マダムが3人それぞれのお洒落をしてコレクションにやってくる。一人でいても目立つけど、グループでいるとより目立つ&ハッピー感がより増してる!

P210
同じブランドを着ているだけでなんだか「同志」感がでます。例え知らない人であってもすぐに仲良くなれる気がする。

それぞれでもお洒落だけど、二人揃うとよりお洒落度が増して見えるとはまさにこのこと!お互いがお互いを引き立て合ってる。

5人それぞれにさりげなく色味の共通項があって、仲良し具合が伝わる一枚。

着ている物に共通項はないのだけれど、90年代テイストが似ている二人組。

P211
個々人偶然おのがじしに歩いているにも関わらず、図らずも醸し出しているグループ感。色味を共通させるだけでグループ感は作ることが出来る好例。

一見バラバラだけど、よく見ると足元(靴とソックス)がおそろい。しっかりと繋がれた手に絆を感じます。良いカップル!

ナイスグループ感なマダム！ハットやスカーフ、ジャケットとアイテムをおそろいにしてアフタヌーンティー。最高！

テイストや色味はてんでバラバラな二人。ただ、好きなブランドがお揃い（この場合はJ.Wanderson）という共通項は二人の距離をくっと近づけてる。

P212
ジェンダーレス
LGBTQが個性として認められる時代になったからこそ、その個性は今「しとやかに心にしまっとく」時代ではなくて「ファッションでも表現する」時代になってきているかと思います。心と身体はつながっている。自分の心が望むままに服を着て欲しいなと思います。ファッションは自由だから！

P213
DIORからJ.Guallianoが去った際に、ショー会場に現われた彼。ファッションを通じて自分自身と自身の想いを、パッションの赴くままに表現しているところに感銘を受けました。

P214
このオーバーサイズ気味のジャケットとワイドパンツと重めでアクの強い着こなしですが、彼の柔らかな顔立ちがそれを中和している。

P215
もはや洋服って、女性の物、男性の物ってジャンルに分けること自体がもう平成的思想なんだなって思います。

P216
中性的な顔立ちの彼だからこそ、よりその『ノージェンダー』感が強調されている。

上だけ無造作に止め、片腕だけ袖を通したこの着方に注目！

自分自身の個性があればこんなクセのある洋服もしれっと堂々と着こなせます！

P217
「良家のぼっちゃん」的な着こなし。

あどけない少年のようなノーブルな顔立ちに、モノトーンのモードなスタイル。自分の魅力をよくわかっている人だと思う。

タイトスカートをこんなに男らしく無骨かつエレガントに着こなせる人がいるなんて！

自分の好きな物を好きな風に着ている人って、自由でのびのびしてて、見てる（撮ってる）こちらまで気持ちがよくなっちゃう。

P218
My favorite!
テイスト、バランス、色に柄。色んな要素がコンボで詰まった、「カテゴライズ出来ない系」の着こなしです。これだけ要素を詰め込んでも成立するのは、やはりその人個人の個性によるところ。また、キャラクターがたった人も問答無用でレンズを向けないではいられない。「人としての魅力があれば何着ても大抵かっこよくなるのでは…」と、そんなことを言うとファッションレクチャーをしているにもかかわらず本末転倒感ははなはだしいですが、つまりそういうことです。

P219
ぼろぼろのデニムに巻きスカートのレイヤード（この一部分だけ巻ききってなくて、インナーのデニムをチラ見せしてる、その巻き方もポイント！）そして首元はエスニックな大ぶりネックレス2つ重ね、足元といえばシルバーの靴、ストリート、エスニック、ヴィンテージ……色んな要素が混ざり混ざった見所満点コンポスタイル。情報量が多い分白のキャップで抜け感を作って。

P220
チェックのクラシカルなジャケットに花柄ワンピースの柄×柄スタイル……かと思いきや、よく見ると足元にはスポーティなレギンス（ヴィヴィッドな色味が差し色になってる）！ディテールを観察するに肩がけしたウエストポーチ、ちょっとフューチャーリスティックなサングラス……、クラシカル、スポーツ、フューチャーに見所満点、なによりこの混みいったスタイルを、男前マダムがサラリ着ているというそこに心を打ち抜かれました！

P221
モデルのHanneはいつも独創的で唯一無二な着こなしをしているので毎回撮らせてもらう人。素肌に直接着たコート（その上にクラフトテイストといっていいのかどうなのか、謎なウエストポーチ状のものをあわせている……！）に一歩間違えたら「巣鴨で買った？」といわれかねない柄のパンツ。そして真冬でも足元はサンダル。「アリなのか？ナシなのか？」のギリギリな着こなしに挑戦している人が本当にお洒落な人なのだと思う。なぜならファッションというのは新しい価値観を提示し、更新していくことで進化をしていくものだから。彼女はファッションを享受する側の人間ではなく、作っていく側の人なのだと思う。

P222
「ファッションというのは新しい価値観を提示し、更新していくことで進化をしていくもの」という観点で市井における着こなしを観察していくと、この二人はファッションを享受する側の人間ではなく、作っていく側の人なのだと思う。左はスタイリストのUrsina。右はご存じ先ほどのHanne。まずUrsina。ストリートぽいポップなフーディは大きめをチョイス、バックはラグジュアリーなシルバーのヴィトン、足元は迷彩柄のニーハイ、よく見たら太めパンツを強引にブーツインして！シルエットの作り方の独特さや、テイストのミックス具合の破天荒さ。自由な感性でファッションを楽しんでる！そしてHanne。ぼろっぽろなヴィンテージのフーディにエスニックテイストなコート、重めのロングコートに足元は90年代テイストの厚底靴。シルエットが大きく重めのボリューミーだからこそ、フーディの白が抜け感につながっている。それぞれ個性強めのアイテムをミックスしているのに「アリ」な感じがしてしまうのは、彼女の持つ独特＆強烈なセンス故。

P223
コルセット型のトップスを着こなす段階である程度お洒落上級者であるというのは自明の理ですが、彼女の場合はそれに輪をかけて色んなテクニックを盛り込んでる！まずチューブトップのストライプ×パンツのチェックの柄×柄。かつ、よく見るとパンツが透けててパンツ・オン・パンツのレイヤードテクニック。「裾を片方だけ出す」という着崩しテクニックも用いていて、一見サラリと流してしまいそうですが、よく見るとこれも見所満点なスタイリング。「何を着るか、ではなくどう着るか」を体現してる人。

これまた人を選びそうな、クセのあるというか「アリなのか？ナシなのか？」という疑問が頭を浮遊する柄のミッ

クススタイル（靴下がしましまソックスなのもポイント）。「適当にそこらへんにあるもの何も考えず合わせてます」的な一見ファッションに無頓着感が感じられるスタイリングですが、綿密な計算でもって色合わせや素材のチョイスがされているところがポイント。

スエット素材の上下（しかも単なるスエットではなくパンツがワイドになっている所もポイント！）にもこもこニットキャップ、首元といえばまたゴージャスな大ぶりネックレス。バックはクラシカルなかっちりしたものをチョイス。カジュアルでもありゴージャスでもあり、リラックスしているようで、ディテールにまでこだわっていたり……。見れば見るほど新しい発見が見つかりそうな探究心をそそるスタイリング。こういうの大好物です！

P224
アンニュイかつ強い目力があるので自然に目が惹きつけられてしまう。そんなミステリアスな魅力があるからこそ、例え色味が少し重くても、少しデカダンスを感じさせる着こなしであっても（下の彼女なんてコート引きずってるし……！）「な、なんかわかんないけどかっこいい！」と衆人環視されちゃうのでしょう。

P225
「人としての魅力があれば何着ても大抵かっこよくなるのでは…」という疑問にお応えします。ハッキリ言ってイエスです。この人は何を着ても、どこにいたとしても、何してたとしてもレンズを向けてしまう人。とはいえファッション、実は綿密な計算が。トップスとスカートの柄×柄、そしてブーツの長さのバランス感の絶妙さ（よく見ると靴下の色とトップスの色が呼応している、渋い紳士なのによく見ると袖が「萌え袖」になってるそのギャップ感もじわじわきます。

P226
「キャラ勝ち」っていうのはつまりこういうことです。個性を存分に活かした遊び心というかふざけ心があるチャーミングなスタイリング。

丸坊主にしたヘアカットにしても自分の魅力をよくわかっている人なのだと思う。彼女の魅力を最大限に活かす細身でロックなスタイリング。

P227
男に生まれて幾星霜、「枯れ感」が身につけばこの先いかようにも生きていけるのではないでしょうか……！このキャラクターがあれば何着ても似合うしどこに行っても引っ張りだこでしょう。ポイントは枯れ感があるからこそ、真っ白のシャツで清潔感をプラスしている所。

全身タトゥー！顔にもタトゥー！彼の場合もキャラクターがたっているので、例えどんな服を着てても撮るだろうな、というキャラクターのインパクトがあります。ボロボロなTシャツであったりわりと「綺麗か汚いかっていえば……後者？」的なスタイリングなんです。汚目スタイリングをするときは、上の枯れ感紳士同様「清潔感」というのはより大事になってくるかと。

P228
即戦力テクニック
つまるところファッションって人間性…、ってそんな言葉でくくる訳にはいけません。ここでは即戦力になる、つまりすぐ玄人感が出せる着こなしをご紹介します。
ENJOY FASHION！

P229
コートの着こなしその①は「コートはもはやアクセサリー」
まずはコート！コートは最早暖をとるものではなく、ア

クセサリー感覚で身につけるものだと割り切って。袖は通さず、両腕にさらりと引っかけるようにして身につける。ダウンコートの黄色の色味が良いアクセントになっていて、かつボリューム感が面白いシルエットを作り出して玄人感を醸し出している。

P230
コートの着こなしその②は「片肩はずし！」
「暖をとる物ではなくアクセサリー感覚で」と言われても流石に寒いものは寒い。そういう細に暖もある程度とりつつ、玄人感も発揮が出来る着こなしのテクニックがこの片肩外し。ガッツリ肩はずしました！みたいな勢いではなくて、あくまで「肩が外れちゃったけどそのままにしちゃった…」的なノンシャランとした態度で着こなして。

こちらも片肩はずし。ちょっと襟も抜いているところがポイント。

片肩外しのテクニックにより二の腕を少しだけ露出してセクシーさを加算。

ストリートテイストでも、このようにモードでも「片肩はずし」はテイスト問わず使えるテクニック。

片肩外しにより肩部分、そしてお腹の露出によって、スポーティテイストにヘルシーに露出を加えている。

P231
コートの着こなしその③は「ベルト使い！」
コートってボリュームが多い分、一回羽織ってしまうと、インナーを工夫する以外では、わりと着回しが効きにくいアイテムになりがち。そんな時に家の中で必ず一本は持ってるであろうベルト！コートやジャケットの上にベルトを巻くだけで簡単にシルエットの変化が臨めるんです。ベルトの太さ、巻く位置、しっかり巻くか緩めにふんわり巻いとくか…巻き方次第で雰囲気が驚くほど変わるので、是非色んな位置で「(自分が)しっくりくる」バランスを見つけてみてください。

定番アイテムのダッフルコートもベルトを巻くだけで新鮮な印象に。

ポンチョもベルトマークすることで新しいシルエットを作る事が出来ます。ドレープの効かせ方もポイント。

カーディガンの上にベルトを巻いて。お腹を見せつつベルトマークという、ありそうでいてないユニークなアイテムの使い方。

大きめコートをルーズに着こなす。あえてベルトもダラリと巻いて玄人感をだしてみて。シルエットがルーズな分、白いシャツでキリッと感をプラスしてバランスをとる。

P232
トップスにおける玄人感を出す着こなしその①は「ちょい入れ」！
方法は簡単、3ステップ！まずはトップスの正面のおへその位置、もしくは少しずらした場所を①つまんで、②入れて、③ちょっと出す(この③がポイント！)これによってやる前に比べてトップスのシルエットにドレープ感や曲線のシルエットが出来、これが「こなれ感」につながるんです。またウエスト位置が上になるので自然足長効果が出る。まずはトップスをつまんで、おへその位置、ややや右、やや左などなど色んな場所で入れる場所を試してみて！自分自身の身長だったり、体型だったり、またトップスの素材(薄い、もしくは厚手)によっても「自分にとってのいい感じの場所」は変わるので、まずは「考

えるより感じろ！(by ブルース・リー)」のスピリッツで試行錯誤することを「楽しんで」もらえたら！迷路には必ず出口があるように、「自分に似合うスタイリングを探す旅」にも必ず出口があるんです！出口に至る過程を含め楽しむ気持ちでファッションに向き合ってもらえたら！

P233
トップスにおける玄人感を出す着こなしその②は「シャツ片出し！」
シャツの裾問題。普段なら「総て入れる」or「全部出す」の「デッドor ダイ」、ゼロ100理論で考えてしまいがちなコンテンツですが、あえて半分だけ入れ(半分のまま)というグレーゾーンをつくる、換言するに「抜け感」を作ることで玄人感を出している。畢竟玄人感というのはつまり「突っ込みどころ」をいかにスマートにこなれた形でスタイリングに取り入れるか、ということに尽きるのかと。

アウターを腰に巻く、というのはスタイリングといえないほどに一般化されたコモンセンスといえますが……。実はこれこそ知れば知るほど奥が深い含蓄のあるテクニック。腰骨の方で巻くとカジュアルなイメージに、上昇し肋骨辺りで巻くと(巻きにくいですが気合いで乗り越えて！)クリエイティブなシルエットが出来るのでモードな着こなしに。

ゆるめのTシャツの裾を①ぐるぐる巻いて、②結(ゆ)わいて身体のプロポーションに沿わせたシルエットに変化させる。結わいた事でボディコンシャスなシルエットも叶ったり、お腹の露出も叶う。そのまま着るカジュアルなTシャツもいいけれど、ちょっと印象を変えたいな…というときにはこのテクニックはおすすめ。前に結わう、後ろで結わう、など結わう位置で印象が変わるので、気分に応じて場所を選んで見てください。

P234
足元における玄人感の演出は、ずばりシルエット操作！編み上げヒールの紐の部分をパンツに巻き込み、パンツのシルエットを変化させてみたり、はたまたブーツインしてパンツのシルエットを変化させる。いずれもストレートなシルエットから、ニッカポッカ風に「ぼわっと」足元に膨らみがあるシルエットに変化させている。今すぐ出来る、小さく些細なテクニック。テクニックを知る事で同じアイテムでも着こなしは無限大に広がります！

足元に注目。よく見ると右と左の靴の色や柄が違ってる。靴って面積的にはミニマルな場所だからこそ(コートやロングなスカートが締める面積のボリュームと比較すると、靴ってとってもささやかなもの！)これくらい振りきってふざけてしまっても良いと思う！ファッションはチャレンジ、あとは「ふざけ心」がが楽しむ秘けつ！

P235
着こなしにおいてはどうやって「抜け」や「はずし」のテクニックを熟知しているのかが「玄人感」を醸し出す鍵になるのかと。「玄人感」はセンスじゃなくて、ある程度テクニックで作れる！最後にご紹介させていただくのはこの一枚。ポイントは腰元。ジャストウエストラインではくのではなく、あえて少し落として腰のやや上辺りではいてみる。まずこれで、いわゆる「ジョガーパンツ」のシルエットを少し崩すことができ、ぴったりではなく「ゆるさ」がでて、それがこなれ感を表現しています。もう一つは、紐(ひも)はパンツの中に入れずに、あえてダラッと外に出しておく。この紐があることで「抜け感」がでてきて、モードな着こなしでも肩肘をはらないリラックスした雰囲気を演出しています。

P236
Small Stories #3
Scott Schuman
The Sartorialist

—スコットが撮る人たちはどれもエレガントやチャーミングを備えた人が多い印象を私はうける。被写体を選ぶ基準はどこにありますか？

うーん、好奇心に身を任せていると思う。いい写真には3つの要素があると考えていて、ひとつはひと、そしてライトとセッティング。私はスタイルやファッションを見る感覚が優れていると思うし、それは重要なことだけれど、ファッションはそのひとがどんなひとであるのかということは少ししか伝えてくれない。彼らのことは分からない。だからこそ、ひとが一番の要素になるんだ。そのひとのカリスマ。特定のひとを撮影しなくてはいけないフォトグラファーと違って、というのは、それが彼らの仕事だからだけど、私は有名であろうがなかろうが、お金持ちでもそうでなくても撮りたいひとを撮る。多くのひとは私が洋服を基準に選んでいると考えていると思うけど、私が本当に惹かれるのは、そのひとのカリスマなんだ。カリスマというと、目立つひとと思うかもしれないけど、例えばレイのように、小さくて、とても物静かで、キュートなひとで、派手でない。でも彼女はとても繊細で可愛らしい。私はそんなひとに惹かれるし、その魅力が引き出そうとしている。大勢のひとを撮影しないから、この人だと思ったら、時間をかけて魅力を表に出していく。時には、「オッケー！撮れたよ」といって、少し休憩してから、もう一度、彼らを撮影する。その時には彼らもリラックスしているから、もう少し本人らしく、少なくとも私が思うに、その人らしい写真になると思う。

—そのひとのカリスマに惹かれるということですが、もう少し具体的に教えてもらえますか？男性を選ぶときの基準で大切な要素は何ですか？

カリスマはとても重要。そして、スタイルのことを言えば、大切なのは、洋服のフィット感。そこが、ファッションのことを知らなくてはいけない点になってくるんだけど。なぜなら、スタイルの中でもジャンルによって、フィット感が異なるから。リック・オウエンスのフィットは、ドリス・ヴァン・ノッテンのフィットと違うし、ヴァレンティノやイタリアンテイラードのフィットとも違う。それが、おもしろいところ。私は、その人の好むジャンルのルックをとても上手におもしろく着こなしているひとを見つけ出そうとしている。異なるスタイルの異なる人々を撮影しているんだ。だから大抵は、「おっ！彼はリック・オウエンスのスタイルをしている。あの彼よりも、すごくうまく着こなしているな」と思ったら、彼を撮影しにいく。それは、彼が彼のバージョンのスタイルを、とても素敵に身に着けているから。誰のこともジャッジしないし、誰だってジャッジなんかされたくない。でも、私から見て、特定のスタイルを上手に着こなしているひとに気づくようにしているんだ。

—そのフィット感は、女性の被写体にとっても大切な基準ですか？

そう、同じことだね。男性、女性で撮影の仕方を変えることはないな。メンズウエアとウィメンズウエア共に働いた経験があるし、写真を見てくれるひとたちも同じくらい。詳しくいうと、女性が少し多いけれど、同じ基準にしている。

—撮影している際の信条(これは絶対貫いている自分のルールみたいな)にしていることってありますか？

これっといったルールというのはないけれど、40年は続けたいと思っている。その頃には、78歳。78歳まで撮影を辞めるわけにはいかない。私の夢は40年という期間のスタイルが集大成となった写真のカタログを持つこととなんだ。78歳になった翌日、座りながら、今まで行ったすべての場所で撮ったすべての写真を見返すのをとっても楽しみにしているんだ。新しい写真集を全編インドで撮影したのも理由のひとつ。スタイル、ファッション、文化的なファッションを含め、あらゆるものが混在するという考えがとても好きだから。だから、信条といったら、ただ続けることかな。マラソンのように、ただ突き進まないといけない。

—スコットはストリートスナップのパイオニアです。いつも楽しんで撮影してるなぁって思うんだけど、そのモチベーションを維持するにおいて何か秘訣はありますか？

ありがとう。うーん、モチベーションを保つ秘訣は、自分に挑戦し続けることだと思う。インドの写真集を作りながら、戻ってきて、今度はメンズウエアの本を製作するというのは、非常に大きな変化。マラソンのように、長期間やり続けるには、自分に挑戦しなくてはいけないし、写真を見てくれる人々にも挑戦しなくてはいけない。自分がどんなひとで、どんなことをよく行うかってことが分かってしまったら、特にインスタグラムやソーシャルメディアでは、見るひとも飽きると思う。人々が関心を持つように、「何だろう？」と思わせ続けなくてはいけない。突然、インドから写真をポストして、次はファッションウィーク、そしてコペンハーゲンというように。興味を持ち続けてもらえるよう努力するというのは、男女の付き合いと同じようなことだよ。

—何がストリートスナップへのモチベーションになっているのでしょうか？

自分の写真を見て、「違う！ どうすればもっとよくなるのか？ 違いをつけるにはどうすればいいのか？ もし、ドリームカタログを作っているのであれば、まだやってないことは何なのか？」。そして、撮影に新しいニュアンスを加える。ファッションウィーク直前の今は、フラッシュをもう少し加えてみたいと試行錯誤しているところ。微々たる変化だけれど、写真上では違うし、室内でも外でも撮影できる。私の場合、歴史的なフォトグラファーの写真を見ることはあっても、ほかの人々を見ることはない。もし、ほかの人々を見ることはあっても、大体は自分で自分自身の作品を見る。もっと「改善したい点は何か？」「どうすれば異なる風に撮影できるのか？」というように。

—一週にどれくらいストリートスナップをしているのでしょう？（まぁ時期にも寄ると思うけど、例えばオフコレクションのシーズンとか）

毎日撮影するようにしている。写真集のプロジェクトが重なったら、毎日は出られないけれど、外出するのが好きだし、撮影がフォトグラファーの仕事で一番好きな部分。昨日もスナップしたし、今日も後で撮影したいなと思っている。そうだね、ほぼ毎日外で少しは撮影している。

—ほぼ毎日カメラを持ち歩いているんですか？

いや、撮影したいなという時は決めていく。誰かに喜ばれるためでもないし、エディターに写真を提出する必要はないから。撮影への心持ちが整った時に撮影するんだ。自分が求めている世界が見えていて、想像できて、瞬間に集中することが欠かせない。常にそんな状態でいるわけではないから、気分が乗らない時は撮影をしない。でも、たいていは撮影したいと思う。外に出て、す

べての条件が整った一瞬のロマンスを捉える。この仕事を生業にしていることがラッキーだと思う。私にとっては、決して難しいことではないからね。

—一瞬のロマンス、瞬間に集中するという表現、とても素敵ですね。

そうだね。10代の娘が二人いるし、若い女性たちと多く仕事をしているからかな。オートミルクとか、（メディテーションで使われるような）瞬間に集中する、いまを意識するといったキャッチフレーズをよく聞くから。50歳の男でありながら、心は基本的に18歳の女子。だから、レイとも気が合うんだな。私たちは若者で、精神年齢も若いからね（笑）。

—世界中で撮っていると思うのだけど、（多分ミラノだと思うけど）一番撮影していて好きな街は？ またその理由は？

そうだね、ミラノでの撮影はもちろん、ミラノにいることも、イタリアならどこにいるのも大好きだな。イタリアからのバケーションから帰ってきたばかりだし。ただ、ファッションウィークの開催地が、ひとつの都市からまた別の都市に移っていくという流れに魅力を感じる。スタイル、食、街並み、家具とすべてがまったく異なる。常に変化することが好きなんだ。ファッションウィークで撮影して、写真集のためにインドに行ってというのは、すごく楽しい反面、時に疲れる。パリからインドはかけ離れているから。でも撮影するどんな街も好きだよ。ただ、一番居心地がいいのはミラノとニューヨークだね。ミラノはスタイルの種類は限られているけれど、奥深い。一方、ニューヨークは、もっと幅広いけれど、スタイルについて言えば、浅い。ヴィンテージスタイルをしているひとがいたとして、あまり多くないけれど、時には、とてもおもしろい着こなしをしているひともいる。ニューヨークにはさまざまなバリエーションがある。ミラノは一般的にみんなが2、3タイプのスタイルをみんなが着ているから、その分、各々のバリエーションが豊富で深いんだ。

—東京にも何度か来てくれたと思うけど、東京のファッションについてどう思いますか？

とてもいいと思う。ただ、ニューヨークから東京に行くには距離もあるし、ヨーロッパに行くほど気軽ではない。だから、いざ東京に行くとなると、さぞかしクレイジーなものを見られるんだろうと、期待が膨らむ。東京のファッションはいい。でも驚くほどではない。日本がファッションにおいて存在感を示したのは、コム デ ギャルソンの川久保玲や山本耀司がほかの誰もやっていない日本独自のスタイルを創り上げた時だと思うし、それは非常に尊敬している。その試みは、誰でもなく日本だからこそできること。驚くべきものになりうる。アイデアを生み出したからこそ、そのスタイルに驚きがあるし、見る者の不意を突くことができる。なぜなら、そのルックを創造した張本人で、誰よりもそのスタイルを理解しているから。一方で、東京でイタリアンルックや英国風スタイルをしている人を見ると、とっても正確すぎて、驚く余地がない。だって完璧だから。スタイルの中に、もっと自分らしい解釈を含めた時、その着こなしは素晴らしいものになると思う。

—東京のストリートキッズについて思う所をきかせてください。

カップルを撮影したことがあって、彼らはとってもクールだった。でもニューヨークでもどこでも同じことで、ニューヨークでさえも、あまりストリートキッズを撮影することはない。私はすごく選り好みするから。きっと撮影方

法の違いなんだ。例えば、ビル・カニングハムのように、彼はその場所にあったものをドキュメントした。彼はそこにあるスタイルを伝えたかった。レイも少し似ている。ストリートスナップをする多くの人は、ありのままを伝えたいと思っている。一方で、私のアプローチはもう少しロマンティックな方法。だから、好きなものしか撮らない。私のインドの写真集であっても、インドの地域を網羅した写真であるかはまったく気にしない。インドの百科事典でもないし、現地の全部のスタイル、すべてがわかるものでは決してないんだ。身構えて、好きなものを撮影しただけ。ただ異なるものを受け入れる視点は持っている。私の写真の強みは、特定の何かを探さないということだと思う。素敵な着こなしをする老人を撮影するのは、その人自体を好きだったから。ただ歳を重ねていただけ。ストリートキッズを見ても、「おっかわいい！ ストリートキッズだ」ではなく、その特定の人がしているスタイルが好きだから。その中でもほかの子は好みではなくて、たった1枚の写真しか撮らないからもしれない。だから繰り返しになるけれど、リック・オウエンスのスタイルを上手に着こなしているひとはわかるけれど、そのほかのひとたちには興味を持てない。なぜか反応しないということに通じる。ストリートキッズのスタイルも理解しているけれど、どこでも同じように、「そうなんだ、オッケー」という程度。難しいのが、ストリートキッズのスタイルはすべて似ているということ。2冊目の写真集でも書いたことだけど、スタイルは自己表現、そのひとを表すというけれど、私は多くのひとにとって仮面だと思う。何であれ友達みんなが着る流行のスタイルに隠れるように。「うん、みんなと一緒だよ。見て、みんなと同じような格好をしているでしょ」というための仮面のようなもの。本当はそういうタイプの人間ではないかもしれないけれど、それが友達になりたいグループのスタイルだから。スタイルは必ずしも本当の自己表現だとは思わない。仲間に入るための仮面にだってなり得る。

—そうですね。仮面にもなり得る。特に日本では、シャイというか、自分をさらけ出すということに躊躇するひとも多いかもしれない。

だから、若い世代の多くのファッションはあまりおもしろいと思わない。繰り返しだから。一方で、とてもかわいいなと思うのは、2つの世界の狭間で揺れ動きながら、自分を見つけ出そうとしている子たち。例えば、サッカーとパンクが好きな子がいて、二つの要素が混在した着こなしをしてしまう。自分がどっちなのか分からず、少し困惑している。こっちの世界とあっちの世界のものを少しずつごちゃ混ぜに着こなしてしまう。そんな子たちの方が、100%ひとつのスタイルを追求している子たちより、ずっとおもしろいと思う。

—他の国や街に比べての特徴や違いは？

うーん、緻密さへのこだわりかな。誰もが日本について言っていることだけれど。とっても正確。ある時代の特定のデニムを欲しいとか、スーツを着た時にイタリアの男性がするように襟を立てたいというひとがいる。ただトリッキーな問題なのが、それがどう見えるか？。1860年代のデニムを持っているかもしれないけれど、履いた時にどう見えるのか？ 多くのひとが鏡を見ながら、「これどうなの？」と確認し忘れている。こういうスタイルに興味があるんだということは伝わるけれど、「ちょうどいいバランスなのか？」「似合っているのか？」を見過ごしているように思う。よくあることだけど、スタイルについての知識が豊富なだけに、日本では少し多いかなと思う。ニューヨークやイタリアは、とにかく美しい姿、シルエットを重要視している。少なくても、自分に似合う質の良いものを持ちたい。一方で、多くの場所では、たくさんの洋服をほしいと思うひともいる。見え方というより、

洋服のストーリーや背景を大切にする。それは必ずしも悪いことではなくて、ただ、東京のストリートスタイルについて言えること。と、以前にオンワード樫山の仕事をしていたんだけど、彼らは、時々、「もういいや！ 型破りでも、ただ好きなことをするんだ」と決心したら、社会のルールから外れたひとたちと見なされるんだと言っていた。でも「常識の枠なんかにとらわれない。自由に、自分らしくあろう」と決めたひとたちは、個性的なスタイルをしているし、とても美しいことだと思う。

—東京の「都市」と他の都市はスコットにとってどういう印象？

まだ妻のジェニーとハネムーンに行っていないんだけど、彼女が行きたいのが東京なんだ。魅力的な都市だから。大体の都市に行くと、みんな「あぁ、忙しい！」と言っていて、ミラノに行っても、「忙しくて、慌ただしいから、ミラノから出ないと！」なんて言うけれど、私にとっては、ミラノはだいぶリラックスしているように見える。ロンドンだって、ニューヨークに比べれば落ち着いているし、ニューヨークはテンポが早い。パリも少しそうだけど、東京がニューヨークのエネルギーに一番近い。そこがいい。しかも、ぜんぜん異なる点もいい。日本人が持つ尊敬、運転手が白い手袋をして、タクシーのドアが自動で開く、そんな風にひとの思いやりや伝統への敬意に魅了されているんだ。伝統への敬意がありながら、さらなる進化を求めるというのは素晴らしい対比。だからこそ、緊張感があると思う。ほかにもいろいろあるね。食べ物が美味しい。東京で食べた果物より美味しいものは食べたことない。東京のホテルで食べるまで、メロンなんて好きじゃなかったんだけど、一口食べた瞬間、「あぁ、こうでなくっちゃね！」って。マンゴーも、あぁ絶品！ フルーツを食べるだけでも日本にまた行きたいよ。信じられない美味しさ！ 美しい文化だし、なぜ多くのイタリア人が日本を好きで、逆に日本人がイタリアをとても好きな理由が分かる。どちらも歴史に深い敬意があって、形式美を重んじる。東京は素敵な場所だと思うよ。

—ファッションウィークについて聞きたいです。年を追うごとにストリートスナップシーンはヒートアップしてる（しすぎてる）気がします。以前にくらべてとっても沢山のフォトグラファーが会場にいたりして。それに関して思う所を聞かせてください。

年を追うごとにヒートアップしているかは分からないけど、しばらくそんな感じが続いているよね。ただ、私はちょっと向き合い方が違うと思う。多くのフォトグラファーは、横に並んで、グループのように陣取って撮影をしている。繰り返しになるけれど、私がほかのフォトグラファーと違うのは、彼らには課題があること。「特定のひとを撮らなくては」とか、「ちょっと変わったひとを撮影しないと」と感じている。結果、みんなが同じひとを撮影している。一方で、私は、少し違うことをしているひとを見つけようと控えているんだ。指示にあるひとを毎回何度も撮影しなくてはいけない新米フォトグラファーも多くいると思う。それはつまらないからやる気を失ってしまうよね。私は、光も美しくて、好みの格好をした男性や女性が現れた時だけ撮影する。それに、いつも、誰もが狙っていないような、みんなが見逃してしまったようなひとを探そうとしているんだ。だから、その流れに巻き込まれていないね。ただ、悪い点とすれば、多くのひとが、私のことをなんか距離感があって、あんまりナイスじゃないなと感じていると思う。でもそれは、自分はそのシーンにいないだけ。多くのフォトグラファーにとって、お互いはファミリーのような存在でいつも集う仲間。でも、ただ私は違うアプローチをとっているだけなんだ。ヒートアップした状況に巻き込まれてもいない。その中で撮影していきたいなら、きっと穏やかに問題ないのかもし

れないけれど、もしその人々や状況に左右されてしまうとしたら、大変になってくるよね。

—スコットにとってストリートスナップの魅力は？

どこも素晴らしい都市。ミラノ、パリ、フィレンツェ、ロンドン、そしてニューヨーク。ほかにもいろんな都市に行くことができる。最近はコペンハーゲンにも行っているけど、とっても素敵だよね。いいホテルに滞在して、いい生活だよ。続けることに何の問題もない。魅力的な都市で、さまざまな食事を味わったり、撮影の合間には美術館にも行ったり、それぞれの文化を体験することもできる。ショーの間にショップや本屋で買い物をするね。ファッションウィークに行く時は、ニューヨークで撮影するように、ただたまたまファッションショーだったって思うことにしているんだ。少し違うのは、数多くのショーに行くから、ニューヨークに比べ、少し予定が詰まってしまうということ。でも、好きなことをしているし、いつでも準備万端、幸せなんだ。

—ファッションウィークの準備のためにいつも行う習慣はありますか？

あるね。今はクッキーとか食べないようにしている。ファッションウィークダイエット。夏の間は、仕事もせずに夜な夜な出かけて、マルガリータ、チップにサルサ、パーティと楽しい夜を過ごしていたから、今は、体重を戻さないと。エクササイズやワークアウトもしている。撮影は体力勝負だからね。たくさん歩くし、疲労困憊にならず快適に動き回れるようにワークアウトに専念している。あとは、洋服選び。ファッションはもちろん、ショーに行くことや、新しい洋服をコーディネートするのも好きなんだけど、難しいのは、そのコーディネートで、撮影できるかということ。運転手付きの車からハイヒールを履いてショーに向かうわけではないから、着心地がよくて、動きやすく、その格好で撮影できないといけない。だから楽しいチャレンジだよね。その中で洋服を決めるのが好き。あと、ジェニーもショーに一緒に行くんだけど、彼女はいつも素晴らしいスタイルだから、彼女のルックを一緒に考えたりもする。あんまり食べないからお腹は空くけど、それ以外は楽しいよ。

—スコットにとってファッションの魅力は？

常に変わるということかな。スポーツのように。これは個人的なファッションへの捉え方だけど、何かの着こなし方が分かったかなと思ったら、次に移って、また次へと絶えず自分の見方を調整していかなくてはいけない。常に変わっていく。色、パターン、素材、技術、マーケティング、写真とアートといった異なる要素が備わっている。幅広く異なる要素を兼ね備えるファッションが好きなんだ。豪華なパーティやモデルより、ファッションのアート性や技術性に興味を持っている。普段は紺色を身につけることが多いんだ、それは自分に似合っていると思うから。ただ、プラダやドリス・ヴァン・ノッテンといったらブランドのショーで、美しいカラーやパターンを見るのが好きなんだ。ランウェイを見て、ストライプにカモフラージュ、紫色のスカーフを合わせたルックを見て、「今のは一体何なのか？」ってね。そんな要素を美しく混在させる人々が、また見たいと思わせる。決して多くはないけれど、素晴らしいデザイナーがいる。そんな類まれなる才能を持ち合わせたひとは、「どうやってこんな素敵な組みあわせを考えられたのか？ なんで自分では思いつかなかったんだろう？」と思わせてくれる。それが、ファッションの魅力だと思う。

—今興味がある、ひと、もの、ことは？ それぞれ教えてもらえたら嬉しいです。

インド。インドの写真集はわりと長いプロジェクトだったけれど、とても楽しかった。今は、メンズウエアの本に取り掛かっているんだ。メンズウエアの歴史を勉強しながら進めていて、とても順調だよ。あと、常にスポーツに興味がある。仕事が重なった時のある種の息抜き。エクササイズしている時には、野球やスポーツ番組を聞いているよ。まったく異なる世界だから。それに写真とアート。歴史的なものを振り返るのが好きなんだ。そして旅。いろんな場所を訪れるのが大好きで、特にミラノはいい例。誰もがパリやロンドン、ニューヨークの歴史を知っているけれど、ミラノの歴史は知られていない。住んでいるひとでさえもよく分かっていないが、素晴らしい都市なんだ。豊かな歴史がありながら、ミステリアスな雰囲気が漂うミラノやジェノバ、トリノなど首都以外の街で建物を巡るのが好きなんだ。少しずつしか街の全容が見えてこないから、街の歴史を学ぶには、もう少し根気がいるんだ。

—インドの写真集を出版して、今はメンズウエアの本を製作中ということですが、内容を少し教えてもらえますか？

あまり写真集っぽくないんだ。今までの本は写真中心だったけれど、今回は、もう少し文章を増やしているから、ちょっと大変。私が文章を、妻のジェニーがイラストを担当している。だから、ある意味、もう少しインスピレーションと教養のある内容。ジャケットはどんなフィットであるべきなのか、背が高い、低い、体格がいいといった体型なら、どのような着こなしがいいのかといったことを語る予定。写真集だけど、もう少し教養を増やしている。どちらがいいか悪いかはわからないけれど、今までとはちょっと違うんだ。私にとってはチャレンジだけど、きっとおもしろいことになると思うよ。

—たくさんのことにチャレンジされていますが、今後やりたいドリームプロジェクトは？

重複になるけれど、私にとって、（写真を撮ることは）マラソンなんだ。だから、ドリームプロジェクトといったら、40年間写真を撮り続けること。15年が過ぎたから、あと25年。40年の終わりに椅子に座って、「ふーん」と写真を見返すこと。なぜなら、写真を見て、「わぁ、これは全然違うな。この時代って、こんなに違かったんだ」と思うようになるには40年くらいかかるから。70年代が今とまったく違うように、といっても、私はその時代を生きていたから、あまり驚きを感じないけど。でも、80年代は若い子たちにはとても新鮮に映ってきているはず。アシスタントのレイチェルだって、80年代はクレイジーだって思っているはずだよ。私はもちろんその格好をしていたから、あまり違いを感じないけれど、やはり時間がかかる。すでに自分の写真を見て、街の背景が様変わりしたなと思うことがあるよ。ラファイエットストリートで撮った写真の場所は、ガソリンスタンドだったけど、今では高層ビルになっている。そんな風に街が、インドなど国が変わったという様子を見るのもきっとおもしろいと思う。時を経てでしか、そこには辿り着けない。だから、私のプロジェクトは写真を撮り続け、自分がやってきたことを誇れる写真の集大成を手にすることなんだ。

Scott Schuman
2005年に自らが撮影を務めるファッションブログ『The Sartorialist』を立ち上げる。単なるファッション写真にとどまらず、被写体との間で対話が交わされた様な独特な作品は世界中で話題に。以降GQ, Vogue Italia, Vogue Parisにてインタビューが特集され、GQに3年以上に渡り写真家兼編集者として活躍。作品はV&Aミュージアム、東京都写真美術館の常設コレクションに所蔵されている。

285

P244

「このレザージャケットの刺繍、なんか和柄の花っぽいから（こういうのって珍しいよね！）、KENZOの派手なパンツにしてみたわ！」盛るときはとことんまで突き詰めるのがせいさん、私が大好きな代官山のヴィンテージショップEVAのオーナーの彼女。

静岡出身の彼女はモモちゃん、大学生。この4月に上京してきたと言っていた。「自分自身がしんどい時、服に救われたんです。だからあたしも、服の楽しさをもっとみんなに伝えていきたい、って。ブログだったりSNSだったり、自分のもってる手段を通じて」彼女の「しんどい」が何時だったのか、何が理由かは聞かないし言わないけどとても底の深い、深いものであったのだろうな、というのはサングラスの奥の瞳がほのめかす。「レイさん、あたし今も、お金ためてるところなんです。長期の海外留学したくて。エステティシャンのバイトを友達の紹介で始めたんですけど、今2ヶ月連続売り上げナンバーワンなんです！毎日は忙しいけど、すっごく楽しいです！」あどけない声で、でもキッパリと。やりたい事を全力投球でやっている人は「忙しい」は「楽しい」と同意語なのだ。

P245

骨董通りのジャケット・オン・ジャケット。ありきたりのモードを「ふざける」スタイル。とりあえずファッションにまつわる諸々を彼は一巡ぐるりにやりつくしちゃったんだろうな、と想像をたくましくして考えてみたり。何となくだけど今のファッションにおける一つの気分って「はずす」というよりも「ふざける」、みたいな所かな、と。正解をあえて「はずす」からこそ正解が際立つ、つまりは亜流の正解を着るって気分ではなく、もう、正解自体が気恥ずかしいからいっそふざけてNGにしちゃうような。よしんばNGだとしても、いいじゃんそれのが面白いじゃん、的な。何かまだ上手く言えないけど。

P246

99%IS-のショーで撮らせてもらった二人組「自分らしさ」が素直ににじみ出たピュアなファッション。つまり、自分と向き合うことのできる人ゆえに出来るファッションだと思う。とても、とてもそれは強いことだ。確かにこれは夜の国立競技場、ビールをいっぱいひっかけながらショーが始まるその時をゆらりと待っているところ。

P247

好奇心およびパッションから始まったプロジェクト。あたしの愛するこの街のファッション・アイコンは、サルヴァトーレ・フェラガモのアイコン・シューズをどう調理するのか。一番に思い浮かんだのはACCOちゃん、大好きな原宿のヴィンテージショップ、lochieのオーナー。「これね、ヴィンテージの水着なの！水着とか、水泳用の帽子の昔のって結構凝ったデザインがあって、かわいいの。だから街で普段着としても着たいなぁって。」ふわふわのチュチュにカチューシャにザバッと引っ掛けて着たメンズ仕立ての大きなコート。例えば何かをカテゴライズすると、意味や用途を明確化できる。不特定多数の人たちに、そのものが伝わりやすくなるのだ。（商品として捉えた場合、売りやすくなる、とも言える）。だけど反面それは「制限」でもあり、意図する以外の使い方、可能性を狭めることにもつながってくる。メンズなのかレディスなのか、インナーなのかアウターなのか水着なのかそうでないのか、そういったカテゴライズは彼女の見立てを前にするといったんすべてがリセットされる。スーパーフラットなまなざしで平等に「もの」を見る力。あたしが彼女を好きなのはそういうところだ。この街随一の目利きの選んだのはサルヴァトーレ・フェラガモの長女が作ったVaraのシリーズ。ほっそりとしたおやかさのあるシルエットは78年の誕生以来世代を超えて愛されてる。ピカピカとしたパテントの黒地、ルビーみた

いな赤色のリボン、ヒールの部分もルビーの赤色。

こうきくん。Choki chokiって雑誌の読者モデル（そういった彼らのことをKingというらしい）さんでこの日は撮影が終わったあと、モデルの友達とばったり表参道で会ってそのまま街で立ち話。街路樹のスツールに腰掛けて、立ち話（座り話？）にちょっとだけ混ぜてもらう。彼の敬愛するカート・コバーンのオマージュとしての冬のスタイル。「カートだったら、多分絶対冬はコートとか買って着るとかじゃなくて、そこらへんにあるもの適当に重ね着で寒さをカバーしてたんじゃないかなって。」枯れ草色のモヘアのカーディガン、ナンバーナインのぼろぼろのマフラー、ヴィンテージのデニム、コンバース。純粋に憧れゆえのファッションはなんて正しく、ふさわしく、そして共感をうむんだろう。こうきくん。ファッションと、カートコバーンが大好きな男の子。

P248

お母さんのお下がりの浴衣、パリ、蚤の市でかった帯留め、アジアンショップでみつけたかごバック。何を見て、何を感じて、何を選んできたかの軌跡が自分の身のまわりを振り返ると見えてくる。周りにあるもの、近くにいる人、そして今自分が着てる物。それは日々の選択の結果。ファッションは自己表現という言い方よりもファッションは自己投影という言い方の方がここ最近は何となくふさわしいような気もする。「表現する」というアグレッシブな行動というより図らずも「にじみ出てしまう」静かなもの。結果としては同じ事なのだけど。

P249

KOBINAIというブランドのマイミちゃん。（何というか「力の入り具合」の垣間見えるナイスな名前で私はそれを健やかでとても頼もしいと思う）※ブランド名KOBINAIは「媚びない」をローマ字にしたものです。いっぱいいっぱいぐるぐる考え、強い思いと熱いメッセージが彼女のクリエイションには込められていて、なんだかそのまっすぐな心意気は私の気持ちも正してくれる。常識で動いたり、周りの空気を読む前に（そして小さく諦める前に）自分が何を思うか感じるか、つまり「自分の意見」をクリアにしてからどう行動するかを決めるらしい。将来やりたいことの欄。「メッセージを伝え続ける」としっかりとした文字で。

「冬でもコート絶対着ない！だって『今日の私のこのスタイリング』を見せたいのに、コートとか着ると隠れちゃうじゃん！寒いけど、でも（服を）見せたいって気持ちの方がはるかにはるかに勝つから！」って。冬の始まり、寒い一日。筋金入りのファッションギークは愛おしい。

P250

CLANEのデザイナー、エナちゃん。エナちゃんの関西まじりの喋り方をあたしはけっこう好きだったりする。「いやレイさん、あたし行動範囲全然狭いし表参道って、あんまり実は来ないんです。でもな、ヒルズに初めてうちのお店が出来るから多分これからこの街に新しい思い出、刻んでいくんかなって思います。」前を見ながら、そう話す。

251

彼女が履いているのはヴィンテージのブルマー（！）。そうだ、確かに水着は泳ぐときにしか着てはいけないという法はないのだ。固定概念にとらわれない彼女の着こなし。

レナさん！スタイリストの彼女は「モード」が見事なまでに日常にサラリと溶け込んだ人。東京でこういう人を撮らせてもらう事って、実際滅多になかったりする。

P252

青山、骨董通り。Wut Berlinのショーの後。このショー。沢山のストリート・ファッショニスタが集まってて、ショーをみて、こころから感動してるキッズや心のとある点に、火をつけられたクリエイター、ファッションを純粋に好き！って人たちで溢れてて、骨董通りは珍しくにぎやかだった。

P253

シェンちゃんは、ファッションをこよなく愛している（彼女のファッション熱の強さといったら！）。と、同様にシェンちゃんはファッションから愛された人だと私は思う。

モデルさん。マレーシアから来たと言ってた。話をすると「あなたがレイなの！あなたが出した本を今探してるけど見つからないの」って言ってくれて、なんだかそれはすごく嬉しい言葉。

P254

原宿にはユニークなお店が沢山ある。個々もその一つ。アポイントメントオンリーの、ヴィンテージのアイウエア&ジュエリーショップ、SOLAKZADE。ワントーンスタイル&レッツおそろいでガッツリ決めたハンサム2人はそこを営む岡本兄弟。一人でいても目立つけど、二人でいるとさらに目立つ!!

麦わら帽子にリボンタイ、レザーの着物、わに革の帯、シルバーのブーツ。ファッションを好きになって、追い求め始めた当初の破天荒さと、ファッションを追求し続け到達した先の破天荒さ。ファッションを遊んで遊んで遊び倒して行きついた紳士のおめかし。着るものは、着る人を映し出す。

P255

渋谷のbirthdeathのバイヤーのみちるちゃん。ニットのジャンプスーツにギャングなバンダナ、そしてハンドマフ。アイテム一つ一つを紐解くと、季節感もテイストもバラバラなのに、この統一感&完成度。あらゆるジャンルの中から自分の感性に従って、好きなものだけを拠りぬいた結果がこのオリジナリティ。ファッションにおける自由を謳歌しているスタイルダと思う。

ふわふわのファーのハットはmonomania、夏だからこそ、のファー使い。撮影のあとに書いてもらうアンケート。「今ほしいもの」の欄で筆が止まる。「沢山あるはずなのに、考えるとかけなくなりますね～」って。

P256

代官山でカフェ&バーを営む紳士は今日はネットで買ったヴィンテージ、ダブルのセットアップ。1930年代から40年代の服が好きな紳士は言葉を慎重に選びながら、（思ったこと、感じたことをそのままに、ではなくてエレガントがある単語に置き換え伝えることを楽しんでいる趣がある）穏やかに話す。背筋はいつでもまっすぐだ。手書きで書いたお店のライブイベントのチラシもくれたりして（またこれも、言葉使い、旧字をあしらってたりなんかしてレトロな風情なのだ）自分の愛する世界観―エレガントな古きよき時代―を軸に生きている人なのだなぁ、と思う。「美意識」は行動の規範、そして人生の軸。撮影の後、さよならしてから気がつけばわたしまで、ふと背筋が伸びていた。書いてもらったアンケートを読み返しながら、自分の「美意識」のあり方を考える。

P257

あたしは昨日、大正時代から続く呉服屋のおじさんと話をしてて。「今年の浴衣をどうしようかしら」なんて相談から、次第に話はファッションへと移り変わる。3代目の旦那は「ファッションは自分のためじゃなくて、そこ

にいる、周りの人のためのものでもあるんだよ。浴衣も着物も夏は着てるぶんには暑いけどさぁ、納戸色の浴衣とかさ、そういったのをノンシャランと着流してる人がいたらさ、見てて涼やかな気分になるじゃない。着るってのは、自分のためだけじゃないんだよね」っていきいきと話す。歌舞(かぶ)くってことは、自己満足のその前におとなしく、そして奥ゆかしくに佇んでいる「配慮」なのだ。周りの人たちに対しての、そしてその場所、イベントにおいての。見る、見られるの関係性。ファッションにおいては切っても切り離せないもの。その関係性を尊重することはファッションのその真髄を守ること、ファッションの奥深さを噛みしめ味わうことだって、東京代表ファッション・ファッションアディクトな彼を見るにつけあたしは思う。

P258
ブルーのニットキャップに半袖トレンチ、確かWut Berlinで行われたショーに行った時に撮らせてもらった一枚。好きなものはそのままるごと好きにならなくちゃいけない訳じゃないし、苦手なものの中にも一部位は「ま、ここは好きかも」な所があるし、好きと嫌いは同じもの、もしくは人の中に両立してて、同居もしてるのを認めると受け入れられる許容範囲が広まる。目の前にあるものも人も変えられない。唯一変える事が出来るのは自分の見方、考え方。

P259
青山、みゆき通り、ヨックモック、伊佑子ちゃん。会うのは確かDouble Maisonの展示会以来。Sorelのブーツの撮影で、彼女が選んだのはツイードのブーツ。なんでもホームページをくまなく探して見つけ出してきた、って。長い、長い月日、ハイブランドからチープなものまで着物から洋装、最新のものから古い時代のヴィンテージ沢山の服を見てきて、着てきてそして「今」がある。ファッションにおける審美眼を研ぎ澄ましながら生きてる生粋のエキスパート。口に手を当てて破顔大笑。女の子ってこういう事だ。

P260
モードスタイルにストリートのエッセンス。彼女は、もう最近はいつも会うたびにレンズをむけてしまう。ファッションにおけるジャンルやテイスト、トレンドだったり、ブランド名、という記号。彼女はそういった全てをいったんフラットにして、ファッションを見てる。スーパーフラットな視点からチョイスされたモノで組み合わされたスタイルはもちろん超越的で、そして何よりも自由で。将来やりたい事の欄。きっぱり「ファッション!」って言いきってある。このビックリマークの力強さと言ったら! 彼女みたいな人達がこの街にいる、という事はなんて頼もしい事なんだろう。オモハラビル前、友だちと待ち合わせ中、これから一緒にごはんにでかける前の一枚。

P261
夜、原宿ラフォーレ前。彼は原宿で良く撮らせてもらう美容師さん。彼は着こなしにおいて「面」で観る人なのかなって思う。絵を描くみたいに「これくらいの分量でこの色(や柄)があったらいい」「これくらいのバランスで色(や柄)を配置したい」って自分の身体をキャンバスに見立てて、スタイリングを組み立てていく。その自由さが、レンズを向けないではいられない理由。ファッションは、自由。

P262
ストリートスナップの女神は微笑んだ。

初めて彼女と会った時は、今のようなフォトグラファーとしてのオーラをまとう前の、若くてかわいくて写真の上手なお嬢さんだった。ただその頃から、写真を撮る時

に被写体に見せるパッと花開くような笑顔は、彼女の写真家としての特別な何かを感じさせていた。彼女が写真を撮り始めた2004年頃は、ストリートスナップというものに対して、モード業界はまだ懐疑的だった時代である。すでにファッションの大きな流行の物語が終わり、「今年の流行」という言葉が空洞化していた過渡期に、東京の街はセレブカジュアルからロリータまでまさに百花繚乱。その混乱した時代にラグジュアリーブランドが大挙して表参道に上陸したのだった。当時はストリートとモードの両立なんてものほか、お互いが無視しあい、時に嫌悪すら感じていたかもしれない。しかし東京のストリートカルチャーはどんどん進化し、音楽とグラフィティとスケートボードは彼らのファッションを拡張していった。長い間、メゾンブランドはそんな若者たちの心を掴めずにいた、というかその気もなかったかもしれない。リアルな街の空気と、白ホリのスタジオでプロたちが頭で考えるファッションは完全に解体していたのだ。東京らしいと言われるミックスコーディネート(スポーツミックス、甘辛ミックス、ハイ&ローミックスなど)は、白ホリのスタジオからは生まれない。「街で映えてこそのファッション」……ファッションがコミュニケーションツールとしていかに有効であるか、この街だからこそこの服があり、この仲間たちがいるからこの服を着る。そんな東京のグルーヴを彼女はおそらく直感で感じ取っていたにちがいない。
その嗅覚は東京でもパリでも世界中の都市で変わることなく、磨きがかかっていった。東京のキッズたちを撮るように、海外のセレブにも臆することなく同じように、彼女はにっこり笑いながらカメラを向ける。彼女のフォトグラファーとしての自信とオーラがメキメキと輝きだす。原宿の路地裏でもパリのショー会場の前でも、そこにビビッと来る人がいる限り絶対につかまえて、同じ目線でシャッターを押す。彼女の被写体を選ぶ視線は、どこのブランドを着ているかではなく、常に全体のバランスだったりその人に似合っているか、ファッション哲学を醸し出している人々だ。彼女は決してセレブだからとシャッターを押すことはない。常に被写体が"ファッションである"か否かである。
それにしても、あのコレクション会場前の人々の喧騒の中で、どうすればあんなにキュートな表情を引き出せるのか。もみくちゃの群衆の中で、どうすればあんな完璧なアングルで洋服を美しく見せることができるのか。それは現場で見ていても常に謎である。唯一他のカメラマンと違うのは、彼女のなんとも言えない無邪気な笑顔なのかもしれない。アスファルトの上でシャッターを切る瞬間、外の世界と切り離されたかのように、被写体と彼女の2人だけの静謐な空間がそこに生まれる。まるでそこだけ無音のように。映画『ピンポン』を見たことがある人は、あの真っ白で美しい空間を覚えているだろう。写真を撮り終え、確認した彼女が「サンキュー!」と声をかけるとその空間はあっという間に消え去り、撮られた側はあっという間に日常へ帰っていく。ほんの少し嬉しいようなくすぐったいような気持ちを抱えながら。世界中で一番オシャレさんたちが集まる場所で揉まれ続け、数々の経験を経て研ぎ澄まされていった彼女は、やがて撮る側としてではなく、撮られる側にもなっていった。
パリやミラノの華々しく喧騒の舞台で、ひとりカメラを構える華奢な姿は、いわゆるパパラッチとは一線を画したスナップフォトグラファーのひとつのアイコンになっている。ラグジュアリーブランドのデザイナーたちがランウェイで膨大な才能と金によって最高峰のものを見せてくれるように、彼女の写真もまた彼女自身もストリートの最先端になった。
時代は変わり、今やメゾンブランドとストリートファッションは切っても切れない関係にある。メゾンは進んでストリートの雄を抜擢して、新たな展望を築こうとするし、ストリートテイストそのものもメゾンに組み込まれてい

った。
シトウレイがスナップを撮り続けているこの10年くらいは、東京のファッション誌のスナップムーブメントとも重なっている。メンズ、レディース、モード誌、カジュアル誌問わず、とにかくスナップ特集なら完売! という時代。読者もアパレルメーカー側も、パリコレ通信ではなく、ストリートスナップから「明日なに着るか」をイメージしてきた。そこには、高い象牙の塔の中のハイブランドではなく、ストリートとハイブランドがミックスされたファッションの提案がたくさん生まれていた。そしてファッションがより自由であることを高らかに謳い、その人が似合ってるのが一番であるというメッセージに富んだ彼女の写真が、あちこちで花開いていく。ストリートスナップに対する時代の熱望と、彼女がスナップを撮ってきた今までの期間は奇跡のように合致する。彼女が敬愛するビル・カニンガムがストリートファッションの重厚な歴史絵巻の作者だとすると、彼女はヴィヴィッドな時代ならではのヴィヴィッドな写真家であり、常に最前線で戦う笑顔の戦士である。ひとりで世界を回り辛い目にも遭ってきただろうが、決して泣き言は言わず、いつも周りがパッと明るくなるような弾ける笑顔で最新のストリートファッションについて楽しげに語るのだ。
これだけ多くの世界の人々のファッションとそこから透けてくる人生の断片、そして彼らのシトウレイとの偶然の出会いと煌めくような一瞬の対峙。この写真集はその貴重な集積である。

中島敏子
大学卒業後、(株)リクルートを経て(株)マガジンハウスに中途入社。『BRUTUS』編集部で約7年間アートとファッションの担当をした後、『TARZAN』編集部に異動。格闘技に目覚め、空手を始める(黒帯、弐段)。『relax』編集部副編集長として、ストリートカルチャーからファッションまで特集を担当。カスタム編集部に異動後、自衛隊の雑誌を作り話題になる。2011年に『GINZA』編集長に就任、ファッションとカルチャーの融合されたオリジナリティの高い雑誌として大リニューアル。2018年に退社、独立。現在はフリーでプロデュース&編集など。

P266
シトウ レイ
日本を代表するストリートスタイルフォトグラファー/ジャーナリスト。石川県出身。早稲田大学卒業。
被写体の魅力を写真と言葉で紡ぐスタイルのファンは国内外に多数。ストリートスタイルフォトグラファーとしての経験を元に TVやラジオ、ファッションセミナー、執筆、講演等、活動は多岐に渡る。
instgram:@reishito

Acknowledgments

Interviewees: Chitose Abe,
Motofumi "Poggy" Kogi,
Scott Schuman

Contribution: Adastria Co., Ltd.

ADASTRIA
Play fashion!